The Adventure Game

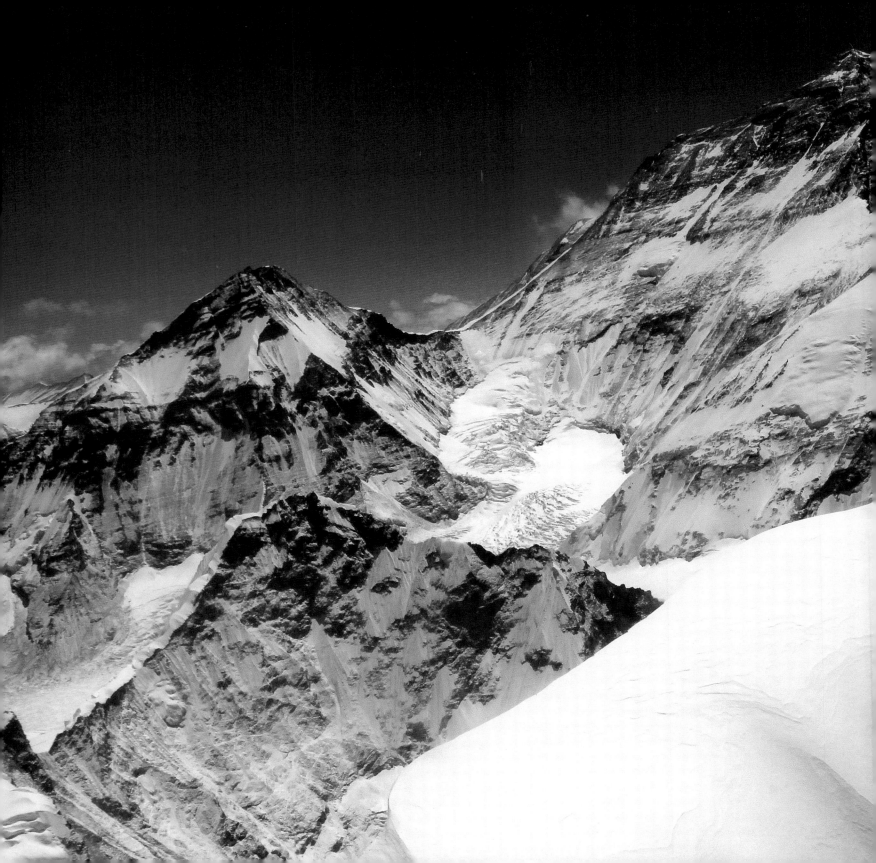

Keith Partridge

The Adventure Game

A Cameraman's Tales From Films At The Edge

SANDSTONEPRESS

Half-title (page 1): Sorting ropes deep inside an Alaskan glacier.
Title page (pages 2–3): Everest, Lhotse and Nuptse with Pumori (foreground).
Pages 6–7: Himalayan flutings.

First published in Great Britain
and the United States of America in 2015
Sandstone Press Ltd
Dochcarty Road
Dingwall
Ross-shire
IV15 9UG
Scotland

www.sandstonepress.com

Editor: Robert Davidson

 The publisher acknowledges support from Creative Scotland towards publication of this volume.

ISBN: 978-1-910124-31-4
ISBN e: 978-1-910124-57-4

Book design by Gravemaker+Scott, Amsterdam
Printed and bound by Ozgraf, Poland

Acknowledgements

This book came about from a chance meeting on a train after I'd slumped into the seat nearest the door, leg in plaster, crutches flailing as we accelerated on our way towards Edinburgh. With eight inches of titanium drilled through my right ankle the man in the next seat, struck up a conversation, 'was it football?'. That man turned out to be Bob Davidson from the Sandstone Press. It pays to chat on trains.

A project such as this I found incredibly daunting and there are many whom I need to acknowledge and thank for their support, encouragement and input. If I've forgotten anyone then I'll offer my humblest apologies.

A massive thanks must go to Steve Backshall, Joe Simpson and Stephen Venables for their eloquent words both on the cover and at the start of this book and to Richard Else who, together with Triple Echo Productions, kicked off my adventure cameraman's career and have kept the ball rolling ever since.

I am also indebted to Bob Davidson and all at the Sandstone Press for believing in my ability to pull a few words and pictures together and to Ruth Killick for 'putting it out there'.

I am also eternally grateful for the following productions in allowing me to utilise my humble skills with a camera in providing moving-image content. I am always stunned that they manage somehow to make sense out of my shots and allow them to tell the stories.

'The Edge', 'The Face', 'Wild Climbs', 'Inside Story – Mountain Rescue' and the 'Great Climb' live on Sron Uladale, Harris – Richard Else, Margaret Wicks, Laura Hill and David Taylor of Triple Echo Productions.

'Venom Hunter' and 'Expedition Alaska – Moulin' – Steve Robinson, Indus Films.

'Touching The Void' and 'Beckoning Silence' – John Smithson, Darlow Smithson Productions.

'The Climbers', 'Lost Land of the Jaguar – Upuigma', 'Lost Land of the Volcano – Mageni', 'Human Planet – Mongolia, Galicia, Greenland, PNG and Indonesia', 'How to Grow a Planet', 'Mountain Men', 'Top Gear', 'Young Explorers – Kaiteur', 'Blue Peter – Swiss Dam', 'Horizon – South Pole' – BBC.

'St Kilda' – Gaelic Arts.

'Old Man of Hoy' for the One Show and Berghaus through Real Life Media.

'Ian Wright's Excellent Journey – Greenland' – Princess Productions.

'Alien Versus Predator' 20th Century Fox.

I am also grateful to the following who have allowed me to use their photographs to supplement my own for it is nigh on impossible to take stills when I am wrestling with film or video.

Steve Backshall, Nick Brown, Dave Cuthbertson – Cubby Images, Tim Fogg, Rory Gregory, Brian Hall, Leo Houlding and Fraser Rice. A special thanks must also go to Brian who's terrific shot adorns the front cover of this publication.

And of course there's the amazing team of people that have enabled me to operate in some pretty dodgy looking situations over the years, Brian Hall, Mark Diggins, Dave Cuthbertson, John Whittle, Rory Gregory, Paul Moores, Harry Taylor, Tim Fogg and so many others that have played such a vital role in all the film projects.

Finally, and by no means the least, to Andrea for holding the fort and for looking after Jamie and Erin while I've been away having all the fun.

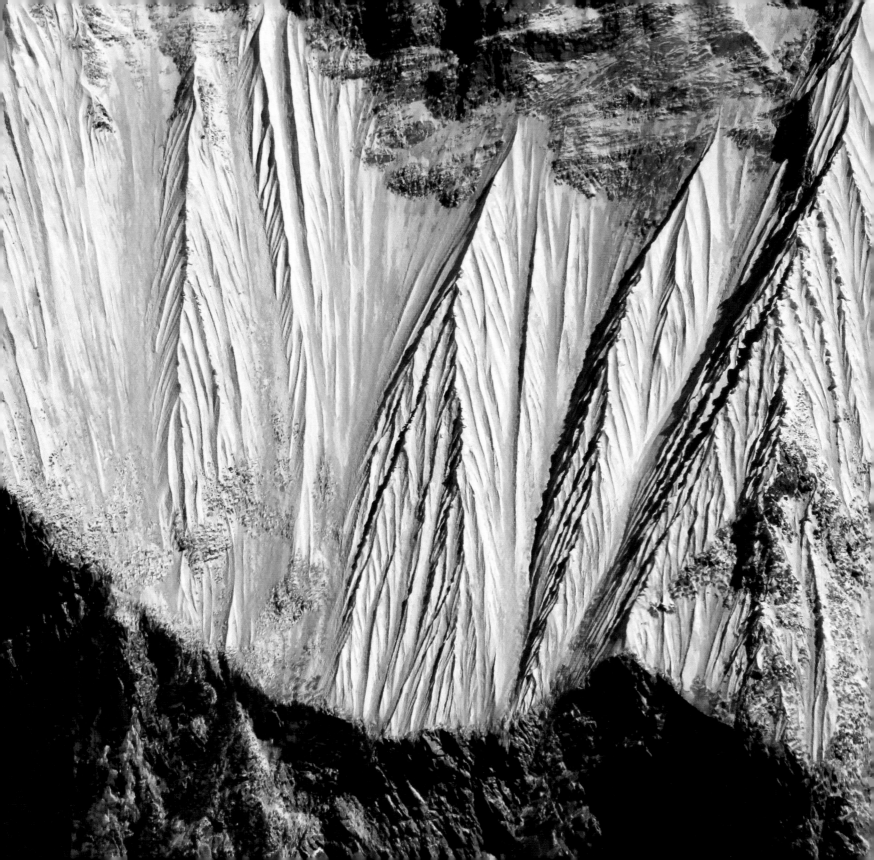

Contents

Foreword

Keith Partridge is to my mind one of the greatest adventure cameramen in the world. Over the last decade, Keith and I have done some wild things. We've made first ascents of mountains, and first descents into cave systems that have never before seen light. We've faced down machete-wielding tribesmen, caught the world's most venomous creatures, and spent many months under canvas in some pretty mad places. On a journey into the moulin maelstrom in the guts of a glacier, I got swept away and found myself teetering over a chasm with nothing but crazy crashing blue and certain death below. Keith got the whole thing on camera, despite the fact that he was standing beneath a zero degrees waterfall. Off the coast of Alaska, we nearly got swallowed by fifteen humpback whales as they rushed to the surface in search of herring. We've endured jungle caves, hurricane-swept mountains and vertiginous drops, and throughout it all, Keith has never missed a shot. Never. When I took my big fall on the first ascent of Mount Upuigma in Venezuela, Keith had spotted the crux and positioned himself above me in order to be framed on the perfect shot when I fell. When I had endured the stings of a hundred bullet ants in a tribal ritual in Brazil, Keith was focused on my face as I screamed like a banshee and passed in and out of consciousness. His concentration is legendary. I've been on overhanging ice, banging away with my axes for all I'm worth, and Keith will be alongside me, twisted backwards, his whole weight supported on one extended crampon frontpoint, holding his breath so the shot doesn't bounce up and down!

All of this makes him sound justifiably heroic, but doesn't tell the story of what KP is really like. The first time I saw him, with his squaddy's haircut, his chunky climber's hands and failure to ever wear anything other than his PE kit, I thought he was going to be an insufferable drill sergeant. However, he turned out to be someone with all the old-fashioned values that a mountain Brit ought to have: loyalty, enthusiasm, courage, and a ruthless determination to see the best in everything. The older and wiser I get in life, the more I like to surround myself with effortlessly capable people. Those who have nothing to prove, whose calm and competence increases the harder things get, whose humility belies great accomplishment. Particularly important as I personally have very few of these qualities! KP however has them all. And however bad things get, Keith never stops smiling. Our lowest moment together was on the exploration of a cave system called Mageni in New Britain. After several weeks of hammering jungle rain, camped out under a leaky tarpaulin, all the film cameras were giving up the ghost. The expedition was brutal, even without the pressure of having to make a movie out of it, and was taking its toll on all of us. Most of all Keith, who didn't just have to lug himself ten hours through the forest and early parts of the cave system before we even started filming, but had to keep the cameras rolling throughout. Eventually we decided to abseil the hundred or so metres alongside the waterfalls pouring out of our caves, to the plunge pool that lay in the canyon beneath. It took two days to rig the ropes, and perhaps four hours to drag ourselves down to the pool itself. But when our feet finally touched down, in this insane, pressure-washer of a Lost World, the camera died. We were in a staggeringly beautiful place, and there was no way to record it. I was beside myself, bursting with rage and frustration. Keith just gave me a big hug and said; 'Let it go Stevie.' He then pointed up to the raging white falls, gushing down from eye sockets in the vertical rockface above us. 'How many people have ever seen this? Let's just enjoy it.'

Keith is also the master of understatement. Situations in which one nearly dies are 'a bit spicy'. Chossy rockfaces covered in

shrubbery, with boulders the size of fridges plummeting off them are 'a little sketchy'. Climbers who dangle solo off El Cap are 'quite bold'. He isn't though always so economical with his words. Whilst we were making our extraordinary first ascent of Mount Upuigma, we were camping out in portaledges on the vertiginous rock faces. Keith was sharing his ledge with Tim Fogg (another filming legend of equal poise and composure), but a little after dawn Tim stepped off the ledge to start packing his paraphernalia, and in doing so overbalanced the ledge, which promptly flipped. Keith was woken up bouncing in his sleeping bag with hundreds of metres of empty air beneath him. Air that Keith soon turned blue. When we eventually summited, we found a forgotten environment that was quite the most beautiful place I've ever seen. For the next four days, we all wandered around, mouths open in wonderment, knowing no human being had ever seen any of it before. It was the most special, most treasured moment of my life.

Keith and I also share a common disability. Both of us smashed our ankles up in identical ways in climbing accidents, and battled with every surgery under the sun before giving in to inevitable fusions to solve the pain. The only difference being that Keith summited Everest before he gave in. I could barely walk to the shops. Everest, Touching the Void, and his other gold-standard achievements have sadly been done with other, much more competent climbers than me, so are best left to others to talk about. I'm just glad and proud that I've had the opportunity to write a few words to say thank you to someone who has done so much for my career, so much to make me look good, and has been the unsung hero behind the lens while I've been flexing and talking bobbins in front of it, getting all the glory.

Steve Backshall, *Television Presenter and Naturalist*

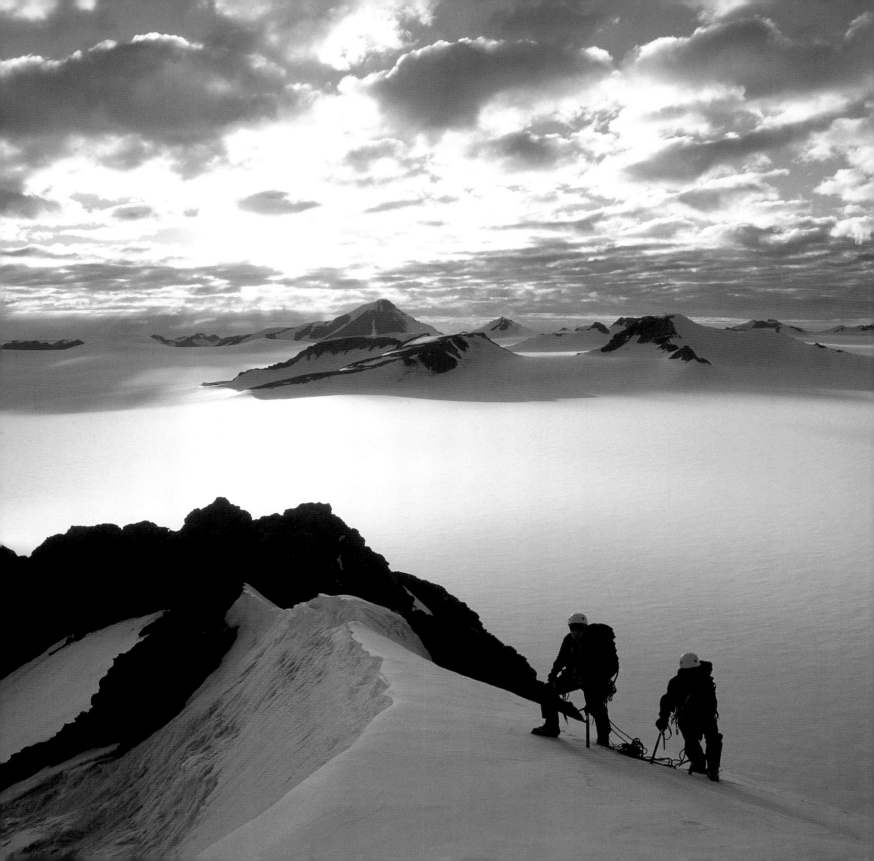

Adventure filmmaking has a steep learning curve that doesn't seem to ease off, even after twenty-plus years. Rarely do things run smooth so, over that time, my sleeves have just puffed out, filled with alternative plans devised through experience. Alongside an overall competency in the hard skills of surviving, in any number of environments from jungle and desert to high mountain, there are the logistical issues: the sheer physicality of hauling oneself and camera kit, mastering complicated rope systems to position the camera almost anywhere imaginable, an acute knowledge of all the elements of filmmaking from the technical to production, not to mention the art of story-telling. Attention to detail is king, as is gut reaction and learning to read people in stressful situations when the best material is often to be had but is the most difficult to record.

Over the years I've filmed on some of the world's most challenging mountain faces, climbed to the highest point on Earth when almost too hypoxic to operate a camera, hung from giant monolithic overhangs and endured the overwhelming vertigo induced by the most gravity-defiant natural structures on our planet. Camera in hand, I have captured thrills and excitement that have inspired many to seek new ways for their own creativity.

The world of adventure knows no boundaries where success is more often driven by the head and the heart. As such, to develop a broad sense of personal limits is a most useful attribute, allowing the transfer of skills to theatres beyond the mountains, be they into the aerated surf of an Atlantic swell, the apocalyptic innards of a belching volcano or deep inside the earth's caverns.

I've grown accustomed to situations that set unusual parameters, but you could say that boundaries exist only in the head: what you're willing to do, where you're willing to explore. Dark recesses are frightening places and dark recesses of the mind especially so. I try not to think about them too much. Instead I try to guess what's out of sight and reach; how I might shine a light on somewhere unknown. It's about a willingness to go beyond, to confront demons. It's about the people you're with, kindred spirits if you like, and for me it's so much more than a job, being an adventure cameraman.

I cut my adventurous teeth in the world of mountaineering. As an activity I have by no means reached the limit of what I might accomplish or, more to the point, come close to the level that my peers operate at, those whose exploits I seek to capture with my camera. I have always had to dig deep within my psyche on filming adventures and most of the time feel like an impostor. The on-camera performers are always better climbers and adventurers than I, but that's not why I am there.

More often than not I am the film equivalent of a hod carrier. I get hired to provide the building blocks for the ideas put to me by a series of very talented production teams who are themselves the architects of the screen.

To capture the essence of adventure through film requires a different set of skills though, enhanced by an attitude comparable to those on the other side of the lens. I too have to be willing to put myself 'out there' to capture the action. Think of watching pass-the-parcel played with a hand-grenade and you begin to get the idea. I have no idea when, where or who will have it when it goes off, but by means of luck, a sixth sense, or a befriending of those demons that conspire against my subject's desired outcome, no matter what, I have to be in position and prepared when the moment arrives.

We all have it in us to be adventurous and explore, in the widest sense, the geographical, the emotional and the technical, but not everyone chooses to do so unless something stirs the imagination and the germ of a new destination suddenly erupts into life. Our first steps towards that new destination begs questions: why, how and when will we reach our goal? The word 'will' smacks with the driving force of commitment but it is the search for answers that powers us. After all, curiosity and creativity are the things that have made humankind. As a species we have always enjoyed an insatiable appetite for the view round the next corner and employed our creativity to make journeys to places we did not previously know existed.

All too often our risk-averse society, or our own over-active thoughts about mortality hold us back. We are more capable than we give ourselves credit for, but the flow of excuses is often hard to stop, and maybe the game is just too complicated to see through to a conclusion. The hurdles look too high and the benefits too difficult to quantify. Beyond all the usual comments about the role of adventure in terms of developing personal traits that may prove useful or compatible with society's expectations, the main thing remains: it is more fun than a child can have in the world's best toyshop and sweetshop combined. Strange then that for a lot of the time adventures are arduous, uncomfortable and stressful in situations that can't end soon enough. But within minutes of arriving back in comfort-land you cannot wait to be back honing the edge.

Some people might use adventure to find themselves, others to forge themselves even if they're not conscious about this at the time. In my mind we must be shaped not only by what we have done, but also what we are willing to do. For the adventurer the unknown develops like a tornado, spiralling upwards on a vortex of previous experiences, each more dynamic and complex than before. Those powerful forces are more in control than we can even hope to be, and the art is in not being flung off, but the endorphin rush of each completed adventure is dangerously addictive. The nearer we come to losing our grip, it seems, the bigger the rush. Like most addictions it's vital to retain control; a hardened user may well err on the reckless side for the next calamitous hit. Withdrawal means frustration and madness. A regular fix is sanity.

Introduction

Chasing
the
Dream

The news went round the BBC studios like wildfire.

It felt like I'd just walked off a cliff and was falling away from all the secure things in life that I'd previously thought important. The impact was likely to leave me destitute and bruised when it came, but everyone dreams and I found that stepping into the unknown was as intriguing as it was terrifying. The news went round the BBC studios like wildfire. 'Keith's given up!'

My resignation was reported in the staff magazine with a mixture of disbelief and curiosity. Colleagues with whom I had worked as cameraman and sound recordist since leaving school all wanted to know why, and I wasn't sure that I was capable of an answer. My mind had been in a quandary, questioning who I was, what made me tick and where I wanted to go, but I didn't like to admit it. It just felt a bit wet.

Each weekend I climbed the mountains and crags of the Lake District, Wales or Scotland. The euphoric feelings of reaching the summit, of days pitted against the elements and epic brushes with misadventure had become obsessional, but a career with the BBC was something to be treasured. Wasn't it? To many I'd just thrown it all away to search for a path that might not even exist. Combining my fledgling career in television with mountaineering, adventure and expeditions did seem like a pipe-dream but if I didn't make the leap I would suffer a lifetime of regret, forever cursing that I didn't have the courage to chase my dreams.

I love the idea of peering into a crystal ball but, as a pragmatist, I'm not sure I would see with any clarity or believe in what it showed. People talk about having 'vision', but no one can predict the future. Ultimately, having faith in my own ideas proved to be my catalyst with eventual commitment providing the vital spark that turned them into realistic possibilities.

I hankered after far-flung places, adventures and a swashbuckling existence in wild and untamed parts of the planet that call for symbiotic relationships, where a close-knit team, that has served its time to better understand how that landscape works, can sneak in under the radar and get things done.

It's been over two decades since I embarked on this journey with its uncertain outcome. It is a journey of a lifetime, and I say 'is' because the end of the road is still not in sight. Some might find that sense of uncertainty unsettling, but the remarkable planet on which we live and the intricate ways we have found to survive and explore our environment are the very things that keep me going. From the white water caves in Papua New Guinea to the Eiger's North Face, the summit of Everest and the sulphurous interior of an active volcano, the stories perplex and inspire.

The day I handed my resignation letter into the personnel office it felt as if a suffocating, black cloud had lifted. There was still no clear view of the future but the overbearing atmosphere of doom and gloom was gone. I headed to the Lake District with my great school friend and flatmate, James. Growing up in the flat-lands of North Norfolk we had stared wide-eyed at books about the mountains and had begun our climbing 'careers' together. The weather was wild and wet but, for a run up Pavey Ark in Langdale, it didn't matter. At the end of the day we stopped off in Ambleside. Sheets of rain blew in on a blustery winter wind. The street lights reflected gold off the rain-soaked tarmac and crazy patterns streaked across the windows. We were in a climbing shop, the two of us gazing at the karabiners, ropes, ice axes and regalia of the modern mountaineer. A notice board by the door was covered in ads for second-hand kit and climbers looking for partners. One scrap of paper caught my eye. Hand-written in blue biro were twelve words, a name and a

'Keith's given up!'

→ Early days –
approaching
winter climbs
on the North Face
of Ben Nevis.

phone number. 'If you fancy coming to Iceland this winter to climb – call me. Paul Walker.'

By the date mentioned I would be a free agent.

Working out my notice seemed interminable but there was now something to aim for besides my 'Giving Up' party – a three and a half week expedition with a complete stranger, battling storms that race unhindered across the Atlantic, climbing and skiing on Europe's largest icecap in winter. I had no idea what I was letting myself in for.

It was early April 1990 when Paul and I headed out to Iceland's 8400 square kilometre Vatnajokull Icecap, a challenging Alpine environment sculptured by volcanic eruption and glacial action. With the weather stubbornly bad, bordering epic, we managed to haul ourselves, all our equipment and food up 1,800 metres of mountainside, dodging crevasses to establish a Base Camp on the flank of Iceland's highest peak.

Storm after storm raged outside our snow-cave. We knew because of the turbulent curls of spindrift that blew through our tiny ventilation hole. If we didn't poke it clear from time to time we would be entombed within the ice. Eventually I pulled back my numerous layers of clothing to check my watch. Paul and I had been in our sleeping bags for almost thirty seven hours. My bed had melted into a kind of half-pipe from the pressure of my body, and my hips, knees and shoulders were aching and numb from the insidious cold that seeped through my thin foam sleeping mat.

I tried putting my rucksack underneath and stuffing mittens down my long-johns but nothing stopped the bone-cracking cold. For a moment's respite I knelt up to urinate into my pee-bottle, the only time I'd ventured into an almost upright position. The moisture generated by my body, my breath and the stove that purred almost constantly between Paul and me had eaten into the goose down filling of my 'pit' and its loft had all but collapsed. In these circumstances the claim on the bag's label of being good to minus 20C was preposterous.

As the blue filtered light of day faded into another long night we lit candles. Cut into their tiny alcoves they burned down, shining a light through the layered textures in the snow as we chatted. It was time to stick a ski pole into the side of the wind, feel the flood of fresh air, have another hot chocolate and map out a future.

We talked for ages and, with hands and arms out of our sleeping bags, wrote in our journals for as long as we could bear to hold a pen. When the chill got to our fingers Paul blew out the candles and we lay listening to the rumble of the wind until we shivered into an uncomfortable doze in our two-man freezer. Dawn couldn't come quickly enough.

↑ Home sweet home – living in a freezer. Base Camp on the flanks of Iceland's highest mountain.

↗ 'Storm after storm raged outside our snow-cave. We knew because of the turbulent curls of spindrift that blew through our tiny ventilation hole.'

→ Blinded by shafts of sunlight, Paul Walker tunnels out after the storm.

→ *Finding gear dumped on the edge of Europe's largest icecap from a previous carry.*

↓ *The Vatnajoull. Peering into the future...*

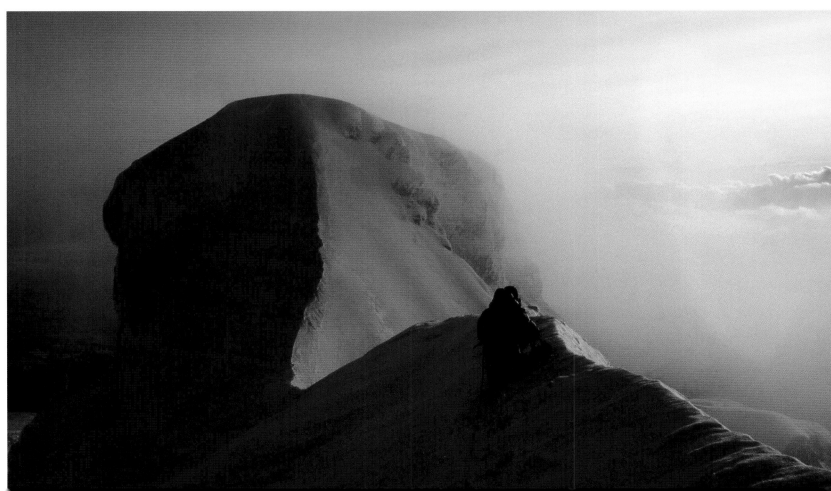

→ *The last kiss of the day
on the summit rime
of Hvannadalshnukjur.*

Encouraged by a brightness at the end of the snow cave's entrance we dared to peek at the outside world. Paul tunnelled on his belly through the giant drift that now blocked us into our cave until shafts of sunlight blinded us. In my frozen leather climbing boots everything below the ankles felt wooden: beyond numb.

For the first hour there was nothing except the worry of frostbite, but we knew that the weather had at last come good and that being active would get the blood flowing. The day was not to be wasted. We roped ourselves together and stomped across deep snow towards the whaleback ridge of Iceland's highest peak; jumping a couple of small crevasses that ran across the crest I began to scream as the blood finally forced its way through the fine capillaries in my feet. It was Easter Sunday.

Below us, to the north, a sensational cloud sea whorled, but the landscape to the west, across the improbable triple-spired Kirkjan, was truly captivating. The storms had coated everything with a thick carapace of fragile rime ice, and the shattered glaciers that cascaded down 500 vertical metres to the coast showed the immense forces that had shaped this incredible landscape. An avalanche thundered off the flank of Hvannadalshnukjur.

Returning home, I went round to the BBC studios to catch up with some of my colleagues in the social club bar. I'd known Richard Else for a couple of years, but only as a face in the building and through his work as a producer. He stopped me in the car park. The conversation was short and, initially, less than complimentary. 'Good grief, you look bloody awful! What have you been doing with yourself?' he laughed. 'I heard you'd given up.'

My face was the shade of old brown leather and my lips swollen and cracked, my hair a tangled mess in need of a cut. I told him briefly about the Vatnajokull and in his next breath he asked if I fancied going to the Himalaya in the autumn with Chris Bonington to record sound on his documentary, *The Climbers*.

The BBC series would be an examination of the history of climbing with this episode looking at the development of high-altitude mountaineering. Fine-art lecturer, painter, film-maker, writer and general raconteur, Jim Curran, would shoot. Bonington, who was fronting the series, would be in the company of Charles Houston and Sigi Hupfauer. Charles, an expert in high altitude physiology, had been on the ill-fated expedition to K2 in 1953 among many other pioneering trips to the Himalaya. The German alpinist, Sigi, had met Chris on the first ascent of Eiger North Face Direct back in 1966. He had also climbed Nanga Parbat, the mountain that we were going to use as a backdrop to the filming.

Nanga Parbat forms the western anchor of the Himalaya and is the westernmost 8000 metre peak, lying just south of the Indus River in the Diamir District of Baltistan. Not far to the north is the Karakorum range, home to K2. The frontier land in northern Pakistan and the eighth highest mountain in the world was such an exciting prospect that I had to bite my lip really hard or I would have taken Richard's hand clean off. We parted company, my head spinning through the door that had just opened onto my first freelance job.

It was late in the summer and hot for England when Jim Curran and I drove to Heathrow with an estate car loaded to the roof with the aluminium flight-boxes that are the hallmark of film teams. I'd read Jim's book and seen his K2 film about the 1986 disaster that had claimed thirteen lives, but sensed he would prefer a lighter tone for our conversation. He regaled me with tales of daring calamity, name-dropping with great regularity: Joe Brown, Don Whillans, Bonington. He seemed to have climbed with or filmed them all. His slightly barrel-chested build heaved as he laughed at

his own stories, his legendary raconteur status fully intact.

I admit to feeling overawed by the company as we sat for dinner at the airport hotel, all people I'd read about and respected for their mountaineering achievements. What had I done to deserve being there? As the new kid on the block I sat quietly, self-conscious and feeling out of my depth, nervous that I had nothing worthwhile to contribute. Underneath though, I found it impossible to keep my excitement to myself. Later I lay in bed and had to phone and talked without drawing breath to James, hardly able to believe what was happening, and didn't sleep a wink.

Somehow we'd ended up in the 'upstairs' bit of the jumbo for the flight which, by the time we'd reached Islamabad, left me wondering how bad economy must have been. However, there were recompenses. The hostesses in their green silks woven with gold looked so alluring and exotic I found myself looking into their rich cocoa eyes for longer than I probably should have.

When the plane's door opened, the humid smell of the tropics flooded in and I was instantly reduced to a sweaty mess. Our Trekking Agents, from Baltistan Tours, met us in the arrivals hall and drove us to our hotel, the 'Shalimar', in the neighbouring old capital, Rawalpindi, where Jim suggested that we head for the Rajah Bazaar for a spot of pot buying or souvenir haggling. Everyone else, veterans of travelling in the Indian sub-continent, took it in their stride. I felt slightly nauseous as we pushed aside the sultry afternoon air hung heavy with the smell of spice, animal dung and sewer.

A battered blue canvas-covered butcher's van was being unloaded as swarms of flies used it as a maternity ward. The joints of meat were like the workings of a tortured, mad axe-man. In the next alley a fast food joint had a row of plucked chickens hooked through their necks and hung in a neat line above the serving counter, behind which the owner sat cross-legged on a raised platform frying pans of onions and tomatoes over a spluttering kerosene stove.

The narrow streets were a chaotic flow of male humanity. After we were nearly mown down by a donkey cart, its solid wooden wheels out of the Middle Ages, I decided to escape back to the calm of the hotel for a second sleepless night, this time not fuelled by excitement but by trepidation and a suffocating air.

Keen for the cool of the mountains, we checked all the gear in for the short flight to Gilgit. As we approached the twin-propeller aircraft on the melting tarmac we were asked to identify our luggage including our fine collection of flight boxes. Duly marked with chalk they were put into the hold, the engines were spun, and prayers were said for a safe flight but, as we taxied to the right, we saw through the plane's scratched plexiglass windows that all our luggage had been off-loaded! Unfortunately for the time being we were on a very expensive trekking holiday to the Northern Himalaya. Chris and Richard were seething.

Gilgit was far less manic than Rawalpindi and there was little to do other than wander around the market stalls that sold apples, apricots and walnuts while we waited an extra day for the gear to catch up. With our equipment returned we headed into the Indus desert as the thermometer crept up to a skin-melting +50C. Our minibus stopped at a dilapidated building at the turn onto the jeep track that would lead us to the trailhead and the Diamir Base Camp of Nanga Parbat. Here the sun cast a thin shadow from the coarse block and steel rebar walls and we stood with our backs pressed firmly into the cool, to prevent ourselves being cooked alive, and waited. Finally a jeep arrived and we bumped up the

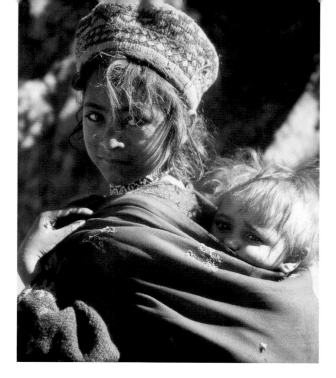

↑ *Diamir children.* ↓

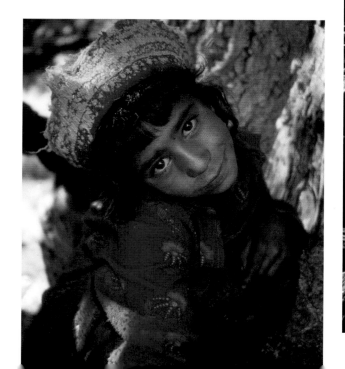

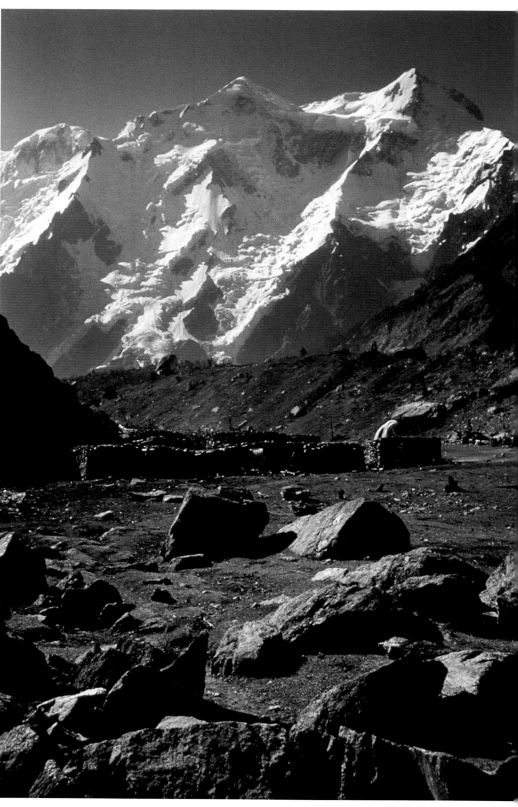

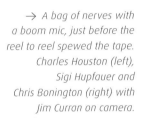

← The upper reaches of the Diamir Valley en route to Nanga Parbat, N Pakistan.

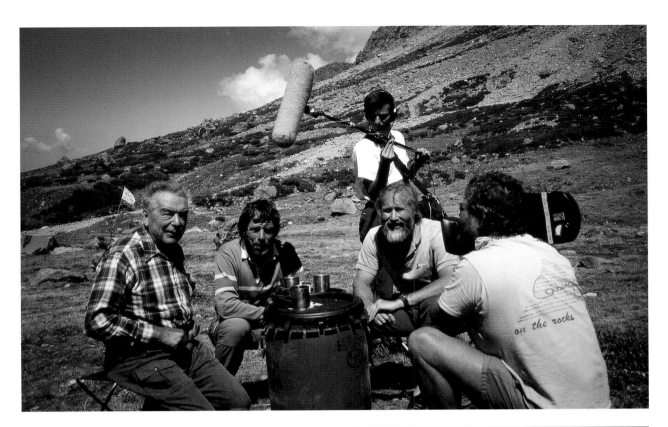

→ A bag of nerves with a boom mic, just before the reel to reel spewed the tape. Charles Houston (left), Sigi Hupfauer and Chris Bonington (right) with Jim Curran on camera.

→ Checking the recording had stuck at Diamir Base Camp.

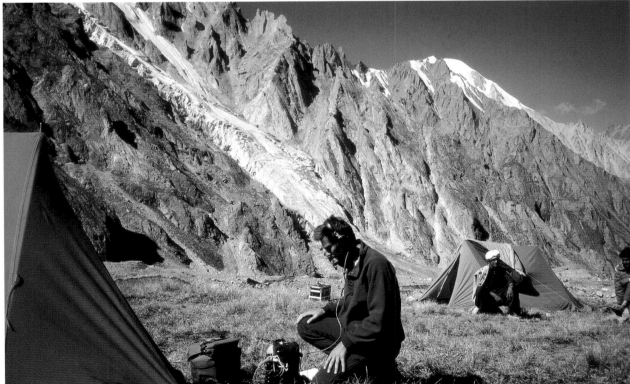

track to pitch tents for the night between a concrete irrigation channel and a deep gorge.

I woke with a violent dose of stomach cramps. Below our row of orange A-frame canvas tents the roar of the river was accompanied by the rumble and clatter of tumbling boulders. There was a gentle rain in the air. The last one up, I went to find a spot for my morning ablution. As I turned the corner beside the irrigation channel a chain of 'Good mornings' sounded. Everyone was suffering from Delhi belly and I joined the ranks. The rest of the trek up to the Diamir Base Camp disappeared in a panicky haze of making it in time, trousers down, retching and general malaise. Richard would come around a corner to find me lying in the fetal position by the trail having just suffered another violent bout.

At Base Camp Jim filmed conversations between Charles, Sigi and Chris. This was the first time Charles had been back to the mountains of N. Pakistan since 1953. He emotionally recounted their rescue of a sick Art Gilkey from very high on the mountain and the moment when they looked back to find that he had been swept away on his stretcher by an avalanche, never to be seen again. This tragedy had, in turn, saved the team's lives, allowing them to concentrate on their own survival.

I was a bag of nerves. It didn't help when the Nagra reel-to-reel recorder dropped a loop of tape and over the next ten minutes filled the entire space under the lid with our precious recording. As Jim cut the camera to reload I squeezed the lid release to see how much was left on the spool and hundreds of feet of recording tape leapt out like a jack-in-the-box. I tried to contain it by slamming the lid shut but Richard had clocked it. I apologised and thought I'd better excuse myself. With the aid of a biro, which was about the right size to manually wind the tape back onto the spool, I sat in my tent on

a mission to rescue the material. Luckily the tape was undamaged and the recording played back fine.

Back in Newcastle I took a long hard look at my finances at the display on an ATM. I was down to my last £27. The pay check from the Nanga Parbat shoot had been generous enough and the shoot, in retrospect, was a heap of fun, but the money didn't last long. Given the precarious nature of my income I could no longer afford to pay the mortgage on my flat or run a car but, since I had taken a radical step in terms of resigning from my 'job for life', it seemed no big step to rid myself of any drain on resources. I wanted to be mobile, free to take off whenever possible, so I put my flat on the market and advertised the sale of my car.

There was enough cash to pay off the outstanding car loan and, fortunately, I found myself with a solid amount of equity from the flat. I rented a room with ex-colleague and climbing partner Phill in the West End and my old boss at the BBC took me back with a series of short-term contracts. This kept me ticking over financially while I was free to come and go as I pleased. I also knew that I had to raise my game if I wanted to take adventure film-making seriously. I was nowhere near experienced enough in the expedition skills, the logistics or planning – or the shooting for that matter. Nanga Parbat had demonstrated that the career I wanted was a can of worms where just being able to cope technically with recording sound or shoot were minor parts of a big, complex and committing game.

Early in 1992 Paul Walker asked me to help guide the first commercial expedition of his newly established company, Tangent Expeditions. It was back to the familiar horrendous weather of the Vatnajokull only this time it was going to be a six-week trip. Expedition members included Paul, Ian Savage – who'd also studied Outdoor Education at Charlotte Mason College in Ambleside, Phil

through the blizzard. My eyelids started to freeze together.

Webster – a client and Stuart Britt, also an O.Ed graduate, with whom I was to share my tent.

During the first nineteen days of the expedition we experienced fourteen of white-out, blizzard and storm. It was winter so I'm not sure we expected anything else. During one such battering, with our three tiny tents pitched on the icecap, the visibility was so bad we couldn't see our feet because of the spindrift (that was before we resorted to crawling). We gave up digging a snow-hole, which would have been much safer and quieter, as it filled faster than we could shovel. The ferocity of the wind was so great it sucked the air from our lungs and it felt like we were drowning in spindrift.

Crouching at the door of my tent I threw an extra bag of food under the snow valance and tied a rope to the snow-stake holding the porch down. Despite Paul's tent being only two metres away I couldn't see it through the blizzard. My eyelids started to freeze together. On my hands and knees I dragged the loose end of a rope towards the other tents and tied it as a lifeline, checking if anyone needed extra food or fuel from the pulks.

Twelve hours later we were still hanging onto our flimsy nylon shelters. Snow had been forced through the tiny vent at the top of the door panel, filling the gap between the flysheet and the inner tent. Thirty-six hours after things had turned nasty Stuart and I were holding the roof of the crushed geodesic tent up with our knees, telling each other jokes and making light of the situation. Paul later told us he'd written an entry in his journal to his girlfriend Lucy, one of those 'just in case' kind of entries.

We tried to lay down ground rules but the natural forces at work in such environments tend not to play within our lowly parameters. Often they prefer to increase the stakes without asking if the players can afford to lose.

Once the storm abated Phil, who was sharing with Paul, refused to continue. It took us a week to get him off the ice, costing us so much time that the expedition's aim of crossing the icecap was no longer feasible. It was bitterly disappointing and our final goodbye to Phil was a confused, slightly frosty affair. We organised transport round the coast to the base of Iceland's highest peak, familiar ground from our expedition of two years before.

With so much to haul up the mountain we decided to leave the tents amongst the stone ruins of the farmstead of Sandfell, but took as much food and fuel as we could carry. Paul and Stuart lifted my rucksack, complete with a two-metre sledge or 'pulk' strapped to it, onto my back. Under its weight I felt my femurs grinding in my hip sockets as I moved off. The lower slopes were relatively snow free but the loose 'clinker' basalt gravel made for an awkward climb. To make matters worse, the sledge acted like a giant sail, causing me to stagger like a drunk in the gusts.

The ascent route hadn't changed in the two years since we'd last used it, effectively short circuiting the first half of the east-to-west traverse of the ice cap. Once again we established a snow-hole on the flanks of the highest peak, Hvannadalshnúkur, but this time Base Camp was a much more luxurious affair with its entrance tunnel leading to the main chamber and a sleeping platform, big enough to sleep six, cut into the snow. Off to the left was the en-suite with a pit dug for a toilet and off to the right was a storage chamber for food. The snow saws and ice-axes acted as hooks for the ropes and harnesses. During the storms we would dig to stay warm before barricading ourselves in, listening to the rumble, all other sound muffled by the metre plus thick roof. One of the pulks acted as a giant door and was marked outside by a single red flag that flapped madly from the aluminium trace-bar.

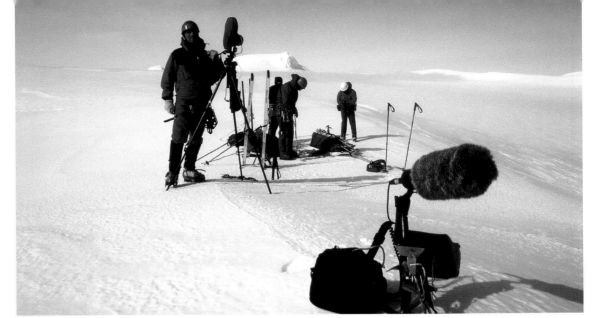

→ *Flying solo – my first film kit in action in Iceland.*

→ *Finally retreating to the tent before being buried alive.*

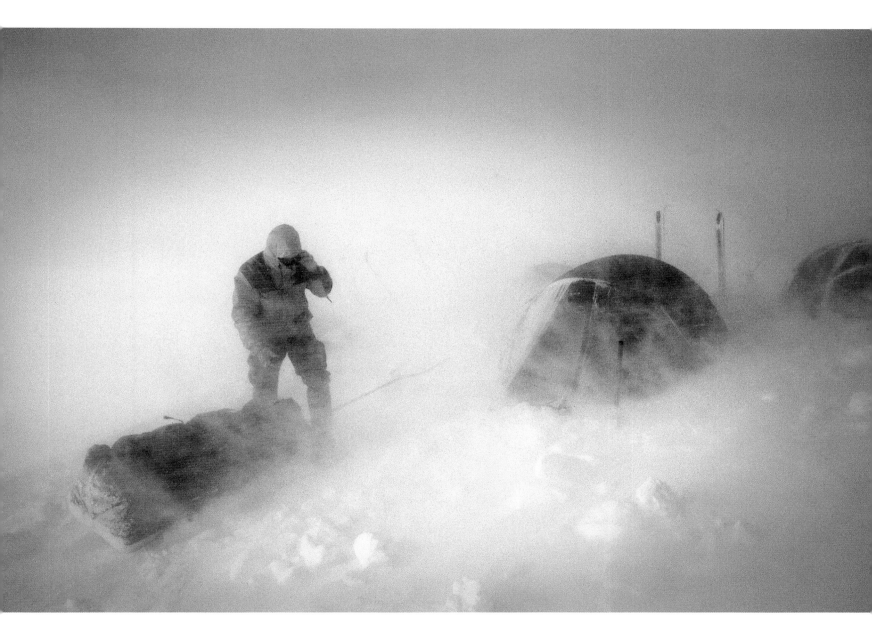

↑ *The ferocity of the wind*
sucked the air from our lungs.
It felt like we were drowning
in spindrift. Storm-camp
on the Vatnajokull.

Stuart and I dropped off the ice to collect two more clients, Kim and Sam. This was to be their first real taste of an expedition. We sprinted off the lower basalt slopes to the old farmstead shouting and waving as the jacked-up bus they should have been on drove along the road. It didn't even slow down, let alone stop. I spent the rest of the day walking the road to Skaftafell in search and trudged the 15km back to no avail. Kim and Sam had hitched to try and find us but like ships in the night we'd passed and it wasn't until the following morning that we were united.

Again we'd left the tents behind, committing us to reach Base Camp in a single, roped-up push. Higher up, progress was tiresome. Under the enormous weight of the packs our boots broke though the fragile crust on the snow with infuriating inconsistency. Most of the time I kept my head down, focussing on the compass, keeping the spindrift out of my eyes. Hours into yet another whiteout, I looked up to regain balance, searching in our horizonless world for something to focus on and became aware of the ground on both sides coming in towards us. Occasionally Stuart, at the rear, would shout for me to swing back left after I was buffeted off course by the wind. We had almost reached the lip of the icecap and would have to navigate across utterly featureless ground to dog-leg around a dangerous area of canyon sized crevasses. Then, in the middle of nowhere, at an arbitrary dot on the map, we would have to alter course to aim directly at Base Camp.

Kim, following in my footsteps, was holding up well but I sensed that she was on that knife-edge between utter exhaustion and the must-have capacity to keep going. Sam was third on the rope. Leaning his whole bodyweight into the shoulder harness, he resolutely pulled the laden sledge over the blown ridges of shifting snow. I sensed his limit was close too. We had gone beyond the

point of commitment, and had no means of sheltering. Six hundred and twenty double paces remained on our 59 degree bearing. Then as we huddled together in another full-on storm I twisted the compass bezel for the next bearing, 354 degrees, and felt their ice-glazed eyes searching me for reassurance. Stuart still appeared strong. I looked at my watch and bravely predicted we'd reach Base Camp at 7.30 pm. Inside I was in turmoil, realizing the implications if I could no longer hold it together. I had to remain totally focussed on spying our needle in a haystack. If we couldn't find the single marker flag, at the entrance to Base Camp, first time, we might never find it.

Unknown to us, Paul and Ian had taken it in turns to stand at the tunnel shouting and blowing whistles every twenty minutes. Having lost so much time tracking down Kim and Sam at sea level we were long overdue and by now they feared the worst but, in the conditions, were powerless to do anything.

Flapping wildly in the mist, only twenty-five metres to the right of our course, and bang on 7.30 pm, after an extraordinary near six hours navigating in a blizzard on two compass bearings, the vague grey shape of the marker flag stood like a beacon. Relief swept through me. Paul and Ian, on hearing us outside, rushed to grab rucksacks, unload the sledge and coil the rope. Stoves ran continuously to provide endless hot food and drinks. Sam admitted it had been the hardest day he'd ever spent in the mountains. Kim sat with her head on her chest, speechless with exhaustion. The Vatnajokull had a very big bite.

During brief periods of good weather, we revelled in the purity of the landscape. Pinnacled, razor sharp ridges soared from the sweeping glaciers and the chaotic debris of collapsed ice. Visibility on such days was boundless, leaving us with a sense of wonder and

we revelled in the purity of the landscape.

spirits that soared and the storms, the cold, the discomfort receded into the clouds of memory left far below. We climbed the magnificently triple-spired Kirkjan which lies in a huge glacial amphitheatre surrounded by the highest peaks in Iceland. 'The Incisor' pierced through a sea of cloud. Jutting nunataks, plastered in fragile rime ice that mushroomed and billowed, offered endless opportunities, but when the wind raced across the ice, biting to the bone and swirling the snow, our days existed in limbo and sips of tea marked only the start of another long wait until the next meal.

In the end we left the snow-cave in reasonable conditions, the horizon just visible through tatters of mist blowing across the ice-plateau. Kim was first on the rope, navigating, then Sam followed by Paul, Stuart and myself pulling heavily laden sledges. Soon we were past the dogleg, through the crevasses and looking forward to the ridge crest leading down to sea level and a sumptuous, warm, grassy camp.

After an hour the shreds of cloud had sewn together. Once again our eyes struggled to find anything to focus on as the numbing white, accompanied by vortices of snow, blanketed our view. We'd done this route many times now. We knew the danger zones. Seduced by a revengeful complacency we continued blindly.

Kim felt the ground under her feet give a little more than usual. Keeping a tight rope on her we backed up and traversed the slope to look for the tell-tale signs of a slot, a slight depression, a thin crack line, when suddenly the ground swallowed her. Sam threw himself on his axe to arrest the fall as the rope cut deep into the lip of the crevasse and lay motionless on his stomach. We feared that Kim would be seriously injured with such a heavy pack.

To stop the sledges careering off by themselves we first had to cut platforms out of the steep slope before we could assist with the rescue. Voice communication was whipped away as the wind tore into us, filling our eye sockets with snow. It was an agonising time, not knowing how Kim was, not knowing that, inside the crevasse, she was telling herself to keep calm and working with freezing fingers to wrap prussik cords around the rope to enable her to climb back up. She'd landed five metres down on the narrow ledge of a collapsed snow-bridge suspended above a black void. At least she was out of the havoc being wreaked on the surface.

It seemed like an eternity before she swam, shaken, onto the snow.

Sam now took the lead with eyes scanning, looking for signs of trouble. We traversed further before descending again. When he disappeared from view, sucked into the thickening ravages of cloud and airborne snow, our only clue to his movement came from the life-line connecting the five of us. Progress was perilously slow as we felt our way down, ever wary of the dangers around and underneath us. Conditions worsened further as the accelerating wind was compressed by the steepening terrain. Fingers of cold and exhaustion tightened their grip as the long hours blended into a struggle to stop ourselves being dragged over some edge or ice-cliff by the stubborn sledges.

Sam's legs disappeared into another void. He sat back, spreading his weight, and slowly moved backwards up the slope. Traversing once again, the rope moved then stopped. We'd strayed into very ominous territory. A line of blue, an edge of ice-cliff, barred our way and we feared we'd done the one thing we didn't want to do, become enmeshed in the tumbling icefalls that bounded either side of the descent ridge. It was time to sit it out till better weather allowed us a safer passage.

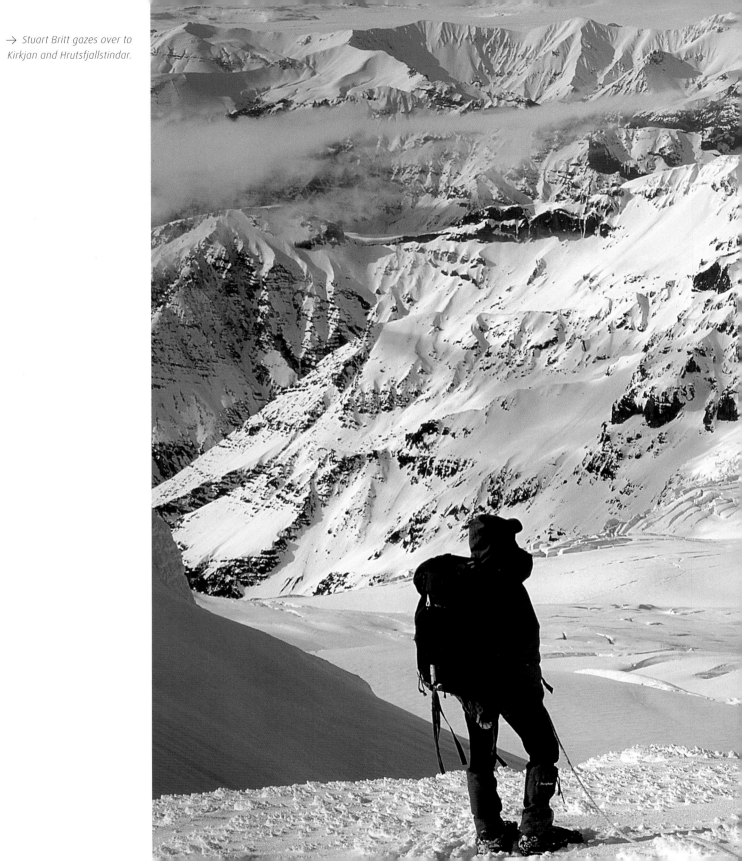

→ *Stuart Britt gazes over to Kirkjan and Hrutsfjallstindar.*

the bathroom. In a wheelchair it was impossible, so Andrea asked if I'd like to move in to her flat above a barn on the outskirts of Durham. Once up the single flight of stone steps it was all on one level and the doors were wide enough for me to trundle myself about. I'd be entertaining the field mice to get through the days, but I could have her single bed and she would sleep on the floor.

Through the kitchen window the wheat fields danced in the lengthening shadows of an evening breeze. We prepared dinner. It had been just five weeks since we'd started going out but it seemed time for the biggest question any young man will ask. With absolutely no hesitation she said 'yes', but added, 'Well, aren't you going to get down on one knee?'

I crashed out of the wheelchair to the linoleum with no grace or style and asked again if she'd marry me. The answer was the same and she added: 'So we'd better go out and celebrate.' At the Traveller's Rest we each sank a large single malt.

I phoned the college in Liverpool to decline the place and explain the situation in which I found myself. I didn't feel that I could fully partake in an Outdoor Education course bearing I mind I couldn't walk and if the Consultant's bleak scenario proved true then it was an impossible circle to square.

← The 'Incisor,' 'The storms,
the cold the discomfort
receded into the clouds
of memory...'

the equilibrium of my position was on borrowed time I tried again but my fingers had become just too greasy and pinged out of the pocket. I fell badly, smacking my wrist off the wall and landing with the arch of my right foot across the edge of the crash mat. The thick PVC covered foam compressed to take the impact but under such loading it was a bit like jumping from ten feet onto a lump of three inch thick timber.

My agonized scream echoed around the leisure centre and I lay crumpled, brain fuzzing, on the mat, burning pain welling though my lower right leg. Andrea ran over as did the only guy still climbing that evening. 'I'm a first aider, out of the way!' Andrea was quick to react, 'So am I. Now go and call a bloody ambulance!' She tried to calm me as the shaking started.

The paramedics arrived and threatened to pull off my tightly laced rock boot. 'Just cut it off!' I cried, before being carted off to the Royal Victoria Infirmary with my right ankle ballooning. The rest of the night disappeared in an opiate-induced haze of x-rays, heavy plaster casts for wrist and lower leg, and trauma.

The next afternoon, while Andrea was at my bedside, the Consultant made his ward round followed by a trail of student doctors and medical staff. His visit to the end of my bed was brief. He peered at the 'obs' charted on the clipboard before delivering the news. 'You've fractured your left radius and the neck of your right talus. The fracture to your talus is pretty serious and you may suffer avascular necrosis.' The medical speak meant nothing but his final sentence I understood fully. 'You'll probably never walk again.' With that he turned, white coat flowing, and hurried off followed by his entourage. Dazed, I lay with my mouth open, unable to process the implications. Andrea rushed after him. 'Hey,' she said, 'you can't just leave him like that', and dragged him back.

The news, once translated, was not good. If there was one bone in the body I didn't want to break it was the talus. As the main supporting bone in the ankle, its complex of joints provides all mobility for walking. If the already poor blood supply in that bone was interrupted during the subsequent healing it could die and collapse. If the talus healed I wouldn't know how much other damage had been done to the joint until I started trying to use it. It was crushing news. I was the fittest and strongest I'd ever been, having been on expedition after expedition. Now everything lay in tatters.

'Keith in hospital following fall in leisure centre' was the headline. It did seem a little preposterous until the seriousness of the prognosis was understood.

Richard Else sent me a copy of the 'Climbers' book that was to accompany the series. It had been signed by Bonington and folded neatly inside the front cover was a kind letter wishing me well. Loads of visiting friends kept me entertained and the regimented ward routine, and the evenings, disappeared watching the Barcelona Olympics. The TV lounge was kept 'out-of-bounds' for the other patients when Andrea and I were in there. The Ward Sister saw no sense in interrupting young love and was very good at turning a blind eye, especially when a group of friends arrived to 'kidnap' me. She was sure that we wouldn't do anything stupid although, as I was lifted over a metal barrier into a brewery's visitor centre, I thought the hospital might have had a thing or two to say if I'd been tumbled out onto the concrete.

It took ten days to bring the pain under control. I was allowed home, but using normal crutches was impossible due to the fractured wrist so I was discharged in an old-school wheelchair on loan from the Red Cross. Home, Phill's flat in the West End, was on the first floor with stairs down into the kitchen and further stairs to

'Keith in hospital following fall in leisure centre' was the headline.

We dug a bivouac, snow whirling into what could only be described as an oversized coffin. There was only room for two to work inside, while a third cleared snow from the entrance leaving two to stamp around in the blizzard. Eyelashes, moustaches and clothes hung with ice. We changed shifts as arms tired and legs cramped, and eventually blocked ourselves inside using upturned pulks and rucksacks, letting the wind whine to itself as we struggled into our sleeping bags. The Vatnajokull didn't want to let us go.

It had been an ideal opportunity to reassess where both Paul and myself really wanted to go in terms of our lives' directions. It was up on the Vatnajokull where our opaque reflections in the lifelessness of that frozen landscape became clearer, much as the snow turns to ice with the passage of time.

Paul went full speed ahead with his expedition company, Tangent, while I was moved towards a new career in 'Outdoor Education', inspired by Paul, Ian and Stuart. I had always felt I'd missed out by not doing a degree and was relishing the thought of student life. I had interviews at Jordanhill in Glasgow and at I.M. Marsh in Liverpool and was offered a place on Merseyside to start in the autumn of 1992. I had finally made a decision. It seemed that my destiny lay in guiding people through the mountains that had taken over my entire soul and where climbing provided endless possibilities for challenge and reward in a melting pot of the physical and cerebral.

For now though, I would work between climbing trips to pay the rent, keeping the funds from the sale of my possessions to finance expeditions.

Just back from a trip to Nepal with James, his wife Polly and their friend Robbo and with a commune of 'blue-green algae', firmly established in my gut I was daring enough to ask a girl I'd met two years previously on an outing to the Lake District. Andrea had been leading an expedition project in the rainforests of Borneo for the youth development charity Operation Raleigh. We'd hooked up many times before when we'd both been in the country at the same time to go rock-climbing. As a long-jumper and sprinter she put me to shame in terms of fitness and her broad smile was disarming.

It was a windless, blue sky day, perfect for a romp across the Central Fells. We headed from Seathwaite Farm up Central Gully on Great End, rescued a sheep from a chewed-bare ledge, continued over Scafell Pike, scrambled through the 'Fat Man's Agony', over Broad Stand and onto Scafell's summit. Lying in the late afternoon sun with no-one else around I asked how her love life was. The question was obviously too obtuse and she started on a long-winded explanation of her old flames and recently ended affairs of the heart. I finally managed to butt in and ask if she 'fancied sorting out her love life'. At that moment my two-year chase for the blonde athlete ended and our life together began.

Two weeks into our relationship we were climbing at the indoor wall in Newcastle. My favourite practice route followed an arch, ascending the inside wall until I hung horizontally beneath the underside of the curving roof. By releasing both feet whilst holding finger pockets I could swing round to face the other way. Pulling hard and swinging my left leg up I would hook my heel over a hold. Getting the feet back onto the wall took some of the weight off the fingers to enable the start of the climb down the other side. I was feeling light having lost so much weight from the six-week intestinal infection I'd brought back from Nepal but it was a highly gymnastic set of moves and late in the evening session, probably beyond my reserves of strength. As I swung I missed the heel-hook, knowing

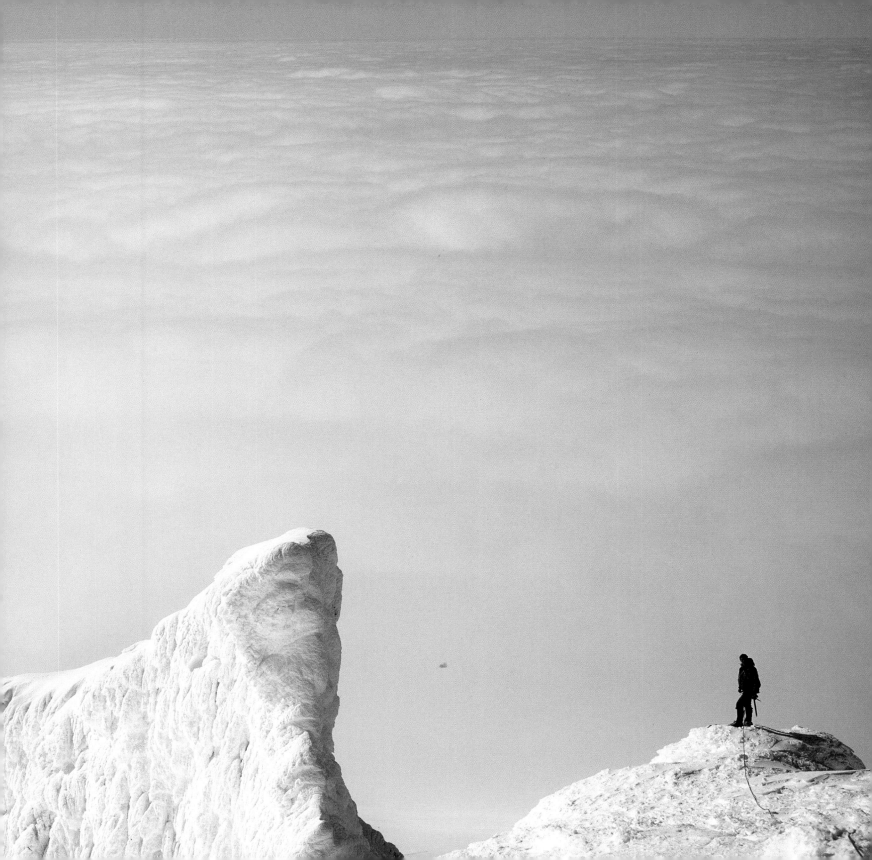

A Baptism of Fire

In 1994 producer Richard Else and his newly founded company, Triple Echo Productions, had been commissioned by the BBC to produce a six-part climbing series with the working title '*A Toe In The Crevice*', which conjured up all manner of alternative subject matter in the team's over-active imaginations. A bottle of whisky was offered to anyone who could come up with a better title and, eventually, '*The Edge* – 100 *Years of Scottish Mountaineering*' was born. I believe the Scotch went to Richard.

The series was to feature classic routes and cutting-edge modern climbs on a mix of rock and ice. If I believed in fate I'd say that my accident was the thing that pulled me back onto my original track. After months of being in plaster, and rehab, the bone healed, but that wasn't the end. As we embarked on filming I still could not walk from bed to bathroom but, each day, I managed to push through the stiffness and pain to loosen off the damaged joint. I wasn't going to miss out on being a part of this team.

Colin Godfrey was a dyed-in-the-wool BBC film cameraman who, as a non-climber, was to shoot from easy-to-access positions. Capturing the action close up would be Duncan McCallum, an expert climber, big framed, strong, and sporting a wiry pony tail. He exuded confidence and had a gift for blagging the latest outdoor kit. Having spent many years as a camera assistant this was Duncan's big break. As with the shoot to Nanga Parbat I was to look after the sound recording using the Nagra reel-to-reel recorder. The pictures were to be captured on 16 mm film with Aaton film cameras. Technology that was reliable, tried and tested.

The safety team (or 'head of knitting') was led by Brian Hall, who'd spent decades climbing with some of the best mountaineers on the planet. In 1981 he had been part of the first team to attempt Everest in the depths of winter by a new route, Alpine style. At one point the wind was so strong that breathing became impossible and the only way he could get air into his lungs was to stick his head into a crevasse. On the high col of the Lho-La they'd been pinned in a snowhole for seven days, unable to move because of the bone-snapping cold and hurricane force winds. When they did eventually move they were so weakened by lack of food and fluid, and altitude, they were forced to abandon the attempt. Brian still believes that the expedition's greatest achievement was that they all came back alive. That philosophy gave me confidence in him, but didn't stop me feeling totally intimidated.

The rest of the safety team included Dave (Cubby) Cuthbertson, a world-class climber from Ballachulish. Dark-haired with a short, wiry frame, he boasted a positive 'ape index' where, after years of climbing at the highest standard, his gorilla-length arms, toughened fingers and short thumbs had developed incredible holding power. No matter how steep the rock or ice his climbing style was effortless. He was to be my 'wingman' for many years to come and remains a true inspiration.

Alongside was the giant of the team, Paul Moores, of Scandinavian appearance: tall, powerful, with piercing blue eyes and blonde hair. He was the 'sharply dressed' man of the team, his outdoor kit never creased or crumpled and his minimalist rucksack always impeccably packed and smooth. It served to reinforce his unflappable, organized, 'sorted' demeanour.

Mark Diggins (Digger) was fast, precise and technically very savvy, able to turn his hand to anything and, finally, there was the roll-up smoking John Whittle, so laid back that horizontal was too steep. His bedside manner oozed calm and, despite a slightly barrel-chested physique, he was a talented climber of delicate touch (although a thunderous snorer).

'Hey mate, you got a problem with your camera?' they asked...

All were strong minded and had views on how things should be done in the mountains where consensus was never likely.

Planning for the following day's filming was always intense and the safety team, all qualified mountain guides, spoke an entirely new language of rope systems, complex logistics and evacuation procedures. There was the A plan, the B plan, running right the way down to what seemed like the X plan. By Plan L I'd been left behind by the what-ifs and buts. I thought I knew a thing or two about operating in the mountains but, compared to the team led by Brian, my knowledge amounted to zero. Filming was split over two mentally and physically exhausting shoots. The first was in winter and lasted 23 days, 19 of which were spent 'on the hill' in what was the best climbing season for years.

The first day we were broken in gently. The Cairngorm Ski Area's piste-basher was waiting beside the Day Lodge. Loaded with rucksacks full of climbing and camera kit we clambered over the caterpillar-tracks onto the flatbed behind the cab and braced ourselves for a bumpy lift to the snow-fence near the left bounding ridge of Coire an t-Sneachda. A short walk down through the deep drifts into the base of the corrie would take us to the foot of the Aladdin Buttress to shoot Rab Anderson and Graeme Ettle climbing the snowed up rocks of *White Magic*.

It was a turbulent day, as is normal in the Northern Corries, and there were problems from the start. I'd wired our climbers with radio microphones but they were soon out of range and all I could hear was ear-splitting shash like a badly tuned radio. I resorted to the boom microphone. Protected in its furry wind-cover it was nonetheless too distant from the climbers to be of any real use. Worse, the film would run through the cameras for just a few seconds and grind to a heart-sinking halt. Detailed analysis of the problem wasn't possible in the swirling spindrift and neither Colin nor Duncan could put a frozen finger on what was going wrong. There was no option but to abandon filming.

Despite the wild weather the ski slopes were fully open and busy, so we retired into the dripping condensation of the mountain restaurant, not the ideal operating theatre for camera surgery. While an exasperated Colin was on the payphone to the camera hire company in London a couple of guys walked out of the blizzard. 'Hey mate, you got a problem with your camera?' they asked, and started quizzing us.

The initial reaction was to tell them to 'clear off back to punter-land', but the questions hinted at real knowledge. As it happened one of them was one of only two Aaton camera engineers in Europe and within minutes he'd nailed the fault. The low temperature had caused the metal of the claw to contract, which meant it could no longer grab hold of the film sprocket to pull it through the camera. Using gash strips of 16 mm film, ripped out of one of the magazines, as a feeler gauge he reset the claw depth on both cameras and within the hour we were back outside. We couldn't believe our luck.

Very late that night and looking 'wired', an Essex-accented Barry White lookalike, dripping with gold chains and sovereign rings, sped his flash white BMW to the door of our hotel to deliver a spare Aaton body from the hire company. He'd never been so far north.

The following day we went back into the corrie, all guns blazing. Duncan's efficiency was enviable as he jumared up the ropes to the ledge system above the crux. I followed, but with so much conflicting advice as to the best system and how the various linking slings should be adjusted, it all felt cumbersome. I was on a sky-rocket learning curve, and we ended on a grandstand perch looking

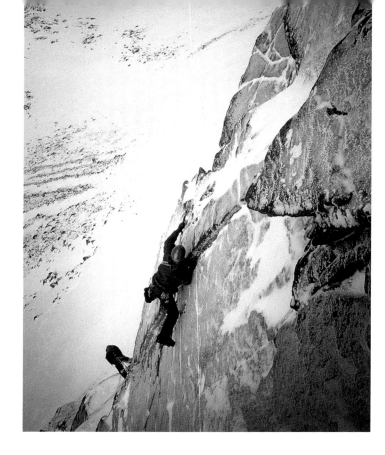

← The cutting edge in 1994. Graeme Ettle on the crux pitch of White Magic VII, 7, Northern Corries, Cairngorms. (© Cubby Images)

These tactics of 'mixed' climbing were new to me. Mesmerized on my ledge I found myself willing him on, listening to the building tension in his breathing. Finally there was a sharp exhale before he launched himself, totally committed, onto the frozen ledge at the top of the climb and safety.

Paul, not trusting my abseil skills, lowered me off the crag on the end of 'Big Bertha', our 100 metre length of static rope, at a rate of knots and I almost tumbled down the final overlaps of granite to the corrie floor for the walk out.

We shifted to the west coast and Scotland's highest peak. Ben Nevis' North Face is revered the world over as a unique winter climbing venue. A stormy maritime climate and the freeze/thaw fluctuations allows for a gradual building up of ice. Snow, driven by howling gales, plasters the steep granite architecture. Small wonder it has such a rich climbing heritage, from leading edge to the classic.

Over the years I've found that climbers love any excuse to dress up, and Tower Ridge on Ben Nevis provided the perfect opportunity with the reconstruction of the 1939 winter ascent by W.H. Murray, J.H.B. Bell and Douglas Laidlaw. At the Mercury Hotel in Fort William our three on-camera climbers, Mark Diggins, Alasdair Cain and Graham Moss, caused quite a stir as they sashayed into the dining room, attired in beautiful tweeds that hid modern thermal layers and wearing nailed leather boots. To set themselves up for the day they headed straight for the bacon, sausage and eggs, cooked to perfection by the hotel's night porter; it was way too early to find a chef.

The other guests, who were on a coach tour of the Highlands, looked admiringly on our stars of the small screen and in bemusement at the rest of us, bedecked in gaudy red and blue Goretex and plastic climbing boots. We were already in our harnesses which must have pushed our image of ridiculousness well

straight down the final steep slabby pitch of *White Magic*. Graded at VII 7, it was at the leading edge of what climbers were doing at the time.

Graeme just managed to hold himself in balance on the crux finger crack. His stubby crampon points scratched against the iced crystals of the pink granite as the picks of his axes searched inside the cracks and fissures for purchase. His racks of wire and hexes clanked as he swung and it seemed as if he might pop off at any moment.

Rab shouted words of encouragement, hanging on the belay way below, swinging foot to foot to keep the circulation going in his legs while Graeme, breathing hard and with focussed eyes, blinkered to the fact that cameras were following his every move, hammered the shaft of his axe vertically into a crack beneath a small overhang on the upper buttress. The metal on metal sound echoed round the corrie, mixing with the rumble of the wind and the distant croak of ptarmigan. Pulling on the pick he torqued the shaft across the sides of the crack to hold it in place.

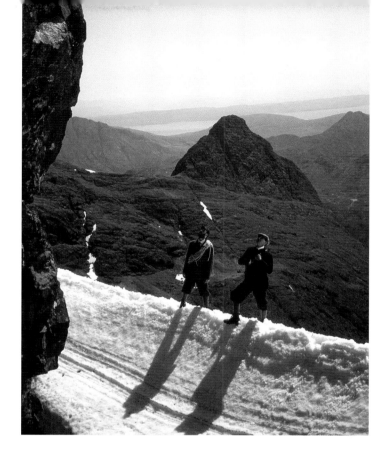

over the edge. Putting the final preparations to our day we decided to pull apart the packed lunches, reducing the weight and bulk of our already gargantuan rucksacks. Glass bottles of sparkling mineral water, polystyrene boxes and crackers would never survive the rigours of the day anyway.

Everything else that was vaguely edible, and there really wasn't much, was stuffed into our pockets and the unwanted detritus was dumped on the reception desk next to a rack of postcards. It was the day before Valentine's Day which, without exception, all of us had forgotten so the very kind receptionist did a roaring trade in Scottish Sunsets which duly had messages of unwavering love to wives and girlfriends scribbled on their backs. Stamps were licked and stuck and she offered to post them for us. We were ready to go with romance still very much in our eyes.

Outside, a luxury coach awaited the tourists. Our transport also awaited but it was far from cosy. Piloted by one of the country's best ever mountain fliers, Dave Clem's plum coloured Squirrel helicopter was already fuelled so, within three minutes of leaving the warmth of the hotel reception, Clem was doing a miraculous job of holding the chopper steady in winds gusting from 0 to 60 knots. Coupled to the downdraft, clouds of spindrift and chunks of rime ice were hurled into the air.

From the crest of Tower Ridge, resplendent in full winter raiment, the sense of verticality and exposure was overwhelming with yawning drops beckoning to anyone who got it wrong. Timing the step out of the aircraft onto the icy crest was vital and crampons were not allowed in the Clem chopper as 'they ruin the shag pile carpet'.

To get ahead of the many other mountaineers who were likely to be on the climb we were to bale out on the upper section of one of the finest Alpine-scale climbs in Scotland. As I teetered on the skid, waiting anxiously for my moment, Richard Else shouted at me, unable to contain his excitement, 'There's no point being part of an adventure film team if you don't have a little adventure yourself!' He had a point, although I suspect that my expression in the buffeting confusion of the rotors and scream of the engine was rather the opposite of his manic grin. With that I jumped. Brian Hall, mountain guide and head of safety, was ready to grab me. Thankfully.

Colin Godfrey shot with a powerful telephoto lens from near the summit of Ben Nevis with the upper section of Tower Ridge in brilliant profile. Duncan McCallum filmed close-up from the ridge itself and I held my boom microphone as near to the climbers as I could. Most of what I heard sounded like three men eating packets of potato crisps whilst hacking cabbages to pieces with meat cleavers, but it was real: nailed boots kicking into perfect névé and the steel of axes cutting into ice. Sound is often overlooked in film-making although it is half the experience. People only notice when it's wrong or not there.

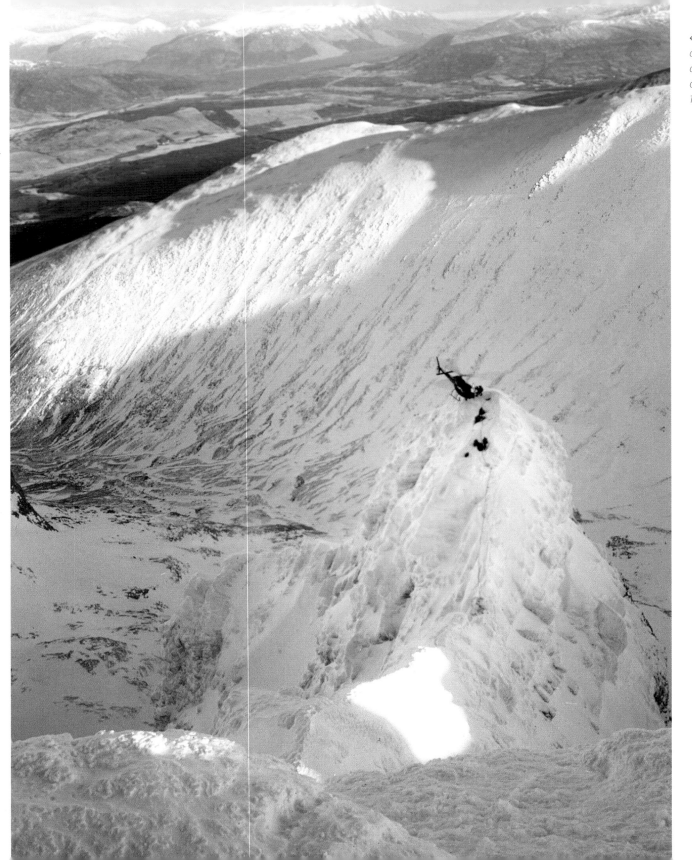

← Crampons were banned and timing was everything as Clem gallantly held control to put a skid on Tower Ridge. →

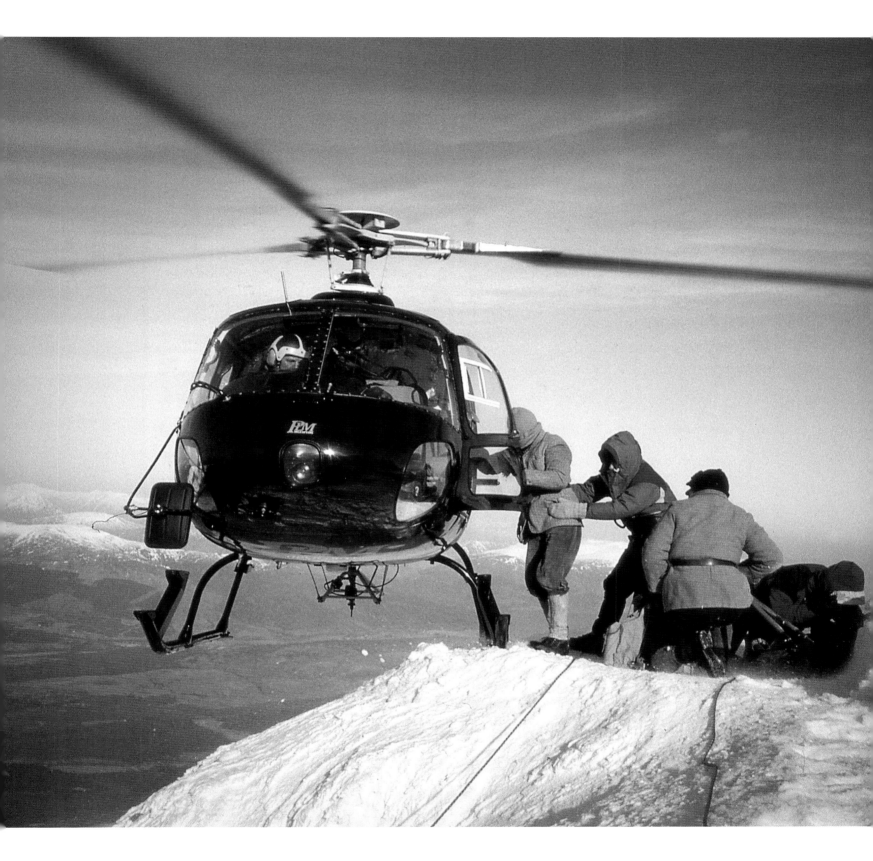

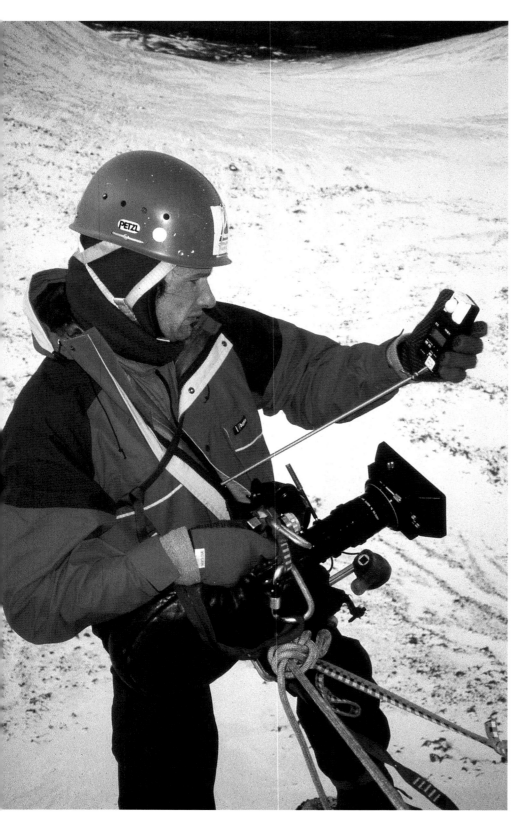

← Duncan McCallum assesses the light on White Magic. Aaton XTR Prod 16mm camera securely tied in.

↑ The 'trusty' lump of Swiss engineering – the Nagra reel to reel audio recorder.

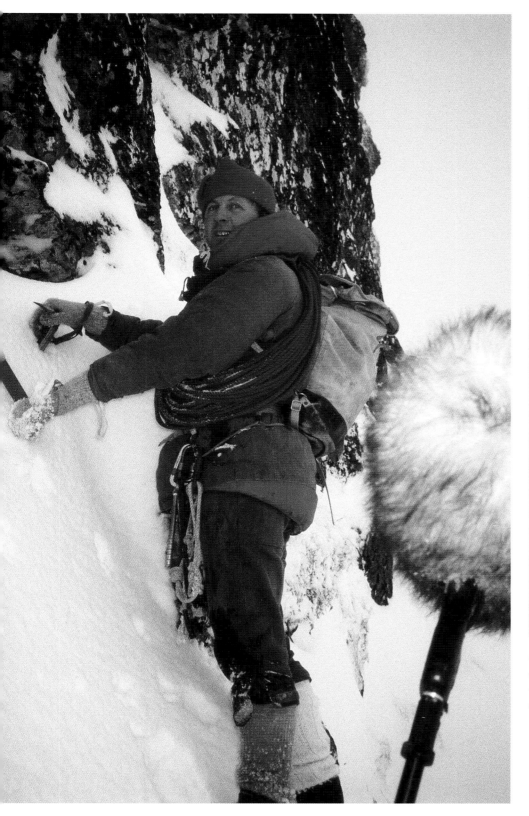

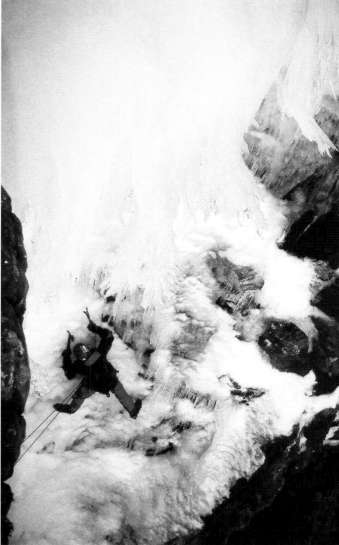

← *Mick Tighe as Tom Patey embarking on* Crab Crawl, *Creag Meagaidh, Central Highlands, Scotland.*

↑ *Mick Fowler leads through the chandelier on the new line* Triple Echo *in the Applecross Hills.*

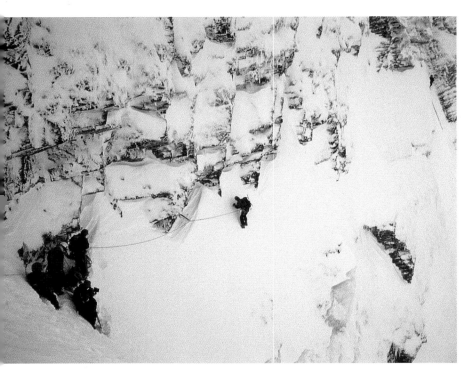

↑ *Filming from a ledge chopped from the snow on the girdle traverse* Crab Crawl *across the vast cliffs of Coire Ardair.*

→ *In the footsteps of Collie and Mackenzie. The Cioch, Sron na Ciche, Isle of Skye. (© Cubby Images)*

Alastair Caine (as Bell) gazed at the airy ledge of the Great Tower as he crossed the Eastern Traverse. Noting it was banked to a precarious 45 degrees with brick-hard snow, and more accustomed to modern crampons than nailed boots and a museum-piece of an ice-axe, he peered over his shoulder at the yawning drop nipping at his heels. We couldn't help feeling the look of terror in his face was uncontrived.

Within my load lessening exercise I had jettisoned the spare brick of 12 D-cell batteries as, with a fresh set in the Nagra recorder, I felt sure of lasting the day, but in the sub-zero of that early winter's morning watched in horror as the power level plummeted like an untethered climber. The machine ground to a halt and we were effectively mute. Richard didn't make a big deal of it but radioed

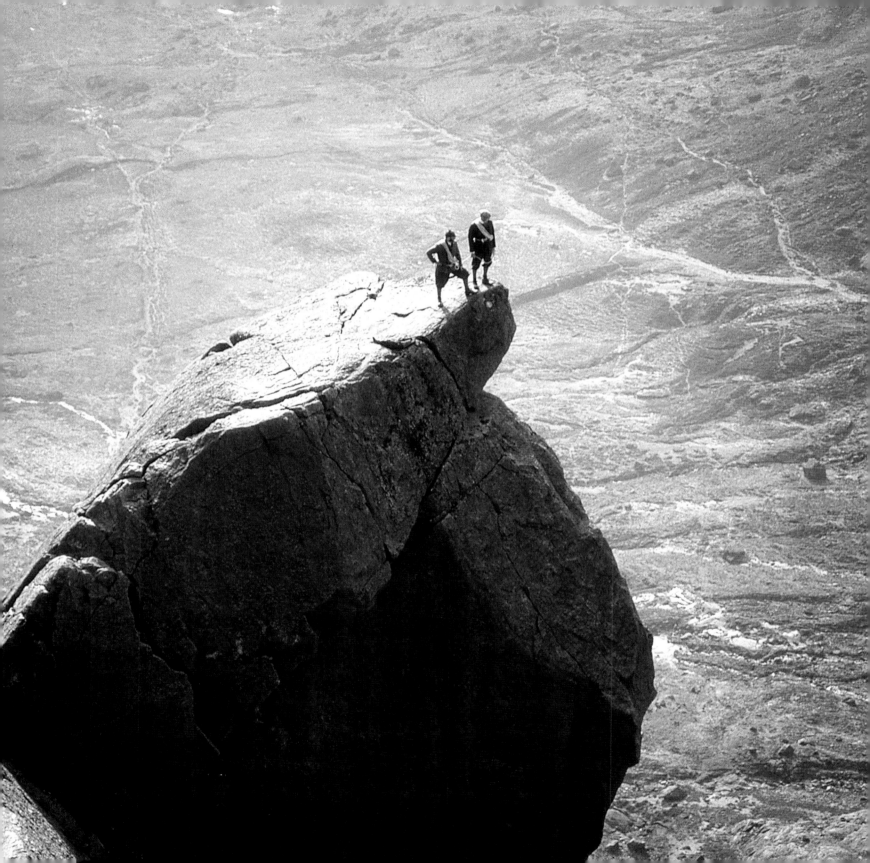

to Clem, waiting below in the chopper and for whom nothing was too much trouble. This didn't make me feel any better about the situation, but kept everyone holding on. Literally.

A few minutes later we heard the noise of the rotors coming up the Allt a' Mhuilinn. Clem swept the chopper up the side of the ridge in an over-dramatic fashion, obviously having way too much fun. Hovering with half a skid on the ridge crest, the side-door opened and a Safeways carrier bag containing the world's most expensive set of batteries was delivered into our hands. Once again we were good to go.

You learn by your mistakes.

Between the Great Tower and the easy final snow slopes leading to the summit plateau the ridge narrows alarmingly before disappearing into the aptly named 'Tower Gap'. A notch in the curtain of rock, it is the sting in the tail and a cause of benightment for many a timid mountaineer. To climb across the Gap our team, in traditional style, had to throw their hemp rope around the rock spike on the far side to safeguard themselves as they crossed.

Colin peered through his telephoto lens. Duncan filmed looking down, balancing on crampon spikes at the edge of a giddying drop. My microphone, out in the buffeting wind, snooped just above the tiny group of tweed-clad mountaineers on their exposed ledge. No more crisp and cabbage sound effects, our 'actors' had to stay in character for the climax of the climb. Everyone was recording. Action! And all I heard was 'Lasso the rock? We're net bloody cowboys!' followed by a lot of guffawing. Needless to say, the audio was dubbed with something a little more lyrical.

On the summit plateau we had one shot left to do. Our three heroes walked, cutting sharp silhouettes between the softened orange hues of the sky and the cold blue kyanite tints of the snow. A solitary cloud band dissected the sun as it dipped fast to the west. The light was sublime. Bill Murray's line was perfect: 'While we walked slowly off the plateau, it became very clear to myself that only the true self, which transcends the personal, lays claim to immortality.'

With that, Clem skied the heavily laden chopper for some distance across the summit plateau to gain 'airspeed' before lifting into the gloaming.

For the entire series the 'Window of Else', as it was dubbed, stayed open, giving us sustained fine filming weather. We shot an impressive tally of routes including: Mick Fowler and Steve Sustad on a new Grade 5 ice-climb, Triple Echo in the Applecross Hills and Cubby making light work of the plumb-vertical ice-pillar, *Mega Route X* on Ben Nevis.

I stood, shaking hypothermia at bay, for hours on a tiny ledge cut into the snow halfway up Emerald Gully on Beinn Dearg, near Ullapool in Wester Ross. The only warming respite came from the gentle puffs of John Whittle's rollie that wafted across our nostrils. I've never smoked but just this once I allowed the aromas to percolate. Three quarters of the way up the climb, as Duncan filmed, the lens decided to part company from the camera. Luckily the body was held in the right hand, the lens caught in the left. Further on he snapped a crampon but eventually they topped out just as night fell. From the ledge I descended with John and Richard. I'd never been so glad to get the blood moving, despite the path back down the glen being awkwardly clad in boiler plates of ice.

Days spent with Mick Tighe playing the part of Tom Patey (inching across the giant *Crab Crawl* on Creag Meagaidh) were exhausting with all available daylight turned over to filming, and around thirteen kilometres of walking to be done with all the gear. Never did anyone complain. To be honest it was way too much fun and

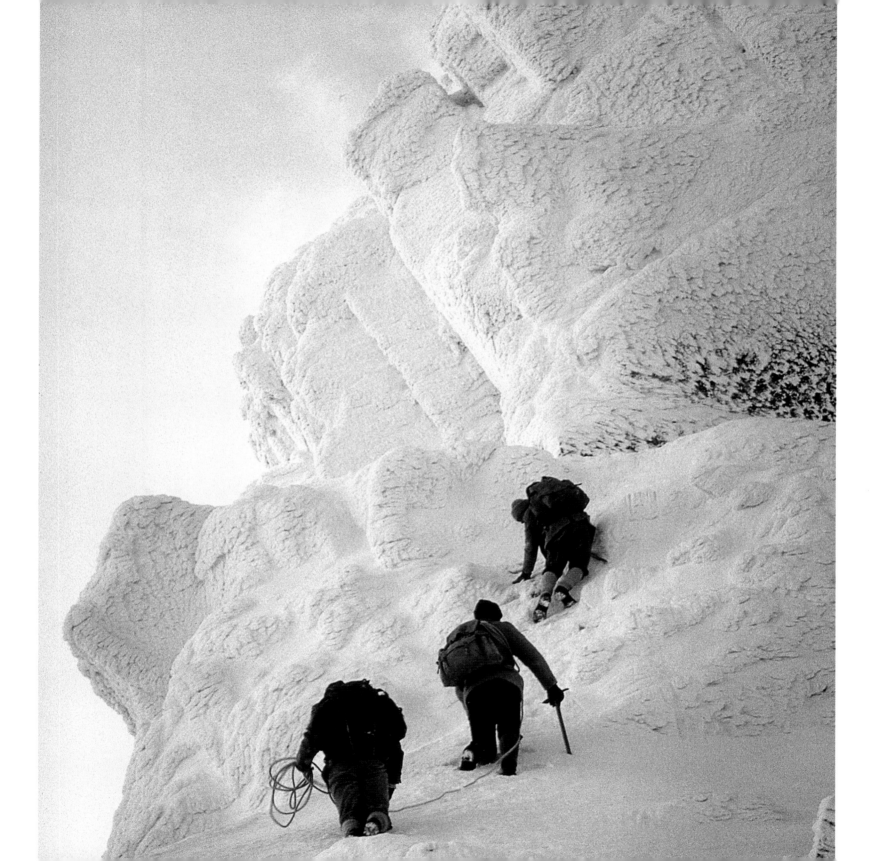

I did have a vision of where I wanted to go,
even if I didn't know exactly how I was going to get there.

by the time we moved into the spring shoot I felt more confident in very exposed situations on the Old Man of Stoer, waves crashing far beneath my reel-to-reel recorder. On the Cioch Nose I relished the dulcet, gravel tones of Martin Boysen and Chris Bonington, waxing lyrical about the best and easiest 'Diff' in the country.

In Glencoe we met legends of Scottish climbing Jimmy Marshall and John MacLean in the lay-by across the river from the little but legendary, black, felt-walled climbing hut of the Creagh Dhu Club, Jacksonville. As a member of the public walked along the opposite bank their heads swung round and they glared, and when the hill-walker started to open the hut door there was much gesticulating and a verbal tirade that exploded across the water and 'Get tha hell oota there!' echoed off the great rhyolite walls of Buachaille Etive Mor. After so many years the Creagh Dhu boys still had a reputation of hard living and hard climbing to uphold and were fiercely protective of their turf. Later, with headphones bolted onto helmet, I listened while I watched them from an awkward ledge, doing what they do best, moving with the grace of a vertical ballet up the 180 metre high Slime Wall. The passing years had not faded their natural talent for overcoming the sheer.

Even on the Isle of Skye we enjoyed cloud-free days, climbing in the Black Cuillin with Alan Kimber and John Lyall playing the tweed-clad Norman Collie and John Mackenzie. Having finished filming Duncan and I lounged on top of the Cioch, a gigantic fist of rock that juts out from the buttresses of Sron Na Ciche, eating the last of our mashed sandwiches. Our rucksacks were packed, ready to go, when we heard the unmistakable sound of our old friend. Clem circled the corrie and brought the chopper skid onto the edge of our lofty perch. It felt so relaxed, in contrast to the commute to Tower Ridge weeks earlier. We opened the door, stepped in and, with that mischievous grin that said so much about our pilot, dropped like a stone, spiralling towards Glen Brittle. Minutes later we were back at the Sligachan Hotel, beer in hand.

It seemed that as a film team we'd all come a long way together. We'd shown each other not only what we were able to do but, more importantly, what we were willing to do. For me it had been a baptism of fire and I appreciated the fact that initially I was held back from getting into tricky and committed positions whilst operating on the ropes. My eagerness had been tempered to the realistic by Brian and the safety team. 'The Edge' was a hugely important series, with Richard picking up a BAFTA for the Tower Ridge episode, but it also marked the beginning of a new transitional era. The following year we embarked upon a mountain walking series, again shot on film, but technology was advancing at a great pace. Video cameras had become smaller, more reliable and offered rapidly increasing image quality. Similarly, computer-based video edit systems were more affordable with exponential improvements in speed, power and software capable of dealing with the large data-rates that moving pictures require. For film buffs the next couple of years was a bitter, difficult time as they saw their 'territory' in the industry eroded.

While it's easy to get nostalgic about film as a medium, as far as I was concerned developments were to prove exciting beyond belief, not that I knew that at the time of course... My crystal ball never really worked very well. Importantly though, I did have a vision of where I wanted to go, even if I didn't know exactly how I was going to get there. We were on the cusp of something big...

...the leading edge of the lightweight video revolution in film-making.

↓ *Sublime light as our climbers wander in wonder across the summit plateau of Ben Nevis.*

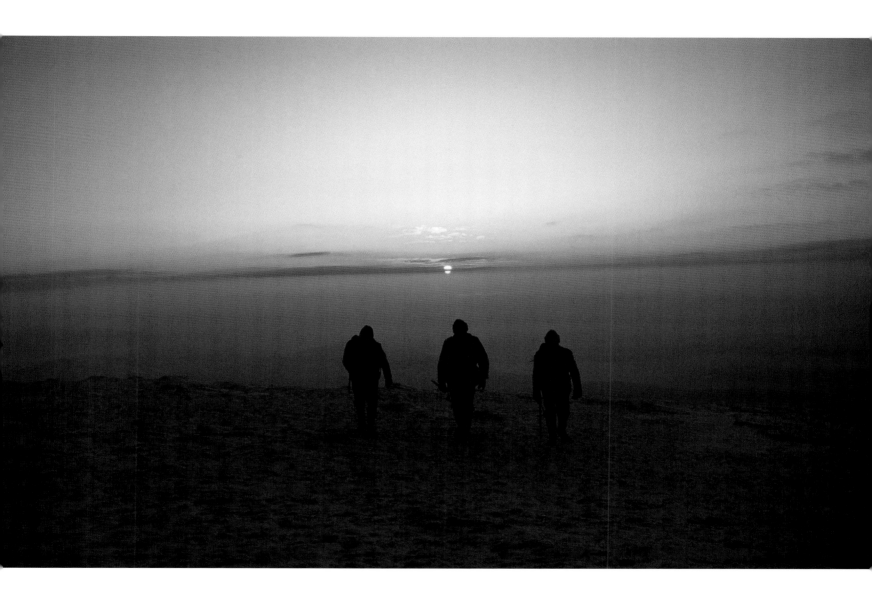

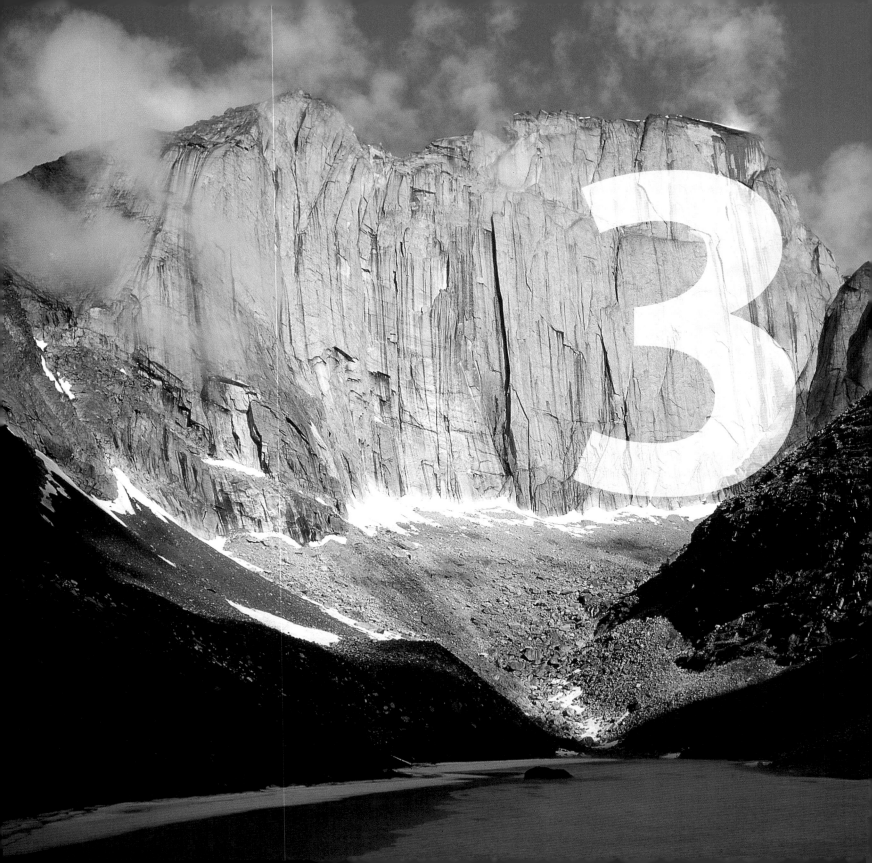

Come
the
Revolution

Sometimes in the mountains there are things

All I could see through the cockpit windows was a vast wall of granite: plumb vertical, unyielding. We had been flying straight at it for too long to remain relaxed but above the drone of the engines no one would hear me scream. Pilot Jaques Harvey finished his game of chicken with the South East Face of Mount Proboscis, banked sharp left, and dropped like a stone towards landing. Again I breathed, keeping the camera steady, as the Twin Otter's floats sliced the silky, smooth surface of Glacier Lake. An hour's flight along the South Nahanni River had taken us over some of Canada's most rugged country. Apart from flying, the only way out was by canoe, taking a full two weeks if the bears didn't take a gastronomic liking to us first. The wooden door and walls of a fishing shack by the shore bore the claw marks of our inquisitive ursine friends.

We'd reached the *Cirque of the Unclimbables* in Canada's vast Northern Territories, a fantasy land of spectacular knife-point summits guarded by imposing walls and impregnable towers. The first team to set eyes on Mount Proboscis were 'awed and a little horrified' by one of the hardest to reach summits in North America, whose logistical difficulties mean that, for many big wall climbers aiming for the best places on the planet, it's a tick never to be inked. Their climb in the 1950s was to be our team's descent line.

Canadian climber Barry Blanchard and Nancy Feagin from the US were to attempt a new route on the 600m main face, the same one we'd just flown towards. The original line up this seemingly blank wall was pioneered in 1963 by a team of Yosemite legends, including Royal Robbins, and they placed over 250 pitons. Since then the 'Cirque' has become a place of legend.

From Glacier Lake we couldn't even see Proboscis, which remained hidden by the bulk of Mount Harrison Smith whose expanses of bleak, unbroken granite were bathed in the strange bruised light of an approaching storm. Soon, lashing rain threatened to penetrate our boxes of equipment in a monsoonal wrecking frenzy. Lightning cracked and thunder boomed around the mountains. Moving all our food, film equipment, camping gear and ropes up to Base Camp would have to wait until conditions improved.

This new series of climbing adventures '*The Face*' had, just a few weeks before, been in jeopardy after a 20% budget cut that had swept across all commissions. Producer Richard Else had delivered the message at a meeting on Salisbury Crags in Edinburgh. 'If we shoot on film there's only enough money to produce the series in Scotland, but if we move to video we can go ahead as planned.'

The way forward was obvious but not simple. Reliable lightweight video systems were still in their infancy but Sony were about to bring out their new DVCAM camcorders. They had offered the 'preproduction' camera together with a second camera flown in from Japan, effectively field trialling new technology.

Duncan McCallum would once again shoot from the rock-face with me looking after the sound and shooting with the other camera from easier to reach positions. For me it was a kind of 'homecoming', having been brought up on video systems. Another issue was how to edit the footage cost-effectively and since there wasn't a video machine to playback the tapes we were entering very uncharted territory.

The other major development had been in the reliability of radio microphones. I hoped that my newly purchased system would let us hear, with crystal clarity, every shout, squeal, cry and whisper from the climbers as they inched their way up. Sensitive microphones taped to their clothing were plugged into high-powered body-worn transmitters to send the signal down to the receivers, the base rig

that lie outwith anyone's control. Luck had been on our side.

of which was equipped with a pair of antennae like giant TV aerials clamped onto a tent A-frame we nicknamed Jodrell Bank.

In addition to Jaques Harvey's float plane, a helicopter had flown in to ferry us and, with the aid of a large net, all the gear to a high alpine meadow, a short hop from Glacier Lake but still around an hour's walk from the bottom of the face.

Rays of sunlight pierced the clouds, igniting our enthusiasm as we prepared the loads. Barry, Nancy and I were on the last flight, and watched as the downdraught sent half-pitched tents flying over the rocky meadow like giant yellow tumbleweed. A posse of mountain guides followed in hot pursuit, but when our two climbers leapt out they had eyes only for the towering edifice of the South East Face.

Early days on the wall found me increasingly isolated, peering into the viewfinder at diminishing dots as they ascended a vertical sea of granite. With the tripod set amid boulders near the base, the lens soon ran out of zoom, but still we watched and now, more importantly, listened to progress. Richard grinned throughout, his hands clamped on his headphones. Sound quality exceeded all expectations, from heart beat to frustrated scream as water hosed down sleeves, soaking Nancy to the skin on the 'waterfall pitch', to Barry with a battle roar struggling with the featureless rock. Finally, we could catapult the viewer right onto the rock face, taking them on the same emotional journey as the climbers. It was like finding the Holy Grail.

As the team spread across the vast mountain we kept in touch by doing a crossword over the walkie-talkies. At the end of each day, while the climbing team erected portaledges and slept hanging from the cliff, Richard, Brian and I made the precarious journey back to Base Camp, leaping between boulders covered in saucer-sized black and grey lichen that turned the rocks into skating rinks at the first hint of moisture.

Late one afternoon there was a deafening explosion as a section of cliff peeled away from near the top between Proboscis and nearby Contact Peak. Hundreds of tonnes of granite thundered down the face and across the valley floor, with dust and debris rising some way up the flank of the mountain opposite. The ground shook and a sharp metallic smell of burnt earth hung in the air. Our radios sparked into life, the team on the face desperate to know that everyone was safe. The only people who might have been taken out were Richard, Brian Hall and me but, fortunately, we'd just made it back to the tents. Our last camera position now lay beneath a new layer of van-sized granite boulders. Sometimes in the mountains there are things that lie outwith anyone's control. Luck had been on our side.

As Barry and Nancy moved to the upper section of the climb, Canadian mountain guide Grant Statham and I climbed the Echelon Spires to take shots looking over at our dots. As I filmed, Grant became curious about a glint in the small summit cairn. It was an aluminium 35mm film can containing dried-out pieces of note paper, a summit register with just a handful of handwritten names. The first was Royal Robbins.

I've always loved the sense of history in mountain climbing, the protagonists and how their lives were shaped by their passions for these wild places. I could only dream of being as talented a climber as the people in whose footsteps I followed, but what mattered was that we were searching for the same things. I guess most climbers like to be part of their tribe, accepted and valued. Our team consisted of 'can do' types, motivated and organized, fresh and fun, all highly skilled climbers. As ever, I didn't feel I was in the same league.

In dwindling daylight another of our Canadian guides, James Blench, descended the scree slopes across from Base Camp with a

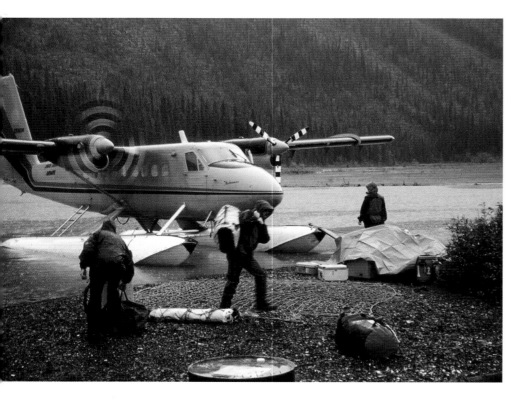

↑ A monsoonal wrecking
frenzy as we off-load the
twin otter at Glacier Lake.

→ Bruised light as thunder
boomed across the bleak
granite of Mt. Harrison Smith.

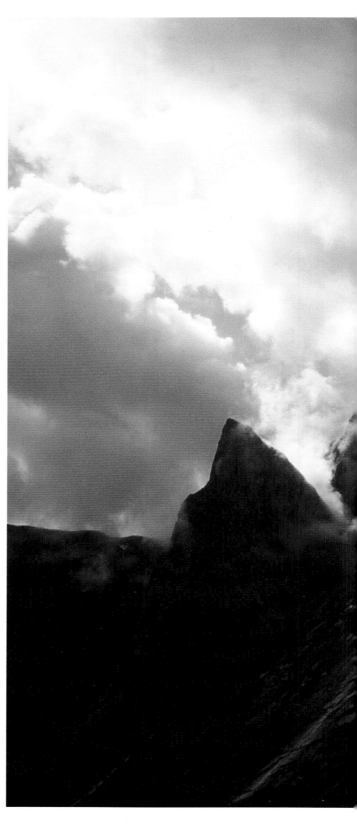

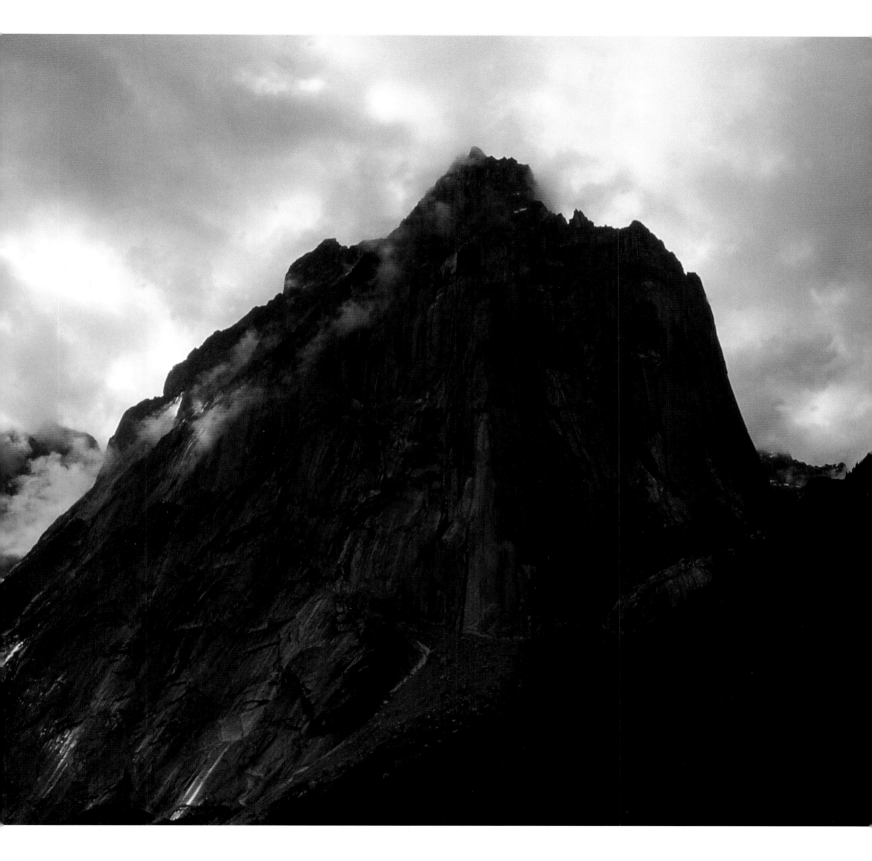

heavy load of rope and climbing ironmongery. The stacked slates were damp and highly unstable, he slipped, put his hands out to arrest his fall and a tile slashed his palm from wrist to finger. On inspection, the grit embedded in the deep, bloody wound was not an encouraging sight, most definitely in need of stitches. Getting him to professional help was vital.

The previous day the power supply for the satellite phone had gone up in a cloud of caustic smoke. Given where we were, it seemed a good idea to cobble together an alternative, so I soldered together an adaptor that would power the phone from our camera batteries. We fired it into life and the chopper was called. Jim the pilot shouted out of the opened door with the rotors still turning that he'd seen no point in flying in empty. So, as James stepped into the front seat with bandaged hand, slabs of beer flew out.

Nancy and Barry were nearing the razor summit ridge of Proboscis when black clouds amassed above the face. Duncan hung on the ropes filming, equipment buzzing and his hair on end with static. Hail rattled into the granite like buckshot from a barrage of shotguns and the holds on the final sixty metres became plastered and wet. Everyone headed for the top as fast as they could but, with other thunderheads gathering, opted to forego the true summit. Instead, with nerves taut, the climbing team traversed the ridge like natural lightning conductors to start their convoluted descent.

The weather clamped down just after we waved goodbye to the first flight out. At the clawed wooden hut back down at the lake Digger, Cubby, Brian and I faced the weather with tents, plenty of food, and a fishing rod. Turned upside down against the wall of the shack was a leaky Canadian canoe which, with the aid of much gaffer tape, remained afloat long enough to cast for grayling. That night we cooked fresh fish rammed with garlic over an open fire and kept vigil for bear.

With the dusky night brightening into day we heard the distant drone of aircraft engines and Jaques once more dropped out of the sky. We were finally heading back to civilisation and a very abrupt police officer, waiting, arms folded on the pontoon. We were ushered, very insistently, into the rear of his squad car and driven into Fort Simpson at high speed, sirens blaring, red and blue lights spinning. We skidded unexpectedly to a halt outside a neon signed bar where Richard and the rest of the team were enjoying dinner and cold beers. There was much hilarity as we walked through the door accompanied by our uniformed escort. It seemed that last orders were about to be called.

The Cirque of the Unclimbables, as a shoot, had ambition and the rest of the films continued in a similar vein, full of surprises and unexpected situations. We headed to Utah where Richard had teamed up Airlie Anderson, a no-nonsense Essex girl and talented sport and competition climber with mountaineering legend Aid Burgess, twenty-five years her senior.

They threw themselves into their four-wheel-drive with its boot loaded with a desert climbing rack, finger-tape, tents and home-brew. We followed in a second truck, heading through the night towards Moab, stopping briefly to drink bottomless cups of weak coffee at a gas station. Airlie sat flabbergasted at Aid's confession that he'd never fallen off a climb. Airlie in her often blunt manner, blasted Aid as a 'wuss' saying that he couldn't have been trying hard enough! She was brimming with confidence having spent years climbing the hardest routes on the 'Grit' in North Yorkshire where jamming fists and feet into vertical crags to aid upward progress would stand her in good stead for the splitter cracks of

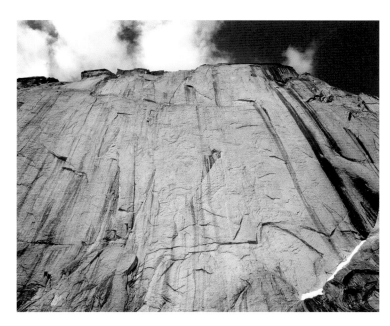

↑ The unyielding 800m vertical South East Face of Proboscis. Barry and Nancy climb the crack system on the left hand third.

↓ Keith Partridge with the second of the two DVCAM cameras in the world. 'Jodrell Bank' listens to every whisper and scream of our climbers.

→ Like a natural lightning conductor, Barry Blanchard descends the precarious summit knife edge.
(© Cubby Images)

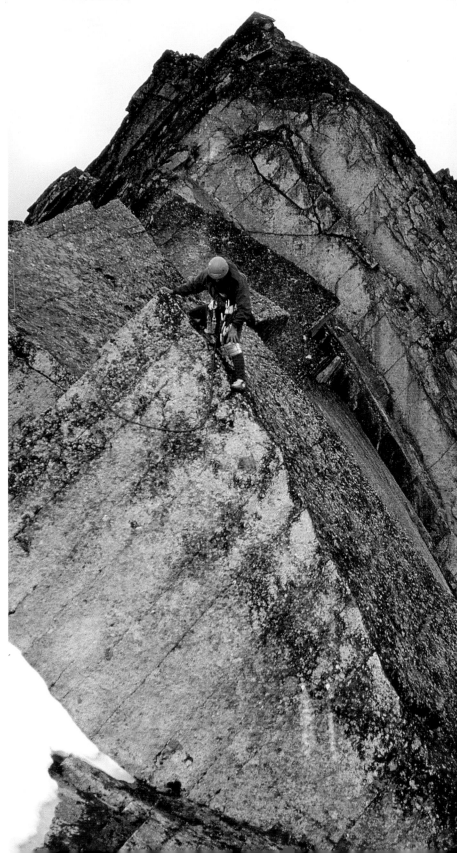

↓ *Moses Tower in Canyonlands National Park, Utah. Almost a challenge too far.*

desert sandstone. It was the old guard meeting a new school, full of fighting talk but with a tail ripe for pulling.

The dirt road to the bottom of the canyon passed pillars and walls of finely hewn stone, glowing from orange and red through to purple. At the camping zone directly below Moses Tower we erected tents for all the team bar one who preferred to sleep in the back of a vehicle.

Filming from below I couldn't see the detail of Airlie trying to round a roof over the corner crack she'd just jammed up but I could certainly hear her. In the final film the beep-machine went into overdrive as the expletives flew. Duncan trained his lens on her from above as she repeatedly poked a camming device at the rock, squealing, 'Is it in?' Two out of the four cams wobbled against the sides of the thin crack and there was so much rope drag that she couldn't make the clip but, finally, the battle for 'Primrose Dihedral' was won and Aid and Airlie stood on the bulbous crown of Moses. It was time to brew a final cowboy coffee, pack and race for the airport.

Our American four-wheel drives bristled like the starship Galactica with courtesy lights. You only had to look and blinding lights beamed from the doors, tailgate, sills and cabin. As we turned the key the starter motor groaned and died. After the long nights in the desert with one of the safety team cocooned in his sleeping bag, reading in the floodlit interior, the battery was exhausted.

We tried to push-start it before realising we were on an impossible task. The vehicle had an automatic gearbox. After much head scratching I suggested breaking out the climbing kit to construct a set of jump leads from 'wires' threaded together. Brian Hall, in his role as Chief Safety Officer, pressed one end of his lead against the battery terminal with a roll of gaffer tape, the other

hand wrapped in a fleece as he held the makeshift lead clear of the vehicle's bodywork. As a precaution I laid a foam sleeping mat between the cars' chassis and gripped my lead with bare fingers. Airlie and Aid sat on a boulder wondering if this hare-brained scheme could work, while the culprit who'd preferred his bed in the boot looked sheepishly on. The second vehicle was revved to within an inch of its 4.8 litre life for forty minutes before enough juice ran into the dead cells of our sick car. With a flick of the ignition we were off.

There were no real serious implications save for the possible expenses of missed flights, but it reinforced important attitudes: 'It ain't over till it's over', 'think outside the box', 'the home run can still mean a journey through the dark woods'.

The remaining 'Face' shoots took the team to the 'Great Arch' on Pabbay in the Outer Hebrides where Dave Cuthbertson and Lynn Hill almost free-climbed an audaciously hard line though a long roof crack above the pounding Atlantic. Unfortunately, time to hang the critical final 'match-box' hold ran out before the boat left for the mainland.

We climbed with Tony and Di Howard in Wadi Rum in the Jordanian desert, following an ancient ibex hunting route over the mountains with the accompanying sound of ripping trousers as I slid down the coarse sandstone on my backside; abseiled into shoulder-width slot canyons in search of shade and Lawrence of Arabia's spring. The camera threw a wobbler with a flashing error code message and just as we were about to throw it off the cliff in desperation, it came back to life to work faultlessly. At the only restaurant, a curvaceous, blonde belly dancer from Sheffield put on a wobbly show and wild camels lay in the sandy car park. Scorpions hid under our groundsheets.

He was in danger of being swept across the South China Sea

In Vietnam things didn't start well. In Hong Kong, Andy Parkin missed the sign pointing left from the top of the jet-way to meet our connecting flight, turned right and ended up somehow on the bustling streets. He enjoyed an impromptu day's sightseeing and bumped into a friend before catching up with us in a sweltering, hectic Hanoi where the people possessed an incredible warmth with a natural, welcoming curiosity. Travelling somewhere so un-Westernised was a refreshing joy.

The narrow road to Halong Bay was chaotic with animals, bicycles, belching rotivators, and trucks; bounded by continuous rice paddies full of water buffalos, wooden irrigation contraptions, and workers with shallow conical hats and yokes hung with pails. The town, when we finally arrived, was relaxed, with no high-rise buildings or significant development. We sat under a bamboo awning and pointed randomly at the menu to order a lunch that turned out to be fried silk worm before walking to the beach to find our boat, our base from which we looked across the thousands of limestone fins, spires and islands that poke through the South China Sea.

Sleeping on deck we were wakened in the small hours by the boom of explosions. At first light, fishermen cruised alongside in their ramshackle wooden boats holding up their wares of dynamited fish to supplement our diet of rice, noodles and chicken; our stock of which was stored in the toilet, no more than a hole in the deck. Refreshing pre-dinner swims had to be on the premise that no one would use the facilities.

We were enjoying cool beers under the canopy when we heard a strange squeaking noise and someone asked if we had seen Brian. Realising that those feeble cries were, in fact, pleas for help, we peered over the side of the boat to see him pinch-gripping desperately onto the bow. He had been enjoying a cooling dip when his legs locked with a severe bout of cramp. Unable to swim against the body-surfing, strong currents that ripped around the islands he was in danger of being swept across the South China Sea or of being blown out by the dynamite fishermen until we hooked him unceremoniously from the water.

Most of the coastal rock was savagely overhanging, offering great sport to Andy and Greg Child although Duncan had a tough time hanging onto the camera. At the end of a long climbing day he lay crumpled on deck, speechless through exhaustion. Most days we'd abseil to just above sea level, ready to drop into a kayak and be paddled back to our anchored boat but one day, as the tropical darkness fell, Digger, fully laden with climbing ironmongery, became aware of a frayed end of rope in his lower, controlling hand. Instinctively he stopped. Coming off the end of the rope, into the sea, he would have sunk like a stone. He radioed for help and the boat was steered from its mooring right under him. He dropped, with much relief, onto the top of the canopy. One of the locals must have spotted the hanging line and shimmied up as high as possible before cutting and dropping back into the sea with the precious rope.

At the end of the shoot we returned to Hanoi, where Duncan, smartened up with one of my collared shirts, the strained buttons of which looked as if they would ping off at any moment, went with Richard to meet with the Ministry. They insisted on viewing our material to ensure we hadn't been filming sensitive areas or military installations and to assure them that we hadn't been spying. That afternoon I'd been handed a flyer advertising the 'Hanoi Roxy' so, after all formalities, we entered a dingy club, the sweaty air turned over by a series of ceiling fans and stormed the dance floor, to the

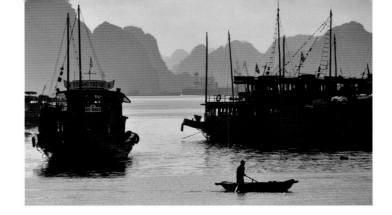

→ *Ha Long Bay 17 years after our visit for 'The Face'. Altogether a much busier place.*

sultry amusement of a line of 'ladies of the night' at the bar. When the place was raided by the police in the early hours we made a quiet retreat.

For the last film Richard asked if I would be happy to cover both camera and sound on and off the rock face. This was a great but daunting opportunity and I wondered why? Had money, over the course of such an ambitious project, run short? It seemed that no matter what I decided, Duncan would not shoot the final film in South Africa. He and I were great friends and I was torn between loyalty and an opportunity I'd been working towards since leaving the BBC.

I had two major problems. I was not as experienced on the ropes as he, and I had neither the strength nor stamina to film with the DVCAM loaded with sound kit. Duncan's exhausting experience in Vietnam was still fresh in my memory. However, Sony had recently brought out a smaller camera on which I could mount the radio microphones in their basic form. Bearing in mind I'd be no more than a rope length away from Joe Simpson and Ed February the problem seemed to be solved; the system would cope at that range. Jodrell Bank was never to be used again. With close and supportive supervision from Digger and Brian we embarked on the shooting of 'Energy Crisis'.

South Africa was a country in transition and for Ed, a black South African, the trip meant a crossing of emotional boundaries. A small workers' cottage had been booked at the Kromriver Farm as our base. A few years earlier he'd been forced to leave at gunpoint by the landowner whose only reason was that Ed was black. With some trepidation he not only entered the same land but also crossed the threshold where, in a monumental shift in attitude, Olive, the landowner's wife, served us all dinner in her dining room.

On the crag Ed was a bold and talented climber whose familiarity with sandstone allowed a fluid style of movement. Joe displayed a less graceful brand of climbing and Ed's gentle encouragement soon descended into climber's banter. Joe, preferring the security of a body height horizontal crack, decided that caving was a more psychologically secure way to complete the pitch. I placed my feet on the top of a horizontal crack and shot with legs placed as wide apart as possible. Hanging on the ropes I slowly bent my knees to track the camera towards him as he inched his way spluttering, with legs flailing out into thin air.

No longer tied to a tripod I sought more dynamic ways to use the lens, manipulating it to reinforce the sense of exposure and intimidation. I experimented with the pan, tilt, yaw and inverse and in addition, since I could hear every word and grunt, I also had a sense of what the climbers were feeling and was able to follow the action in true fly-on-the-wall style.

By the time the follow-up series, *Wild Climbs*, had been commissioned I had developed my 'jet-pack'. The sound kit was mounted inside a rucksack, the camera plumbed into the electronics via a complex of cables and with the flick of a switch mounted beneath my walkie-talkie I could power everything in an instant. The icing on the cake was the ability to transmit both pictures and sound to the Director (Richard) so he could see and hear what was happening. The lightweight revolution was now properly upon us. Embarking on this next series we could shoot on three cameras with the safety team providing additional coverage.

In 1998, *Wild Climbs*, again by the prolific adventure filmmakers Triple Echo, and in the same vein as *The Face*, visited the world's most iconic climbing and mountain locations that would figure on every climber's tick list. From impressive cliffs and spectacular ice structures to improbable natural rock formations; from the

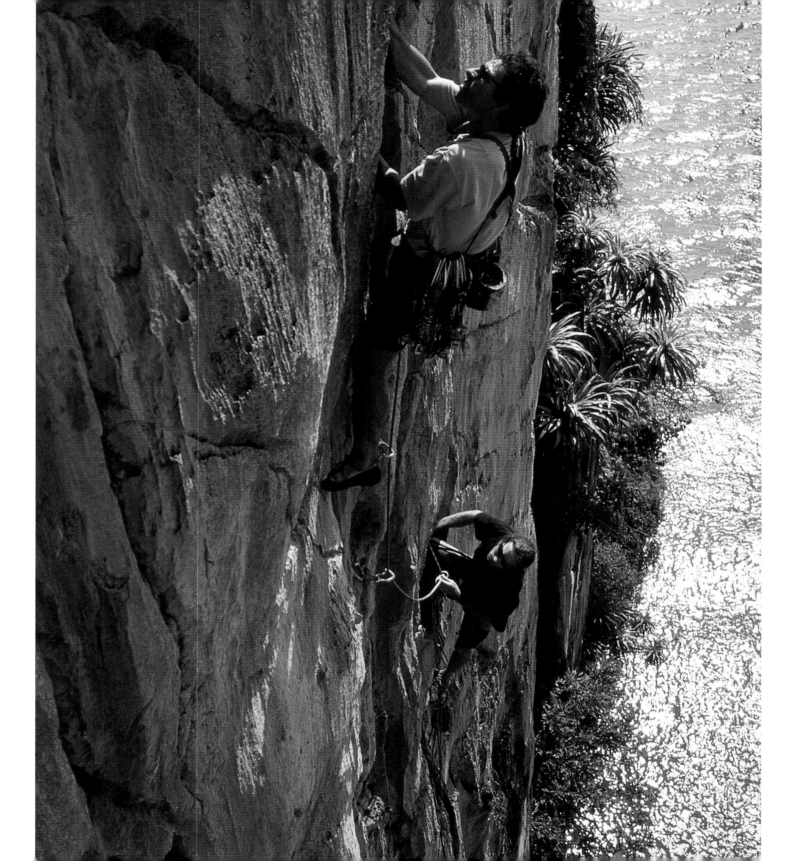

Totem Pole in Tasmania, a 65m high, 4m wide sea stack ,to ski-mountaineering in the remote St. Elias range on the Canada/Alaska border, the six films pushed me to the limit technically, physically and mentally.

Filming often didn't go to plan. We found the snow in the St Elias range in a highly dangerous state with a thin crust overlaying 25cm of depth hoar. On the first attempt at shooting Vaila Stock and Sarah Ferguson, both world class skiers, making turns down a shallow couloir, the radio rattled into life with a very forceful message from Brian Hall. We were ordered to evacuate the mountain and return to Base Camp. The slope behind us had spontaneously avalanched and that was the end of the skiing.

Conditions in other locations were more predictable and after filming in Ouray, Colorado, arguably the most reliable ice-climbing location on the planet, we moved to Vail where a very outspoken Stevie Haston, together with his partner Laurence Gouault, were searching for the hardest climbs of the day, ice pillars hanging free from vast overhangs of limestone. Stevie, originally from the east end of London, trains hard for such routes, doing 2000 pull-ups a day in his basement flat in the Chamonix Valley.

His physicality struck me immediately and with his opening interview running, 'This stuff about being physically aggressive? It's because people are horrible to me. If you're horrible to me I'll just smack you in the face', I remember filming those lines and feeling that we were in for an interesting time. I found Stevie utterly charming but, unlike certain members of the safety team, I posed no threat to his status. I kept my head down, tried to be professional and capture whatever happened as it happened.

We ploughed a trench through knee-deep powder snow into a natural limestone amphitheatre where a series of huge ice formations dangled like drools of melted candle wax. With balletic grace Laurence tinked up the first pitch of *Reptilian*, a thick smear of ice with water running just below the surface. Mixed in its quality, sometimes brittle, it required a light touch and concentration. Stevie, in his own mind the 'best climber in the world', suffered an embarrassing slip while trying to look good for the camera and exhausted himself working through a complex series of moves along a hanging traverse. The following day we were at it again but Stevie forgot his crampons. John Whittle (safety) was despatched to collect them from the hotel and it did feel a bit like the point-scoring ball had just been batted over the boundary.

Stevie climbed the first pitch in borrowed gear and was sorting out the belay at the start of the crux when his own crampons arrived, were clipped onto the ropes and hauled up. Digger and I lay in wait, lenses primed, stabilising our filming positions in mid-air from a giant aluminium A-frame, watching Stevie as he climbed from beneath the rock roof and pulled round onto the upper wall. From there he should, if his strength didn't fail him, be able to reach a free hanging icicle the size of an intercontinental ballistic missile. I couldn't imagine many climbers capable of following this line.

From the belay he launched across the rock, the picks of his axes all that he hung by. Hook by hook he climbed towards the lip of the roof under the encouragement of Laurence's soft French accent, his legs swinging on fresh air. At the crux came the 'figure of four' where Stevie, hanging from his axes, raised his left leg up between his arms and hooked the back of his knee over his right wrist. Now levering with his hip he raised himself enough to release his left axe and reach quickly beyond the overhang to search for an edge of rock no thicker than a pound coin. Then, hanging from the single axe he brought his right pick to sit alongside his left. As he tried to

65

Success is not always about 'pinnacles' of achievement but about processes...

calm his body-swing his axes threatened to part company from their slender hold. I crash-zoomed the camera, trying to control my own excited breathing. Watching any athlete at the top of their game is inspiring but rarely do we get the opportunity to observe this close.

In my new role I took huge enjoyment and privilege from watching feats I would never be good enough to even attempt. Most operators at the top level look effortless, but Stevie sounded like both sides of an all-in wrestling match which, to my mind, elevated what we were witnessing. With a herculean effort he pulled up on tiny finger holds – axes flailed from their leashes, harpooning his face! His hands pawed at the sloping rock but, with the screamed words, 'I blew it! No! Block. BLOCK!' echoing, he fell, a black cruciform against the sky before the rope caught him.

After resting he went back up and did it all again, this time surmounting the crux moves and swinging his axe across to the hanging chandelier where shards splintered into his face. As he topped out he declared, 'I am actually the best in the world.'

The 'best' at anything is always arguable and open to debate, especially now climbing and mountaineering have splintered into so many different variations: rock, ice, mixed, alpine, high-altitude, competition, sport, specialist or all-rounder.

The series continued with pairings of the best climbers, characters of contrast and undeniable dedication. It was said of Leo Houlding that if he made it to 25 he'd be one of the finest climbers on the planet. With frequent and continued exposure to the cutting edge of adventure climbing, the chances are that something will go wrong.

Through climbing, or other immersion in challenge in an outdoors arena, people often report heightened sensory awareness, of being in tune with every element of the surroundings and themselves. Fingers of light across distant ridge crests, the sound of thrumming rockfall, thunderous avalanches, babbling water, breathing, the tactile nature of the rock, the taste of freedom and smells of life, all build the picture.

People talk of the fine line between success and failure where maybe the advantage lies in sneaking up when the conditions, mindset and motivation coincide like the alignment of stars. Success is not always about 'pinnacles' of achievement but about processes: good judgement, deeper experiences, friendships, respect for each other and the wild places.

Leo has not only survived but also lived up to prophecy with climbing achievements on some of the world's most technical and challenging rock-faces, including the first 'team free-ascent' of both the North West Face of Half Dome and *The Freerider* on El Capitan, in Yosemite, in a single day. Over a mile of hard climbing, for which most strong teams would require more than a week.

For '*Wild Climb*s' we followed him to the spectacular sandstone towers of the Czech Republic where he was teamed up with Andy Cave, an ex-Yorkshire coalminer with a calm, mature approach to counter the Houlding whirlwind. Leo, a fresh-faced 17-year-old at the time, headed out across the cobbles of Prague in search of nightlife – which wasn't hard to find with lager around 50p a pint. Despite such temptation the rest of us retired to the hotel.

Rumour has it that he found his way into a basement nightclub where the music ratcheted up the entertainment and things began to kick off. Girls jumped onto giant barrels, gyrating in rapidly increasing states of undress before breathing fire from flaming torches. One local was so flabbergasted he almost choked on his vodka, in the process spraying through the flames. It blew back and set him alight but other customers came to the rescue with beers to douse the fire. Our hung-over 17-year-old climbing hot-shot

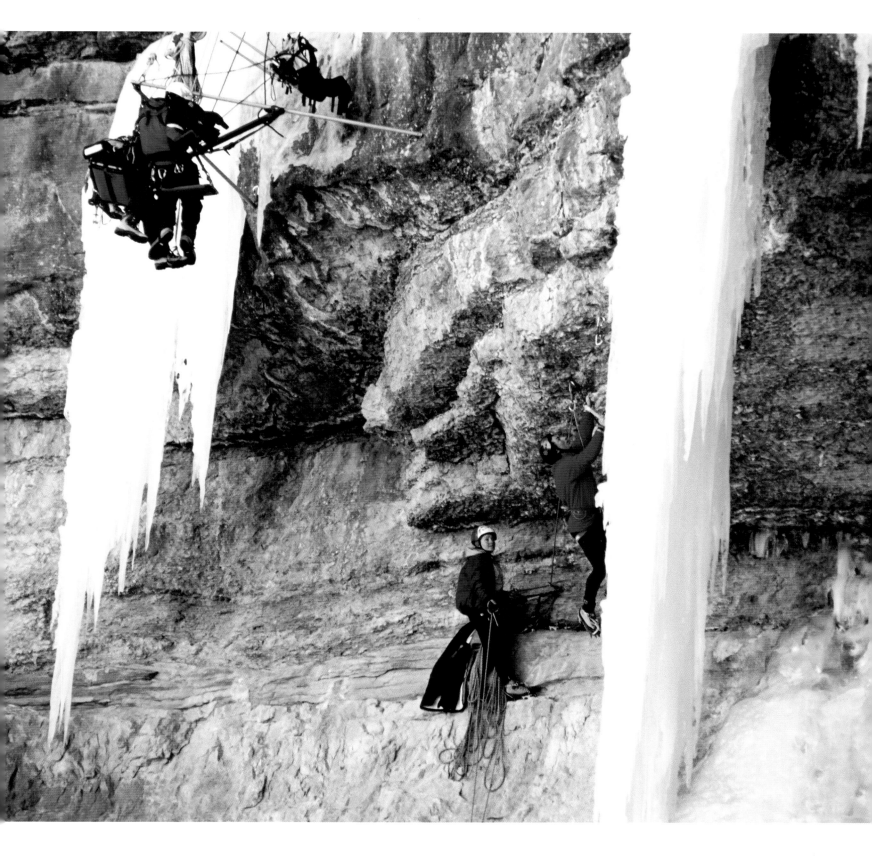

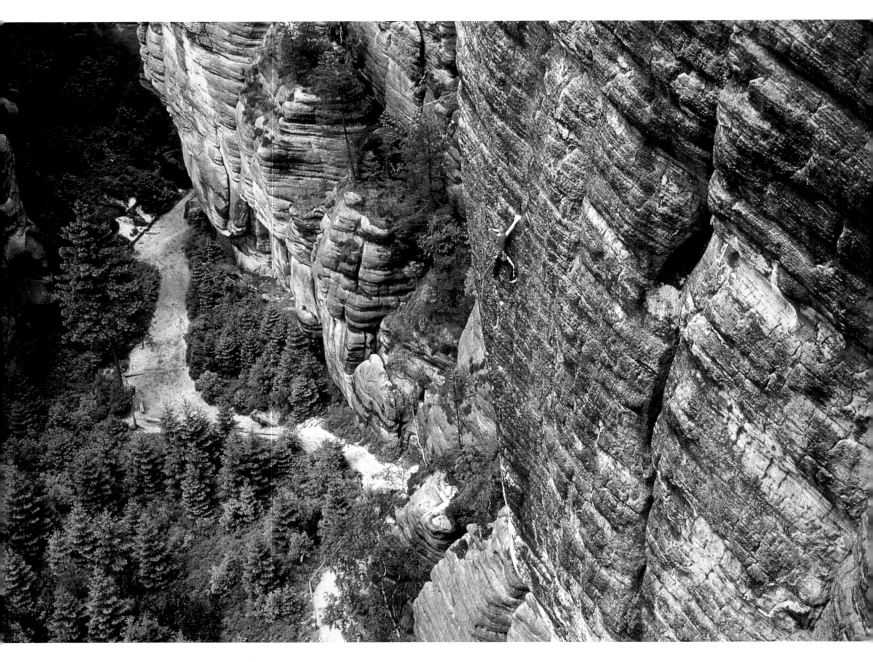

↑ *Protection from an occasional ringbolt or knotted slings wedged into the soft sandstone added a certain spice to climbing Czech style... (© Cubby Images)*

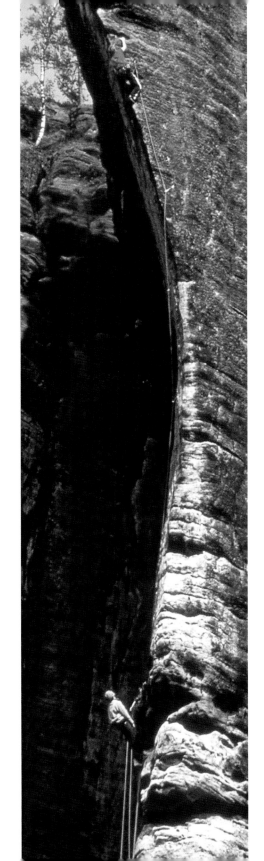

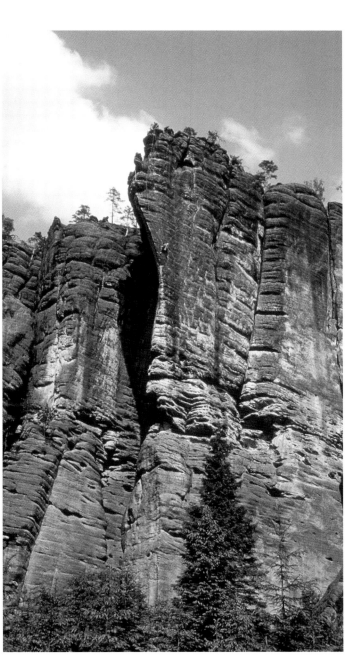

↑ Mid-air filming.
The only way to see
down the entire route.

↖ ↑ Curving rock in every
conceivable direction, Leo
Houlding and Andy Cave on
the local test-piece, Tsunami.

To shoot meant hanging in mid-air with little to stabilize you

continued the journey with his head out of the minibus window, reviewing the night before.

We had little idea where we were going but nonetheless careered along rough tracks, and through fields and forests. Near the Polish border the guys announced that we were lost and progress slowed until, over the tops of the pine trees, we saw a cluster of sandstone pinnacles. We had stumbled into the climbing area more by luck than judgement.

The local test-piece was *Tsunami*, an elegant piece of rock that curved preposterously to the left and overhung wildly at the same time, its mellow sandstone edges rounded by years of wind and rain. To shoot meant hanging in mid-air with little to stabilize you except an occasional ring bolt. The stone was so soft and easily damaged that the use of metal climbing protection was frowned upon. Leo and Andy clipped their rope to loops of tape and cord that had been knotted and then wedged into cracks, or larks-footed over slender nubbins descriptively called 'chicken heads'. Everyone wondered how effective these systems would be against the dynamics of a falling body, which added an additional frisson.

Traditional climbing Czech style, and the filming of it, meant bypassing that primeval vertigo. Keeping a toe on the wall gave a large amount of psychological comfort, unlike hanging in space where isolation accelerated the giddying effect. Digger offered a piece of advice that has stayed with me: 'Abseil over the edge, stop a few metres down and have a good look around, get used to the fact that you are in control.'

The series also took us to the world's Big Wall epicentre, Yosemite, in California, where Tim Emmett's boundless energy and enthusiasm coupled to the smooth, effortless climbing style of Colorado's Alison Osious jacked us up to Division One of the

exposure league. Climbing the ropes, with camera clipped to the 'jet-pack', beside the famous lines of *Wheat Thin* and *Ladies Fingers*, I looked down and soon noticed that the detail merged. It made no difference whether I was 50m off the deck or 500m. Confidence is everything when it comes to holding the shot. From that moment I accepted that both heights would be terminal if the rope systems failed and, bizarrely, from then on ceased to worry. With Digger's words in my mind, I began to really enjoy the sensation of being somewhere that few could reach, including me unless it was stitched with rope.

Climbing away from the hallowed lines freed us from the binocular-equipped, neck-craning audience far below. Yosemite Valley was choked with lines of tourists, white ranks of permanent tents and jams of 'toy' vehicles and buses. El Cap and Half Dome, revered by granite aficionados, towered vertically over 1000m above the scorched meadows and the fabled Camp 4, home to the 'dirt-bag climbers' who lived away from the regulations, untouchables hand-jamming up the sun baked slabs to sleep on airy ledges.

Moving to the renowned climb *Separate Reality*, Tim wedged almost every body part into the 6m horizontal roof crack before hanging out over 200m above the valley, a distant and lonely place to be, and something that encapsulates the very essence of the route.

Far out of sight, there are many places where climbing just happens. In the Arctic archipelago of Lofoten Mick Fowler and Mark Garthwaite were tasked by Richard with finding a new route. Mick is one of the finest seekers of the unexplored, an exponent of the noble art of suffering. A master of understatement with a sense of mischief and a classically English accent, he exudes enthusiasm for all things mountain (except bouldering). He also holds down a suit

except an occasional ring bolt.

and tie job with Her Majesty's Revenue and Customs but somehow stretches his annual leave to at least one big expedition per year. Mick teamed with Scottish GP Mark Garthwaite, who possesses a tall, powerful, no-messing physique and No.1 all over hair-cut. His email of doctordeath@something-or-other.com hinted at his own brand of humour. The opportunity for such climbing activists to be handed an exotic new route on a plate was an opportunity not to be missed.

Lofoten, home to whale steak suppers, the Maelstrom, and mortgage sapping lager, with its vast swathes of rough granite, came up trumps with a 350m line that was christened by the on-camera first ascensionists as the *Cod Father*. It was Day Two and I'd 'jugged up' past the previous day's high point, just below the blank slab that was the probable crux of the climb. Hanging in wait, I sensed that Mick, who'd positioned himself, somewhat by mistake, to lead reluctantly through a series of committing moves, was rather nervous, exposed above his last protection at a 3m section leading to a thin finger crack. The small depressions offered nothing positive for fingers or feet and, after a series of step-ups and retreats, he decided on a rash course of action. His lunge for the hold ended in a high-speed slide, fingers grating painfully against the coarse crystalline rock until, approaching terminal velocity, he slammed his backside into Mark's shoulder at the belay ledge.

Turning to Mark he asked if he'd enjoyed his bloodcurdling scream and set off for another go. This time he knocked his elbow so hard it started an internal bleed ending with a balloon of skin full of blood. Dr Death's suggestion of a course of ice and beer was most welcome.

The following day, in glorious light and with the swelling almost gone, Mick moved smoothly over the crux to a roof where Mark took the lead. Over a long, sun-drenched day, where daylight was not going to be in short supply but good weather might, we moved steadily upwards until I felt a twang at my waist. I spotted the problem as my radio sparked into life. 'Keith, hello, Richard here. Are you okay to talk?' Richard was with Brian on a ridge watching. I squeezed transmit: 'No. Soon.'

The repeated motion of ascending the ropes for over 300 vertical metres, with the rubbing of the tape that connected my jumars into my harness, had caused the gate of the maillon to undo. With visions of me plummeting to earth, I grabbed a spare screwgate karabiner from my gear loop and worked fast to back everything up. This sounds like a potentially catastrophic situation, but we always work with a double rope system. If the maillon had parted company completely, which was unlikely, I would have been caught by the second system, but it was an unnerving moment.

When everything was in order I called Richard who was simply curious as to how things were going. I admitted I was getting pretty exhausted and, as we approached the top, I radioed Brian to short-rope me along the airy summit ridge despite it being merely an exposed, easy walk. My legs were so wobbly I didn't trust myself not to trip.

We'd been racing the weather, which in Lofoten often doesn't stay fair for long. The following morning John Whittle's snores from under the stairs were drowned by the hammering of rain on the roof of our wooden fisherman's cottage. Most of the team went to explore some 'climbing problems' they'd spotted sheltered by large overhangs, but Mick categorically stated that he preferred to go 'proper' climbing. I also don't do much bouldering, given the ankle injury and so, in the Arctic Norwegian equivalent to the monsoon, we embarked upon the classic four-pitch route called *The Goat* on a tower overlooking the town of Svolvær.

With water running down my sleeves and into my underpants I climbed onto the top of one of the horns where Mick belayed me from his seat in a puddle. We looked around for the abseil line to get back down, the chains for which lay in a cheeky 'come and get me if you dare' manner on the top of the other horn. The gap between was not excessive but enough to make the heart leap as we made the jump between the two blocky pinnacles. After threading the ropes through the chains Mick threw them into the mist and secured his abseil device. 'See you on the ground,' he said. Having just grovelled up four hideously wet pitches I thought it unlikely and, behold, a matter of seconds later a squeak rose through the swirling clouds, 'Err, we appear to be somewhat short'.

The Adventure Game is dangerous. Play it for long enough and something will probably go wrong, sometimes catastrophically, but for those who are redefined by such events, if they have previously explored what is possible, they will never stop needing to reset limits, even if it means relearning from the ground up.

Paul Pritchard, as a hemiplegic with a four-inch hole in his cranium, revisited the pinnacle that almost took his life. Like many top adventurers Paul possessed a single-minded approach to life, his distant eyes always focussed on new projects and far away objectives, always wondering if his own accident had weirdly saved his life given the risks he had taken. In the 1980s and 90s Paul was one of the UK's leading lights in the sport with a reputation for succeeding on hard and poorly protected routes at the upper limit of difficulty for that time. He went on to take his ability to 'deal' with risk on many lightweight mountaineering ascents all over the world, from Baffin Island and the Himalaya to Patagonia.

His first book *Deep Play* won the 1997 Boardman Tasker mountain literature award and with the prize money Paul financed

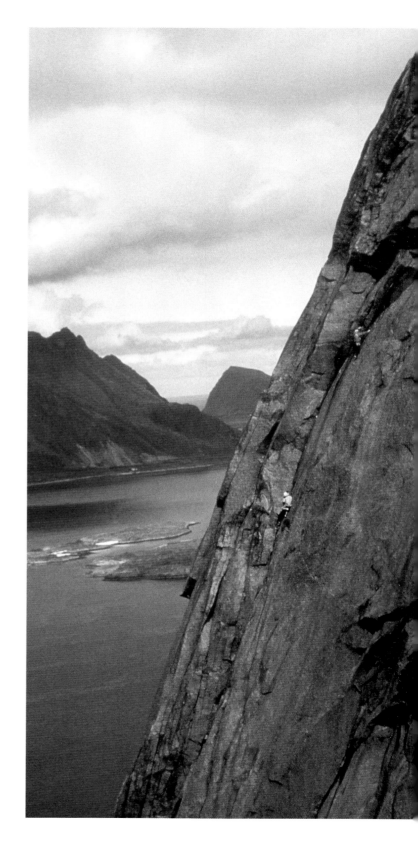

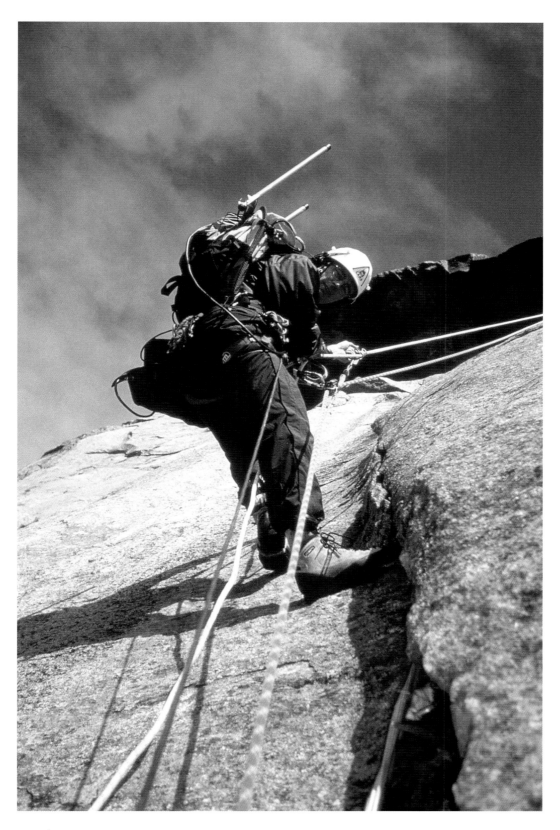

← *Mark Garthwaite and Mick Fowler cruising 300m up the* Cod Father *in Lofoten.*

→ *The Mark 1 jet pack.*

↑ *This way to the Totem Pole. Paul Pritchard points the way in Tasmania. (© Cubby Images)*

a world climbing tour on which he found himself on Tasmania's Totem Pole. This single column of diorite stands in perfect isolation in a narrow zawn at Cape Huay, and ranks as one of the world's finest climbs. To 'free' it was a must. The day he walked in with his partner Celia Bull, he met Steve Monks, a powerful looking climber with a Bristolian lilt and his American partner on and off the rock, Enga Lokey. Steve had been part of the team to make the first 'free' ascent of the stack in 1995. Paul hoped to make the second.

Having slid across the gulf to the top of the stack across a rope that had been left in place, Paul abseiled to its base where he slithered off a seaweed covered boulder into the swell. Drenched, with a chalk bag full of sea-water, he decided he would just make do with the top pitch and clipped his jumars onto the rope to climb back to where Celia was waiting on a ledge. With all the slack and stretch taken out of the rope he swung around the arete and in doing so dislodged a block the size of a portable television. After tumbling 75 feet it collided with his head and he hung, bleeding profusely, into the swirling kelp beds of the Tasman Sea with his brain exposed. Celia managed to haul him to the ledge and then ran to raise the alarm. Paul's survival is a miracle in itself, with the links between his brain and the limbs on his right side severed. Rebuilding those pathways was key to any level of recovery. Speech and memory were other issues, and he often stopped mid-sentence having forgotten his train of thought. Along with producer Margaret Wicks I first met him, sporting a crop of bright blue hair and matching nail varnish, in the Clatterbridge neuro-rehabilitation unit in Cheshire where, three months after the accident, he took his first steps.

Then a year after the accident our pilot held the helicopter steady two kilometres from the Totem Pole, with the skids jostling the top

or simply being in the mountains, once in the blood, is hard to shift and nothing compares to the draw of the high places.

of the low brush and boulders. The door opened and Paul slid out of the back seat with Mark Diggins and Brian Hall ready to catch him if he fell. Paul walked by swinging his right leg out and round rather than lifting it forwards. On the same side his arm hung awkwardly, off-balancing, but he progressed unaided to the edge of the mainland cliff where he took up position amongst the wind-bent bushes ready for his grandstand view of a climb that, for him, never was.

It is a wonder the Totem Pole stands. At 65 metres high it is a mere 4 metres wide at its base and tapers upwards. It looks diminutive next to its thickset neighbour, the Candlestick, but size isn't everything. Its wave-scoured smoothness yields little in the way of holds, just an occasional finger crack or break. Steve Monks, back to lead the climb on camera for us, abseiled down the cliff with an extending linen pole with a karabiner taped to the end with which to make the first clip. He lowered himself across the swell with spume tumbling in great clumps as waves parted around the base of the stack. Once at the bolt he made his belay and Enga Lockey joined him. Paul looked on through a pair of binoculars, often speaking into his dictaphone about feelings of sadness, adrenaline surges and jealousy at seeing Steve climbing fluidly around the arete to the cracked wall and the top of the first pitch. Below, a curious seal popped its head up.

I filmed wide shots from positions hanging down the mainland cliffs while Steve and Enga climbed. They dragged a rope behind them to establish a Tyrolean traverse between the summit block and the top of the main cliff. Zipping across I could position myself to shoot close-ups on a second take. I abseiled down the overhang above Enga's first stance and it became increasingly difficult to maintain contact with the rock in the howling gale that accelerated

through the narrow channel. I shouted to Brian on the belay ledge for another rope to hold me in place as the route spiralled around the stack. Thrown squarely into the wind the end whipped back to me and miraculously whacked into my helmet. I clipped on and heel-hooked the corner of the stack to film as Steve moved smoothly around beneath me before moving up to the belay ledge. Looking vertically down I followed Steve's fingers as he jammed them into a thin crack, climbing with poise and efficiency. On the upper part of the stack my ropes had been blown into a twisted knot through which I struggled to push my jumars. Eventually I arrived on the top ledge in an exhausted state, ready for Enga as she attempted the second pitch. She was blown off, hanging in mid-air momentarily before gravity took over and she fell, thankfully not far. Steve took over the lead to the top from where we clipped onto the Tyrolean, zip-lined across the gap with belly-full of gut wrenching exposure, and ran back to the landing spot. '*Wild Climbs*' as a series, and this episode in particular, had certainly lived up to its name.

Paul's thoughts, watching Steve's fluid movements, had turned from envy to joy. The return to the Totem Pole now had the feel of a pilgrimage, and animosity towards this inanimate pillar was gone. Passions, and the possibility of climbing, thought to be out of the question, were stirring again. The thrill and joy of such an activity, or simply being in the mountains, once in the blood, is hard to shift and nothing compares to the draw of the high places. Paul has returned to a life of adventure: to cycle in Tibet, to climb Mount Kilimanjaro and Mount Kenya before returning to rock-climbing in his beloved Wales.

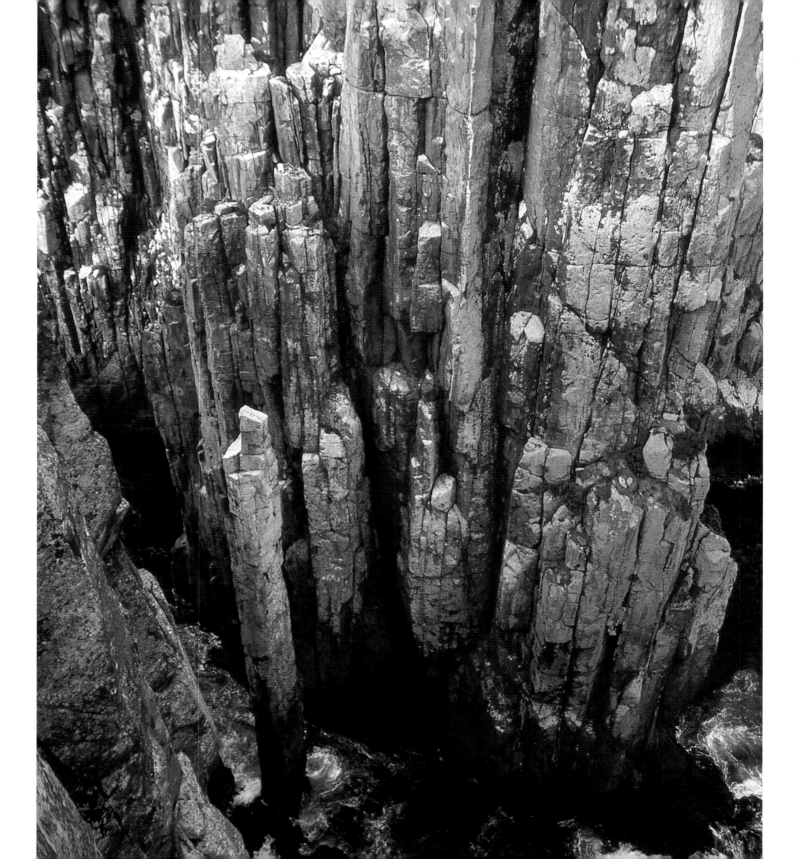

←← *A single column of rock defiant against the pounding Tasman Sea. Specks in red climb the first pitch. (© Cubby Images)*

← *It is a wonder the Totem Pole stands. (© Cubby Images)*

A
Bigger
Stage

I finished with the words 'count me in', hung up and only then thought about what I'd just signed up for and how we were going to make it work. I've heard it said on countless occasions that the 'film didn't do the book justice' and now we were to shoot one of the most compelling mountaineering stories ever told. Ulla Streib, from Darlow Smithson Productions, had just asked if I wanted to be involved in the making of Joe Simpson's *Touching the Void*, a book I had been transfixed by, that without fail gripped anyone who picked it up, climber or not. As a piece of mountaineering literature it is a storytelling masterpiece that also asks questions about the will to survive in desperate circumstances. The actions and story of Joe and his climbing partner Simon Yates provoked fierce criticism and debate. It has become the stuff of legend.

In 1985, ambitious mountaineers Joe and Simon set their sights on the unclimbed West Face of Siula Grande (6,400 metres) in the Peruvian Andes. It had been described to them as a 'challenging day out' in that understated, rather bleak, tone that climbers use to hide a very dangerous reality. Joe's opening words to the film would set the mood impeccably; 'they climbed mainly because it was fun... we were anarchic, irresponsible, we didn't give a damn about anyone else... we just wanted to climb the world... But it was fun, just brilliant fun. Every now and then things went wildly wrong and then it wasn't...' Those words still send shivers down my spine.

Having reached the summit via the West Face they continued their wild traverse across a heavily corniced and complex ridge seeking an easier descent. Down-climbing, Joe struck his axe into the ice. The top layer shattered, 'dinner-plating', making the placement feel insecure. As he tried again his other axe ripped out and he fell. Crashing into the ground his lower leg was forced violently upwards, shattering his knee and, in that explosion of pain, the pair were surely doomed.

Simon, however, made the brave decision to attempt the impossible: a single handed rescue from high on the mountain. Avalanched from above and with the snow collapsing all around, he knotted their ropes together and fought to lower Joe down without being pulled off himself. In darkness and storm he blindly lowered Joe over an ice-cliff until the knot jammed in the abseil device and they were stuck, Joe spinning in space. With no other realistic option Simon, fearing for his own life, was forced to cut the rope and Joe plummeted fifty metres into the depths of a crevasse.

Consumed by guilt and grief Simon survived the night and managed to reach Base Camp believing that Joe had perished. Joe however, was still alive and miraculously found a way out of the crevasse to crawl for almost four days to Base Camp. On the edge of death, he called like a ghost into the darkness to be found a few metres from their tent by Simon.

I'd met Joe a couple of times before, once when Jim Curran took me to his house in Sheffield in the winter following our Nanga Parbat shoot. Jim wanted to take me up some climbs on the 'Grit' at Stanage Edge but I was without gear. Joe lent me his rock boots and harness and, as we stood in his kitchen, he scribbled 'I hope you don't go deaf' in a copy of 'Void', thrusting it under my nose. Our paths crossed again in 1998 when I had filmed him in South Africa climbing with Ed February in the Cedarberg. Joe is highly opinionated and always on for a lively debate, he calls a spade a spade and likes a pint and I like to think I get on well with him.

In July 2002, at Schiphol Airport, Amsterdam, a team comprising Joe, Simon, Kevin MacDonald (Director), Mike Eley (Director of Photography), familiar mountain guides of Paul, Cubby, John and

'they climbed mainly because it was fun...

Brian plus Rory Gregory, doctor and climber Martin Rhodes, Gina Marsh, better known as Miss Moneypenny the Production Manager, Justine Wright, the editor, and Dan Shoring, Camera Assistant, assembled for the first time. I was to look after the specialist climbing photography for the main film and record sound for the 'Return to Siula Grande' documentary. Shooting on the actual mountain high in the Andes was the first phase of production. Later in the year we would be in the Alps to film the more difficult and dangerous sequences.

Lima was as I remembered it: humid, grey-skied and with an edgy, crime-infested feel. We piled the gear into a room in the Gran Hotel Bolivar, an old colonial building where the bar staff served pisco sours in white gloves tinged grey by the grime and pollution of Peru's capital city. This was merely a staging post before Cajatambo, the end of the road, in the Cordillera Huayhuash where a range of soaring, impossibly slender, fluted mountains pierced the blue Andean sky.

The day's drive over rough roads was interrupted as we passed through a small market town where many of us disembarked in search of suitable receptacles to act as pee bottles. John Whittle arrived back looking overly smug and I tried to imagine the stall-holder's expression as he poured the entire two kilos of toffees into a bag, holding them up ready for his best sale of the year and John then waving a wad of notes frantically at the jar. With its screw-top wide lid and huge capacity John was sure to relieve himself in comfort in the cold dead of night at camp. The bus zigzagged higher, swinging round blind bends with the driver's fist constantly on the horn before we were dropped at a small guesthouse to bed down for the night. Early the following morning we were met by seventy donkeys and their owners who would carry our gear up the valley. Splitting the equipment into 20 kg loads was a tedious process and, once on the trek, the trick was not to get stuck in the middle or behind our beasts of burden as their hooves kicked up vast clouds of throat-scorching dust and their flatulence was utterly overpowering. So, while the last of the loads was being strapped on we secured a healthy head-start.

High on a narrow section two gauchos galloped towards us shouting and waving aggressively. The reason for such action was not at all obvious but they kept repeating toro, toro, toro! We racked our brains but, when we spotted a tell-tale plume of snorting dust barrelling towards us we ran in full comedy fashion, scrambling up the rocky, cactus-strewn hillside, getting pierced from the waist down by dozens of long spines. Angry bulls stampeded past on their way to slaughter in the local bull-ring. It was a dangerous start to the trip.

Each day we pushed higher and further into the range, feeling the altitude, finally making Base Camp and then pushing even higher, past a beautiful emerald lake before gaining the glacier and establishing a high camp on the left side of a set of angry crevasses.

Filming was bound to draw powerful reactions from Joe and Simon, back for the first time in seventeen years and offer an insight into just what it was like to confront the mountain that almost killed them both. Climbing in the Andes has a fearsome reputation. Usually snow will slither off a slope of seventy degrees or more, but not here. Climatic conditions breed huge, unstable structures that defy the laws of physics. Mountaineers not wanting to swim up near-vertical snow would do better elsewhere.

After a few days of acclimatising, easy filming, and considering what parts of the mountain we might be able to safely reach, plotting their rightful place in the story, we all felt it was time to

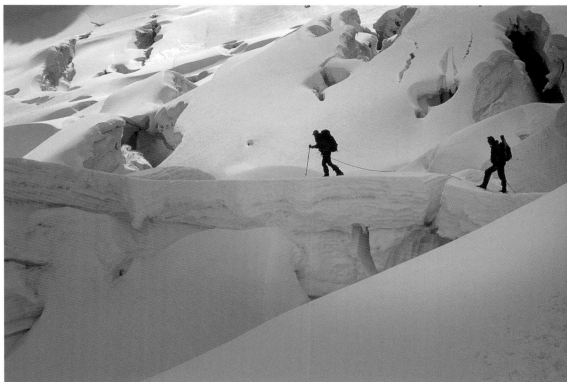

↑ '...where they're going
is really dangerous.' Joe
evoked the ultimate irony
of one of us being killed
making the film of what
he had previously survived.'
(© Cubby Images)

← Looking up the tortuous
route crawled by Joe after he
escaped the crevasse. Siula
Grande remains hidden to the
right of the boiling clouds.

I was on a vertical plate of ice hovering above a black void.

get stuck in. Mornings were slow to warm but it was a windless, blue-bird day when I looked up at the Siula Grande's West face. Enormous. Intimidating. Huge cornices and fragile mushrooms of snow overhung the area of filigree snow-flutings in which we were to film.

Breakfast had been a pretty meagre affair, a bit of porridge that barely covered the bowl mixed with a few nuts. Lunch was just half a dozen boiled sweets shoved into a pocket. I grabbed the handle of my sack, got my foot underneath and, with a combination of a snatch lift and kick, thrust my arms through the main straps. I jostled the load until it felt as comfortable as it was likely to get and clicked the hip-belt shut. Paul passed me the end of the rope to tie on. Sucking at the cold high-altitude air nothing seemed to happen, my lungs still felt empty and my legs were listless. There was a nervous tension. As we departed camp Paul reminded Joe to be 'careful on that big bad glacier'. He was going to spend another day reconstructing his own epic crawl across the crevasse-riddled ice.

Joe replied firmly, 'You be careful on that face. I feel sick at the thought of you on it' and Kevin, sitting on the side-lines, asked: why? 'Because it's incredibly dangerous up there... where they're going is really dangerous.' In this way Joe evoked the ultimate irony of one of us being killed making the film of what they had previously survived.

Turning our backs on the camp we made our convoluted way through a maze of holes, cracks and chasms. When we were forced to double back, I would peer, curious, into the black bowels of the ice. Why are we drawn to such places? I wondered. The back of my head pounded and my heaving lungs struggled to keep up as we slowly gained height. Paul probed at the lip of a crevasse and looked at the difficult uphill jump we had to make to reach the other side. 'If I go in, you hit the deck,' he called. With me watching, ready to react, he ran and jumped and, on the far side, plunged his axe into the snow.

I looked over the lip and into the void. Dazzling white turned green-blue and faded beneath an old collapsed snow-bridge. Light didn't penetrate the real depths. I doubted that I'd make it across, my rucksack weighed a ton. As I leapt, Paul yanked on the rope and I landed just inches from the edge. It collapsed under impact and I threw myself forwards, driving my axe into the snow. I'd made it, if only just.

Rory Gregory and Cubby caught up with us as I filmed some landscape shots and 'point of views' and turned to shoot Cubby crossing the bergschrund doubling for Joe. Rory belayed, playing the part of Simon. At first the mood was relaxed but the higher we climbed the more tense things became. Tell-tale hairs rose on the back of my neck and there was that gentle nag in the subconscious of things not right. Paul put in a belay and called for me to climb. An icy layer to the left of the fluting seemed good and I moved up as smoothly as I could, swinging axes and kicking in with my front points. When the ice ran out I was forced into the centre line of a giant, frozen four metre deep 'half-pipe'.

My axe rattled as I planted it into the ice. I took it out to have another go, the cause of Joe's fall flashing through my mind. On the next swing splinters of ice showered into my face; my left axe still wasn't holding. Gently pulling on the other I peered into the hole that my sharpened steel pick had just made. My heart sank into the pit of my stomach and, as the adrenaline surged, I almost threw up. I was on a vertical plate of ice hovering above a black void. Beneath the air-gap was a bottomless layer of gravity-defying powder snow. I peered beyond the rim of my helmet up to Paul who

simply mouthed the words, 'Don't fall', slowly shaking his head. He was calm, understated. It was an order I was happy to obey as I reached higher to the left and with a downward swing drove the pick into another patch of rotten ice. It held and I stood up, tinking my crampons into my crumbling world. Climbing until the snow felt firmer I kicked in as best I could but it all still felt highly precarious. I shouted up to Paul, 'If I gently load that belay is it going to hold?'

Looking around at the possible shots, I shouted to Cubby to wait and pulled the camera out of my pack. The magazine had just over a minute of film left but I had a couple of spares ready loaded. The tension was palpable.

Gently weighting the rope with my upper body twisted clockwise, feet planted in the snow and looking straight down, I framed up and pushed the 'run' button. The camera whirred into life, the dim image in the viewfinder flickered and I called for Cubby to climb steadily up and then to the far side of the runnel away from camera: wide shots to make the most of the location, crash in for some close-ups, following the action. Cubby kicked at the fragile meringues of snow sending them tumbling away, ploughing furrows with his axe to find something worthwhile in the powder snow. To keep the camera steady I took the largest lungful possible and held my breath, but as giddying hypoxia took over I was forced to gasp and hyper-ventilate unable to hold the shot any longer.

Spinning gently back round on the rope I released the spent magazine and reached into the bottom of the sack for the next. Working with my gloves off, I threaded the tail end of the new film round endless bobbins, counting the number of sprockets to make sure it wouldn't jam and then round more in the drive mechanism. Without warning, snow avalanched from above, filling the entire open side of the camera. Luckily the slide was a small one and not enough to force me off my stance. Once it stopped I reached into my chest pocket for a paintbrush and flicked away most of the snow from the camera's innards, closed the side and clicked the fresh magazine home. Desperate for warmth, I slid my hands back into goatskin gloves. 'OK guys,' I shouted. 'Once this load is shot that's it. We're out of here.' I sensed relief.

I filmed until the camera whir changed tone and the last frame flicked through the gate, rammed the camera into my rucksack and retreated with the others down the flutings and across the crevasse-riddled glacier. Afternoon clouds built ominously across the summits.

Exhausted by the continuous flood of adrenaline, I was glad to get back to camp. While we were fighting our battles on the mountain Joe had been sliding for hours on his backside around the crevasses, across the rubble-strewn moraine and into the depths of 'Death Gully'. Feeling as if the years since the accident had been some weird hallucination, he relived his agonising journey after he'd escaped from the crevasse. Mike Eley filmed from vantage points near the camp with Kevin directing by walkie-talkie, which served only to accentuate Joe's sense of isolation in this powerful landscape, maker of demons. Eventually, he reached melt-down as he filmed himself for the 'making-of'. At the bottom of a loose gully all the mental torment from his epic survival flooded back as he sat back against a rock and closed his anguished eyes.

I was sharing with Joe at the high camp when a light breeze flapped the door of our tiny tent to reveal a jet-black velvet sky, bejewelled with flickering stars. As we lay cocooned in our down sleeping bags, I could hear the tizzy spill from Joe's ear-buds, another club dance track soaring to a frenzied 140 beats per minute. I was reading, unable to sleep despite the day. Joe rolled over to face me and pulled his headphones out and, in the light of my headtorch,

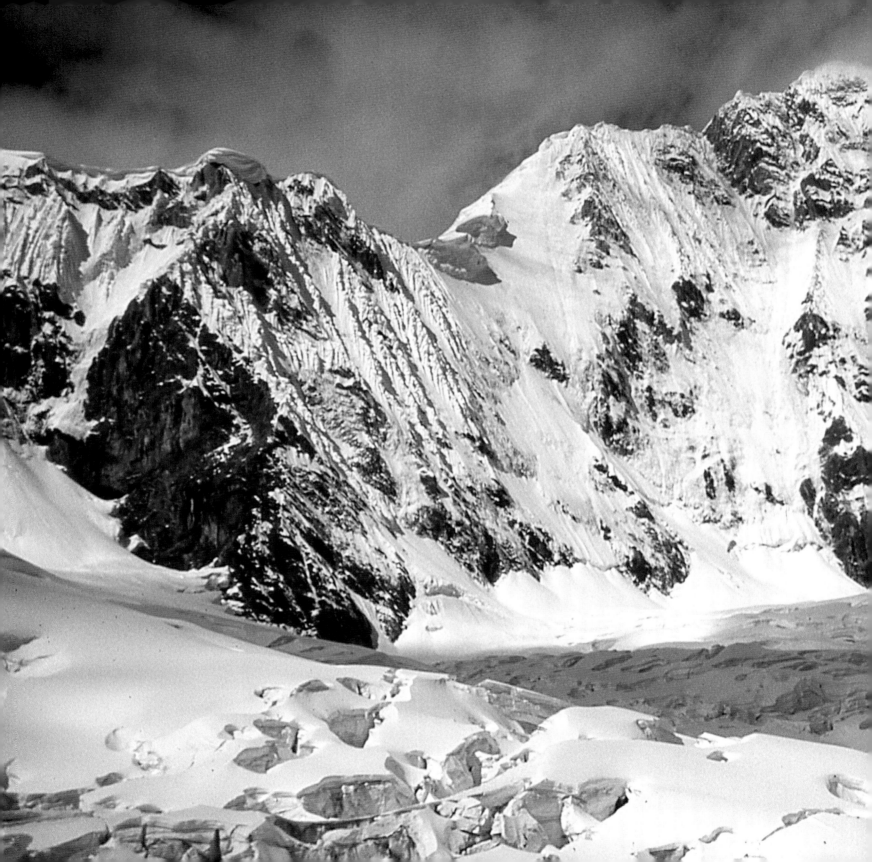

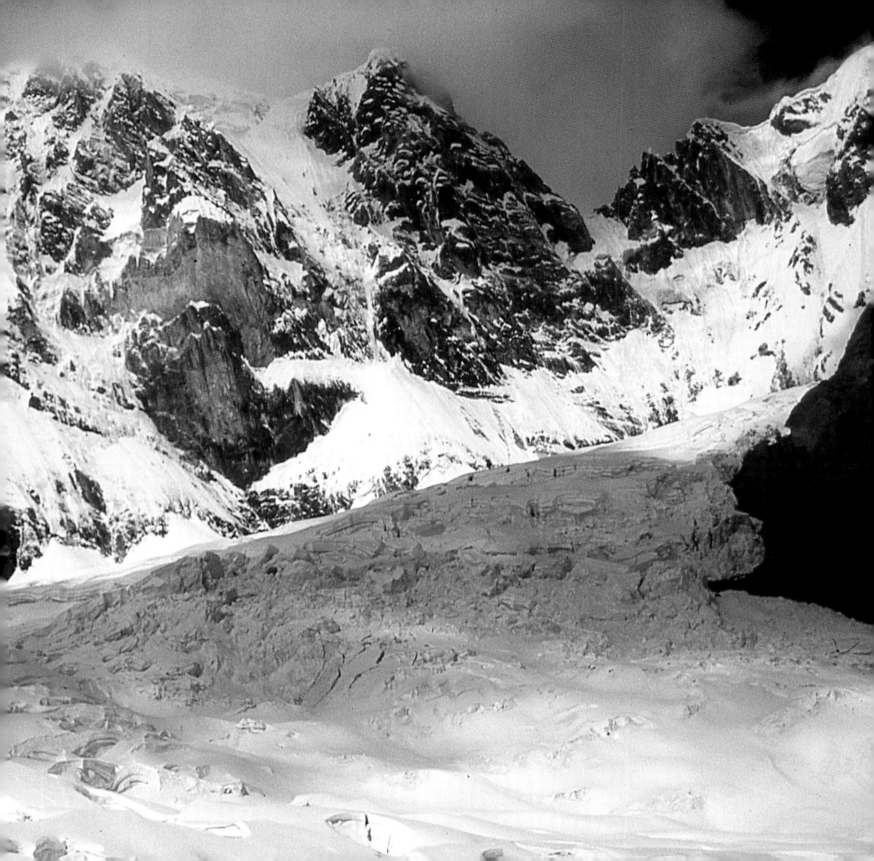

I sensed torment. 'Jesus, it's taken me seventeen years to put the ghosts to rest... now it's going to take me another damned seventeen.'

Speaking to me in confidence, it also felt part confession, he told me that he had not a single desire to re-enact the darkest moments of his life surrounded by the overbearing demands of film-making. Part of me wanted to have that moment recorded but, coming out of the blue as it did, it was not to be. Some things are best left. We spent much of the night talking. Me trying not to rake old coals, but offering reassurance that the film would turn out fine. Joe replaying the struggles that had shaped so much of his life since.

Simon found a location for the 'summit' on a small peak immediately above our high camp, with a corniced, mushroom top that matched Siula Grande's perfectly. We accessed it by climbing a rocky gully rising directly above the tents to a ridge, making a right turn and climbing steeply up the snow. Wanting to do a shot handheld, following Cubby (Joe) and Simon (himself) over their shoulders as they climbed this final section, I needed both hands to operate the camera although upward movement was difficult with snow collapsing all about us. Paul, beneath me, pushed upwards on my backside to stop me falling back until, confident I'd got the shot, I cut the camera and we looked down with a slight gulp at the ice axes far below. To our right and left the ground dropped away for hundreds of metres. My crampons dug around in the depths of the snow as I sought purchase. If I had ever tried descending a knife edge covered in granulated sugar I would have known that controlled slithering was the best option.

Back at the camp we packed all the kit on top of our already heavy camera equipment and began the long, knee-grinding descent down the glacier and across the moraines, finally reaching Base Camp by head torch, guided by the warm glow from the lamp inside the mess tent. I slumped into one of the folding chairs, so exhausted my brain no longer connected to my mouth.

Over our mutton dinner I heard that John Whittle had been spotted legging it across the boulders in chase of his sweetie pee-jar, blown away by the strong katabatic winds. Having rugby-tackled it to the ground he returned to camp, grinning as he had in the bus weeks before, with his pride of possessions. At night he had been caught short. As fast as he poured it in the top, it emptied all over his sleeping bag, out through a hole that had been punched in the bottom. The cruel news lifted my spirits.

When I returned to the home Andrea and I now shared, I strolled in the sunshine to the village harbour and there bumped into my friend Len who insisted I get my wetsuit. Sailing across the bay out the front of our house in his racing dinghy, in my jet-lagged state, I was a little too slow across the boat and, off balance on a tack, we capsized into the cold waters of the Firth of Forth. It was the perfect tonic.

October in the Alps seemed a far cry from the blue sky days of the Huayhuash. On the train from Grindelwald John Smithson, Executive Producer, wished for bad weather to make the storm scenes look genuinely hideous. He got what he asked for. Working out of the back of the Jungfraujoch Station, Rory Gregory, just a few metres from the lens, frequently disappeared in spindrift as he belayed Cubby leading a small pitch up a buttress during a full-on storm. We managed around forty minutes before having to retreat, my hands barely able to operate the camera. We'd warm up and head out for another stint. At one point I hadn't seen anything through the viewfinder during three days of shooting. If I paused to clean the eyepiece snow immediately plastered the lens. I thought I'd better mention it to Mike Eley. It turned out that Mike had been operating in the same way, keeping the lens clear, using

After the test drop the bag was replaced by a real person – Cubby.

the distance scale to focus, framing by seeing vague grey shapes through a fogged eyepiece where the heater coil had failed to do its job. On one afternoon alone two cameras froze and refused to work. Operating in 50-knot blizzards at -20C was never going to be easy.

By this time the actors playing Joe (Brendan MacKey) and Simon (Nicholas Aaron) had been cast. It has been said to me on many occasions that the terrified looks on their faces are uncannily realistic. In fact, acting in the maelstrom or being thrown down an ice face with a view of a quaint Alpine village 1,200 metres below, they were scared witless most of the time. Acting? I guess they were just being themselves. We were compelled however to continue using doubles for the scenes that involved highly technical stunts or that were utterly terrifying.

For the shots of Joe's journey into the depths of the crevasse we used three different crevasses in three different countries. Each was more intimidating than the last, cut together to take the viewer into a hopeless world from tight slot to chamber to ice-dagger festooned cathedral. The crevasses were located by the safety team sending a 'sacrificial offering' out in front with an avalanche probe and a shovel, roped-up of course. The critical linking shot in the sequence is the moment when Joe hits the roof of the crevasse and he crashes through, a silhouette falling towards camera shot from deep within a hole in the glacier. This involved Cubby, tied to a rope, jumping backwards off a ladder that bridged the two sides. It was one of those shots that took all day to set up but was over in just a few seconds.

For the actual rope cutting scene, the safety team found an overhanging ice-cliff not far from the Jungfraujoch mountain hut we used as a base. Before the big day they buried a two-metre scaffold tube deep in the ice at the top and reinforced it with snow-stakes.

Everything was allowed to freeze-in overnight. This was to be the stunt's main anchor, with static ropes laid to the edge of the cliff where a ledge had been chopped out. Here the safety team placed more ice screws than I knew existed, creating a pattern like the back of a biker's studded jacket, linking them to share any loading from the fall, and tying the whole lot back to the ropes attached to the scaffold tube.

A large blue PVC bag the same weight as a body was attached to a modern dynamic climbing rope and then, with around 25 metres of free rope laid across the snow, this was connected to the anchor system with a very large knot. After the test drop the bag was replaced by a real person – Cubby.

I abseiled down the ice cliff and traversed to where Cubby's fall was likely to end. Dan stood half way down, shooting profile, and Mike peered over the edge at the top. Kevin MacDonald, down below on the glacier radioed, 'Everyone ready? Turn over cameras and let me know when you're all rolling!'

In turn all three cameras called back, 'Speed', before Kevin called, 'Action!'

A wide-eyed Cubby looked up at Brian and asked in a small whimper, 'Is this safe?' to which Brian, grinning while brandishing a razor-sharp knife, replied, 'I don't know. Shall we find out?'. With the sun glinting off steel he sliced the thin cord that held Cubby in position.

He yelped as he effectively fell from a fourth floor window ledge before the stretch of the rope arrested him. I knew instinctively that I'd got the shot. He had almost punched a set of crampon points into the front element of the lens.

Kevin radioed, wanting to know how it looked on camera because, from where he was, it looked a little 'slow'. At this Cubby had a minor fit. Free-falling just cannot be sped up. It's physics.

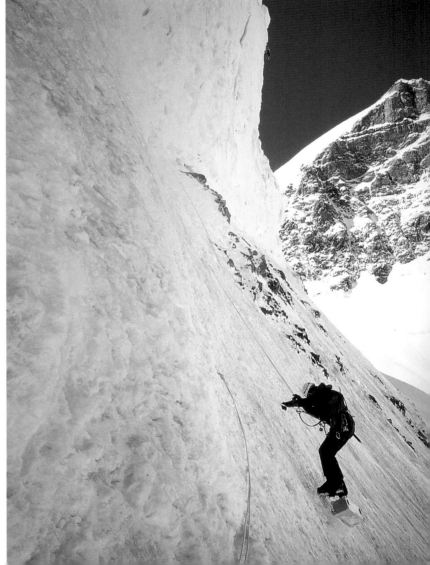

→ Having almost punched his crampons through the lens Cubby is hauled back up for Take 2.

↑ The key moment in the film when the rope is cut. Cubby awaits his 'flight'.

→ Paul Moores traverses beneath the ice cliff accessing the camera position at the end of the fall.

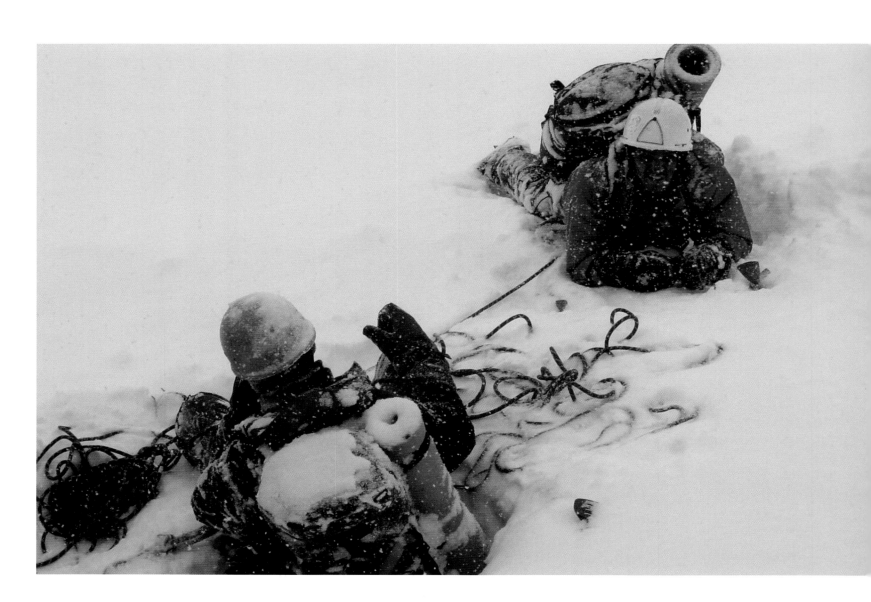

'All good on camera.' We were unanimous.

'Right let's go again then!'

So Cubby was hauled up and dropped again. He screamed the second time as well.

The film was premiered at the Kendal Mountain Film Festival in November 2003 and expectations were sky-high. All of those involved were nervous. Playing the film to a specialist audience including many top mountaineers, we could have been lining ourselves up in front of a firing squad. The 800 seats in the Leisure Centre sold out weeks before and even I couldn't get a ticket. Fortunately, a kind member of the door staff let me sit on the steps in the centre aisle. I spent most of the time watching the audience reaction. Eyes widened, mouths fell open and gasped. Tears welled. The first storm scenes were impressive on the big screen, the powerful sound system rattling ribcages with that deep roar of the gale. From the first frame to the last, even after the credits finished and the lights came on, no one moved or spoke. It was as if they'd been stunned, were in some kind of state of shock, awed by what they'd just endured rather than enjoyed; for I'm still not convinced that anyone really enjoys the film. Its journey is too traumatic.

When *Touching the Void* went on release, was it doubted that the film would have a broad appeal or was it that there just wasn't sufficient money to make enough prints? Either way, it could only be shown in a handful of theatres at a time but very quickly the film gathered so much momentum it exceeded all our expectations and became a 'must see'. More copies were made, pushing the film into every cinema in the country and beyond. I went to see it again in Edinburgh with a 'normal' audience and the reaction was the same: stunned, traumatised silence, testimony to the power of the story.

Over the years I have read of triumphs and tragedies in mountain and exploration literature but, although inspired, I've never felt capable of emulating the achievements penned with such masterful detail. My engagement with those books came not only through the power of the natural amphitheatres in which the stories were acted out, but also through the characters and how they somehow found a sense of overwhelming joy despite their youthful complexions being scoured old by the winds and scarred by terrifying events. Among the many books by alpinists such as Bonatti, Buhl and Cassin there is a volume by Heinrich Harrer, *The White Spider* which sits, pages curled and thumbed, on most mountaineers' bookcases. Joe's was one. He read it at the age of fourteen, gripped by the early attempts on one of the world's most iconic mountain faces, climbs that represent the essence of mountaineering; 'committing, bold and inspirational'. Seminal, defining for many, including Joe, the North Face of the Eiger represented a lifetime's ambition.

The most famous cliff in the world invokes images of struggle, joy, and places resonant with the dreams and nightmares of

climbers: Death Bivouac, the Difficult Crack, the Swallow's Nest and the Traverse of the Gods, each with a tale to tell. In league with the storms, the Face can turn from benign to snarling and contemptuous with little warning. For many mountaineers, this vertical mile of avalanche, stonefall, waterfall and ice has proved too powerful a magnet to resist and, from the hotels in Kleine Scheidegg, tourists peer through telescopes, catching glimpses between the boiling clouds of those doing battle. Voyeuristic lenses always watching.

I have filmed on the Eiger's North Face three times, always aware of the overwhelming atmosphere, where even the most innocuous of ledges compels towards the fallen, and dark recesses inspire more fear than if they were lit red by the sun. On the brooding North Face those spirit lifting rays offer only a glancing, retaliatory blow across the upper sections late in the day. Joe has made six attempts to climb the face, none successful. In his book *Beckoning Silence* he examined the events of the 1936 attempt, a story that has gone down in the annals of mountain history as one of the most tragic, and with an uncanny parallel to Joe's own. This book

gave the follow up film to 'Void' its title. Again Darlow Smithson Productions were steering the ship.

It is impossible to know exactly what happened on the Eiger's North Face in 1936. Details can be matched only at those opportune moments when a misty vignette presented itself to the hotel terraces, or by informed interpretation of the likely chain of events. As their uncompromising adversary bared its teeth the two rope teams of Hinterstoisser and Kurz, Rainer and Angerer combined forces at an area known as the Difficult Crack. A short climb up and slightly left they reached an almost featureless section of rock, devoid of positive holds. Today it is festooned with tatters of fixed rope, whipping testament to the wind and the level of climbing skill required to secure passage across the 'key' to the Face.

Hinterstoisser used a high placed piton and tensioned across, beckoning for the others to follow. Still in need of their ropes they pulled them down after themselves, across the limestone slab, 500 metres above the lush pastures at the bottom of the face. This decision was to seal their fate. Higher, Angerer was struck by stone-fall but they climbed on until they realised that, given his deteriorating condition, they must retreat. The weather turned violent and in the plummeting temperatures and storm the Traverse became covered by a thin veneer of ice. Hinterstoisser tried to reverse the moves back across to familiar territory but failed. They had no choice but to descend into the fateful unknown, down precipices and round bulging walls, in the firing line of everything coming off the Face.

For the film, Joe and I were to make our own journey onto the Hinterstoisser Traverse and continue part way down the 1936 line of retreat. As filming days go it felt, on the surface, that the team was very much in control, strong, and easy going but there was a noticeable tension in the breakfast room, our normal banter tempered by the focus of the day. In addition, the safety team needed to get the last train back to Kleine Scheidegg having stripped all the backup ropes off the mountain. So everything had to be finished by 5.30 pm or it was going to be a very long walk back. Bearing in mind the complexities it was no wonder that mountain guides and film team were less than keen to clutter their brains. No distractions meant less risk of forgetting some climbing widget that could become the linchpin of the whole operation.

With the pain au chocolat nestling nicely with the coffee, Paul Moores, Cubby Cuthbertson, Joe Simpson and I shouldered our rucksacks and posted holes in the snow round the hotel up to the helicopter landing spot. Swiss mountain guide, Hansruedi Gertsch had already been flown in to prepare our 'drop-zone'. The weather was perfect, and five minutes later that lack of turbulence held an elevated importance. With the rotor blades whirling just metres from the rock and ice of the vast face, the pilot positioned us directly above a stair-tread sized ledge at the edge of the first ice-field, right next to the Swallow's Nest bivouac. From here we were lowered into our filming location half a vertical kilometre above the ski runs of the Oberland. Amongst the clatter of lifts and shrieks of skiers fluttering on the updraft came the booming of a PA system. The Canadian singer, Bryan Adams was to play his gig the following day and, within this surreal mix of good-times and 'Anything I do, I do it for you', we were on our commute to the Hinterstoisser Traverse.

In the meantime, the four mountain guides playing the 1936 team climbed fixed ropes from the Stollenjoch – a tiny gallery window leading from the Eiger railway tunnel onto the face. On their way up to the Hinterstoisser Traverse they were filmed by Jeremy Hewson

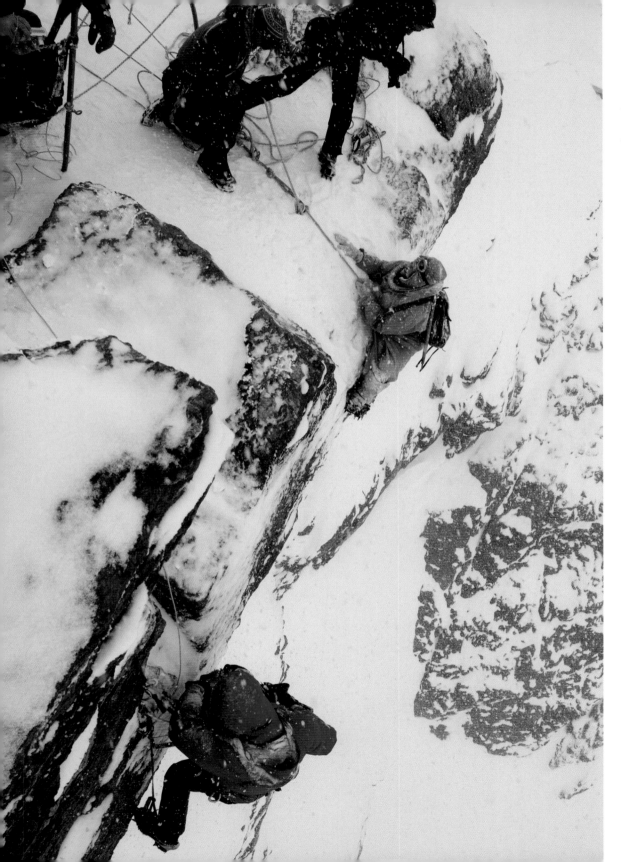

← *Over the edge. Filming the team abseiling in a blizzard. (© Brian Hall)*

→ *Joe climbs the First Icefield using modern tools.*

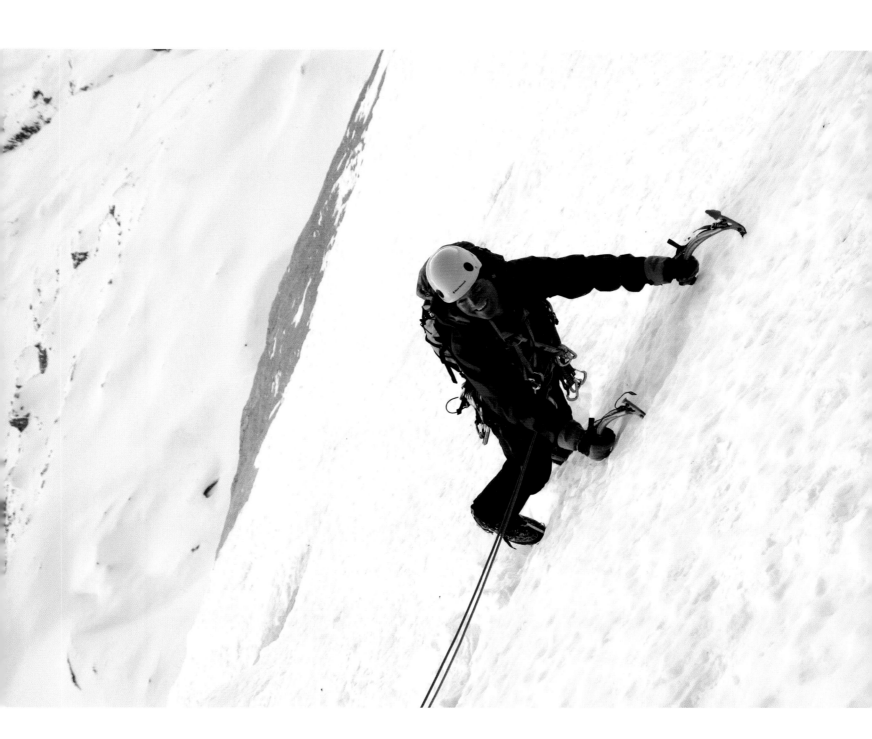

and Director Louise Osmond at the ledge outside the window and by a second camera with a powerful telephoto lens down in Kleine Scheidegg. Once Joe and I finished on the Face we were to be choppered out, leaving the way clear for the 1936 team to be filmed on the Traverse itself. With all that done they were to return to the Stollenjoch, stripping out any ropes as they descended to catch that all important last train. It was people logistics of the highest order.

Joe and I abseiled down a groove from the Swallow's Nest bivouac ledge and continued over near blank slabs of limestone that were not only the key to the first successful ascent but also the point at which the balance tipped in 1936. After the first section of filming I suggested that we needed to do some elements again from different and highly precarious angles that would require us passing each other on what is most definitely a one-way street. In return I was met by a 'you've got to be joking' tirade of expletives. Noticing the fixed rope was frayed to just a couple of strands I thought that maybe Joe's complaints should be upheld, but still pushed the point that we would cope. Having added some additional protection we tangoed over the steep section of rock, often with just a match-stick edge of rock on which to balance a couple of crampon-points. Below us trains snaked through the dazzling snow, their passengers filling the hotel terraces. It all felt a million miles away, far beyond reach.

Back in 1936 the sector guard in the Eiger railway tunnel popped his head out of the Stollenjoch window and shouted through the wreathing mists. The four climbers' spirits were lifted at the sound of his voice and they called back with no hint of peril in their voices. The guard returned to keep vigil over his kettle, ready for their arrival.

From the left edge of the Traverse we abseiled to where the '36 team must have gone in their search for sanctuary, lowering themselves down the precipice after wrapping ropes around their bodies to create friction. The terrain was committing, serious, bordering terrifying, even with the benefit of modern nylon ropes capable of holding a small car, and self-locking abseil devices. Joe perched with his front crampon points on the lip of an overhang, peering into the abyss. Before climbing back I did the same to film Joe's view down into a no-man's land that no one should have to enter. I tried to imagine the courage of Hinterstoisser and the team to head that way, carrying injury down a ranting face.

Back at the Swallow's Nest, shooting done, our evacuation could, quite literally, swing into action. At the end of the ledge Joe sucked hard on the soggy remains of his last roll-up and I guessed he hoped it wasn't the final cigarette before the gallows call. He stubbed the remains into the rock as his lungful of smoke made its exit round the protective overhang above our heads, signalling to the pilot that we were ready. Then came an awful understanding of the final phase of our day as the chopper swung overhead and the ludicrously thin steel cable came down.

It's not considered good order to remain clipped to the mountain while clipped to the winch-line. Effectively tying the helicopter via your own body to a mile-high crumbling heap of rock and ice tends to worry the pilot so there is a moment when you are indeed clipped to utterly nothing. It's not a time to panic or to do anything in haste, especially as the karabiner from the winch line finally clicks reassuringly at your waist. Since jumping off could pull the chopper into the cliffs bringing the whole kit and kaboodle down on you, it's best to bide your time.

With an air of total control, mountain-guide Hansruedi had the bedside manner of a brain surgeon; calm, cool, collected, but we knew that with just one slip of the metaphoric knife it could all go

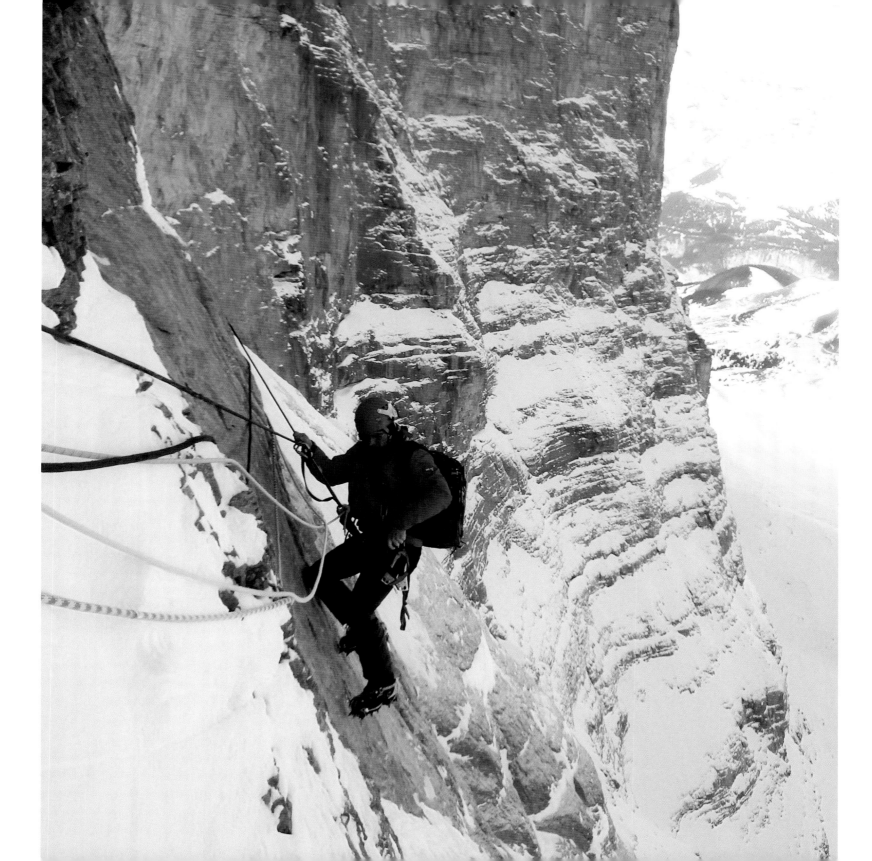

As we landed I spotted three open beer bottles jammed into the snow by our thoughtful fixer.

horribly wrong. He grabbed the winch line, opened the gate on the karabiner while Joe unclipped from the belay. Only then, standing unattached, did the winch line's karabiner get snapped onto Joe's harness. Double-check everything. Wait for the tension to come on the line. Bend the legs to sit gently onto the cable, just like you might on an extremely rickety chair. Sit on it too fast and the whole thing might collapse. Wouldn't want that. The pilot then peels away like he's being sighted by a maniac with a missile launcher, taking you on the swing of your life over a drop that would swallow one and a half Empire State Buildings.

Joe grimaced as he swung out over the void although, by the way he turned it into an ear-to-ear grin we surmised it was a ruse for us, the mountain paparazzi gathered on the tiny ledge. Five minutes later the chopper returned for me. I don't know whether the winch was on a go-slow or the chopper crew felt that I would enjoy an open-top kind of experience but, feeling the 90 knot wind-rush trying to tear the hair from my scalp, I held my helmet in place to prevent a premature balding. I remember spotting the 1936 team through a flood of airstream-tears waiting, as planned, at the start of the Hinterstoisser Traverse. I gave them a single, emphatic sweeping salute and, for most of the ride back to the landing spot, spun on the winch line before finally being lifted enough not get my toes squashed under the skid as we put down.

As we landed I spotted three open beer bottles jammed into the snow by our thoughtful fixer. It was 12.45 pm, the valley sunshine was well over the yardarm, time to relax after the adrenaline-fuelled morning with an ice-cool beer and lunch on the terrace.

Re-enacting the events of 1936 were four world-class Swiss mountaineers whose performances proved utterly credible. They fell fully and easily into their roles, understanding exactly what their characters would have done and felt and how they would have reacted. Nothing was too difficult. Ask them to hurl themselves off a crag and they would ask how far. They stood bravely in the firing line as we tumbled sack loads of 'stunt rocks' down ice-faces and launched avalanches out of loaded tarpaulins from ledges above, which was not as easy as it sounds. With too little snow the effect looked pathetic. Too much was likely to cause injury. Moving onto steep ground much of the visual drama came through the destruction of the horizontal by removing reference points and creating perspective lines to compel the eye downwards, the idea being to unsettle the viewer. Manipulating the lens along all three planes, going way beyond just being suspended, induces vertigo within an audience. To achieve this it was imperative to create stability in very unstable locations, so I found myself contorted on terrain with little room for error, fighting with a 10kg camera. In thirty metres of abseil there would often be just one foothold that would take my front-points.

In the climax to the story all hell broke loose on the Face. Fusillades of stones rained. Waterfalls that cascaded over the rocks froze solid. The team were barely seventy metres from safety when a devastating avalanche broke over them like a giant wave. Hinterstoisser was swept away. Still attached to the rope, Angerer and Kurz were launched into space. Angerer was killed. At the belay, Rainer was yanked up against their anchor piton by the combined weight of his companions and the rope around his waist slowly asphyxiated him. Kurz was left hanging, the only one alive.

The sector guard, tired of keeping the tea warm, wondered what was keeping them and headed through the door onto the ledge. It was as if the entire Face was alive with the whirr of rock and the roar of the wind. Once again he shouted but this time heard only

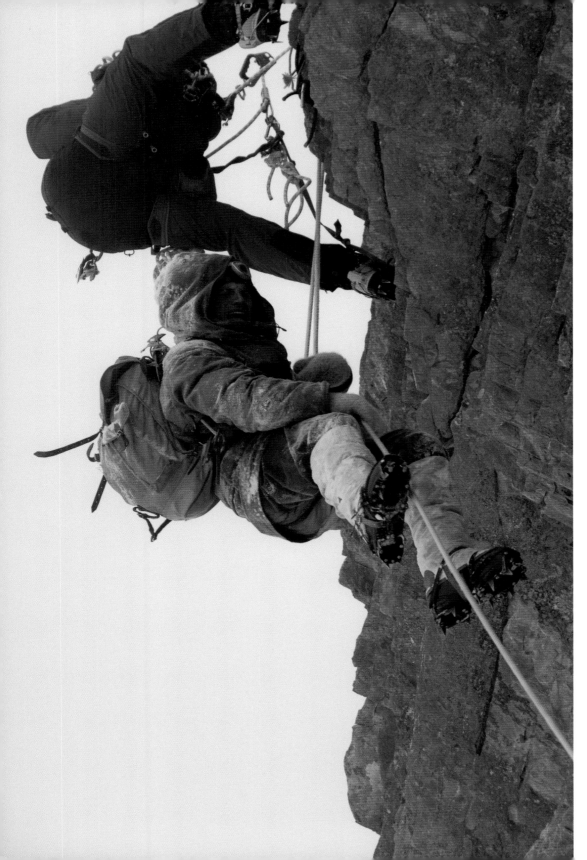

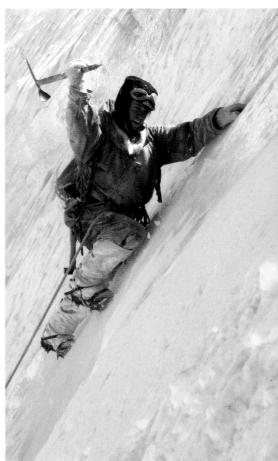

← Filming up close and precarious. Roger Schali as Kurz trusts me not lose my footing. (© Brian Hall)

↑ Simon Andermatten as Hinterstoisser.

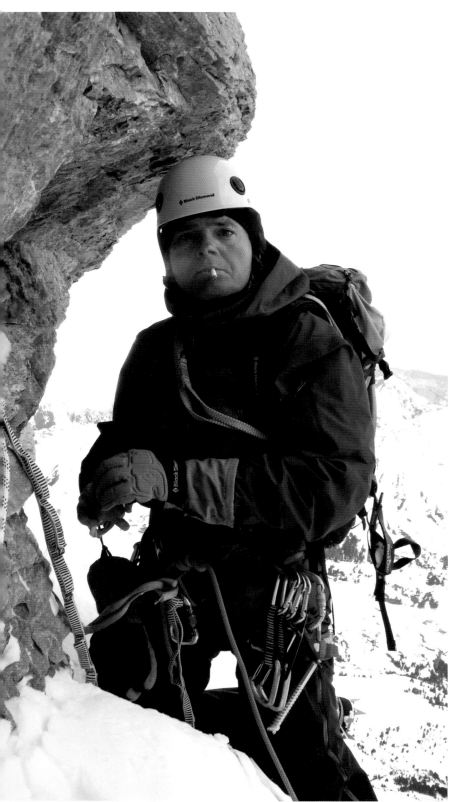

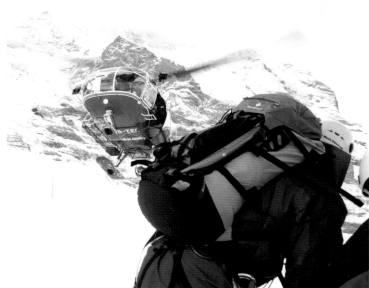

↑ The paraffin budgie
destroys the peace on our
commute to Hinterstoisser
Traverse.

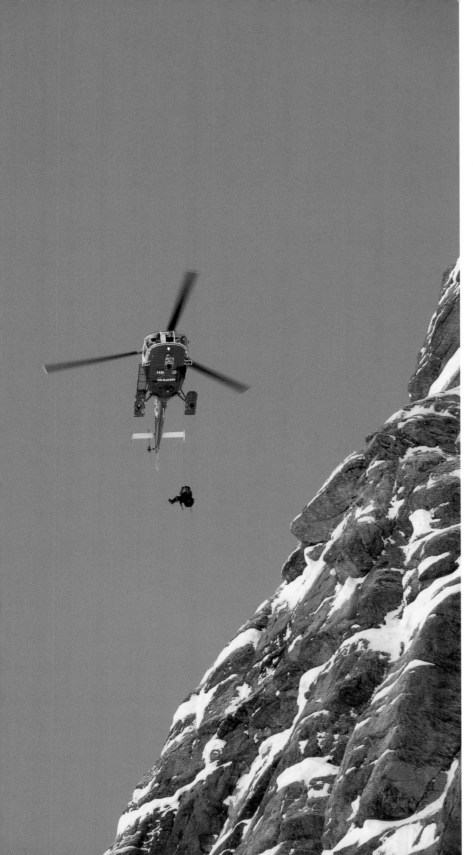

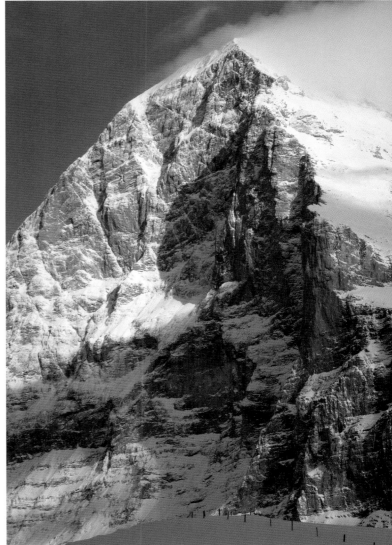

← *The pilot then peels away like he's being sighted by a maniac with a missile launcher. (© Brian Hall)*

↑ *'...the overwhelming atmosphere, where even the most innocuous of ledges compels towards the fallen.'*

Abandoned, he hung in space, beyond reach.

Toni Kurz's desolate plea for help. The guard shouted back, urging him to hold on, but could do nothing himself, and telephoned the Eigergletscher station to raise the alarm and amass a rescue team of local guides. A train took the rescuers to kilometre 3.8 where they exited onto the Face through the tiny door and traversed up the awkward sloping ledges, getting to within a hundred metres of where Kurz hung.

He was pleading that they should try to climb up and approach from above but the rocks were cloaked in a horrifying glaze of ice. With the Face in such a rage and in fading light the guides were presented an impossible task and decided to retreat, promising to return at first light. Kurz's cries sent shivers down backs as they turned. Abandoned, he hung in space, beyond reach. In the tormenting darkness he lost a mitten, his left hand crystallizing to a useless lump as a penetrating frost sank its teeth. Icicles 20cm long grew from his crampon spikes.

In the cold light of day the rescuers could scarcely believe that he was still alive when they shouted to him. Now having climbed closer, but still out of reach, a plan was hatched.

The rescuers heard Kurz hacking at the rope below with an axe, cutting himself free from the body of Angerer, now frozen to the wall. He hauled himself up to the ledge, driven by the encouragement offered by the rescuers. It took five hours with teeth and frozen fingers to unravel the strands of what little rope was left, link them together and lower the thin line down for a new rope to be tied on. As Kurz hauled, the rescue team realised that it wasn't long enough so joined another length.

Kurz fixed the rope into the piton and prepared his final abseil, feeding the new rope through a karabiner at his waist for added security. So began his journey to the waiting arms of his rescuers.

He slid down the iced-up, coarse hemp fibres until he felt the knot jamming against the steel of his extra karabiner. The rescuers urged for one more attempt, but it was useless.

Drained of the will to live, with his last vestige of energy, he spoke in a clear voice, 'I'm finished', submitting to the grim circumstance of hanging from a rope where the rescuers could touch his crampons with the tip of an axe held at full stretch.

Powerful connections to stories are made through the demands they place on the audience. What would you have done? In such committing and demanding environments, where the stakes are so high and the margins so slender, in circumstances that accumulate and change, people make decisions based on the information they have at the time. Therein lies the nub. How would you cope? It's all about decisions, all of which seem right at the time. Only in hindsight might it become obvious that a wrong choice was made. Connection strengthens with a never-ending series of problems; never give in to the temptation to yield or stop trying to find a way.

With such strong emotional responses it can be hard to detach even when filming. Peering into the viewfinder I often found myself swearing under my breath on both *Void* and *Beckoning*. During Roger Schali's powerful performance as Kurz in his last moments, I found myself welling up. Recently, during a presentation on adventure filmmaking, I dried up while talking about *Void*, remembering the physical and emotional journey we went through, and often while talking about the final moments of the 1936 Eiger story, with Kurz just beyond reach, I've felt a lump at the back of my throat. Maybe I could imagine myself in the images, reeling from the stuff of nightmares, or maybe a nerve, still raw from previous experiences, was being rubbed.

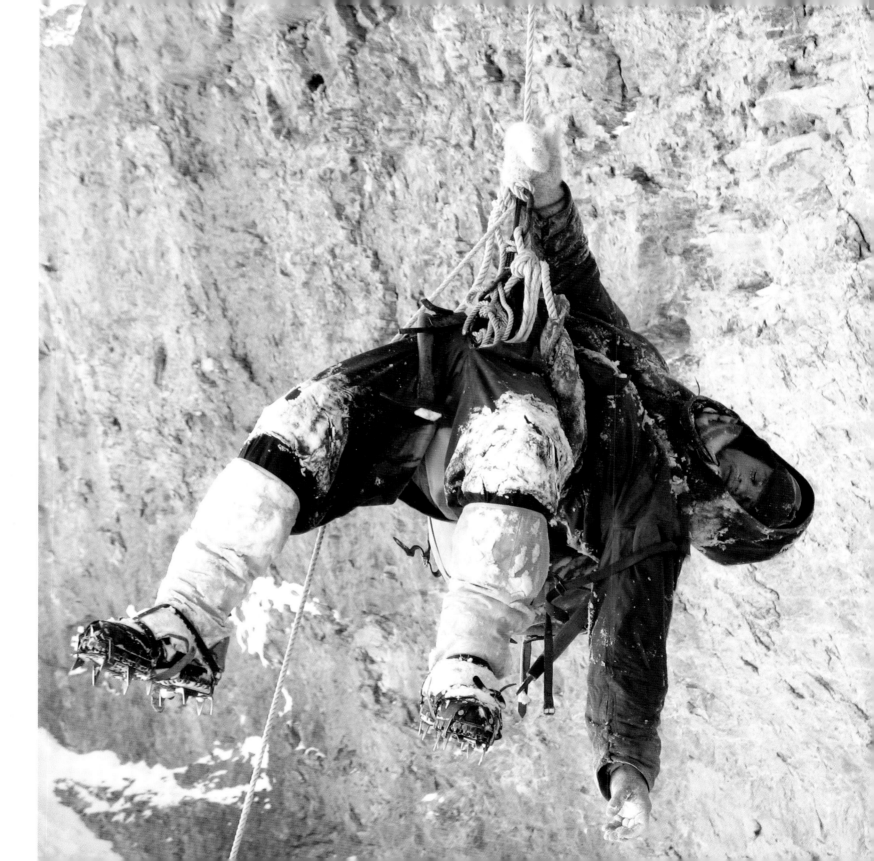

Jungle
Drums

← Head for the trees.
Avoiding the forest elephants
of Gabon, West Africa.

→ Steve and John wake
to a blazing sunrise after
a 'comfortable' night strung
from Mount Upuigma.

After two weeks of constant rain, what should have been a gentle slither of river was bank full, foaming over a single drop four times higher than Niagara. The mighty Kaiteur Falls disintegrated into a smoking, seething mass of white water streaked with silt washed from Guyana's rainforests. It didn't seem much like dry season.

As I abseiled over the giant overhanging walls, swifts darted around the dancing rainbows, flying to their nest sites in the cavern behind the falls. In the plunge-pool over 220 metres below, high waves swept over the boulders and crashed onto the shore. For the expedition team below, crossing the torrent would prove impossible.

We felt that we'd exhausted all possibilities; they couldn't get to us, we couldn't get to them. Since we needed to give the team of young explorers aged between 12 and 16 an experience to remember, a finale to their time in the rainforest, we set up one of the most spectacular abseils anyone could imagine. With adventures you sometimes don't get what you want, but apply a bit of imagination and alternatives can be found. The opportunity for young people to experience the rush of adventure is something I think should always be given, a chance to spread wings, fly and overcome fears.

The team tracked back down the gorge to where they could cross the river and then followed a series of slopes and ledges, shoulder deep in vegetation, to the rim. There they took turns to lower themselves, shrieking in delight, beside the thunderous roar of the falls, climbing back up the ropes before flying home. It was first order vertigo inducing exposure.

The forests and mountains of Guyana and its neighbour Venezuela have a prehistoric feel. To the west of Kaiteur lie the fantastical Tepuis, preposterously steep mountains that erupt straight from the rainforest, whose summit plateaus are a Conan Doyle world of cliffs, caves and vapour trail falls where nothing is easy and little is explored. We landed in the tiny village of Uneq, in the Parque Nacional Canaima, by light aircraft loaded to the roof with cameras, climbing kit, tents, portaledges and food.

Steve Greenwood, Producer of The Lost Land of The Jaguar series, and Tim Fogg, Safety, completed the behind-the-camera team. Wading rivers and trekking through forests, we circumnavigated the unclimbed Mount Upuigma in search of an easy line. Translated as The Fortress, it looks like a sugar loaf, impregnable as its name suggests. As an objective it was going to require a tour de force with Tepuis-virgin Steve Backshall, TV naturalist and adventurer, joining the climbing team of John Arran and Venezuelan duo Ivan Calderon and Frederico Pisani, who have more experience of these sandstone walls than possibly any other team. In 2005 John succeeded in climbing the main amphitheatre of the Angel Falls in 31 pitches over 17 days. Lithe and ripped, Ivan and Frederico had Tepui climbing running through their veins.

Steve B. wielded his machete at the undergrowth and scrambled over fallen blocks to forge a trail beneath the most likely viable climbing route. We made camp on top of a series of rippled sandstone boulders the size of vans. There was no mystery about where all this debris had fallen from, and alarm bells sounded about the solidity of the cliff.

Strings of pearly raindrops poured from the overhangs at the start of the route. Steve shouted up, wondering how things were going as he belayed Ivan. The strained reply filtered through the rock: 'I cannot talk right now...' words tailing off. Then the first lot came down; rocks the size of small televisions exploded into the ground at our feet. We were in for a serious few days, but the first section of climbing proved to be a good acclimatisation, learning the rock where, curiously, the green sections were less friable than the rest

→ *The mighty Kaiteur Falls.* →→ *Admiring the acrobatics of swifts across the 'smoking' waters and crashing waves of the plunge pool.*

and not as slippery. At the end of the day we returned to Base Camp for our final night of relative luxury.

Steve Greenwood kept vigil from our camp, radio in one hand, satellite phone in the other. He also operated a camera with a powerful zoom lens, giving context to my up-close shooting. Later, he would join us on the summit plateau, load-netting the heavier camera equipment up by chopper. During that process Steve filmed us from the air, through the side door of the helicopter, as spiders on the wall.

On Day Two we jumared back up to the previous day's high point, heading skyward, John and Ivan alternating the lead, Steve climbing second after ropes had been fixed from which I could film. We climbed until dark before hauling up the portaledges. With thunderstorms approaching speed was required in erecting our rudimentary shelters. It was like wrestling a pair of snakes in the darkness, hanging in our harnesses, trying desperately not to drop anything, piecing the frames together and slotting them through the nylon decks and canopies. From our hanging hotel rooms we watched the storm moving across the forests and out of harm's way. Ivan clipped his hammock to anchor points above the portaledges, just within reach of the stove, in turn set on a ledge little bigger than the pot itself. Boiling water was mixed into our pouches of dehydrated dinners giving the consistency and taste of wallpaper paste.

When the air cooled the metal frame provided a surprisingly comfortable pillow but sleep never arrived for whenever Tim turned-over, the portaledge wobbled alarmingly. We remained fully harnessed and firmly tied to the cliff.

At the start of Day Three we stared into the sky-blaze of a new day through flocks of darting swifts in search of their insect breakfast. Tim sorted his things, packing for the climb, and the aluminium frame scratched in stages down the rock. On the third lurch the contraption flipped to leave me hanging underneath. Still in my sleeping bag, my boots and climbing paraphernalia dangled and hit me in the head with hundreds of feet of fresh air sucking at my heels. It was no place to freak out but the air turned blue as I swore my way out of my cocoon, put my boots on while hanging in space, and hauled up to start the day's filming. We were still the equivalent height of Canary Wharf from the top.

Steve led the next pitch up a chossy, shrub infested gully beyond which John Arran took over again, pushing the route up steep, broken walls and over a tottering flake the size of a fridge. I swung carefully to its right side and, using full body tension and what little friction was on offer from the fine sandstone, fought to hold my position and not kick the block down onto Steve as I filmed. Frederico was also below and within the firing line. Warned about the loose rock Steve climbed, nerves jangling, breathing hard, moving with precision but brushing momentarily against the block which rocked and settled again. Just above he moved his right foot onto a small nubbin which snapped under his weight. For a moment I feared he would fall and dislodge the block. Luckily his handholds were good.

Frederico's role was to escort the haul bags of food, water, bivi kits and spare filming kit up the cliff, ensuring they didn't snag. He arrived at dusk filthy and sweaty to heave our additional supplies and equipment into the mouth of the narrow slot cave where we would bivouac. With its sloping, muddy floor it was no more comfortable than the portaledges but at least we could take off our harnesses, stand upright and even walk the few metres to the back of the cave to examine our next challenge.

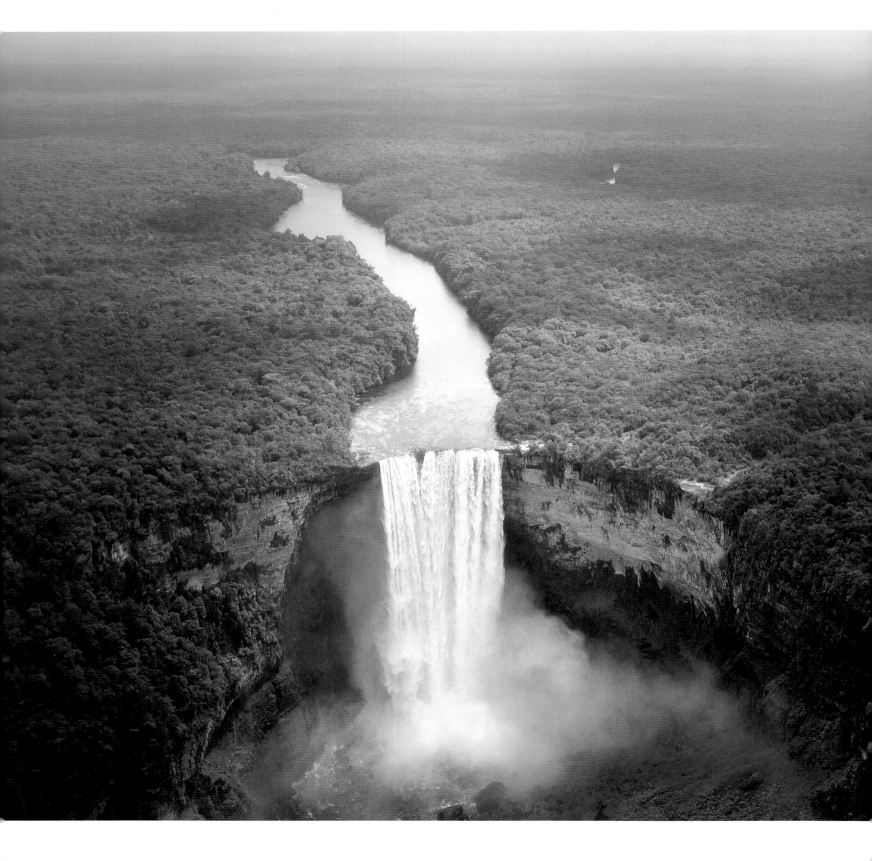

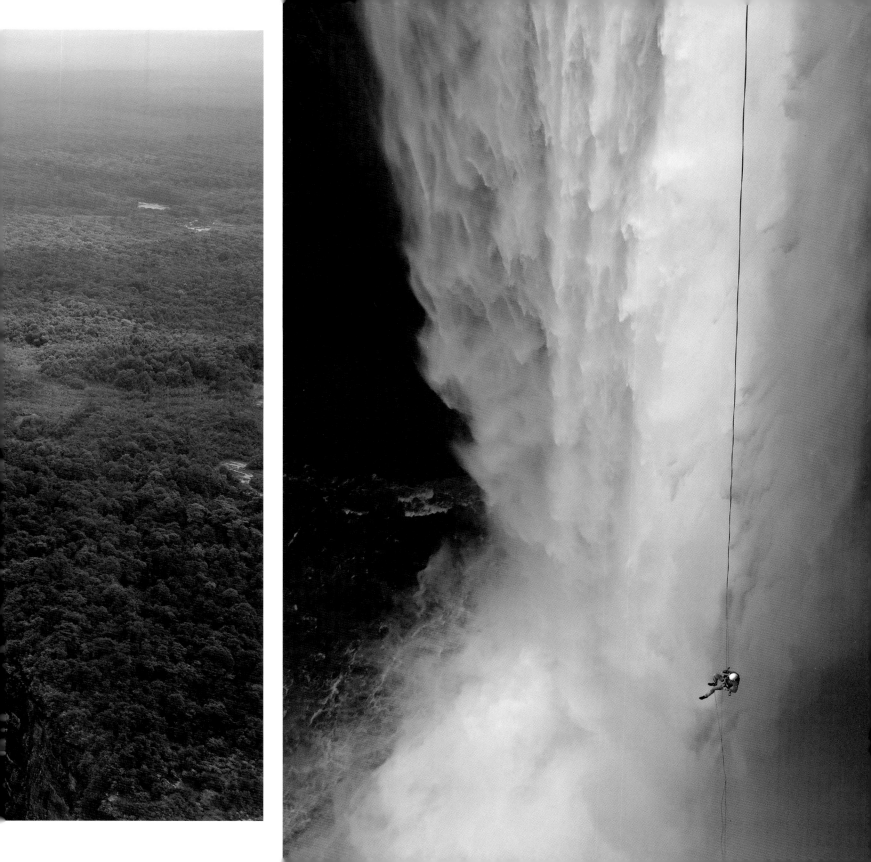

On Day Four the cool of night gave way to steaming day with clouds boiling out of the forests far below. An inquisitive dazzling-green humming bird hovered directly in front of us at eye level.

A short steep wall at the back of our cave abode reached into the light and at the top, a narrow ledge covered in the bones of countless swifts continued round a broad rib. We looked up at the next stage of the climb, a curving line to an overhanging leftward traverse. John led confidently, dragging behind him the 6mm cord that connected us and would enable us to haul up my 'work' ropes. Listening intently to his radio microphone, midway across the traverse, there was a change in John's breathing, still controlled but with a more intense pitch. Steve shouted up, 'John, is this within my grade?' John kicked a foothold which made a hollow note: more loose rock. The pause was just that bit too long. 'Yes but not by much...' Steve winced, unsure what to believe.

I squeezed the transmit button on my radio, clipped to my rucksack strap, 'How good is the belay?' The answer from John: 'Not good'

I asked if he could make it 'good'. After ten minutes he thought it was 'OK' and I secretly hoped that he was a master of understatement. We attached static ropes to the 6mm line and, as John hauled, Tim, Steve, Ivan and I watched the ropes curve out over the 200 metre drop. Once they were fixed I hooked on, working out all the stretch before swinging gently into space. The exposure was giddying, the wrong side of sketchy. This was the first time we had all worked together and this was the moment we had to believe in each other.

I ascended like a spider on a gossamer thread to get my feet onto a hanging slab at the far left of the traverse. John had placed a cam in a finger crack, now in the left corner of my frame. It seemed the perfect shot, looking across and down the whole pitch and those difficult moves across the blank slab that Steve would climb.

He began his airy traverse, feet smearing the fine textures of the rock. With fingers stretched, forearm shaking and teeth clenched he reached desperately for the hold next to the cam, but it lay beyond his grasp. Even with a shift in body position it remained tantalisingly out of reach. Steve's elbow unlocked and his fingers uncurled as strength failed and he fell, swinging directly below me, way out in space. Unable to get back onto the rock I clipped my spare mini-traction ascender onto Steve's rope and sent it down. He clicked the teeth into the rope and hauled himself above the crux. The end was in sight but the unusual nature of Tepuis climbing was about to rear its head.

Jungle poured over the plateau edges and the final two short pitches offered nothing solid to hold. Instead, we clawed our way up great columns of free hanging moss and tangles of roots, digging our fingers deep. On the final pitch Steve knocked off a small block that tumbled through space until it became too small to see. The route overhung all the way down to the forest.

Once on the plateau we met a near impenetrable wall of vegetation. In failing light John, Steve and I cut our way to a broad palace of a cave in which to sleep. We lit a smoky fire, shared a bar of chocolate, brewed tea and thought about Tim, Ivan and Frederico with their legs sticking into fresh air from their limited ledge.

We had entered a pristine world of spindly bush, waving ferns, beds of scarlet fungi and colourful orchids. Giant pitcher plants waited for their prey and we joked about discovering dinosaurs. Moving around was akin to crossing a heavily crevassed glacier but, instead of snow bridges, rafts of bromeliads hid chasms between colossal boulders. Sometimes the ground would flex precariously; occasionally our legs would punch through.

On a sandy rise Steve knelt and poked at the ground with his machete. We were following the tracks of an animal, maybe the size of a stoat or a weasel, but how did it come to be on the plateau? It was obviously a fine climber. We set mammal traps, keen to catch, record, and photograph our mammalian friend. Steve discovered a small musty-smelling hole in the rocks and pushed a night vision camera inside. It was empty.

Summit Camp was established beneath a long overhang where we could roll out our sleeping bags and stay dry. Frogs with shattered eyes bounded and croaked as night fell. We pinned up a white sheet lit with ultra-violet light and examined the dozens of strange moths that were attracted. When we inspected our mammal trap the door had been sprung but not by a weasel. Inside was a mouse with the most beautiful long whiskers and enormous elliptical ears. Steve held it gently to camera. The following day we were joined by a pair of orange-breasted falcons with their juvenile shooting the breeze.

At the end of our time exploring Happy Valley, as we'd called it, we netted much of the heavier equipment and flew it down by chopper. John, Ivan, Steve B, Tim and Frederico embarked on a series of long abseils. I harnessed into the back of the chopper and we shot aerials, meeting the rest of the team at the edge of the forest. It was a long trek across burnt savannah and through patches of rainforest, crossing rivers before climbing the small rise back to Uneq. The adventure was over. Almost.

On a windswept pitch-cum-landing strip local children thrashed us at football while storm clouds gathered over the distant Tepuis. We retired for the night, rain dripping through the thatch of our hut onto equipment cases and bags packed for our return to civilisation. As I zipped myself into my sleeping bag Cocky the Roach ran across the

mud floor, clicking legs, bidding us goodbye before we fell into an aching slumber.

Next day, at almost beer o'clock, we sat in anticipation, ears pricked for the drone of propellers, scarf blown horizontal from a pole. The white Dornier circled, dropping height before slamming wheels onto the touchline of the pitch with a burst of dust. We watched in horror as it slewed across the ground. The pilot must have realised that he was about to score the biggest own goal of his career so, rather than slice off the wings as he hit the goalposts and put his machine in the back of the net, he slammed on the brakes and nosedived in the penalty box. The plane had effectively crashed. Beer time was cancelled.

With a rope thrown over the tail and three of us swinging on it the Dornier popped out of the mud. Upon inspection the nose cone was totally staved in and all hopes of escape were dashed... momentarily. Most camera crews carry duct tape somewhere in the bottom of a bag. Steve lifted Ivan on his shoulders and began to stick layers over a double layer of cardboard to make repairs to the nose while the pilot caressed both propellers, checking for damage. He seemed remarkably calm as we loaded the gear but Steve Greenwood opened the peli-box containing the satellite phone and contacted the airport. Three hours later, just before the afternoon storms hit, two little Cessnas dropped out of the sky and we made our escape, wing-tipping over Angel Falls.

Back home Andrea and I, dressed appropriately in high-vis jackets emptied my stinking bags onto the concrete at the back of our garage, dispatching Cocky's stowaway friends with shovels.

That was my first adventure with Steve Backshall but by no means the last, and over the years I've come to know him well beyond the man with an impressive physique and well defined six

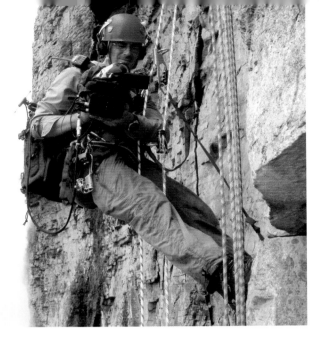

↑ Lying in wait at the critical hold. The one that would be just out of reach...

→ Steve Backshall about to part company with the rock, to leave him hanging in space.

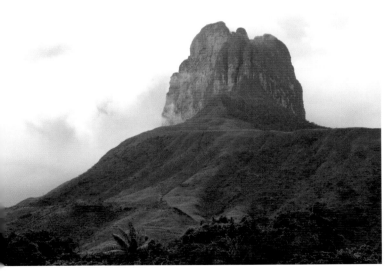

↑ The towering fortress of Mount Upuigma.

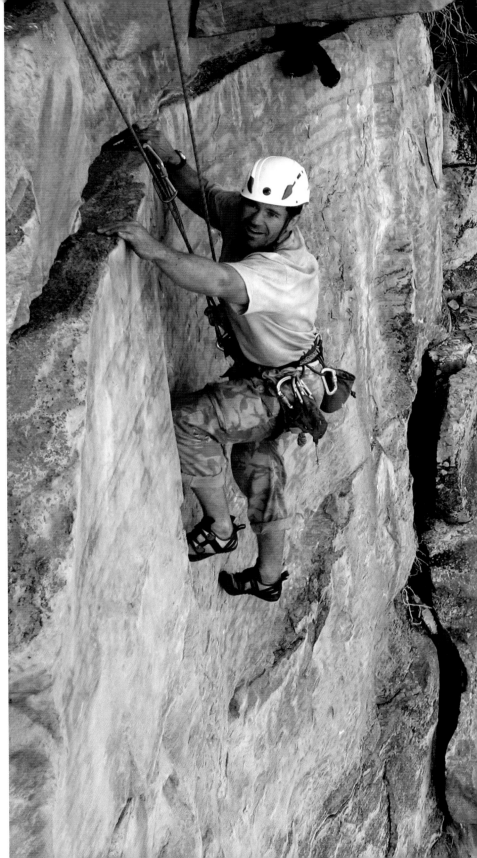

→ One of the inhabitants
of an over-populated
'Tarantula Town' that
we'd just walked into.

pack. We are like kindred spirits, fuelled by the same thirst for the wild and inaccessible. Not long after our Upuigma adventures, Steve B. and I were back in South America for a very different adventure, this time in the Amazonian rain forests.

Darkness sunk through the canopy, dense and heavy as an oily slick, bringing a change in tone to the forest when the noises of the night: the chirp of crickets, the deep croak of frogs and distant thunder, rolled into the single cacophony of a child's nightmare. As I set the tripod near to the hammocks, our refuge from this strange world, and reached under to release the levelling bowl, I noticed the ground all around was a sieve of burrows, each about the size of a golf hole. In one, just a couple of inches beneath the back of my hand, a pair of long slender legs waved nervously. As the nosey arachnid curtain twitcher poked out to check on the commotion a hundred spiderlings scurried away. We'd intruded into a densely populated housing scheme for eight-legged friends.

I finished levelling the camera, moved my hand steadily away and framed a shot of Steve lying on his stomach, studying an adult tarantula, describing how they shed their barbed leg hairs as a cloud of irritant into an intruder's eyes and mucous membranes as a first line of the defence. With a small stick he teased it from its lair and examined its centimetre long fangs. Its venom poses little threat to humans.

In daylight it was all such fun, running along faint trails, keeping up with our barefooted guide Dudu, avoiding showers of fire ants or watching a weaving line of bristly caterpillars masquerading as a snake. It was an intoxicating place – full of wonder and surprise where the seemingly innocuous could hold nasty surprises. The spines along the back of those processing caterpillars would irritate for years if touched, and the fire ants' injection of alkaloid venom

gave a painful sting similar to that of a red hot needle, hence the name. The tiny stings swell into clusters of red bumps with a white capped pustule which, if scratched, provides a home to infection. I always wore a long sleeve shirt, buttoned and tucked into the waist-band of long trousers and, unlike Dudu, I wore boots, often with gaiters despite the heat.

By the light of a pale moon we stalked through the forest, daring to make no sound. Across a lagoon the eyeshine of submerging caymans sent silent ripples across the black water. Steve lifted the broken branch of a fallen tree while I focussed on macro at whatever lay beneath. In the unearthly glow of Steve's ultra-violet torch Black Forest scorpions scurried across the log to escape capture. He kept scorpions as pets and was adept at handling them, showing their needle point sting, capable of killing a man, to the lens. We were shooting a project called 'Venom Hunter' for Indus Films.

Before entering the rainforest, in the Amazon city of Santarem, we had interviewed casualties and the doctors who were treating them in the local hospital. Envenomation has become common as people encroach further into the forests, denuding them for grazing and agriculture. In the corner of a sweltering ward nurses cleaned an open necrotic wound in a man's calf. The bite of a lancehead

viper had rotted through the muscle to leave the bone exposed.
With a short temper and lightning quick reflexes this snake is much
feared, injecting its haemotoxin venom with terrifying efficiency via
hinged jaws and retractable, syringe fangs, causing massive internal
bleeding, organ failure and almost certain death unless action is
taken quickly.

In a side room a young boy, Antonio, lay at death's door, unable
to move either his arms or legs. He'd been dozing in a hammock
suspended from the roof beams of his verandah and swiped at
something as it fell – a Black Forest scorpion. He felt it sting and by
the time he reached hospital his lips were paralysed, his urine jet
black. The venom had started to rot his flesh from the inside. He had
already undergone dialysis as his kidneys went into failure.

The devastating effects of the venomous creatures of the Amazon
sat uncomfortably in the deep furrows of my mind as we continued,
often knee deep, through the muddy swamp overlain with a thick
layer of invertebrate infested leaf litter. Steve climbed a sapling
and waved his net frantically to catch moths the size of a side plate
before noticing a black spider of similar scale. He picked it up with
a piece of bark and let it walk its length before flipping the bark
upside down so it could explore the other side. Shooting with the
lens just a few centimetres away Steve talked of the 'Murderess'
for this was the Brazilian wandering spider, a creature capable of
inflicting serious harm to a human, with the strange side effect of
leaving its victim, if male, with a painful, permanent erection. They
are aggressive hunters and can jump two metres. Then, almost as
if the spider had heard Steve's words it leapt, as did we, out of our
skins, hopping around wondering where it had landed.

In daylight, back at camp, we conducted an experiment to
make sure that Steve was not going to have any seriously adverse
reaction to a particular type of venom. We were about to depart
for a very important date with the Satere Mawe tribe whose rite of
passage into manhood involved the wearing of feather decorated
gloves, woven from palm fronds, through which the abdomens
of dozens of bullet ants were poked, stingers facing inward. The
tribesmen believe that the initiation makes them stronger and
better hunters. After enduring hundreds of stings I wondered if the
wearer's pain threshold is reset to such an extraordinary level that
nothing could ever be worse.

A single bullet ant was placed on Steve's forearm and, through
the borescope lens, I observed the abdomen pierce his skin and the
instant overwhelming pain that was obvious in Steve's face. The
Schmidt Pain Index is a scale 1 to 4+. The sting of a bee is rated 2.
Top of the scale is that of the bullet ant – so called since the pain
level is said to be 'like walking over flaming charcoals with a three-
inch nail stuck in your heel or, more simply, the same as if you
were shot'.

We travelled by boat for a day and a half up the Amazon,
sleeping in hammocks strung across the deck, before turning
up a tributary and finally into a lagoon to navigate between
forests of partially submerged broken trees. When the bow ran

aground in soft mud the gangplank was slid onto a grassy bank. From a flotilla of dug-out canoes children threw themselves into the shallows.

At the collection of thatched huts we met the Satere Mawe, the men armed with digging implements and a large, ancient looking bamboo receptacle. Not far inside the forest a nest was located at the base of a small tree and excavations began. Bullet ants marched to defend their territory and were captured and imprisoned in the bamboo. Within minutes a seething, angry mass of black invertebrate, all squirming heads, bodies and jaws had been collected and the realisation dawned that the rotted bottom had literally fallen out of the jail. In a mad dance we all whirled around the rainforest, sure that retribution would be exacted before the tube was repaired and recapture could begin.

On the return journey, handfuls of leaves, similar to bay-leaves, were stripped from bushes beside the trail. Back at the village they were mashed with water to make a sedative into which the ants were poured. Within the central communal hut a man carefully prepared the gloves, poking the abdomens of the ants through the weave just as the sedative was wearing off. Trapped, like medieval criminals in the stocks, they squirmed to free themselves and I could sense just how pissed-off they were as I filmed close up, peering into the eyes of these alien looking beasts as their jaws chomped on the humid air.

A wizened lady grated the zest from a fist-sized fruit before crushing it to make a natural tattoo ink. Those who were about to embark upon the ceremony decorated their faces and bodies, applying the ink with a sharpened stick, stripes across the face, scorpions on the back. A pretty girl with a harelip joined in. It seemed the ritual was a family affair.

With the gloves placed on the hands of a young boy, the line of men chanted trancelike and danced to the rhythm of drums as consciousness drifted through the open timber slatted walls of the hall, the toxic course of the venom of an army of the world's most powerful ants. The chanting stopped and the boy was carried out, a man under each arm. Now it was Steve's turn.

The ants were fully awake and mighty annoyed, their home wrecked, held captive in blackened transit, drugged but with freedom within tantalising reach. Steve held his arms outstretched and the gloves were slid over his hands. The beat of heart, dance and drum came together in hypnotic crescendo with his body in turmoil. After ten minutes the gloves were removed and he staggered from the hut howling like a banshee with arms crossed, hands held claw-like and swollen and remote from his body. Dudu comforted him, shaking consciousness into an unwilling brain.

I found filming the experience disturbing and intrusive. I wanted to help Steve or at least not record the moment when he was most vulnerable, but at the same time knew there was nothing I could do. He drifted away in mind as the villagers looked on with serious eyes and I mentally pleaded for him to stay. Hours later, in an air of enhanced tranquility, we sat on a driftwood log on the sandy river bank. With his left hand as swollen as an inflated rubber glove and blackened by the inking he admitted on camera that if we'd presented him with a machete at the time he would have amputated from the wrists down.

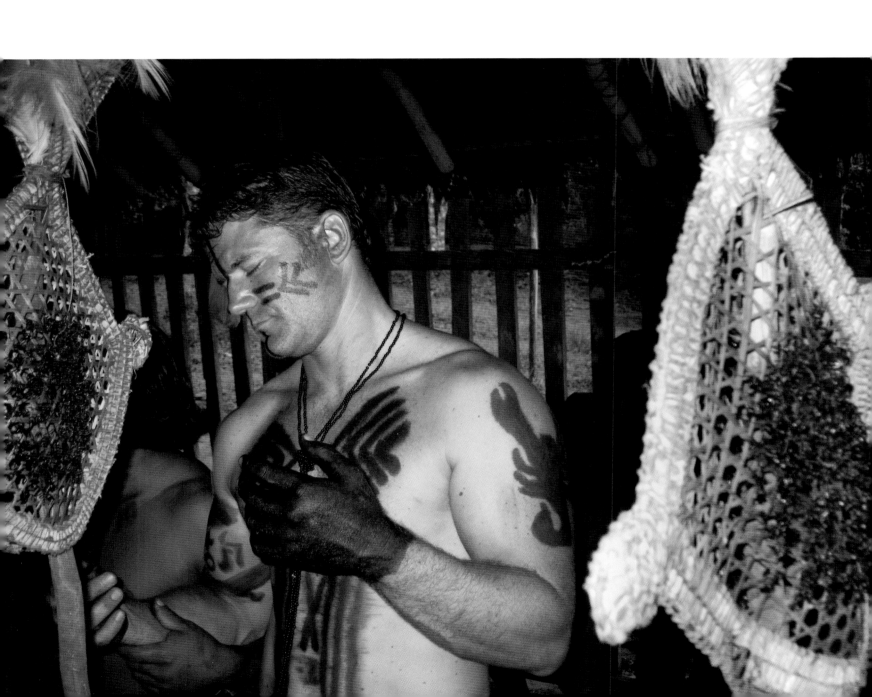

↓ Steve drifts out of consciousness having just gone through the Bullet Ant Ritual.

The
World
Underground

Cavers were once described to me as 'climbers with their brains removed' which is a little harsh, but they do have a mindset that can be hard to fathom. Deflating one's chest with a desire to squeeze the body between layers of rib-crushing rock is almost incomprehensible and not high on many people's lists of weekend entertainment. However, with their capabilities elevated above the eccentric mud squirm, they manage highly skilled travel within their difficult and sometimes dangerous subterranean world. Generating computer 3D maps from in-situ laser surveys to second-guess new links and passages has taken the sport to an astonishing scientific level, but climbing through underground waterfalls in big boots still takes courage, especially when limited by the dim beam of a torch where depth and distance are hard to gauge. Developing complex rope systems to embark on a 'free' abseil into a five-storey deep pit might sound the wrong side of mad but to the modern caver it's all part and parcel. The two greatest remaining regions of discovery lie beneath the oceans and within the subterranean landscape. Therein lies the draw.

We were heading to the Nakanai Mountains of New Britain, Papua New Guinea. Our mission was to explore the Mageni River Cave and search for species of animals new to science for the BBC's *Lost Land of The Volcano* project. As if this wasn't as wild, rugged and remote as it gets the cave had a thunderous, white-water river running through it. Relatively unexplored, its one previous expedition had pushed the route 7.2 kilometres into this most serious of caves with highly technical and committing passages, many with vertical sections, plus difficult and remote access and high flow rates of water. It all sounded a little spicy.

On the film team were presenter Steve Backshall, the two producers Johnny Keeling and Johnny Young, caver and safety man

Tim Fogg plus Pam Fogg, an expert caver in her own right. Dave Gill was to act as Base Camp Manager. For the expedition itself, the team would be reinforced by two of the big guns of French caving, Jean-Paul Sounier and Willi Michel who'd been on the first expedition into Mageni with the final member of the team, Dave Nixon, better known as 'Moose'. Moose can sniff out new passages a mile off and squeeze his gangly 6 foot 5 inch frame through pot-holes the size of a tennis racket, all in search of new wonders.

Underground, Moose's lunch may consist of a tin of cold baked beans eaten with the spanner used to tighten expansion bolts in the rock. It's part of his minimalist, pragmatic approach. He is credited with breaking into Titan; twice the size of St Paul's Cathedral, it is the biggest natural vertical shaft in the UK at 141 metres and was reached after a dig that lasted three years. Moose's commitment and enthusiasm for a new lead is utterly irrepressible. There was no-one better to take us into Mageni.

Our first real meeting was at the National White Water Centre at Bala in Wales for a training course in the art of river rescue. I had no idea of the purpose of any of the gear that hung from the walls and it was hard not to garrot ourselves as we squeezed our heads through the neoprene neck seals of brightly coloured drysuits. We took it in turns to crush the breath out of each other as we tightened the straps on our 'personal flotation devices'. Our head protection had more holes than helmet, no doubt a sensible design element. We exited from the changing shed looking more like the Teletubbies than a group of hard-core cavers.

After taking it in turns to hurl ourselves into the cataract and be bounced over the river boulders towards the 'chipper' – a steel grille that would protect us from a more significant plunge, our instructor taught us to flip out from defensive feet-first, on-

→ *The kitchen floor. An early squalor had descended into Base Camp.*

the-back swimming, commit to a breakout point and aim for the eddies. Next came the 'stoppers' and how to escape the turbulent water behind a giant boulder that can pin you in its recirculating flow until you drown. Tim Fogg volunteered, flopping over a rock before disappearing beneath the surge, resurfacing downstream ages later. It didn't look like he'd had much fun. Next, our aim was tested as we threw rescue lines to colleagues as they were swept downstream. Doing the exercises again at night they became utterly hit or miss and it became obvious that if anyone 'lost it' underground they were probably on a one way ticket.

To establish Base Camp we made the very long-haul flight to Papua New Guinea via Australia, followed by a charter flight from the capital, Port Moresby, to the grass landing strip of Palmalmal. A pick-up truck shuttled us to a small jetty from which a helicopter took our netted loads to a drop zone in a clearing in the rainforest. Between shuttles a school of spinner dolphin swam past and Steve and Jonny K jumped in to join them. When the chopper returned I was harnessed up and ready to shoot from the air.

The door remained off to give a clear view as we swung between the spurs of the canyon, its sides hung with masses of tangled vegetation. At the bottom was a wall to wall tumultuous white-water river. It was an exhilarating ride and then there she was! Two-thirds of the way up the side wall of the gorge: the entrance to Mageni River Cave, from which a series of waterfalls erupted into the open and fell into the most perfect paradise I could imagine. We were buzzing, totally fired with the prospect of exploring her dark secrets.

Landing in Ora Village we sat in awkward anticipation of meeting the locals within one of the mine-dark huts to ask permission from their Chief to enter their land. I powered up one of my LED lights,

specially constructed in my garage for lighting a cave rather than something the size of a garden shed. Strangely clothed, armed to the teeth with gadgets and modern wizardry, we might as well have come from a different planet. Outside, a child toyed with a machete. The meeting was stilted but harmonious with access and rates agreed and so, with our line of local porters, we trekked through the mud of the forest as the darkening clouds swirled into towering thunderheads. Base Camp was located on a plateau above the gorge and our arrival was timed to perfection, with rain bouncing off the leaf litter to knee height. Steve and Moose grabbed the two shovels and began digging drainage trenches around the basic tarped shelter. Too late: three inches of mud squelched over the new kitchen floor, our camp was descending into an early squalor. Steve dug the latrine at a discreet distance behind panels of woven leaves. Dave Gill wired the camp with electric lights and built a plywood 'light-box' large enough to take several of the cameras. Housing two 60 watt bulbs the heat generated would help drive out any accumulated moisture. Moisture and video cameras are a bit like cola and a malt whisky, never to be mixed.

Before erecting my luxury jungle hammock I tried to order the plastic boxes that held the ten camera kits, and so discovered my sodden camera pouch. My stills camera had become the first item to drown. That evening the first pow-wow was called to discuss our plans for the first day in the cave and the reality of what we were to embark upon hit hard. The upshot simple – any accident underground would be catastrophic with little or no chance of rescue even if the outcome was that positive. Sleep didn't come easy.

To reach the cave entrance we embarked on a heart-stopping abseil from the plateau, redirecting the ropes via tree roots and

branches in a vertical rainforest oozing with rotten rock and dripping moss. Holding the 10kg Varicam I filmed Steve descending though the fug of humidity, holding my breath to keep the camera steady. Stomach and arm muscles screamed after each shot and I hyperventilated to prevent myself passing out. The exposure was giddying as we spiralled down flimsy threads like spiders to a new home. Nearing the cave I could see the river gushing out of the main entrance before thundering down in a majestic waterfall. To either side, from a further three major sockets in the gorge wall, cascades descended into a lost verdant world of giant plants and cavorting rainbows.

Suddenly, with a flash of warning lights and a rapid beeping, the first of our ten video cameras died and an air of gloom descended. The scene was now set for the expedition proper, we were enmeshed in a war of attrition not only with the technology but also with our own bodies and spirit.

We made a short traverse into the cave mouth to wait for a spare camera, the squash-court sized chamber dripping constantly through countless cracks in the roof. A family of bats took off in fright and it all felt rather black and uninviting in contrast to the light and life in the world outside.

We were in a classic limestone Karst landscape, characterised by the numerous caverns, sinkholes, fissures, and underground streams that are formed in areas of plentiful rainfall. The limestone bedrock is easily dissolved by mildly acidic water and the hidden labyrinth was already proving who was boss.

It had been a frustrating start but getting down to the entrance proved to be the easy bit. Constantly immersed inside the cave or even after having a bath in pools within the entrance at least I left each day for the final stretch back up to Base Camp feeling clean. However by the time I flopped back onto the plateau I was invariably an exhausted, filthy heap after a hard haul though the jungle back up the ropes. The physical nature of each day, sheer levels of concentration to avoid injury or worse and general day to day living conditions took a heavy toll on the team. Early on, Moose, Tim and Pam were laid low for a couple of days by diarrhoea. Willi and Tim developed a weird irritating rash and most of us suffered trench foot. Left untreated the consequences could be appalling with blisters and open sores, fungal infections and ultimately gangrene and amputation.

Each night I washed and dried my feet before covering them with anti-fungal foot powder and, in the mornings, plastered them with nappy cream before donning wool socks. Willi used horse cream he'd obtained from a vet. Steve B doused his big-toe with iodine to stave off a pus-filled infection and, ultimately, Jonny Keeling's socks were infested with maggots. It felt as if we were slowly falling apart both in body and in our filming of the expedition. Above ground the humidity was enough to kill the cameras, underground amounted to technology suicide. Towards the end we struggled to keep any of the cameras operational despite their nightly desiccation in the light-box. However, we kept nibbling away, pushing further each day into the system.

Underground we would wade waist or even chest deep, feet feeling for purchase on the rocks. While traversing the left side of the Canal, a passage of smooth black water in the early stretch of the system, a foothold that Jonny K was using to step out of a deep pool broke away. The rocks were covered in layers of calcite that lacerated and abraded skin and he ended up with a two-inch gash in the palm of his hand. It had been the rare occasion that he hadn't been wearing industrial work gloves. Where the flow rate was high I

... ultimately, Jonny Keeling's socks were infested with maggots.

had to assess the possibility of being swept away while continuing to film. I kept the camera framed with my left hand, operating almost on autopilot while holding on to the ceiling, walls and stalactites with my other. Opening the seals on the camera's protective bag would have meant instant death to the delicate electronics, so each camera was limited to an hour's recording time – the length of the tape. Any sophisticated operation was impossible and I obsessed against the limitations that stifled a more creative style of shooting.

Sleep deprived and desperate I worked late into the night on the sound systems. Everything had to survive total immersion. Armed with finger condoms, tiny balls of foam, minuscule cable ties and electrical tape, twiddling gain controls and shouting madness to the outside world I devised the best possible waterproofing that didn't muffle Steve and Moose's voices. In the cave with the roar of the waterfalls we could hear every word crystal clear. Steve B. wore a camera mounted on the side of his helmet, wired to a recorder the size of sandwich box rammed into a bumbag. The system became the bane of his underground life when time after time the cabling snagged and his helmet was forced sideways. Steve B. is an adventurer at heart but would probably admit that caving is low on his list of preferred activities. In spite of this, his enthusiasm dial was permanently turned up to eleven.

Three kilometres in we entered a bristling, church-sized chamber. It was dry, apart from the occasional echoing drip, and for the first time screaming to make yourself heard was unnecessary. There was, however, little chance to relax. Clinging stalactites like an arsenal of giant Swords of Damocles threatened from above, while, underfoot, a stunted forest of stalagmites made for precarious progress. Balancing on their stubby points, a fall would have been hideously messy. Beyond lay the 'Derbyshire Downfall', the biggest

waterfall so far. As we approached the main plunge pool, wind generated by the full width of the river thundering down into the choppy water sent waves of spray into the air and our six LED panels and three dive torches didn't generate enough light to punch through. We left dejected.

Next time we brought in the hard hitter, a battery powered arc light. The whole area lit up and centre stage was the mighty Derbyshire Downfall, a pluming wall of white water smashing into the pool. We set off, initially able to teeter close to the right shore over submerged rocks, soon stepping into chest-deep water with waves breaking over our heads. It felt cold, not numbing, but debilitating enough with only thin thermal layers beneath our cave suits. Tim aimed an additional light as Steve climbed the rock wall to the right of the main waterfall.

I filmed from below as he reached up, searching through the spume for a hold with his right hand. With fingers curled over an edge he pulled and the rotten flake ripped out. His hand found another hold, this time secure and pulled up. He disappeared round the bulging rock and onto the final wall where a smaller offshoot of the downfall pummelled into his head. He finally stood into the black hole of the upper chamber, a shadowy figure with a pin of light on his helmet.

Steve descended so we could shoot again, this time with me beside him. With my feet just on top of the bulge, hanging on the ropes, looking down and across the side wall of the cavern, an arcing wall of white water framed Steve as he launched once more. The image was striking, showing a willingness to explore limits and confront fear. The arc light went out.

Head torch beams swung frantically as the team fired it up again. As it warmed I reframed and signalled to Steve to start climbing

There was a reek of danger now, but we couldn't go back.

immediately the light stabilised, but it blew again. He retraced his moves. The battery should have been good for an hour. We'd run nowhere near that and I wondered if the spray had reached the electronic ballast that powered the lamp-head. After the third attempt I waved to Steve to just keep coming. With the beam from Tim, still chest deep in the plunge-pool, there was just enough light to film close-up.

Bridging wide between footholds, Steve leaned his head to the right to keep most of the water from his face, moving quickly. Water ricocheted over his head, smashing into the camera lens. He was shaking slightly and at the end of his tether, trusting that the rock wasn't going to fail him. His hand groped over the overhanging wall for that elusive final hold.

As dramatic as the downfall was it just wasn't enough. We craved real first-hand exploration, the Holy Grail of caving. Without this our expedition had little purpose and the pressures were mounting to deliver. On a subsequent day Moose arrived back and his grin said everything. Just off where we'd been dumping gear in the main chamber a short stoop through a boulder choke led into a totally new section of the cave system. Fuelled by a renewed vigour of enthusiasm we passed through a curtain of water, the roar of a distant waterfall increasing with each new step. Moose blew across the top of his dive light. The condensed breath was whipped away by the air movement: a through passage, our excitement and energies raced.

Heading downstream with water tearing at the backs of our knees, using the stalactites as handholds, I tried not to think what would happen if I lost my footing. Beams of light behind us represented a psychological antithesis of solitude, silhouettes in the full width, seething mass of white water. Pam decided to sit tight on a shelf, her light frame no match for the power of the flow. Escalating noise made communication almost impossible. Water sprayed above our groins as it parted around our legs. Hanging from our harnesses, dive torches lit the spume, the red of the cave suits, white of the water and the blackness of the cave, daggers on the roof.

My hackles were rising. There was a reek of danger now, but we couldn't go back. Adrenaline brought sharp focus to everything: test the holds, leave nothing to chance, traverse the walls on side-pulls and under-clings before crossing, my foot dragged from its grip as I filmed into the cataclysm, relying on instinct, fast switching my attention between holding on and filming through a hallucinatory white-water hell.

With a thunderous, pulsing roar the water plummeted over an edge into black oblivion. A probe downwards with a torch showed that at the bottom of this new waterfall the passage halved in width with an implied doubling of the flow. There was a way down but not for today. Tim shouted, obviously concerned, 'I'm heading back to Pam. She'll not have a clue what's going on'. We would abseil into the boiling mass tomorrow.

The next day we picked up where we'd left off. Moose abseiled first, next Steve, then me followed by the rest of the team. The descent was short but it felt like we were on that fine line between danger and outright lunacy, the line that great adventures tread. I had to keep focussed, follow the side and cross, when I would be most exposed. Moose had rigged a diagonal traverse line which I clipped onto. The power of water was immense as I slid over, following Steve. Ahead, the roof lowered, leaving just enough space to keep a head above water. The far side was undercut, fast flowing and almost certainly a death trap. We regrouped on

→ *A last cup of tea before the cave. Steve ignites the eye-brow trimmer.*

a tiny ledge and discussed what to do next. Tim was noticeably anxious, his voice forceful and blunt. We were at the limits, maybe even beyond.

Moose and Steve headed off with a camera to see where the 'duck' led. For the rest of us waiting, fifteen minutes became an eternity. It was the worst case, the black-hole of not knowing. What was taking them so long? Willi hung from a sling threaded through a hole in the roof to get a better view. We changed over so I could shoot with the spare camera. When a flash of light reflected in the river everyone breathed a sigh of relief. Moose and Steve had gone as far as they could. It was quieter on the far side of the duck but in a short distance the roof had lowered, sumped out to a watery grave of a place to get swept into.

On the way back out Jonny Keeling lost his footing on the traverse line. Tossed like a rag doll at the rear he had to summon all his considerable strength to tear himself from the pull of the water. In the main passage, battered by noise and effort, we teetered under the million- dagger roof, through the hanging chambers, and abseiled down the double waterfalls of Sagi and Sapi. Climbing through the dry passage we dropped over the triple falls and waded to the final easy section of river. At the cavern entrance I could smell earthy, pungent and wondrous, sharp green wafting on a breeze, the best smells in the world.

For much of the expedition I was in despair at the repeated failure of the cameras. The end of each day was like a roll call of the dead and wounded. The 'hotbox' became the camera hospital and each morning we'd count how many cameras were even partially operational. The stress of filming weighed heavily but I never mentioned it. Maybe that was my mistake. Things came to a head in Base Camp where in an atmosphere of total depression Jonny Y

tried to replay the material shot from the chopper and in Ora village. Key sequences, but they wouldn't replay in the camera. At that moment I felt held to blame for all the woes of the production. The material had been shot in a different camera and had replayed fine just weeks before. I didn't know what to say.

It was hard not to take out frustrations. The squalor, the sheer physicality of each day, the creeping humidity ground us down, so we made the decision to break from the cave and shoot from the gorge, at the bottom of the waterfalls that poured from the entrance. Steve, Tim and I abseiled the left side of the falls, following a rock rib at the water's edge. The descent was mesmeric. Looking into the cascade I tried to follow individual drops arcing down to an azure pastures fifteen storeys below. We ploughed a trench through shoulder-height vertical vegetation, bloated by perpetual mists and with roots calcified into living fossils. Some hung free of the rotten rock and drooled water over our legs and feet. It was a land that time had never known.

Having thrashed our way through a tangled mass of fallen trees we discovered that the ropes didn't quite reach the bottom, but got there on a stretch and a bit of down climbing. The azure pasture was like a monsoon-powered jet wash. Water ran down the port of the camera's underwater housing in great waves, and suddenly it failed. Steve raged with frustration and inside I felt sick, fed up with the whole expedition. There was little we could do, but we were in a place that few had set eyes on and not yet stopped to look and savour. I gave Steve a hug and, to preserve our hearts and sanity, we spent precious time drenching ourselves in sweet water and bounced on domes of moss like spongy trampolines.

Over the course of the expedition my hands became badly blistered and, despite treating them with iodine, a wretched, raging

infection set in. Clutching the rest of the antibiotics, I lay awake all night in my hammock, my right hand blown up like a bunch of bananas, alternately burning with fever and shaking with the chills. The pain was intense and I was scared like never before. In the morning I showed my forearm to Steve. Scarlet trace lines had migrated towards my elbow, sepsis on the march. I had no movement in my fingers. Holding a rope, holding a camera, was out of the question and the consequences of the antibiotics not being able to cope were too awful to contemplate. The chopper was called and, guilt-ridden, I missed the final three days of the expedition. I'd always been in for the long haul, and hated the goodbyes, but wondered if, secretly, my team mates wished they too could have been out of the jungle.

That expedition should have put me off caving for life but, strangely, I wanted more. The level of personal discovery and high adrenaline were like my first expeditions. The trip pushed the 'reset' button on 'keeping going' and 'willingness to try something new' and 'redefining', but there was something else. Moving through that impenetrable black goes against our primeval survival instincts. Deprived of a major sense I felt exposed and vulnerable, like a child lost at night. Maybe that's what sets cavers apart from other adventurers: their willingness to travel where they can't see what's coming, good or bad, the element of anarchy in being somewhere we aren't designed to be. I also wonder if the joy of discovery underground is heightened because it is impossible to second guess what lies around the corner. Any surprise is total. With my move over to the 'dark side' over the past few years I've developed great respect for these explorers of the deep, be it in Gaping Ghyll or Jingling Pot in the Yorkshire Dales or in the exotic Hang Son Doong, all caves that I've filmed in since Mageni.

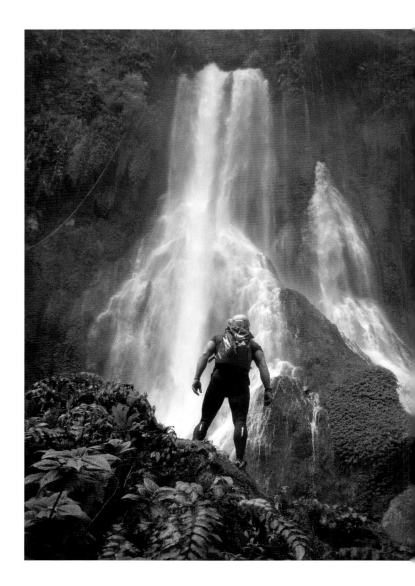

*Moving through that impenetrable black
goes against our primeval survival instincts.*

Hang Son Doong is tucked beneath the jungles of the Annamite Mountains in Vietnam, close to the Laos border. In 2009 Howard Limbert and his team were the first to enter and I'm sure they could scarcely believe their eyes. Hang Son Doong is big. Across the way you wouldn't scrape the wings of a jumbo jet.

It is the largest known cave on the planet and Howard and his team were to guide us through its giant passages for the BBC series *How to Grow a Planet*. Examining how plants have shaped every aspect of our planet the film sequences, presented by Professor Iain Stewart, involved everything from flower ceremonies with the saffron-robed monks of Angkor Wat in Cambodia to 'post-apocalyptic' colonisation in the acid soils of an active volcano off the coast of New Zealand. Plants and caves did seem an odd combination to me at first but the idea was to consider the importance of light, with the underground world obviously having none of it. While the cave we were to enter had been explored to some degree, only a handful of people had walked its passages.

Logistically, things were going to be awkward. From the road a couple of hours of trekking and a scramble up razor fins of limestone would take us to the cave entrance. After dropping into the system we'd be faced with an abseil down the 60-metre 'Great Wall of Vietnam' into a subterranean lake. The plan was first to lower an inflatable boat and our 400 kg of equipment. After rowing everything across the lake, the Vietnamese porters and ourselves would carry the loads through the cave. The plan seemed plausible enough but only provided a starting point.

The cave's darkness consumed us, leaving our headlamps to make sense of the dank topography. The ground steepened and we fed our ropes through our abseil devices, sliding backwards to a ledge at the top of the bulging main wall. Peering over the edge, our pin-pricks of light revealed nothing of the lake. The plip of a kicked stone never arrived. It had drained to a knee-deep mud-bath. The first issues were how to get the equipment down without bashing it to pieces against the wall and conversely how to stop the equipment knocking lumps out of this precious environment. Cavers are magicians of the rope world and out-of-the-hat they established a zip-line down which the waterproof boxes were lowered onto a tarpaulin.

I fired up one of the big arc lights to see better what lay ahead. The route to what should have been the far shore involved walking pigeon-stepped along a leg-sucking 'V' shaped trench with vast, shoulder-scraping mud walls on either side. As we slipped and slithered, the silty ooze reached places that mud shouldn't reach and by the time we reached 'dry' land we looked as if we'd been wrestling each other in a vat of newly mixed plaster. So filthy did we become that we were refused entry into our hotel at the end of the expedition. Simon, with whom I have worked for more than twenty years, and I were thoroughly hosed down in the car park before being allowed in, but even this was not enough. In his room he luxuriated in a hot bath, pulled the plug and photographed the aftermath, a thick, brown slurry that clung to the enamel.

As we walked I peered upwards, the pencil beam of light from my headtorch seemingly scattered by the breeze before it could reach the roof. Even the retina-burning night-ride bike lights worn by Howard failed to reach the outer reaches. Mostly caving is associated with claustrophobia but in Hang Son Doong it felt more like a wander across the wilderness on a moonless night. The wind picked up as we meandered our way through a cluster of stalagmites the size of Nelson's Column until, suddenly, a blinding sunrise of green exploded through a vast opening hung with wisps of mist.

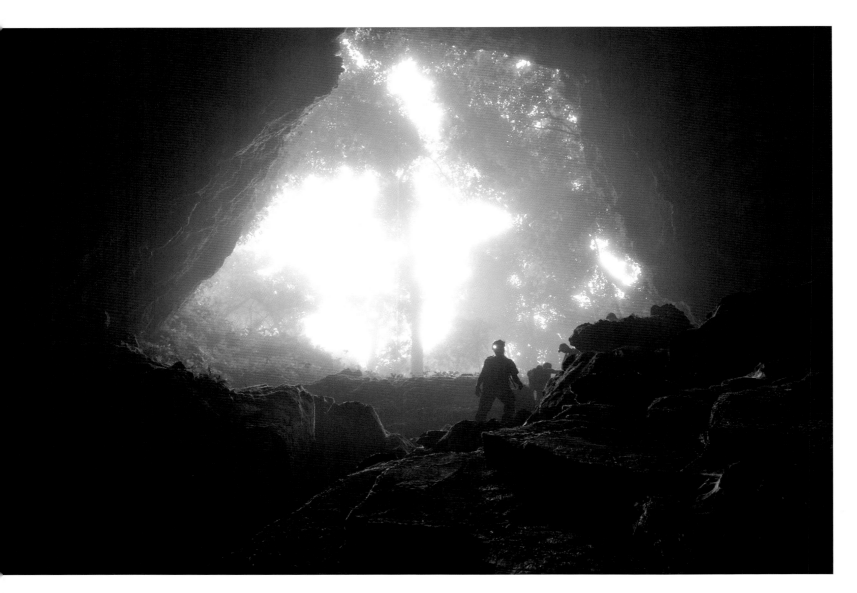

↑ 'The cave's darkness
consumed us, leaving our
headlamps to make sense
of the dank topography.'

→ Rain forest tumbles
through a collapsed roof
into the Garden of Edam.

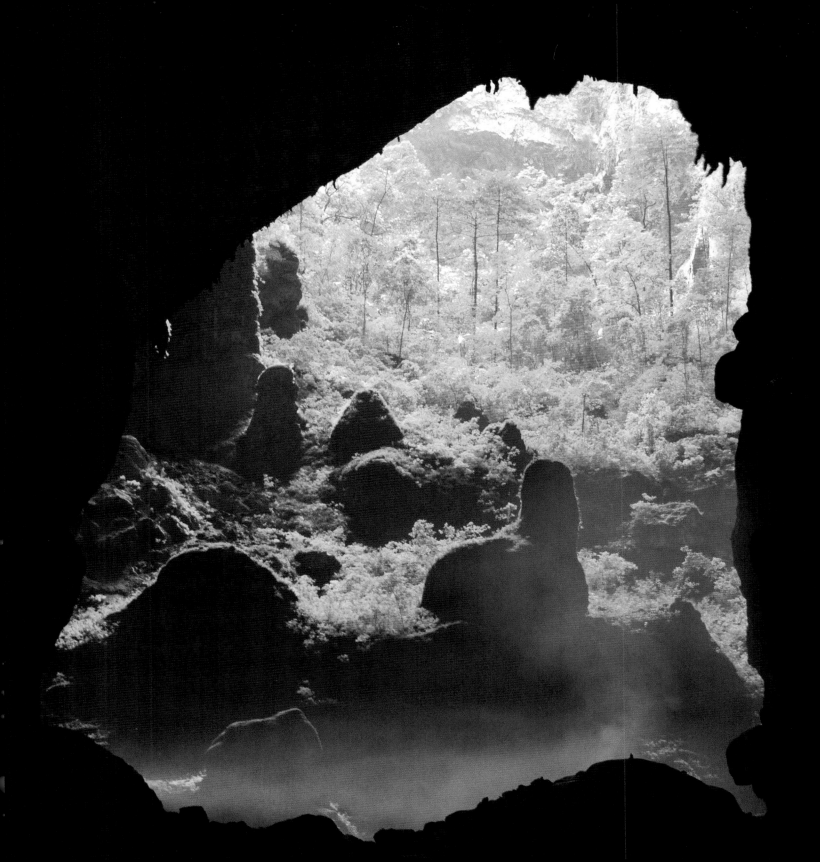

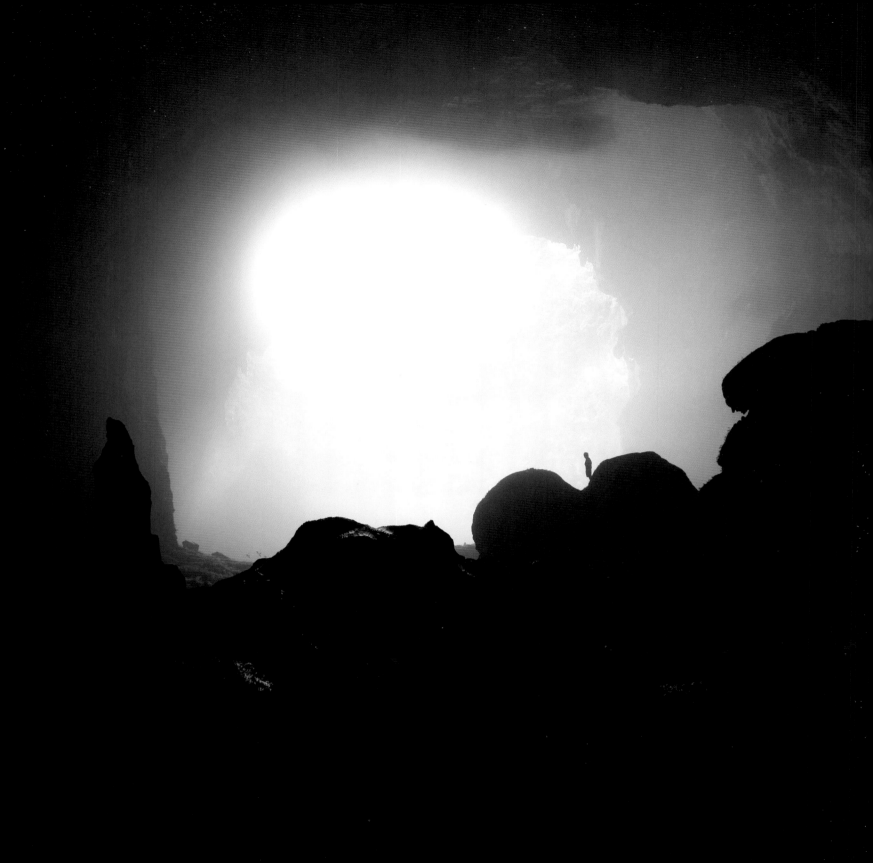

The roof of the cave had collapsed to form a near perfect circular sink-hole, or doline, of giant proportions. Over the years seeds had fluttered down to establish a rainforest within the cave. Here, thread-thin Polyanther trees, rooted in shallow soil, pushed upwards towards the light. Ferns grew on the terraces in neat rows with their leaves turned flat, feeding off the distant sky. It was a glorious, almost prehistoric world in surprising isolation. Blue smoke hung in the air at the edge of the 'Garden of Edam', as Howard's team had named it. The porters were sitting round a small fire, boiling water for tea and noodle soup, our diet while underground.

Sheltered by the roof of the cave we arranged our filming equipment into some kind of order. Our incongruous documentary arsenal of computers, raid arrays, dazzling white lights, cameras, lenses and tracking dollies seemed so out of step with the pristine location. We tensioned a wire between the side wall of the doline and some massive boulders and from this rigged a radio controlled cable-dolly to fly the camera through Iain's explorations, its graceful, otherworldly perspective adding to the sense of wonderment.

Scale is often difficult to convey so we set the camera on a high ledge, and Iain climbed, silhouetted, onto a series of house-sized stalagmites, eventually standing in mesmerised wonder beyond the five pinnacles of the Hand of Dog, the fingers of which grasped 80 metres into the darkness. As he turned to look into the cavern his headtorch blinked into the lens and I operated the zoom control, pulling back and back until he became so small he disappeared from the screen. He was standing over a kilometre away.

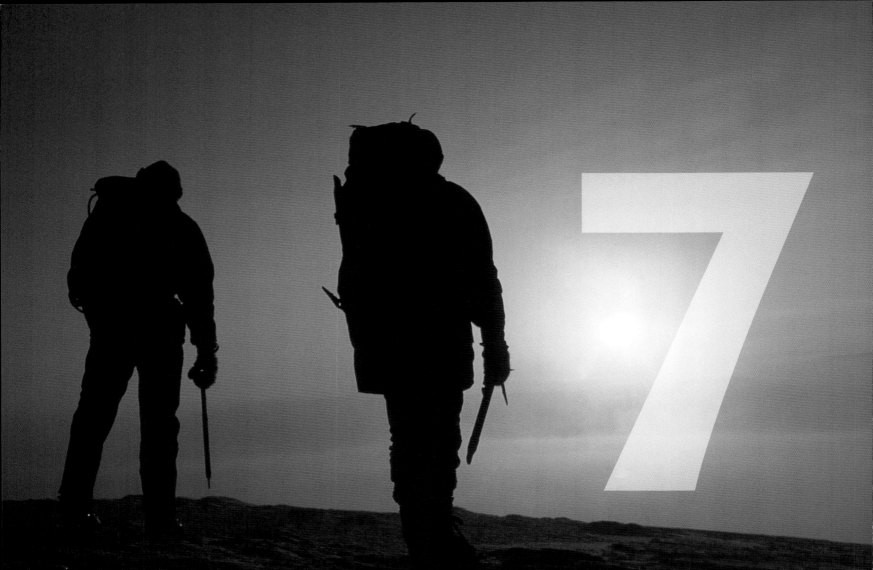

Close
to
Home

← An end to the
technical difficulties.

→ It was a classic mountain
apprenticeship. Suilven,
Wester Ross, Scotland.

Only now do I realise that my first real summit proved to be the genesis of my passion for the mountains.

I'd walked up a cloud-covered Ben Nevis one August as a ten-year-old wearing an Aran jumper, knitted by my Nan, topped with a blue cagoule, trousers tucked into coarse woolly socks. Near the summit my brother and I had a snowball fight in the wind and rain with our Dad before scrambling up the rocky summit cairn. That was the first hill I remember.

Forays into the mountains proper had to wait until after my sixth form studies when James and I, together with another friend, Beverley King, went on a backpacking trip into the Cairngorms. After two days Beverley's knee complained so bitterly we embarked upon a Scottish road trip. It was an eye opening experience with James and myself lining up years' worth of future hill objectives, our sights on everything higher and steeper than we could find in our home county of Norfolk – which wasn't too difficult. From scrambling over the superlative mountains of Glen Coe to climbs on the isolated peaks of Wester Ross, we moved over ever more challenging terrain. Starting on some normal route but spying a 'more entertaining' way, going 'off piste' became *de rigueur*. Sometimes we should have been roped but we were green, living off the adrenaline surge, invincible and probably the wrong side of stupid. Moving onto the pure-vertical at the diminutive but steep sandstone crag of Bowden Doors in Northumberland my fingers gripped so tightly my forearms went solid. When I tried to write a letter that evening my words looked like an explosion in an ink pot. The final rock-climb of the day, *Scorpion*, certainly had a sting in the tail.

In 1998 Phill Dobson moved from London to the BBC in Newcastle to work as a cameraman. Originally from Sunderland he was also keen to get back to the mountains. An archetypal action man with dimpled chin, sharp eyes and a fine crop of ginger hair extending to a well-trimmed beard, what really impressed was his calm demeanor and sense of fun. As an added bonus: he knew what he was doing and had all the climbing paraphernalia, including a rope. Climbing in Northumberland soon became a twice a week affair with weekends spent in the Lake District, or in Scotland where familiarity with some routes meant relieving oneself of all equipment. Solo climbing was a liberating but committing experience with potentially serious consequences.

The two of us often headed up to the cottage James now rented with his new wife Polly near Inverness. Anything went. We walked up Ben Nevis with other friends, seven of us in total, to camp on the summit one New Year's Eve, James carrying his rapper-at-large ghetto-blaster to tune into the 'bells'. Unfortunately the cold zapped the batteries dead, for which he received a merciless ribbing. Early in the evening he asked if I fancied a beer. I replied, 'Who'd be mad enough to cart beer up here?' To which James and Phill chorused, 'You!' They'd sneaked cans of Export into the bottom of my rucksack, but the cold had frozen them into beer popsicles in a can. We managed a half hour of dancing round the summit as the clock moved past midnight before the intense cold forced us back to the tents, held up against a boisterous wind by guy ropes an inch thick with rime-ice. On January 1st we headed north to bivi by a hoar-frosted roadside beyond the Aultguish Inn on the road to Ullapool, and to ascend the west buttress of Stac Pollaidh, watching the sun set over the lochan-studded moorland, completing the top half of the climb by the light of our dim headtorches.

It was a classic mountain apprenticeship from hillwalking to scrambling to rock climbing to winter mountaineering and ice climbing, and there seemed nothing better in the world than a hard day, great company and a few beers in the evening. We invariably

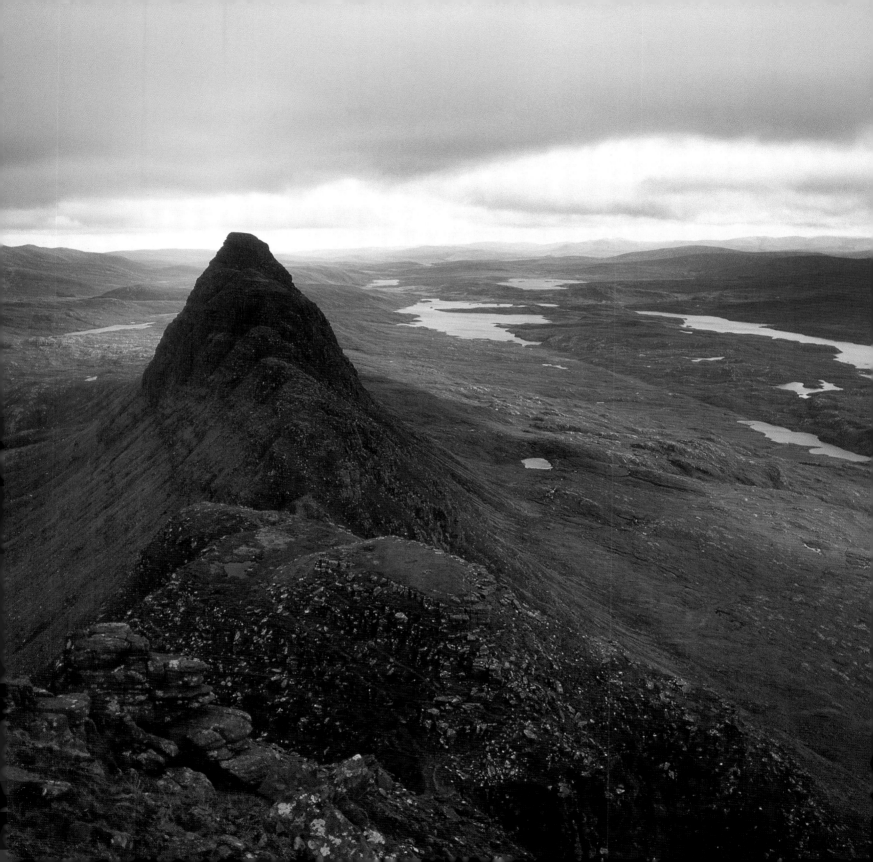

↓ *Climbing solo Phill Dobson clears powder snow off the holds on the Aonach Eagach.*

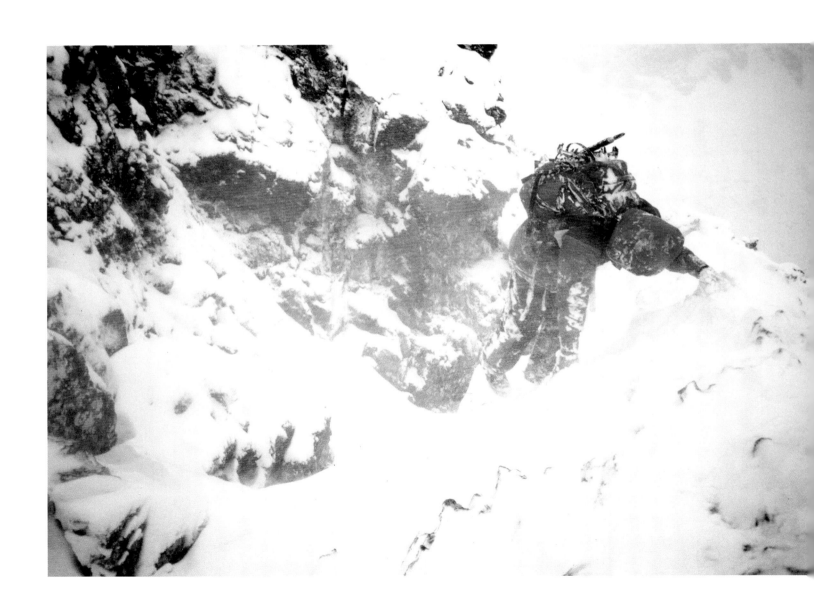

I have developed a huge respect for what the mountains can do...

pushed it and, buoyed along by each other, thought we could get away with anything.

One storm damaged February morning, Phill and I climbed Glen Coe's northern bounding ridge line, the Aonach Eagach. Snow lay deep on the narrow ledges and a savage wind whipped around its towers and pinnacles. Past the descent from Am Bodach, the first summit, we heard a scream and looked back to see a female body slithering down a rock slab, out of control. Her mittened hand grabbed an old fence post and she swung violently to a halt and so narrowly avoided plummeting over the edge into a misty oblivion. We shouted back to see if she was alright and if the team that she was with were going to continue. Obviously shaken, through the buffeting wind she replied, 'Yes'.

It took all our concentration to make the traverse, clearing snow off the holds as we went. Climbing unroped, we reached the end of all the technical difficulties at nightfall leaving the steep descent to the valley floor and a well-earned pint in the Clachaig Inn. At the top of the glen, where we'd left the car, the blue lights and roof mounted search beams of the Rescue Team's vans lit the lower flanks of the Aonach Eagach. The group we'd met earlier had tried to descend directly from the ridge crest and become cragfast. Luckily they were all plucked to safety. We had got away with the day.

It is said that experience is the sum of near misses. That may be true but experience is something that builds imperceptibly. Over the years I've became less brave, more open to assessing the conditions and planning around the available daylight. I have developed a huge respect for what the mountains can do, and pay careful attention to those who are indeed vastly more experienced than I. In the UK, when things go wrong, we are lucky to have a network of highly trained volunteers who are willing to take on the weather and rugged terrain to help those in need.

In February 1995 Mountain Rescue was a political hot potato. There were deafening cries for risk-junkie climbers to carry insurance and the Rescue Teams to be 'professionalised'. No one had thought to give the viewpoint, or even an accurate warts-and-all account, of what mountain rescue was like from the inside. The BBC's current affairs *Inside Story* commissioned Richard Else and Triple Echo to produce a film to do just that.

Driving north up the A9 on the Friday night in Duncan McCallum's Trooper 4WD, we discussed fear, worst nightmares and predictions for the next two weeks, while hypnotic, storm-blown trails of snow snaked through the headlights. Things did not bode well for the mountains. The forecast was dire, but no one foresaw just how bad things were to get. That Friday evening was the only time I actually stayed in our guest house in Lossiemouth.

That winter 64 people had already been caught in avalanches and ten had died. During the next two weeks the toll was to rise significantly.

Duncan, together with Mark Diggins, was to be embedded with the RAF Rescue helicopter. My wingman, Cubby Cuthbertson (as on *The Edge*) and I were to join the rescue teams on foot, wherever in Scotland they got a 'shout', knowing that we owed it to ourselves, to the teams and to the close-knit climbing community, to deliver an accurate representation. What followed left an indelible mark.

Saturday morning in the Northern Corries of the Cairngorms, we expected to find victims buried in snow the consistency of concrete after an avalanche on the Goat Track. At almost the same time a climber had fallen, suffering head injuries. Six were injured in total. Duncan jumped out of the chopper as the winchman assessed and prioritised the casualties.

By midnight the sound of the wind and the booming of avalanches was immense and I sensed fear.

Meanwhile, Cubby and I jumped onto the back of the piste-basher that was taking the ground-based Rescue Team as far as it could before they raced in on foot. Luckily, the corrie was busy and climbers ran to dig folk out. By the time we arrived, casualties were being put in the chopper and flown to Raigmore Hospital in Inverness, many with broken bones. All survived. The weather continued foul and the rescues kept coming, some with happier endings, most with unsatisfactory outcomes.

That evening at the curry house Richard's brick-sized mobile phone kept us on tenterhooks like a menacing alarm clock and, as the waiter came out of the kitchen carrying a tray of desserts, we sprinted for the door. I caught a glimpse of horror on his face, but we'd emptied enough cash onto the table to cover the bill.

Five teams were on a missing person search in the Blackmount Hills between Glen Etive and Bridge of Orchy, an area of 250 square kilometres. We joined the RAF Leuchars Team for a miserable day of tramping across ankle-breaking terrain, slush, and slippery iced-over rocks. The camera lens ran with waves of the downpour as the team diligently searched every stream bed and gully, the stair-rod rain turning to blizzards as we gained height. When the search was called off for the day, Cubby and I were offered places on the last flight out in a Navy Sea King to the Kingshouse Hotel. We took them gratefully, but were careful to ensure that all of the Rescue Team had already been evacuated or were on board. Richard booked us into a hotel in Glencoe and went out to buy me a toothbrush. All I had was my soaking hill gear. The missing person's body was finally discovered on the fourth day of the search.

On Lochnagar, the jewel of winter climbing in the Eastern Cairngorms, an experienced local mountaineer fell and broke a leg. His climbing partner soloed off the 250-metre cliff to raise the alarm

and the Braemar Rescue Team prepared to head into the darkness on foot. Richard careered the Land Rover over the ruts and bumps of the track heading towards Meikle Pap. Ahead we could see the head torches of the rescue team before they split into two groups, one attempting the summit plateau, to lower one of the team and stretcher down the mile-wide cliffs, the second heading into the corrie as a reception committee. On the initial stretch of the walk in to beneath the cliffs we were sheltered from the worst of the wind by the mountain itself. Occasionally the moon broke through layers of black scudding cloud, but conditions deteriorated rapidly. Gusts, recorded by the Cairngorm weather station just a few miles away, were ramping over 130mph and the chopper was grounded, as were Duncan and Digger. The ground-based teams were heading for a difficult and dangerous mission. Cubby and I filmed them trying to get to the lower-off zone as quickly as possible, staggering in the deep drifts and snowstorm, moving with vigour, speed of the essence.

Eventually we all huddled under a nylon group shelter and waited for news of the summit team's progress. By midnight the sound of the wind and the booming of avalanches was immense and I sensed fear. Fear that the mission faced impossible odds, conditions beyond the edge. Suddenly the whole shelter was ripped from us by either a massive gust or by someone terrified that we were about to be buried. Then came the news that the summit team had been forced to turn back, fearing for their lives as they crawled through the blizzard, unable to stand or navigate through snow-plastered goggles. Functioning was impossible.

A piste-basher with a crew-cab back had been driven to the lochan and waited to evacuate us. We navigated our way down until guided by its headlights and climbed into the back. In the

hurricane winds the whole vehicle felt as if it might shudder free of its caterpillar-tracks. The banshee howl was like nothing I'd heard before. It had been a difficult call by the team commander. Everyone felt like they'd abandoned their mission, but to press on in such fierce conditions was a risk too far. The injured climber, known by many of the rescue team, would have to endure the night on his own. Everyone knew his chances of survival were slim. It was 2.00am.

By midday there was a slight improvement in conditions and the chopper managed to land a team, including Duncan and Digger, near the summit. Duncan filmed the frantic activity as anchors were established, ropes sorted and a stretcher readied to go over the edge. Digger assisted the rescue team, his skills as a mountain guide better deployed with them. Cubby, Richard and I set off on foot, well behind the corrie reception team. On the third time over the edge of the cliff, trying to find the exact lower-off line, the team member radioed to say that he was with the casualty. There were no signs of life. Duncan witnessed that it looked as if the message had instantly taken away the rescue team's very own life blood. All activity ceased, people dropped to their knees and hung their heads. Snow swirled and streaked across their goggles, hiding sadness and defeat.

From a low ridge, distant from the corrie team, I filmed an image that stays with me to this day: an ethereal image of men bent double against the wind and the drag of the laden stretcher, coming and going through the mists and spindrift of a soulless day. That was the moment when being in the mountains ceased to be all about fun.

At the end of the two weeks filming I returned, dishevelled, exhausted and traumatised to the guest house in Lossiemouth to collect my belongings, most of them still in the bag that I'd dumped two weeks before.

When the film was aired we all hoped that it offered politicians and public a real insight into what mountain rescue entails; that the teams genuinely just want to help fellow stricken climbers and mountaingoers and hope that, if they ever get into trouble themselves, someone will come to their aid. I also hoped that it demonstrated the raw power of the Scottish mountains in winter, and that it might save anyone who was not experienced enough to tackle such conditions from making a grave error. If so, the film had done its job.

The filming over those two fateful weeks affected me deeply and caused me to wonder: why are we compelled into the mountains? Despite their harsh brutality their allure is overwhelming and, ultimately, they give us more than they take away, but reward and tragedy are as old as the hills themselves. For as long as people have ventured to the summits they have revelled, not only in the risks but also the escape, challenge and camaraderie of the rope. The Press, and I could put myself in that camp but won't, likes nothing better than a bad news story where the protagonists can be labelled by a risk-averse society as reckless and foolhardy. There are thousands of people who partake in activities in the mountains but accidents are thankfully rare. We are better equipped now than ever before to face the mountains and any aftermath should anything untoward happen. We have the benefit of knowledge, technology, better clothing and modern equipment but to counter that, as mountaineering and climbing have developed, boundaries have been pushed and standards raised. From time to time things can and will go wrong.

Back in the days of tweeds, nailed boots and hawser laid rope, tragedy was probably no more than a loose cleat away. In 1865 Edward Whymper, a man who recognized a challenge when he saw

one, became obsessed by 'the last great problem of the Alps'. The Matterhorn was the Everest of the Victorian era. After eight failed attempts he reached the summit, but the success was marred by a chain of events that not only had a profound effect on Whymper but also proved a turning point within mountaineering. It was the first time that a mountaineering tragedy hit the headlines big time, with all shades of journalism applied.

The Matterhorn is most people's idea of what a mountain should be like, pyramidal with sharp angular ridge lines, a snowcap and an air of lofty impregnability. When viewed from Zermatt in Switzerland this is the case, and is only marginally less so from Cervinia in Italy. Most mountaineers felt that an ascent from the Italian side would be more achievable. To claim the summit became a matter of national pride for the Italians and it was clear to Whymper that to prevent them from poaching it he would have to pull off what most thought impossible, an ascent of the fearsome Hornli Ridge from Zermatt.

However, as the seven-man team ascended, through a series of teetering towers and across loose gullies, the climbing proved to be surprisingly straightforward, except for a brief foray across a section of the North Face high on the mountain. Beyond, the summit lay within their grasp up an easy snow-clad ridge just two boots wide. As they stood on the spiked top they spotted the rival team on the Italian Ridge 300 metres below and shouted, waved, even kicked rocks down to attract their attention. Buoyed with this jubilation and possibly distracted from their concentrations, they started their descent. Then it all went wrong.

Above a steep kink in the ridge line known as the Shoulder, Haddow slipped and fell onto Croz, dislodging him. Lord Francis Douglas and Hudson were yanked from their footing. Above,

Whymper and the two Taugwalders braced themselves to hold the fall and prevent themselves from being ripped from the mountain but, as the rope became taut under the weight of bodies, it snapped. Four fell to their deaths including a 'Lord', which lit the blue touch paper with the press. The tragedy would haunt Whymper and, as the European newspapers and *The Times* ran often confused reports, the same questions touted today about risking life in such a pointless activity were asked then. It seemed that little had changed between Whymper's day and when we filmed with Richard for *Inside Story*.

Stephen Venables, writer, climber and allround gentleman of the mountains, set out to explore Whymper's story for part of the BBC *Mountain Men* series. Stephen, dressed as Whymper in tweeds and nailed boots, was climbing with Cubby, dressed in modern Goretex and fleece.

I'd been in the Alps for the previous few weeks and it was to be my second time on the Matterhorn within a week. Just three days prior I'd climbed and filmed to the summit for a National Geographic production, so felt very well acclimatised. My climbing partner for this second job was Brian Hall who had just flown out with Cubby. They'd only managed a swift climb on a neighbouring, much lower, peak to kick start their altitude training and were likely to puff like steam trains. Director Mick Conefrey wanted to film aerials of Stephen on the summit, preferably with no one else around and in a very narrow time window due to availability of the helicopter. On top of this, the mountain's microclimate often deteriorated to storm in the afternoons so speed was of the essence. With well over a hundred climbers a day trying to reach the summit, it was building to be an impossible task.

We set off at 4.30 am behind the Zermatt Guides into the chill of a starlit predawn. The terrain was familiar, even by the meagre

should be like...

light of my head torch, and with Brian brilliantly forging around any bottlenecks of climbers we maintained speedy upward progress in tandem with Stephen and Cubby. Sometimes we deliberately went 'off-route' to overtake, breathing hard and deep with the added load of camera and sound equipment. With dawn the whole mountain glowed with promise. When climbing was interrupted by the necessity to film on the upper half of the ridge, our pace inevitably slowed and we found ourselves enmeshed in descending climbers.

Having already lived their dream of standing on the top, they were now being lowered at full speed, often out of control, plummeting onto my backpack with their crampons or kicking off rocks. It seemed the Hornli Ridge had become a battleground where the main thing was to stay out of trouble but where room to manoeuvre was scarce. Somehow we navigated ourselves into a gap between climbing teams and Stephen stood on the blade of a summit at 12.30pm as planned. The chopper spiralled round him, clattering blades drowning the solitude of a lone figure above a broken sea of boiling clouds. It seemed a far cry from Whymper's day. Brian and I lay on the snow a few metres away from the actual top trying to look like piles of rocks

The descent took as long as the ascent and was brutal. The terrain, while not especially difficult, always demanded the utmost concentration and with no effective belays between us the consequences of a slip could have been disastrous with history repeating itself. Our throats rasped at the dry air and our water bladders had frozen solid. That night we luxuriated, feeling mildly seasick, while sleeping in the lap of luxury. To our surprise there were heated waterbeds in a room on the first floor of the Hornli Hut.

The following morning we headed back up to shoot the lower sections of the ridge. The clouds continued building in great, gloomy

layers and soon snow tumbled through the mists, wreathing round the red towers. Stephen climbed with great aplomb despite his museum piece alpenstock threatening to prise him off the crag, but soon the lack of visibility forced us to retreat. Halfway on our descent, still with tired limbs from the previous day, we decided a break was required for food and tea from the flask. Stephen, in full tweeds and hat, sat on a narrow ledge a few metres away and, as the white stuff accumulated across his shoulders and hat brim, we heard the scraping of boots on rock and voices coming closer. A guide and his German client discovered a motionless, half buried tweed-clad figure and almost fell off the mountain in fright uttering the words 'Mein Gott! It's zee ghost of Whymper'.

It was a remarkable achievement by a remarkable man.

In 1865 the Matterhorn was seen as a test piece of mountaineering skill. For many today it still is, and it's easy to see the appeal. After Everest, it is probably the most famous mountain in the world. Its image adorns everything from bars of chocolate to sunglasses and cosmetics. The shops of Zermatt are full of Matterhorn memorabilia from bier-steins to snow-domes. People can imagine the Matterhorn even if they've never actually seen it, let alone been on its slopes. As a mountain, its iconic graphic shape is rooted in the subconscious, holding hostage our imaginations. Its geometry, symmetry, structure and line create a simple urge to explore where the vertical arena has the added temptation of the untouchable. It seems the more slender the proposition the greater the sense of wonder and, as you tour the world, the best shapes seem to offer the fewest lines.

There is elegance in the perfect triangle, the mountain shape of a child's drawing, but simplicity in a tower with stick figures on top. What better than to climb a tower with a base more slender than its top, an upturned elongated triangle. Surround it with sea and you have arguably the perfect adventure objective.

Probably the most famous 'tower of the sea', or 'stack', sits on a granite plinth, resistant to the pounding surf, 150 metres of tottering, guano smeared Orkney sandstone where the erosional forces low down are greater than those higher-up, creating its top-heavy form. The 'Old Man of Hoy' was as firmly planted into peoples' minds as the Matterhorn, attaining almost celebrity status, when in 1967 the BBC broadcast a live ascent.

Spread over three days and requiring the services of a military landing-craft, it was a logistical triumph and a technical marvel of fuzzy black and white images and clipped voices. Chris Bonington and Tom Patey repeated their original route from the year before, whilst two new lines were climbed by Joe Brown and Ian McNaught-Davis, and by Pete Crew and Dougal Haston. Presenting the transmissions was Olympic athlete Chris Brasher. Following the broadcast, the 'Old Man' ranked on climbers' bucket lists in a similar way as the Matterhorn. It simply had to be done.

In late summer 2014 Sir Chris Bonington was, once again, to attempt his original line on-camera for the BBC and for Berghaus, this time with Leo Houlding and TV presenter, Andy Torbet, a very experienced climber in his own right. Leo dubbed our small expedition as the old man on the 'Old Man', as Chris had just turned eighty. It had been a difficult time for him with the recent loss of his wife, Wendy, to motor neurone disease and she'd been under Chris's devoted care 24/7. For Chris, this ascent was about catharsis, a new beginning. In his own words, 'It's a big challenge to face life by yourself, but it's something you've got to deal with. I felt stressed out of my mind and wondered if I was really up to it or not (Hoy).' Given the circumstances he hadn't been able to climb for a full twelve months.

We walked and filmed along the path from Rackwick Bay on a dreich Monday full of streaking rain and gales, with water from the burns blown vertically as they tumbled over the cliffs. Seeing the Old Man in a seascape of white spume and foam, Leo spotted a change in Chris's demeanour, an inner turmoil of shock, worries and doubts. As he peered over the edge everything about the day felt intimidating. The damp, cold atmosphere had rotted all positivity. It was a serious reality check and, back at the Hoy Hotel, Chris confessed that the previous day had taken its toll physically and mentally.

Leo called it. We were not going to climb the Old Man today. Instead Chris and he were going to be in the company of friends on the beach and in the bothy at Rackwick Bay. Everyone there had

→ *Sir Chris Bonington.*

known Chris for a very long time, in many cases decades and we spent the day chatting and filming amongst wave rounded boulders and in the peace of the rough stone bothy. Without saying as much I think we all wanted Chris to know that we were there for him.

The improving forecast came and went sooner than expected and by Wednesday, whilst the weather was by no means as awful as on Monday, the day had an air of expectant drizzle at best. The scramble down the steep, vegetated and rocky slopes of mainland cliff, and the boulders on the decaying neck of land leading to the base of the stack, were dangerously slick. Chris threw aside his walking poles to free both hands for the final section before settling into a small cave to gear up and eat an early lunch, sheltered from the worst of the weather. Once underway, the Old Man seemed friendlier and it was a relief to be searching for holds on slightly more solid and amenable rock.

Andy led the first pitch, followed by Chris. Once Leo was on his way I hooked onto the ropes leading to the crux, 'hanging coffin', section. After 60 metres of fully-loaded free-hanging jumaring I pushed off the rock to pendulum round a rock rib and grab a small vertical edge to place a camming device. Clipping to this prevented me from hanging directly on the climb line. Once in position Leo made light work of the pitch, climbing with confidence and poise across the traverse and into the Coffin. The exit onto the top wall proved more awkward and, mindful that Chris was following, Leo laced the moves with plenty of gear.

Chris, with the benefit of a top rope from Leo and a back-rope from Andy, dropped the few feet to commence the airy traverse marked by Leo's chalk. Exuding an air of thoughtful confidence, he whistled tunelessly across a series of exposed ledges into the hanging crack and through the first roof, his helmet clattering

occasionally off the crumbling sandstone. He passed an old wooden wedge festooned with loops of questionable rope, old school protection of the sort used in 1967. Back-and-footing up the bottomless chimney of 'The Coffin', he wormed his way until his head scraped the capping roof. On the TV broadcast Chris had climbed it 'free' while his rope partner Tom Patey pulled on a sling. Now 'less flexible' than he was 47 years earlier, Chris joined the 'Grand Old Master' Patey and held onto the nylon tape placed by Leo. As he finally gained the upper wall, he paused to regain his breath and, through a series of long exhales, declared that he couldn't do these big bold bridging moves anymore. His legs didn't want to stretch that far.

At the top of the second pitch things were a little crowded and, with Andy in a holding position below, getting cramp in his calf, I climbed delicately over Chris and Leo. Beyond lay an awkwardly blocky chimney where it was hard not to bash the camera as it swung from my bandolier. I was heading into position to match a shot in the 1967 film, looking down a rather green wall with the crashing sea beneath, only to be met by a squawking fulmar that was clearly filling the back of its throat with fishy smelling vomit to fire in my direction. I kept my distance as best I could, teetering with my feet on the edge, just out of projectile range, and waited for Leo and then Chris to move through before ascending to the final open book corner. With a splitter crack through which you can see to the horizon and feel the wind whistle, it feels like half the stack is about to peel away. It was a pitch to savour and a sense that we were marking a moment in time. Very soon Chris stood again on the Old Man.

It was a remarkable achievement by a remarkable man. Chris, in modest mood, felt that he 'creaked' up the Old Man but on camera he looked smooth and effortless, a man who can pull on vast

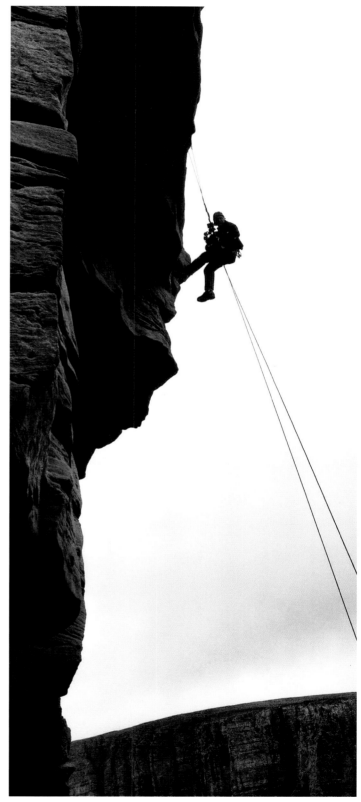

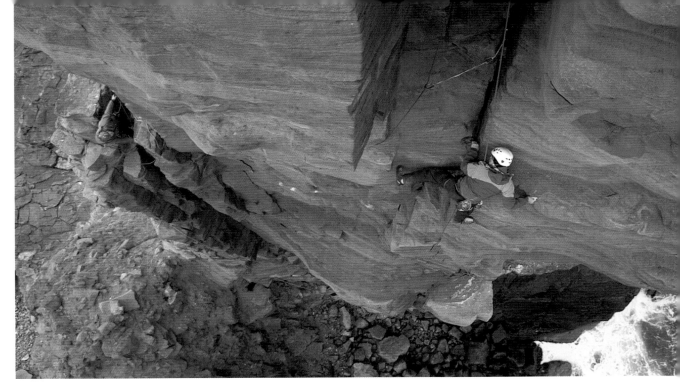

←← *150 metres of tottering, guano smeared Orkney sandstone. The Old Man of Hoy.*

← *Keith hanging out 60m up the Old Man. (© Leo Houlding)*

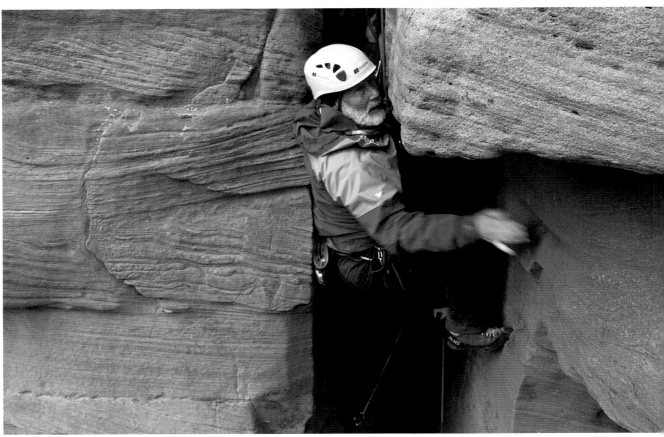

Chris stood again on the Old Man.

↖ '...an intricate journey
from the past to the future,
testifying that just because
you're eighty you don't have
to stop living.'

← Back and footing out
of the Coffin – the crux of
the route.

↑ Raining champagne.
Sir Chris celebrates with
Leo and Andy.

experience and the smallest of holds to get the job done, all with unrivalled enthusiasm.

The Old Man of Hoy represented an intricate journey from the past to the future, testifying that just because you're eighty you don't have to stop living. People overcoming fear, pushing the limits of their ability or seeing something through to the end regardless of age, or gender, will always inspire. It was a privilege to see this man who has done so much to further the sport of mountaineering, and who has enthused generations of climbers, through a shower of champagne, grinning behind his famous beard.

Photographers talk about compositional elements such as leading lines and perspective, shadow, form and texture. The Old Man of Hoy has everything. A simple but appealing structure, it is far from blank. Close up, its intricate series of roofs, ledges, cracks and corners permit an entertaining and meandering line, not perfect but still a challenge that would never be a 'given'.

Climbers search for that perfect line. To my mind the Hornli Ridge on the Matterhorn comes close, albeit when viewed from a distance, as does the Nose on El Capitan in Yosemite, lines that go from the bottom to the top like an arrow. Both rely on the weathering forces of the planet to give them their stature. Granite walls of sheer oceanic proportions, faces that Leo is world famous for climbing, such as in Yosemite, are possibly the nearest nature offers in terms of a blank canvas on which to climb.

To aid upward progress we need something on which to gain purchase. The ease with which a mountain or cliff gives up its lines is often beholden to a time. The ridge lines were often the earliest to fall to the climbers' hand, as with the Matterhorn, then the buttresses and finally the more esoteric lines. Modern climbing, while steeped in tradition and history, has grown off-shoots and

specialist areas from rock to ice, alpinism, big wall, high altitude, solo, sport, speed, simul. Nowadays most climbers' first experience of the sport is on an indoor climbing wall, an 'artificial' environment where one can safely learn the ropes and techniques of footwork and body positioning. It is an engineered form of climbing contradictory to the purely gymnastic, almost balletic approach that is ultimately required for Sport Climbing.

The Swiss, famous for feats of engineering, road tunneling, ultra-reliable railways and hydro-power, have also provided the ultimate in engineered blank canvases. The Diga Di Luzzone allowed climbers the opportunity to 'build' a route up its otherwise smooth 165 metre high concrete dam. With 650 plastic climbing holds bolted from bottom to the top's steel balustrade, it is the world's highest artificial climbing wall. For the flagship BBC children's show *Blue Peter* it was an obvious challenge to set a presenter whose experience was measured in weeks.

Radzi Chingyanganya joined Mountain Guide Libby Peter on the five pitch climb, Brian Hall and I having recced the route with Libby and Rory Gregory the day before. As the route swung up and across the wall in an elongated 'S', devoid of any reference to scale, the exposure was truly gut-wrenching. My forearms blew up after the first three pitches, a legacy of not climbing much after ankle surgery, and it was steep, requiring a steady head for heights. I imagined it as being like trying to climb the inside of a goldfish bowl, and that filming would mean some entertaining 'swims into space'.

With my two ropes running the full height of the dam, crossing over in the centre of the 'S', they were only clipped into the occasional bolt to keep the actual climb line clear of my clutter. On unclipping the quickdraws that held my ropes I flew away, at the

end of my over-long pendulum. To me this was mere play, fun at the park. Serious fun.

As Radzi climbed he looked totally in control, moving in a considered, economic way, aware that conserving some strength for the top pitch was going to be vital. When it came, Libby handed over the lead and, with eyes firmly focussed on the top rail and the finish, Radzi rocketed past the final two bolts without clipping them. I muttered under my breath for his grip not to fail him now, anxious that he would go one heck of a long way before the rope held him. At least the wall was so steep he wouldn't hit anything. He tumbled over the top bar and onto the road that ran across the top of the dam utterly euphoric and, possibly, a little bit relieved. Filming was as much fun as anyone can possibly have, and the great motivator for filming adventures is that it has to be fun. However, playing around in such places can also breed complacency which can, very quickly, change the dynamic into something far more serious.

In neighbouring France lies the Verdon Gorge, mecca for adventure enthusiasts and lovers of steep limestone climbing. In 2005, BBC's *Top Gear* had lined up a challenge for one of their presenters. Think what you will of the show, the *Top Gear* team certainly know how to have fun, although for many years the shoot also left a bitter taste. Armed with an Audi RS4, Jeremy Clarkson pushed his pedal to the floor to run the gauntlet of motor homes and hairpins on some of the worst roads in Europe. On the surface the Audi looked like a standard family saloon but the way it rasped and snarled made you think again. The race was against Leo Houlding and Tim Emmet, who were to speed-climb the 400 metre high canyon wall. First to reach the top won.

Brian Hall and Paul Moores had laid a complex rope system to allow me to film from both sides of the climb line. By using a linking rope between the two systems I could move across the cliff diagonally. Having heaved myself up near overhanging rock all morning, by late in the afternoon I was battling exhaustion, my chest harness left at the top in the rush to get going. What a stupid place for it to be, and what I'd do to have it and the chest ascender now! Clipped onto the rope at least they would keep me the right way up. My elbows also felt like they'd rip apart as I hauled myself upright again. Past the rim of my climbing helmet, my two ropes soared towards a bruised, purple thunderstorm-sky. I felt useless, helpless, hanging, trying to make upward progress, and after a pathetic hand's width of ascent there was still a depressing 50 metres to the top and safety.

A helicopter whacked through the air beneath my heels and the thunder ripped. Rain hosed the limestone, running off the overhanging rock, smacking me in the eyes and mouth. The sun-drenched beaches of Nice, two hours away, might as well have been on the moon. Spinning in space, struggling to maintain contact with the rock, I was the barrier stopping the rest of the team getting the hell out. On my back, a fully loaded camera rucksack the weight of a sizeable television was dragging me upside down.

My stomach muscles shook uncontrollably with the fight to stay upright but, almost worse than that, the leg-loops of my harness began to cut off the circulation, numbing my thighs. I rested for the tenth time in minutes to take some pressure off my legs, but knew that dangling on sopping ropes on the side of a gorge capable of swallowing a stack of eighty double-decker buses in a storm wasn't a good idea. We'd heard many stories of climbers being fried as lightning zapped down their lines. The static electricity in the air made my hair tingle wildly.

On my back, a fully loaded camera rucksack the weight of a sizeable television was dragging me upside down.

When Leo climbed past with Tim at his heels I paused so as not to kick his rope. Not that I minded another rest. Tim offered to take my camera sack up the last section and it was the first time anyone had ever stepped in to help in all the years. I guess it dented my pride.

Paul Moores was below dressed in shorts and a T-shirt, stripping the ropes as we moved up. I sensed his frustration at my lack of pace. I suppose he knew that I was totally aware of our situation, so what good would shouting do. Believe me, I was hauling as if my life depended on it.

Les Marches Du Temps was an appropriately named climb to film. The *Course of Time* reminded me of all I'd been through to get here, a place with so much verticality that, when you peer from the top of the gorge, you do actually feel slightly sick. I also thought about the unstoppable nature of time and things running out of control if you're unable to keep up, the strange feeling that in moments of stress everything happens in slow motion, as if the brain has moved into hyper drive to record, absorb and analyse every minute detail. It exacerbated and confused my current situation with all progress now in danger of grinding to a halt.

I handed my camera sack to Tim who climbed through the small overlap in the slabs onto the upper wall, which now angled back. He sprinted to the top and safety as thunder roared through the valley. Now travelling light I moved upwards at speed, pulling over the final moves to the belay. Paul was behind me as the rumbles moved away and cracks of lightning struck the distant hill tops. It had been my mistake, leaving behind what turned out to be a really useful piece of equipment and the sense of embarrassment lasted for many years.

Over a beer in the Hoy Hotel, checking equipment for the 'Old Man', I finally talked it over with Leo. Ultimately, that was it – off MY chest. No one else thought much of it, but I had allowed something so simple to act as a beating stick. It taught me a salutary lesson in not being rushed but, as with many of the shoots over the years, there's something to take away. Filming in difficult locations can be downright dangerous if not managed correctly. Not having a chest harness on my person in the Verdon was not by itself dangerous but, with the thunderstorm and the need for speed, the situation was pushed closer to the edge. I never let it happen again.

Clarkson lost, and in a double or quits race back down Leo employed gravity. He ran to the edge and, with a few deep breaths to calm his nerves, jumped. It seemed a very unhealthy distance to free fall before he pulled the rip cord and his parachute burst open. 400 metres in twenty seconds was an impossible time to beat in any car. The twenty quid ended up in his and Tim's pockets.

Leo and I continued chatting in the Hoy Hotel's dining room, inevitably reminiscing about the *Top Gear* shoot. He reminded me about when he and Tim took the RS4 for a 'spin', which was probably the most risky thing the Audi representative could have done, and the ten days climbing in the Czech Republic with Andy Cave on the sandstone towers, bolstered by unfeasibly cheap beer, 'El Sendero Luminoso, the Shining Path in Mexico with Timmy O'Neill, and having Paul Moores pop his head over the bivi ledge to utter the words 'dial a pizza anyone?' to produce boxes of thin crust with mozarella and pepperoni from his rucksack. Then there was the previous time we'd been with Bonington ten years earlier for Chris's 70th birthday.

He was spending time with his family in Sydney so we joined him in the Blue Mountains just north of the city with producer Richard Else. For the 'Blues' everyone was so relaxed it felt like a bunch of friends on a climbing holiday.

→ *Pushed into space above*
Nuit Blanche *to film the*
opening to the Hollywood
movie Alien Versus Predator.

Jet-lagged and lying awake in the small hours I received a call from the *Alien Versus Predator* production office asking if I'd shoot the opening sequence for the Hollywood film. Flabbergasted by the request I agreed and only after hanging up did the reality hit me. I'd never even seen the camera they wanted to use and, since I was in Australia, familiarising myself with it was going to be impossible. The shoot would also back directly onto my return; I phoned the office. Having explained the 'timing issues' the Production Manager, on my behalf, found a very helpful Camera Assistant called Ralph who offered to pull a kit list together and sort out the whole job, even operate the camera! This final part of the offer I wasn't too sure about. I explained the technicalities of just where we were to film but sensed my words falling on either super-confident or inexperienced ears.

Back home the fax machine in the dining room whirred into life and spat out a series of pages emblazoned with the 20th Century Fox logo and marked confidential. As openings go, the script that spilled onto my floor was straightforward; introduce the lead character as a diehard female mountain guide Alexa. She climbs vertical ice-pillar, mobile phone rings (but it's okay, she's on a sci-fi, poke-the-ear, blue-tooth earpiece), she answers phone (as you do when ice climbing) to be told she must go to save the world. Reluctantly, as she'd rather be ice climbing without disturbance, she pulls over the final moves to discover the chap on the other end of the call waiting for her, ready with a helicopter to whisk her away on her mission to deter the planet's demise and death by aliens.

Just before the shoot, Paul Moores, leading up safety, and I were summoned to Prague to meet the Director, Paul Anderson, to talk through the sequence. On the flight I consumed the camera's instruction manual, familiarising myself with the knobs, dials and settings. In Prague we were driven to an active military airbase where the Alien Queen, eight feet of robotic terror, wrought havoc amongst the cast in an aircraft hangar, dressed as a field station in Antarctica.

As lunch was called we stepped into Paul Anderson's Winnebago where he produced a pile of images he liked and said with a wry smile, 'if you can't give me shots like these there's something wrong'. They were all frame grabs from *Touching the Void.*

On location Ralph was still keen to shoot for me, so we harnessed up and I took him to the edge of *Nuit Blanche*, a 150 metre pillar of ice above the dark mouths of crevasses of the Argentiere Glacier in the French Alps. Peering over the giddying drop he sensibly uttered just two words, the second being 'off' before heading at speed to safer ground.

Cubby and I manhandled the tripod to the edge of a rock prow. With Sheffield climber Debbie Birch doubling for Sanaa Lathan (Alexa), in position way below, we clicked the camera onto the tripod, checked by radio that Debbie was ready, and tilted the camera vertically down to frame the shot. The camera fell off the tripod and both pieces of equipment toppled over the edge. Between us, Cubby and I caught everything but found ourselves swinging from our safety lines, peering into the black holes far below, trying to stop the camera from smashing into the cliff. We had tethered ourselves and all equipment to the safety lines so, apart from a moment's excitement, no damage was done. Upon inspection we discovered that the jaws which normally clamped the camera's baseplate to the tripod had frozen open.

On Day Two we were 40 metres down with Debbie kicking giant icicles into the lens as Brian and I handled the 35 mm camera. Rory Gregory, normally cool as a cue, shouted from above and,

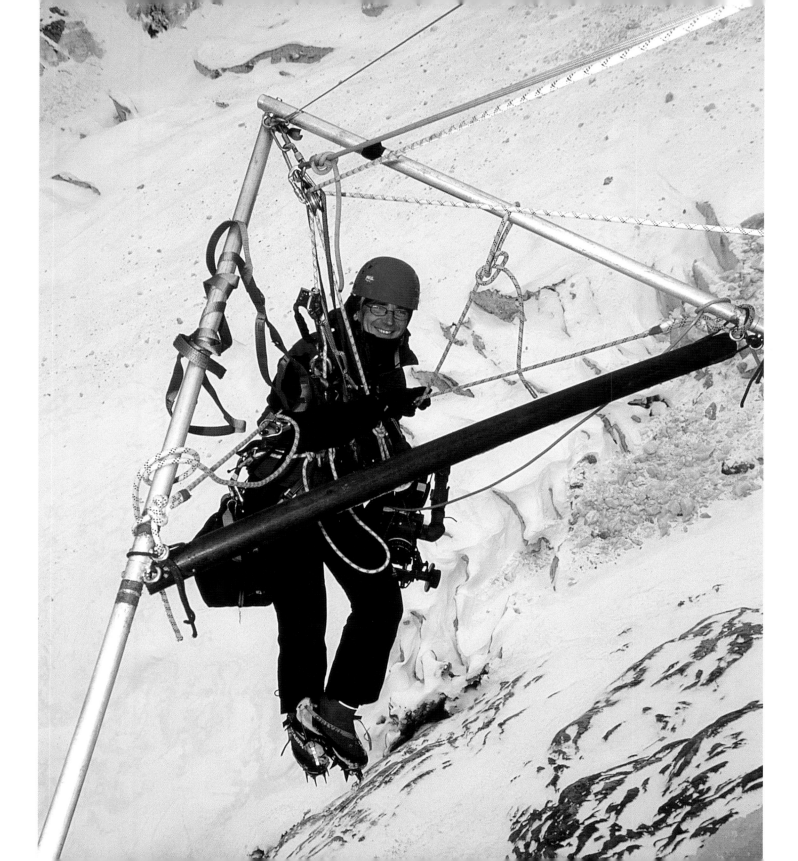

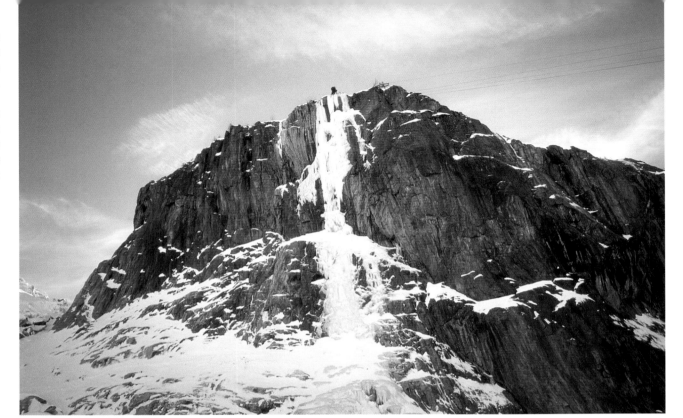

→ The classic Chamonix
ice route Nuit Blanche
before the flood gates
opened on us.

↘ Shooting through
my legs – the camera
looks straight down into
the jumbled ice of the
Argentiere Glacier.

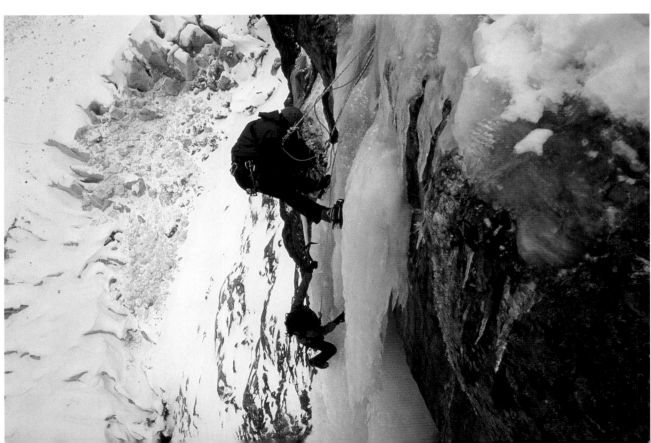

We were in our very own ice storm.

as we looked up, it seemed that Niagara Falls had relocated to France. A wall of water poured down the ice and froze instantly on hitting ourselves, our equipment, ropes and camera. We were in our very own ice storm. The route was formed by the overflow pipes from the tanks holding water for a hydro-electric scheme, and the automatic pressure release valves had opened. Debbie climbed spectacularly through the torrent but, with our climbing equipment and ropes encased in ice, the only means of extracting the very expensive camera, Brian and myself, was for Paul and Rory to haul us out. Of course, the camera was packed into a waterproof rucksack and rescued first, almost as if we'd expected the unexpected. While it's easy to get into trouble on these jobs it's certainly trickier to get out.

Common to most of these shoots is the style of movement. Despite the physicality required to overcome gravity, the polished performer still has a look of ease and balance. Over recent years I have worked a lot with Scottish Ballet, and much of the classic and contemporary dance I've filmed on stage reminds me of the movement I've seen on cliffs and even ice. Debbie Birch is a superb technical rock climber who is able to transfer her poise and balance onto technical ice, always looking immaculately precise with both tools and body position. Radzi, despite his relative lack of experience, still managed to look relaxed. Leo Houlding, when climbing in highly dynamic situations, is always sure footed and smooth with a self-belief born of years of training. Climbing is a form of dance where grace, balance and fluidity are the key and, while strength obviously plays a part, style and technique are the hallmarks of the master. Great climbers are the choreographers of the vertical.

Possibly my most unusual job has been with a group of aerial dancers. We were to project their filmed routines onto a large screen installed as part of an operatic stage production about the people of St Kilda for Gaelic Arts. Due to the delicate nature of access, not to mention the volatility of the weather on St Kilda, we shot on the impressive sea cliffs of the Screaming Geo at Mangarstadh on the west coast of the Isle of Lewis.

On its solid orange walls of gneiss plunging into the Atlantic with a solitary camera, we rigged ten camera positions to cover the various dance elements, all in very sporty-to-get-to locations. The most beautiful performance was of a love story we called 'Duet', performed on a slabby headwall above a church-sized cave.

At the end of a tiring week's shoot Brian and I packed the camera away on the end of a narrow ledge above a considerable and overhanging drop to a seaweed covered, wave cut platform. Brian was still stuffing things into his pack as I set off along the ledge rigged with a fixed line back to easier ground, my rucksack overloaded with broadcast camera, spare batteries plus ropes and climbing equipment.

The weather had deteriorated slightly with drizzle in the air when, beneath me, I saw a small nubbin of rock I thought might just stick in the vibram tread of my left boot, giving greater security on the greasy rock. Instead, it flew out from under me, catapulting me over the edge. As the tension whipped up on the fixed line I saw it yank sharply at Brian's waist just as he lifted his sack and thrust his arms through the straps. Within a split second he too was over the edge, both of us now hanging more than 30 metres above the incoming tide. I slammed a jumar onto the rope and hauled myself back up to the ledge in an adrenaline fuelled, panting mess that was quickly followed by Brian. A simple slip would have been fatal had we not adhered to our motto of always clipping-in; a reminder that these are serious environments.

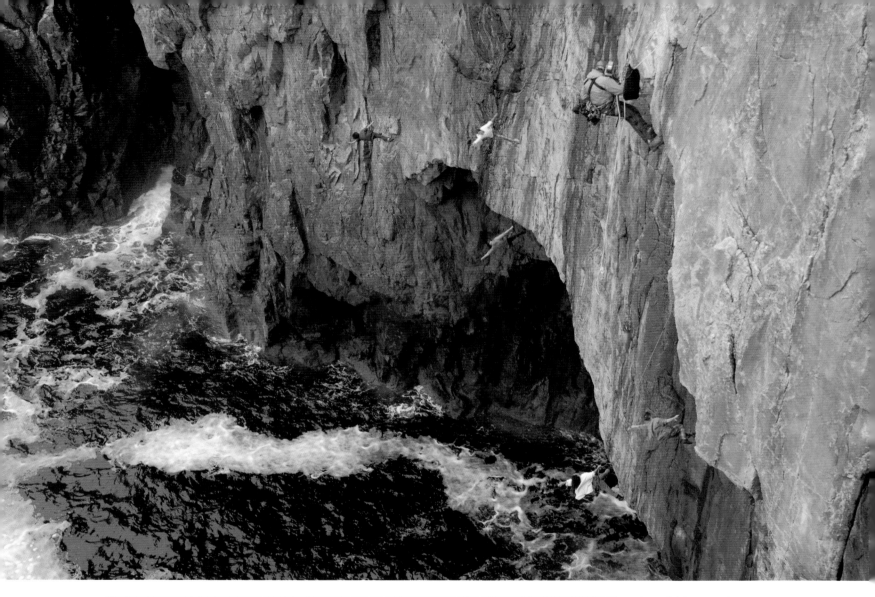

↑ *Aerial dance on the great gneiss cliffs of the Screaming Geo at Mangurstadh, Isle of Lewis.* (© *Brian Hall*)

← *Duet – a love story.* (© *Brian Hall*)

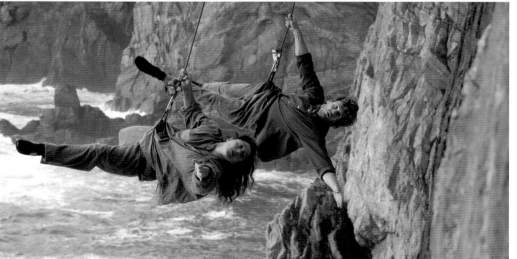

... clinging to a finger edge no thicker than a USB memory stick.

Just to the south of Lewis lies a landscape much more mountainous and wild in character, the centrepiece of which is the most savage piece of rock in the whole of the UK. Sron Uladail, on the Isle of Harris, is a monster of a cliff, its 200 metres of height so preposterously angled that a rope suspended from the top would land 50 metres out from the base of the cliff. There is barely an inch of its complex architecture that doesn't overhang. We were about to witness Dave Macleod and Tim Emmett climbing a new free line and deliver arguably THE hardest, most sustained climb in the UK – LIVE.

It would also be a demonstration of just how far we'd come technologically since that first climbing Outside Broadcast on the Old Man of Hoy. In 2011 Richard Else and Triple Echo Productions stepped up with BBC Scotland to push the boundaries with a six hour, live, climbing extravaganza in High Definition. Equipment was flown in by chopper to minimise any environmental impact, and built by the engineers inside what looked like a couple of garden sheds. There was not a single landing craft, truck or simon-hoist in sight, and the crew walked in and out to do battle with clouds of midges as we rigged the cameras.

Brian, Rory, Digger, Iain Peter and Cubby pulled off the most strenuous and difficult rig they had ever done but, when one of the ropes prised off a rock the size of a breeze-block, it almost finished the 'OB' before it started, as it sliced across Dave MacLeod's ankle. Just a few days later he was attempting the climb badly bruised and sporting a zipper of five stitches.

Stephen Venables was in the commentary tent together with Duncan McCallum, Mark Garthwaite and Cameron McNeish. Behind the lens were the cream of British cameramen. All were at home on horribly overhanging terrain. Harry Potter had not a patch on this team, hanging out in space playing a game of real-life quidditch, clutching cameras tethered to harnesses and fed into small backpacks festooned with antennae. It was as if my jet pack of old had been dipped in shrinking serum, and for the hours spent pointing cameras at MacLeod and Emmet we hardly knew they were there. The mid-air camera mounted on a long pole did indeed look like a broomstick silhouetted against a brooding sky.

Having prerecorded the first pitch we went live for the second and its crux moves straight off the belay. Dave quite literally defied gravity, roaring with the effort, clinging to a finger edge no thicker than a USB memory stick. Beyond, he cut loose, hanging from one hand to link a sequence of moves never before climbed, moving horizontally along a curving crack. With arms 'pumped' the rests were not giving back much power as he committed to the most audacious piece of climbing I'd ever witnessed through my viewfinder.

The rain increased, falling in great sheets, propelled across the glen by a blustery 40 mph wind, but on the cliff we were protected by the greatest umbrella in Scotland. Once Dave and Tim were beyond the scope of our lenses Dominic Scott and I abseiled off and hiked over the heather slopes up to the top, dropping down, dripping sweat with the raindrops, to film the final stages. In my headset I heard Ian Russell, the Director, wondering just where we'd been. It had been quite a thrash to get there.

Dave and Tim had made brilliant progress and were in danger of climbing into 'uncovered' ground where only one camera, from across the valley with its powerful lens filming through the obscuring weather, could actually get a shot. I pulled the handle on the abseil device and slithered over the skating rink upper sections of the cliff, now exposed to the full force of the elements.

Dave and Tim were on a real mission to make the top for the end of the broadcast. With the final pitch falling to Tim, I twisted

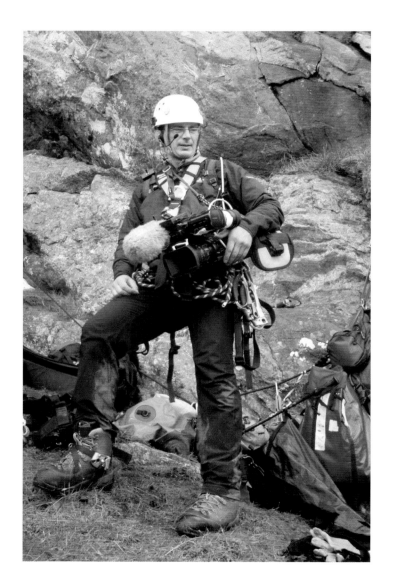

over my right hip to film as he climbed the lichen covered, rounded edges now running with water. His eyes were on stalks, his grin manic, but he never allowed his focus to drift as he traversed leftwards beneath my position and then crossed again to the right where Dominic was waiting to film him rounding the grassy ledges to the belay. In the dry Tim would have run up. In the wet the way was treacherous, a complex problem linking together the few sharp edges that were worthy of being called a 'hold'. No sooner were the ropes into the belay than Dave was on his way, his foot skating, almost forcing a fall, with Tim shouting down to hurry up until, with one minute to spare, he pulled over the top.

The whole production was an example of what the right team could achieve given an objective that would fire everyone's imaginations and, for that, Richard Else with the rest of Triple Echo Productions, and David Harron at BBC Scotland are responsible for having the gumption to stay with such a high-risk project. Filming 'live' has a truth, what you see is what you get, no tricks or clever editing. The 'Great Climb' had the essence of the best adventures, where the margins are so slight, that to succeed by the seat of the pants in good style brings the best rewards. Close to home is double-edged, for you do not have to go far to find challenges or run into trouble. In between lies a treasure of lessons, experiences and memories.

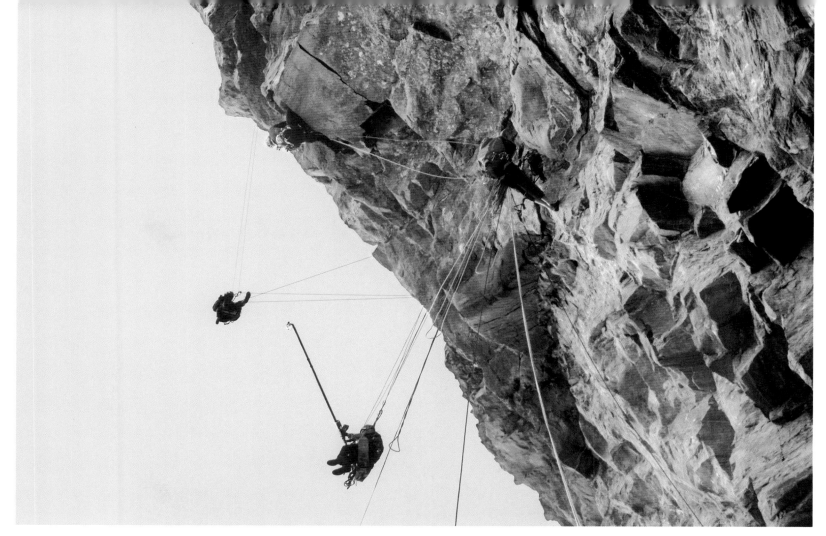

↑ 'Quidditch' with cameras instead of broomsticks. Dave and Tim climb their audacious new route. The Usual Suspects *E9 7a.*

→ The topping-out welcoming party, Rory Gregory and Cubby sum it up.

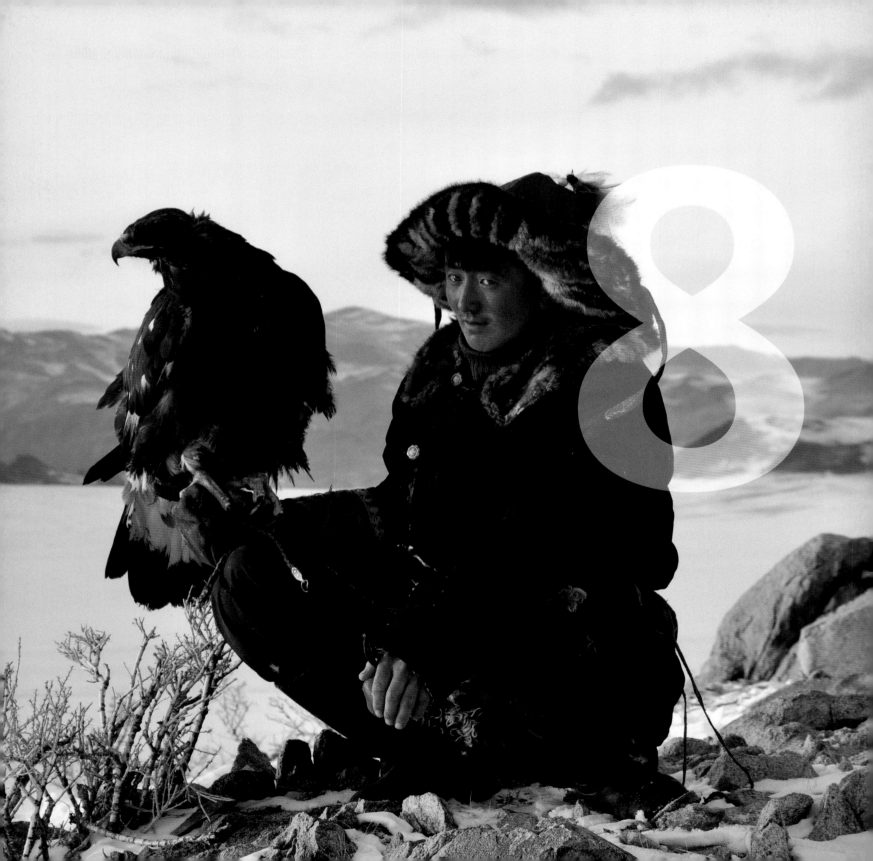

People
of the
World

Javier, dressed in a shredded wetsuit and plimsolls, looked out of the narrow zawn. From the ledge above a warning whistle came from his sidekick, Angel, who'd been keeping a watchful eye for rogue waves. Wrestling the camera, equivalent in weight to a dozen bags of sugar, I had no option but to brace myself and hang on for all I was worth, strapped into position by a series of front and back anchors plus ropes heading up the granite sea cliff. The wave shattered just in front of me and rolled along the cliff. I closed my eyes and held my breath, ready for a pounding. As my head emerged from the surf I looked to see if the coast was clear. Javier had scarpered up out of harm's way. A boat-swallowing hole opened in the water as the next curving, green-walled wave thrashed the coast of Galicia.

'Hey, Percebero!' Javier peered down with an ear to ear grin, gave the thumbs up and it seemed that I was now a member of their exclusive, if diminishing, club. Javier and Angel were two of the best gatherers of goose barnacles, or *percebes*, in this forgotten corner of Spain. Clinging to the rocks of the aerated surf zones these shellfish offer rich, if risky, pickings, reaching 200 Euros a kilo in the Madrid fish market. On average, five of these daring fishermen die every year, either swept out to sea or dashed against the rocks. I smiled up at my new Galician friends; funnily enough I was enjoying the experience. Javier again climbed down into the water, tied onto a length of frayed polypropylene rope. The next wave swept him through the alley in the rocks but then, as the water receded, he pendulumed back to harvest just a metre from the lens, chiselling at the strange molluscs with a sharpened steel bar, nervously glancing out to sea. He tucked small handfuls, accompanied by hair-like seaweed and tiny mussels, into the net basket at his waist until it was full. Then Angel took his turn, unroped. Time was of the

← *The storm thrashed coast of Galicia and its aerated surf. Perfect for percebes.*

→ *A delicacy – goose barnacles or percebes. Rich if risky pickings.*

↙ *Javier and Angel wait for low tide when their quarry becomes accessible.*

essence since these creatures were only exposed an hour either side of low tide. Moving faster between waves meant he could go further and pick out the larger, more difficult to reach, specimens.

This was where climbing met rope access, met white water and surf. The clothing and equipment of wetsuit, kneepads, helmet, harness and 'personal floatation device', while never comfortable, were comforting and made immersion in the cold Atlantic an almost masochistic pleasure. It felt good to cope with the tide of new experiences, as with the steep learning curves of early ventures, even if, on this occasion, I was submerged in the process.

Shooting this story and others for the BBC's *Human Planet* series proved to be a humbling experience. With many mountains climbed and filmed, opportunities arrived in the guise of accidental adventurers, people eking a living out of extreme environments. The requirement for basic needs, such as sustenance and shelter, gave rise to many of the stories. Whether for profit, as with Javier and Angel, or for subsistence, the search for food often required a resourceful and cunning approach, especially if it was scarce or difficult to reach.

In the remote rain-forested mountains of Papua New Guinea, meat is hard to come by, but one source is the fruit bat, or flying fox, which roosts during the day and feeds at night, travelling on wings that can have a span of 1.8 metres. A large male can feed a family when served with rice and vegetables. To trap them means carving the forest itself into a giant trap.

Guided by Marcus, Andrew and George, we headed deep into the forests of the Prince Alexander coastal range. When happy with the location they dropped off the ridge crest and worked their way back up, swinging razor sharp machetes at dense vegetation and tree trunks as thick as a man's thigh. Puzzlingly, none of the trees

were felled. Once back on the crest Andrew chopped a wedge out of the downhill side of the largest tree until a splintering crack sent it crashing into the others that, in turn, toppled like dominoes to create an easy route to fruiting trees in the valley, a 'bat flight path'. Like all animals, the bats do not like to waste energy in search of food and will take any short-cut to save a few wing beats.

Andrew shimmied up trees on either side of the notch and strapped long sticks equipped with pulleys to the upper branches. On these a gigantic net, invisible to the bats, was hoisted, keeping it clear of any foliage, to enable a speedy drop after an unwitting bat had blindly flown in.

By the light of a gibbous moon, warmed by a flickering fire, we waited in silence, ears attuned to the jangle of the bat alarm – tin cans filled with seeds tied to the top of the net – until the harrowing squeals of a trapped bat galvanised the hunters into action. Marcus released the net and Andrew finished the animal off with a blow to the head from a heavy stick. He hung it from a roof beam and, through the night, our collection of bats grew. At day-break, two had their fur singed off in the embers, were put in a pot with a crush of leaves and boiled for a protein rich breakfast. Everything was devoured, including the leather from the wings, stripped clean off wire-thin spars by Marcus's blackened teeth and sucked through betel stained lips. It was an image with primeval shock and eyes-wide fascination. By the end of the meal, there was nothing left but a neat pile of bones lying on a broad leaf.

Collecting, catching or earning a living is something we all have to do and in our modern workplace, particularly in the West, there seems comparatively little to complain about. Most of us have it easy, but one of the stories filmed for the series gave an insight into an industry that nothing could have prepared us for. My schoolboy

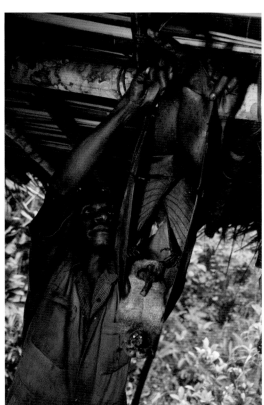

→ Wild forested lands
of Papua New Guinea.

↖ Protein is scarce and
the fruit bat or flying fox
provides a welcome addition
to a subsistence diet.

↑ Two bats boiled with
a crush of leaves provides
a hearty breakfast.

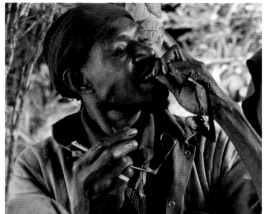

↑ Andrew devours the
leathery wings from spar
thin bones.

← We waited in silence
for the bat alarm, tin cans
full of seeds, to jangle.

interest and enthusiasm for volcanoes is undiminished. It's about being close up and personal with one of nature's most impressive forces, about feeling small. Inside an active Indonesian volcano was a workplace like no other.

Low down the rainforest was lush and complete but the higher we climbed up the outer slopes of the volcano the more the vegetation appeared scorched, leaves shrivelled, branches and trunks blackened. Cresting the crater rim we looked down on a procession of basket carrying miners making a zigzag descent by the light of flaming torches. It was an apocalyptic scene, denuded of all life by the caustic, dense clouds of hydrogen sulphide and sulphur dioxide that poured from the guts of the earth. The ash soils all around were cracked, riven into deep gullies by tropical rain, and on the surface lay a thin layer of green tinged powder dumped by the gas. There was a strange filtered light as if we'd found ourselves on an alien planet: blue, green, sometimes tabac. Deep within the crater the world's biggest acid lake, 2.5 million tonnes

of battery acid, lay dormant with a peculiar pall of smoke rising from its surface.

The men working by its shore rammed damp rags in their mouths, their only protection against gas which was often so dense they could not see their feet. Escaping over the rough terrain, while effectively blind, was a dangerous occupational hazard, so much so that they often stayed put until the gas cleared sufficiently, although the choking fumes often burnt their eyes and made them spew. It was a sight of labour from a pre-biblical time. Although our two miners were young they rasped like chain smokers forty years their senior.

Ijen Crater was the factory floor for Siluman and Hartomo who hacked a living from its yellow gold, pure sulphur that runs out of pipes forced into the volcano's fumeroles. As it cooled it solidified until it could be chiseled with a steel bar and placed in baskets. With loads weighing as much as 80kg the miners suffered sores and blisters and had strangely developed muscles at the back of their

necks where the yoke bore down. At the mining company's weigh station, halfway down the outer flanks of the volcano, they received $5 for their load. Often they would shuttle double sets of baskets; more income for their families.

For Nick Brown (Director), Dina Mufti (Researcher) and Patrick Murray (Technical Assistant) and me it was a shocking sight.

The entire area belched poison. Dina held an analyzer into the gas. It shrilled immediately and displayed toxicity levels of 40x the safe working limit. We felt guilty at our own fortune. Each of us had the benefit of a full face particulate gas mask, contrasting with the chewed rags of the miners.

On Day One the delicate tape-based cameras clogged almost instantly. Patrick and I walked for two hours back to our shack to perform open heart surgery on the recording mechanism, using a Leatherman, a cotton bud and an alcohol impregnated lens cleaning tissue. We managed to resuscitate the camera and sealed it with cling film covered with gaffer tape. The following day the camera went down again and so the path was laid. Every time the gas cloud threatened to smother us we rammed it into a heavy PVC dry bag, but we still needed to film the lives of the miners close-up and from within the gas. For this I took the smaller solid state 'making of' camera, which performed faultlessly until the last day when it too died. The environment was caustic beyond belief. Every connector and switch on the sound equipment turned green. My spectacle frames de-coated and the lenses clouded. The gas mask fogged in the steamy heat.

There was a sense of looking out for each other amongst the miners, in addition to looking over their own shoulders. They told us stories of times the lake exploded, raining acid. At the 'coal face', listening to the men choking before they began to wretch and

vomit, unable to move, with the gas pouring over in dense clouds for what seemed like an eternity, it felt like we'd entered the jaws of hell. Really, no one should have been there. Miraculously, Siluman and Hartomo collected enough sulphur for a load and began the brutal carry up the steep trails out of the volcano, away from the acrid stench into clean air.

The processing of the sulphur was a simple affair. In a rudimentary, slatted-wall barn, a vast fire roared beneath rectangular vats into which the chunks were tipped. Molten sulphur ran along open channels, where the impurities were skimmed off before the pure 'liquid gold' was allowed to flow into metal cauldrons. They were then emptied onto the smooth tiled floor. When cool the pure sulphur was pulled up in shattered panes like brittle toffee.

At the end of the shoot I added sugar to a coffee at Jakarta International Airport. Sugar that had probably been bleached in an industrial process that used sulphur. The cost was $5 – the price of an 80kg load of yellow gold.

The series offered glimpses into ways of life far removed from most of our western experiences and that was the appeal. From behind the lens it by no means felt voyeuristic, for all the stories were led by the protagonists. They were the experts in their environments and our reward was to be welcomed into their lives. After Ijen I pondered the differences in our societies, about our reliance on technology, the smart-phone, and questioned how far we had really come when such working conditions were considered acceptable. To Siluman, Hartomo and the rest, working in the volcano offered a better than average wage with which to feed and clothe their families. With that there was no argument, but surely there must be a better way. At the end of our time in Ijen our gas masks and spare filters went mysteriously missing.

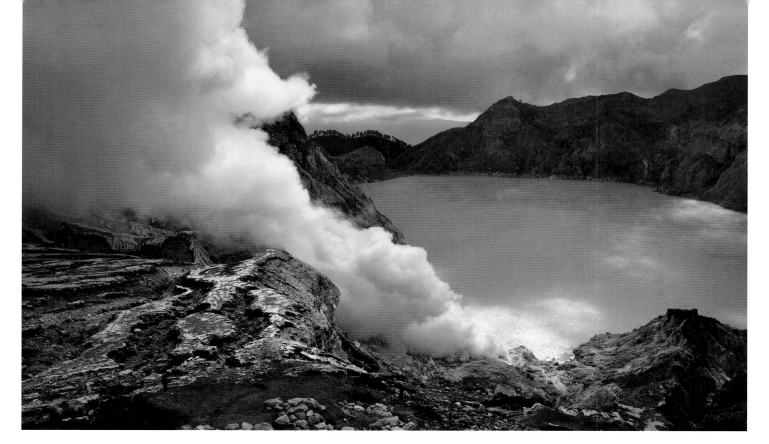

↖ In the far west of Java coffee plantations nestle amid the forested slopes of a string of active volcanoes.

↑ Ijen Crater belches poison and houses a vast lake of acid. One of the most toxic places on the planet.

↖ Liquid gold – pure sulphur runs out of pipes rammed into fumaroles.

→ Like the crumpled legs of a felled fighting machine from the War of the Worlds...

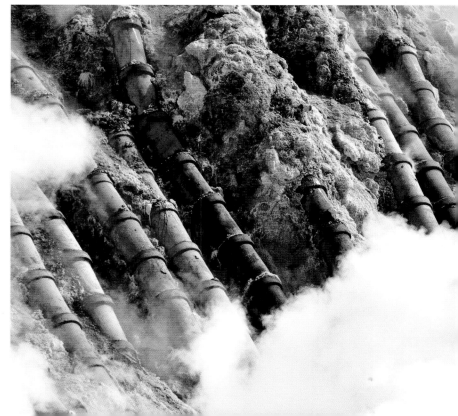

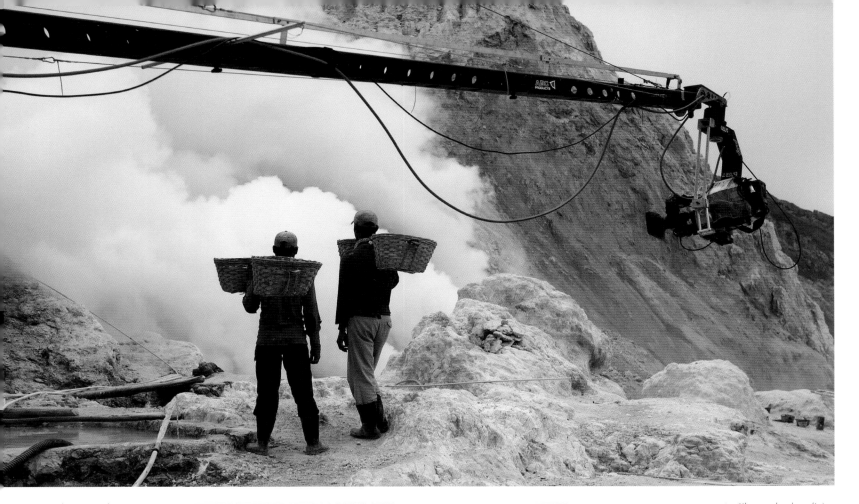

↑ Siluman and Hartomo wait for the gas to thin while we film set-up shots of our two miners.

→ The cameras were eaten alive by the gas.

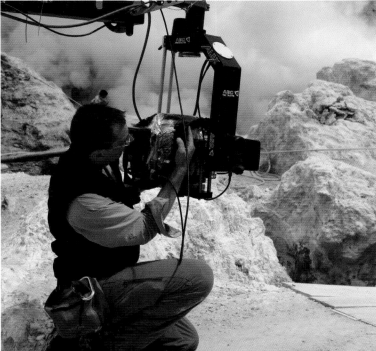

→ Siluman hacks a living before becoming engulfed by clouds of sulphur dioxide and hydrogen sulphide.

↗ Miners and the 'Jaws of Hell'.

→ A wooden yoke bears down on shoulders as the men carry their 80kg loads.

↘ Finally out of the acrid stench and into fresh air.

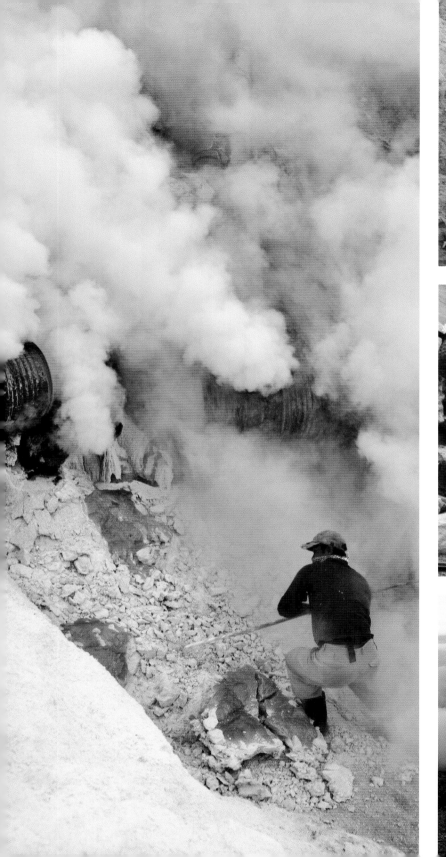
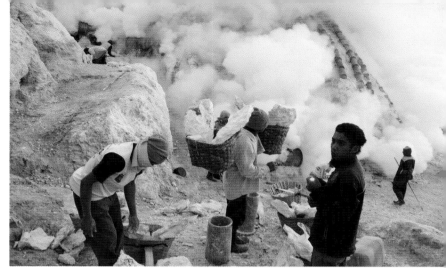
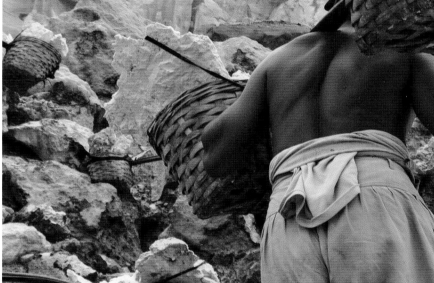
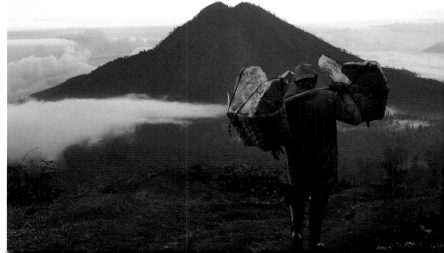

← We climbed down into the eyrie where two female golden eagle chicks had been left by their hunting mother.

In building working relationships, as with Javier and Angel, Marcus, Andrew and George, Siluman and Hartomo, trust was vital. Beyond that it was about developing friendships and respect for their values and traditions. Documenting their lives in an observational but cinematic style demanded a tricky balance in terms of controlling the shooting or letting everything flow freely, especially when filming traditions that had changed little over centuries. Our hosts in the west of Mongolia could not have been more welcoming, fun, and willing to let us witness the making of a man. When a boy and one of the world's most spectacular predators teamed up on a rite of passage, it soon became clear that little control was on offer anyway. This, in turn, increased the need to work really closely together.

In the Altai Mountains, Berik looked anxiously over his shoulder at the drop, his leather-soled riding boots searching for the next foothold as he climbed down a shattered cliff in the teeth of a chill wind. His father, Sailau, held him by a rope we'd brought rather than the normal length of plaited, dried horse intestine. Sailau looked concerned. These are Kazaks, and 16-year-old Berik was out to catch an eagle, his future hunting partner in a vast landscape where prey can see a rifle-toting horseman before he can even think about taking aim. He stepped gently into the eyrie where two chicks seemed more curious than alarmed. In a cloudless sky, above a distant ridge their mother soared, wing-tip feathers caressed by a strong updraft. We're certain we've been spotted but she cared not about our eagle rustling. Berik took a blanket from inside his jacket and carefully swaddled his chosen bird, the larger and more active of the two females, before climbing up to receive his father's approval. The eagle would be Berik's weapon of choice where rabbit, fox and even young wolves are no match for its vision, speed, power and surprise; the prey only becoming aware of attack as the shadow of the bird darkens over it. Berik and his eagle would be partners for many years before the bird would be released to breed and sustain the population.

At our camp Berik's bird, named Balopan, was fed strips of meat by her new parent. Throughout the summer and autumn training would continue and be rewarded with food, training which would entail her attacking a fox fur dragged behind a horse. We said our goodbyes and promised to meet again at the first snowfall of winter.

Six months later our Russian four-wheel-drive bounced across the rough track out of Ulgii. At the top of a narrow rock-strewn valley we saw the silhouette of a horseman dressed in a heavy coat: Sailau, resplendent in fox fur, waiting in the chill of the Mongolian winter, his horse snorting at the snow. He led us to the group of round tents, gers, pitched beside a frozen river, our base for the coming nine days when we hoped to film Berik make his first successful kill and become a man of the Altai.

One of the gers housed two tonnes of equipment that had been air-freighted to Ulan Bator and driven across country for days in a beaten-up truck. With the air at deep freeze temperatures the driver kept a fire going under the engine to prevent the fuel from becoming waxy overnight. In the ger we found all the toys: a five metre camera jib with hothead, the radio controlled cable dolly, six scaffold poles and clamps to erect two five metre high tripods for the cable, from which we could suspend and fly the camera across the rocks, tracking with Sailau and Berik as they charged through on their horses.

The first day we tried, like our Mongolian colleagues, to hunt on horseback. I am not tall by western standards, 5 ft 10 inches, but in

*16-year-old Berik was out to catch an eagle,
his future hunting partner...*

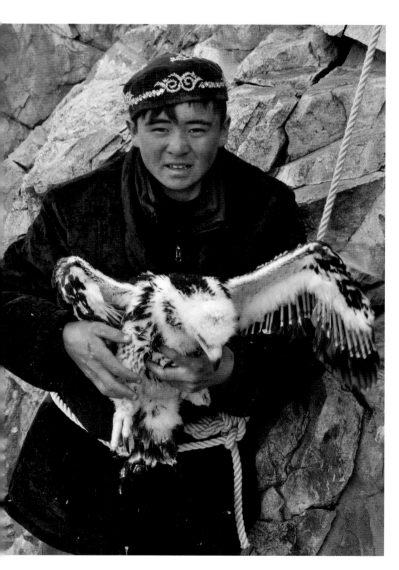

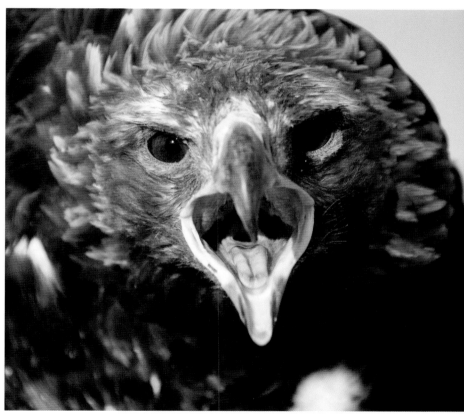

← *Berik takes the more
active bird. He hopes it will
make a man of him.*

↑ *No messing with
a fully grown golden eagle.*

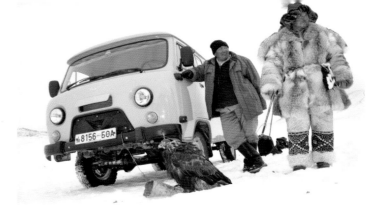

Mongolia I am almost a giant. On my diminutive but sturdy steed I must have been an amusing and disproportionate sight. Leaving camp my horse was doubly spooked: by the noise of its hooves on the creaking ice of the river, but more so because I'd never ridden so much as a donkey across Blackpool beach let alone a fine thoroughbred on a mountainside. In the end we moved through the gears to a trot. The camera kit was strapped onto other horses with Agii, the fixer, carrying the camera in its expedition sized rucksack. We soon found that securing the equipment took too long in the stop and start of hunting and filming.

Sailau and the others couldn't help but laugh as I stepped off, trying hard not to get my boot stuck in the stirrup to be dragged off like a comedy stunt from some cowboy film. He shouted to me through the dense minus 20 degree air, 'Keith, you are a good man except for your nose'. This organ being so much longer than the standard Mongol feature I would doubtless suffer frostbite at high speed on horseback. This banter suggested a degree of comfort with each other's company if not the means of transport. It was time for another strategy. We opted to stack the rucksacks of camera and sound kit into the rear of the 4 wheel-drive and, when the terrain became too steep or rocky, jump out and run to keep up with the hunt.

It was like trying to find a needle in a haystack but with the additional issue that the needle kept moving. No sooner had we arrived at the crest of a mountain ridge than Sailau and Berik would move off, certain that there was no prey to be had, while their fellow horsemen swept round the base of the next hill trying to flush out their quarry. By the third mountain range we'd been given the slip by the locals and, when this was repeated over several days, the pressure to deliver became overwhelming.

By the end of Day 5 we'd filmed nothing resembling a real hunt. We had however, succeeded in mounting a small camera on the back of Sailau's eagle. At the end of the summer we'd given him a dummy camera and a rudimentary harness with which to train his bird. Our first attempt with the real camera returned reasonable results but the contrast and intensity of the light had pushed its limits. Armed with a sharp knife I cut a neutral density filter to size and taped it into position. This improved the results slightly but we were keen to try a newer, slightly larger camera, capable of higher picture quality. We prayed that we wouldn't overload the plane, so to speak, but Sailau's eagle seemed totally unperturbed and the results were breath-taking. Some later argued that it detracted from the reality of the moment but, to my mind, the unusual point of view engaged the viewer at an all new level.

On Day 6 our luck changed. With Berik and Sailau on their horses on high ground, eagles poised, the sweepers' whoops signalled they'd found something. The game was on and the eagle's hood removed just as a fox understood the grave threat it was under and sprinted across the snow. With the calls he'd used every day in training, Berik lifted his right arm and with just five beats of her two metre wings, Balopan swept off in pursuit of her first kill. Sailau looked on nervously, hopeful that this was indeed Berik's moment.

With wings tucked hard against her body Balopan dived, unfolding at the last moment, slowing, crushing talons forward and open. The fox stopped, puffed up its fur, turned and snarled. Startled, Balopan veered to the left to put down on the snow and the fox, sensing its opportunity to escape, ran into the rocks. A dragged fur doesn't bite back; the first hunt had ended in failure.

↓ *The vast space of*
the Altai. Silau and Berik
hunting for foxes.

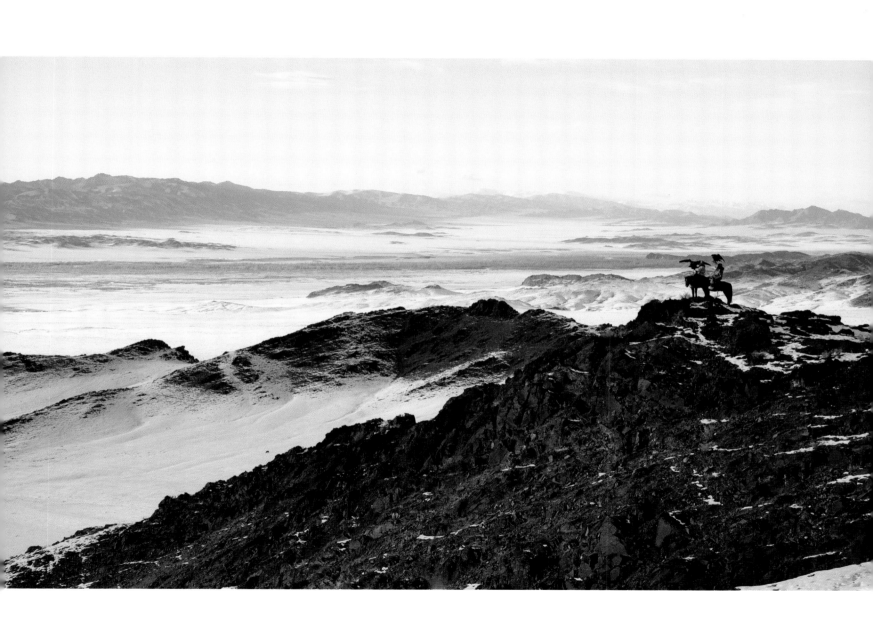

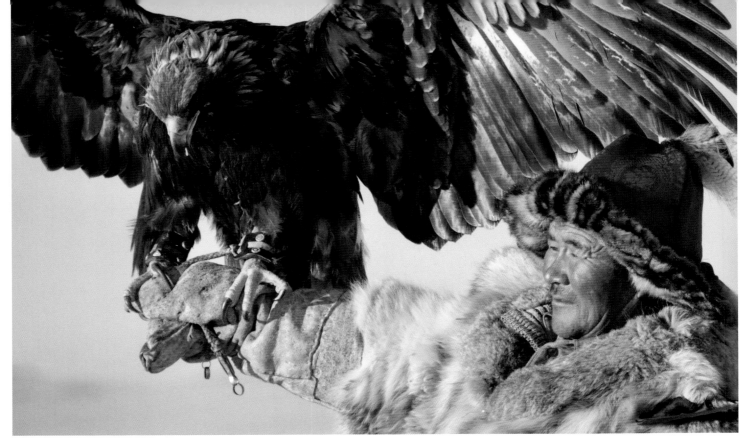

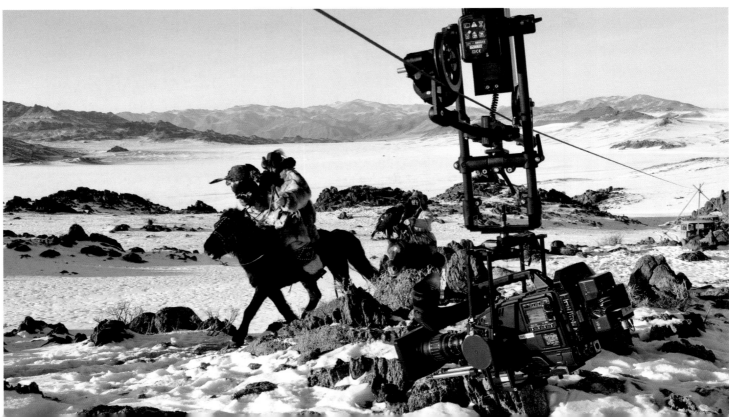

← *Massive wings*
and crushing talons.

↙ *A cable dolly suspended*
from scaffold-bar tripods
tracks through the rocks
with our two horsemen.

→ *Rivers of ice join*
and flow from the
Juneau Icefield, Alaska.

↓ *The striking silhouette*
of a natural born killer.

A fireball sun silhouetted father and son with their eagles flapping from their forearms as they rode out the following morning. Balopan surely wouldn't fail this time.

Once again the whoops carried across the snow covered mountains. Through the viewfinder I picked up the fox and moments later Balopan scythed through the corner of the frame. I had 'THE two-shot' – the all-important shot that puts both elements of the story together in context. A second camera, operated by Pete McCowan and hidden amongst rocks downstream from the sweepers, was equipped with a powerful zoom lens. It captured the moment when Balopan sunk her talon into the fox's thick fur at the haunch, but the fox wasn't going to give up without a fight. Balopan's other talon was too slow to muzzle the jaw, the fox landed a bite on her leg and the two beasts became locked in a violent tussle. Sailau kicked his horse into action, shortly followed by Berik, and they barrelled down the mountainside towards Balopan before she sustained serious injury.

On the ground Sailau finished the fox off as quickly as possible and, as Kazakh tradition dictates, opened it up to feed the lungs to Balopan. Its thick pelt would be used to make winter clothing and, in particular, the eagle hunter's hat that Berik could wear with honour, symbol of a successful hunter. Sailau beamed as much as Berik, who'd certainly earned his wings.

At the celebratory banquet we downed the last of the mildly intoxicating mare's milk, moving via beer onto vodka as a boiled sheep's head arrived on a platter. Its eye sockets stared blankly at the ceiling of the main room in Sailau's winter house as I carved the lips, took the first morsel and passed the rest round. The texture was slightly rubbery, the taste charred and bitter. As I tried to keep everything down Sailau stood and proposed the first toast

accompanied by more shots of Genghis vodka, downed in one. I tried to reply but my brain was no longer connected to my mouth. Agii tried to translate but collapsed in snorting laughter and the party descended into a drunken evening of endless toasts, song and dance.

It was a privilege to be welcomed into their lives, to witness such commitment to tradition, a rite of passage and such a proud moment between father and son.

177

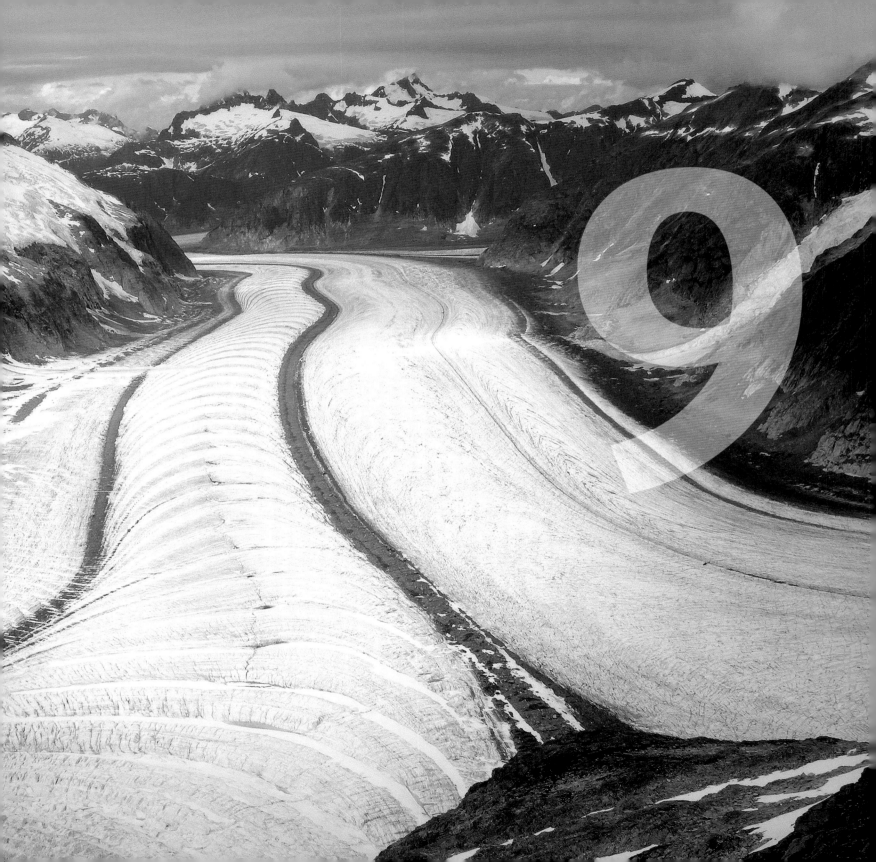

Cold
Climes

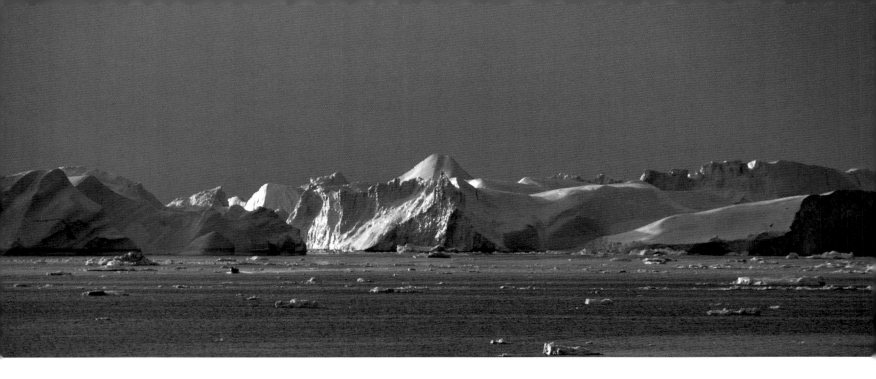

Off the coast of West Greenland, giant icebergs floated in a velvet sea and the lights of Ilulissat sparkled against the coming Arctic night. Through the door of the helicopter I watched car headlights below, sweeping along snow-covered roads, clouds of spindrift billowing behind.

Turbulence buffeted the camera as the rotors thwacked through the dense air. My fingertips were numb and my eyes beginning to stream cold tears into the viewfinder. In contrast to this modern city of 3,500 people we'd filmed Nils from the air as he drove his dog sled across the mountains towards his fishing camp. Dressed in a fox fur rimmed anorak and polar bear trousers he looked as timeless as the landscape, a man who had embraced both the modern and the traditional. He hunted seal, fished ice holes for halibut and drove taxis part time in town. What's more, he had a 'potting shed' to die for, festooned with bits of sledge and dog harness, crampons and a fish propped against a giant blue plastic barrel. This was the final shoot for the *Human Planet* series.

Through the push to explore for oil and with established self-governance changes are afoot in Greenland. Amidst this, climate change is altering the Arctic. Where there was sea-ice years ago, now there is none. Further north, where sea-ice does still form the periods when it is too rotten to travel on and too broken to sail through are becoming longer. As a result, windows for hunting and fishing are shorter. Word is that, off the West and East coasts there are greater oil deposits than in the entire North Sea. Black gold will bring boom times and lots of money to Greenland, more money than hunting or fishing, trampling traditional occupations under the march of progress.

The previous day Nils and two of his hunter friends, Emile and Anders, had taken us by dog-sledge over the 600 metre climb to their fishing-camp on the ice of a distant fjord. He'd talked with fond passion about his tent, a double canvas-skinned, box shaped affair that was pegged firmly against the katabatic winds barrelling off the icecap. A few metres beyond its door was a jutting berg of blue glacier ice and, out on the flat sea ice, four winch-lines on metal frames. Thick nylon twine disappeared through holes in the ice and winding the handles might haul up a catch of halibut or a Greenland shark. The journey usually took Nils two hours, but with a layer of deep snow and a load of camera equipment it had taken us five.

Clouds of powder kicked up on the descents and often we would swerve off the track, leaving the dogs to whine and yelp at the crack of the whip as they hauled the sleds back out. We would help by pushing, shoving and wading before jumping onto the caribou

← *Icebergs like mountain ranges are grounded at the head of a fjord.*

→ *Winter in Illulissat, West Greenland.*

hides laid on top of the wooden slats. On really steep sections the dog lines would be run under the sled between the runners so that a dozen canine bodies could act as a kind of drag-braking system. On less steep downhill terrain the dogs ran as fast as they could and hoped that the heavy wooden sled wouldn't mow them down. Only once did one get caught under the runners. Holding up its lame back leg up it ran on three for a while.

Nils was obviously concerned about the time. The winter sun was already low in the sky as we shot a simple sequence of melting snow. The old brass Primus stove soon sent a cloud of steam out of the tent door. He grabbed the pot grips and walked outside to throw the pan of boiling water into the air. In the freezing Arctic fresh water is a precious commodity but, at temperatures below minus 32°C, hot water instantly turns to snow and it was this phenomenon that we wanted to film. As Nils swung the pot forward an arc of snow and frozen vapour was blown away as a fine white powder by the wind. Just a few drops splattered onto the ground.

We left the fishing camp at 4.30 pm. Through the bergs and away from the broken ice that marked the tide line, our inward tracks had frozen so the trail proved easier. From the start of the return climb Emile, my driver, and I came off the sled, building up heat by giving the dogs a helping hand, putting our body weight behind the sled. Panting, I pulled down the balaclava that was covering my mouth and nose and ripped the velcro off my down jacket's hood to let air in. I thought I was going to suffocate. Every so often we would stop to unravel the knotted trace lines but after four hours we crested the hill to see a thin strip of orange sky between a serrated line of peaks and a dark band of cloud. The Arctic dusk rolled over us faster than we could run.

I was mesmerized by the constant creaking of the runners and the hiss of snow as the dogs clawed onwards. There were no shouted commands, they sensed home and supper and were drawn through the dark by their acute sense of smell. Then, with eyes accustomed to the night I discerned a strange light, a steel blue shaft shone across the snow. An invisible full moon was rising, its light piercing just one tiny hole in the cloud. When it closed the night's cloak finally smothered us.

Emile leapt off and grabbed the back of the sled as we started down a steeper section. Twice we took to the air as we ricocheted across the ground. Some of the dogs yelped and came dangerously close to going under the runners. We turned on our head torches which, at speed and with a limited beam, showed why we'd left

the ground, but didn't give enough warning to slow down, even if that were possible while flying down 600 metres of mountainside. Eventually, as the lights of Ilulissat came into view, we failed to make the sharp left turn and piled into a wind-scoop around the base of a granite rock wall. It was just as well. I knew what was coming and remembered the sweat and toil of the first section through the rounded rocky slabs just out of town, the steepest section of the whole route, a line that would be impossible to descend in the dark.

Emile hauled the sled out and lined the dogs up at the back. Immediately it felt all out-of-control. Sparks flew off the runners as they slid over rock not snow and the dogs howled as we tore down the hill. We hit a boulder that almost flipped us and veered left into a deep drift. The dogs ended up in a pile of tangled legs, submerged and knotted in their trace lines. We pulled ourselves out, sorted the mess and moved out of the way of the other sleds to wait. The glowing street lights tinged the town with an eerie green.

Having spent their lives traveling across the mountains and sea hunters like Nils, Emile and Anders have developed a sixth sense. Aware of the interaction of light and wind with the ice and the quality of the snow, the surface seems to speak to them and they listen. Not far from Illulissat is the 'Dead Glacier'. Previously used as a route to other fjords it is now so cut up and riven with crevasses there is nowhere on which to land a helicopter let alone drive a dog team. Negotiating such terrain is precarious in the most complex, shifting maze imaginable. Out to sea, travel is equally unpredictable. Full thickness cracks in the ice create 'over water', deep pools or, after snowfall, thick layers of salty slush. It's the Arctic equivalent of moorland bog in which sleds or snowmobiles can get stuck, but the worst case is when a simple change in wind direction or speed breaks up the sea-ice with frightening speed.

As winter progresses into spring, the melt kicks in and the glaciers run with torrents, small rivulets amassing into great surges. Where these rivers happen upon weakness, a crack or crevasse, the sheer volume cascading off the ice 'drills' a cave system. These moulins transport the water to the bedrock where debated theory is that the ice then 'floats' and is accelerated on its downhill course to melt into the ocean.

The greatest ice mass outside of the 66 degree Arctic latitude is the Juneau Icefield in Alaska. At 3900 square kilometres and up to 1400m thick it is shrinking fast with concerns that a modest rise in annual temperatures could cause a catastrophic melt-down.

Working once again with Indus Films we found ourselves on the Mendenhall Glacier, only 20 kilometres from downtown Juneau, Steve Backshall and I peered over the edge of a moulin the size of a small church. They are highly dynamic places with high flows of near freezing water pummelling ancient, bullet-hard ice that can shift without notice. We were wearing full dry-suits over several layers of insulation, thick neoprene gloves and ice climbing boots onto which were strapped our sharpest crampons. The hairs on the back of my neck tingled as my eyes followed the tumbling water into the blue depths. Exploring these moulins felt like a grand order trespass into the behemoth's lair.

My orange ropes dropped 25 metres before reaching the waterfall pool that marked the entrance. Daring a look downwards as I abseiled I saw the tails of the ropes being flicked and mashed by the turbulent water, twisting them into a great knot. The water's impact with the ice sounded like a freight train and made communication almost impossible where shouting in close proximity was the only option. Steve made his way down the opposite wall, carefully inching the rope through his abseil device. A slip would

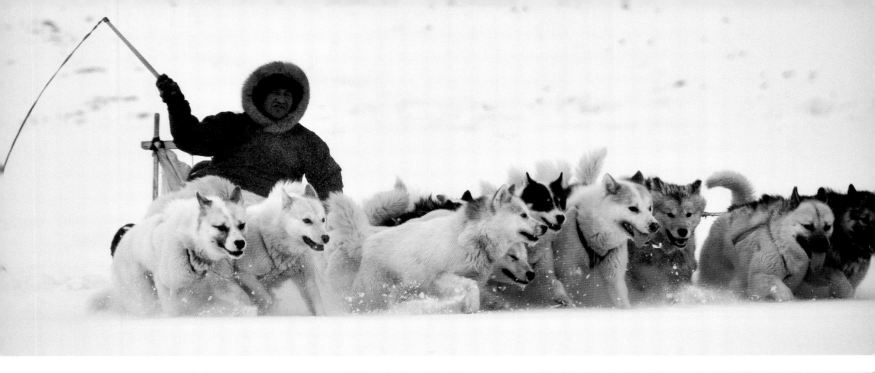

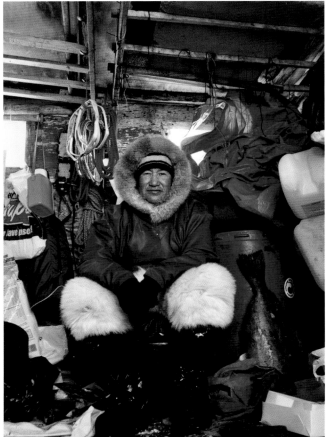

← Polar bear trousers and a fish by his side. Nils in his 'potting shed to die for.'

↑ Splashes of pink.

→ Meltwater bores a cave system into bullet hard glacier ice to form a moulin.

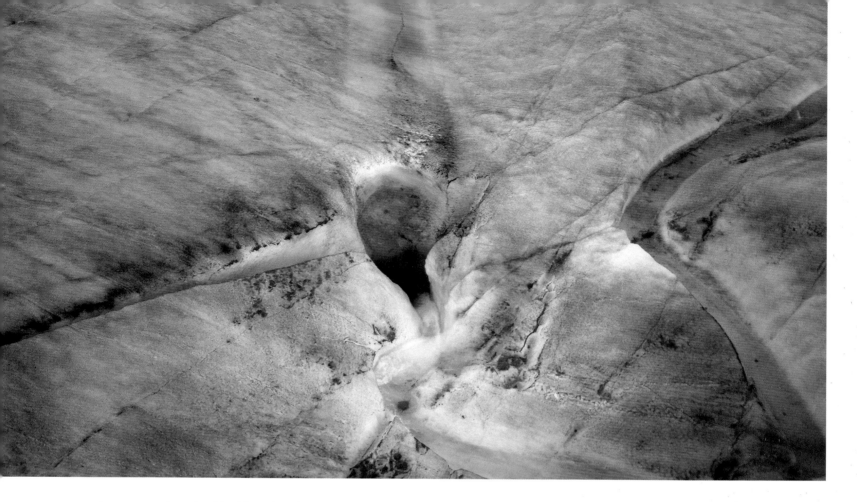

have meant the ride of his life and, without being melodramatic, possibly its end. There could be absolutely no mistakes.

Looking around our new found, deep blue world I felt nervous. It took me back to the Mageni River Cave in Papua New Guinea although the ice was so much less permanent, moving up to a metre a day with moulins opening up and closing down. These places were uncaring and unpredictable. I placed an additional ice screw as a directional anchor for my ropes and unravelled the ends to continue my journey with Steve into the moulin's narrow throat. Our crampons barely nicked the surface, providing little security on ice with the hardness of concrete. The volume of water tugged at our legs as the passageway curved and dropped in a beautiful meander of sculpted cobalt. Nothing inspired confidence, but something drew us on against all common sense.

Steve moved down a steepening slope to the edge of another waterfall that thundered into the depths. I felt we'd gone far enough, sensing that a journey down the next narrow tube would leave us too exposed and overcommitted. Shouting that we should think about getting out I wondered what I would do if Steve insisted on moving further into the guts of the glacier. I felt the short circuit to all reasonable and unreasonable argument had been thrown and we should listen to that deep gut feeling. Steve's hands were numb and despite the dry suit he was soaked, frozen to the core. Thankfully he agreed and we began to move back towards the light.

As I filmed, he called for a bit of slack and, without warning, as if his rope had flicked round some obstacle higher up, large amounts of slack arrived at once and he lost balance. His feet pinged out of the ice and he was flushed away, bouncing off the side walls and

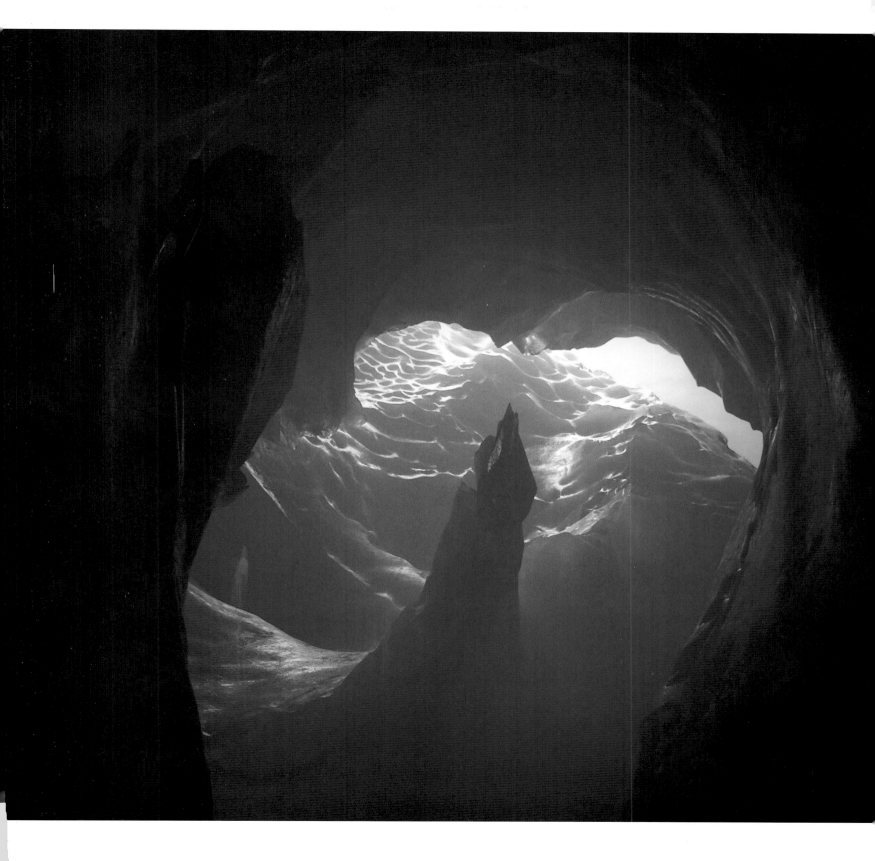

out of sight. I dropped the camera onto its leash but left it running, ready to embark on a solo rescue, working fast. If Steve had been knocked unconscious and was hanging beneath the waterfall he would certainly drown. I'd released my ropes and was ready to descend once more when he reappeared. I breathed a heavy sigh of relief when, in a slight yodelling voice, he asked if I'd got it all on film. He'd missed the drop into the falls by less than a metre. Now, all we had to do was extricate ourselves against the flow of the main waterfall. I filmed, hanging horizontally, as Steve jugged up the ropes, water hammering over his body and into the lens. Finally we hauled onto the surface into the refuge of a sunlit day.

There is a pristine quality to these cold climes with their powerful structures, austere clarity, subtle hues of light and clean textures. Their sparse habitation and wide expanses give a feeling of unfaltering remoteness. Alaska, Baffin Island, Greenland have an almost mythical atmosphere, evoking the romance of exploration, still with almost limitless possibilities. Here you can ski off the map to a place bereft of official names, where virgin summits gleam like lighthouses across a distant horizon. Flying over these vast expanses of mountain range and glacier or standing on a summit with a 360-degree panorama is an awesome experience I'm sure we would all want.

When ex-England and Arsenal footballer Ian Wright was asked where in the world he would like to go he replied: 'The Arctic'. A plan was hatched by Princess Productions, Tangent Expeditions and myself for him to attempt the highest peak, Gunnbjorns Fjeld (3700m) in the Watkins Mountains in Greenland's Eastern ranges. It's not a particularly technical climb, but being dumped by ski plane some 40 km away from its base camp and having to haul all the food and equipment on pulks, we hoped it would be challenging enough.

Ian was so immensely strong and fit I was concerned about

keeping up. The deal was that, as a film team running in parallel, we were not to have any impact on his expedition. It was to be a true fly-on-the-wall affair. I would film all day on skis, or when climbing, and Richard Harrison, the Director, would take over at camp. To add a little spice I'd opted, once again, to use a brand new model of camera, untried in such arduous conditions. It offered reasonable picture quality (for 2005) and was relatively light. That said, with a backpack loaded with three radio microphones, a small sound mixer, the camera with spare tapes and batteries and a tripod on top of my normal glacier travel kit, it was going to be a 'big haul'.

Compounding this was the idea that I never wanted to see my own tracks. I therefore had to ski in big loops, travelling both further and faster. As his companion, Ian had brought along Novello Noades, wife of Ron Noades, the Chairman of Crystal Palace Football Club, Ian's first professional club where he'd been taken under Novello's mothering wing. They'd become the best of friends.

Once the pilot had revved the propellers of the Twin Otter to screaming pitch he released the brakes and the plane bounced over the surface of the glacier until it finally bounced so high it became airborne. A few seconds later it shrank over the mountains and a snow-muffled peace settled over us, abandoned to our own devices at the edge of nowhere.

There was much to sort and pack into the pulks for our journey across the glaciers and the gradual ascent to Base Camp. Ian and Novello were assisted by guide Nigel Edwards with an additional guide, Robin Beadle, who sorted food rations and split loads for Director Richard Harrison and me.

'Come on Nigel. Let's go!' Ian shouldered hard into his harness, barely shifting the two metre long fibreglass sledge. Novello tried the same but nothing happened and any bravado evaporated. The pulk sat

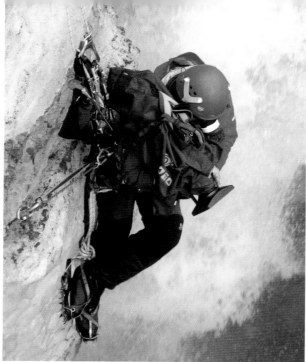

← *Being tethered to a dozen ice-screws allows for a relaxed attitude to filming.*

↓ *Steve swings the sharpened steel of his tools into the ice under a cacophonous cascade of water.*

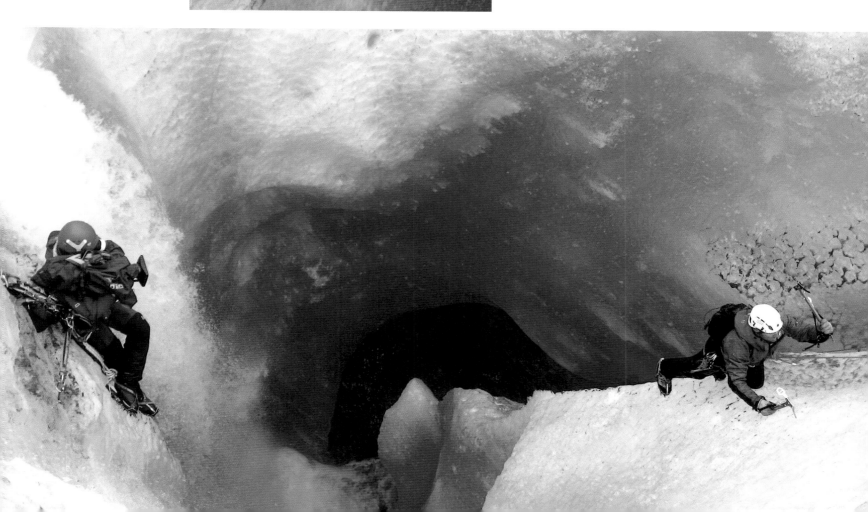

I was there to capture whatever happened – warts and all.

defiant and stubborn on the sun-softened snow. On the third attempt it started to slide and Novello, using what little mass she possessed to overcome the dead weight, followed in the tracks of Nigel and Ian.

Travelling through East Greenland's vast glaciated valleys you witness an incomprehensibly slow pace of change in the views of the side valleys and across the horizontally banded mountains that protrude through the ice sheets. The intensity of the sun is exacerbated by the clarity of the air and reflection off the snow turns the terrain into a blast furnace during the day and a freezer at night. Ian wondered just what he'd got himself into. Old injuries came back to haunt and the war of attrition began.

A pattern developed. Spirits were high for the first two hours of each day, then it was like a plane running out of fuel as Ian's energy level crashed. It took a while for the penny to drop. He was incredibly fit, but his training was geared to the match and extra time. I also knew that, unless he regularly topped up with food, natural glycogen levels would dive and he'd effectively hit the 'wall'. After the first couple of days I realised that I could afford to take my foot off the gas. I wasn't sure things were much easier for me, but I was used to long mountain days, maintaining pace for 12-15 hours. I had also skied and dragged sledges around these environments on three previous expeditions, so I knew what to expect and my techniques were honed to some degree. For Ian and Novello, each step was a step into the unknown where lack of familiarity bred doubt and the never-ending trail perpetuated the negative.

By Day 3 we'd begun the slow uphill grind into the valley leading towards Gunnbjorns Fjeld. I suppose I'd inadvertently been nibbling at Ian's psyche. The zip, zip noise of the skins on the underside of my skis, a suede-like layer with a pile direction that allowed the ski to move forward but prevented it from sliding back, ate away at

him. Oh, here comes Keith with the camera, keep pace, easy for you with no pulk as I'm here hurting. Oh yeah, there he goes, overtaking us again, skiing in massive loops.

I had to be close in moments of pain and anguish, exactly when Ian and Novello's souls were revealed. Everyone was wired with radio microphones so, even at fifty metres, I could hear everything clear as a bell. If I sensed from Ian and Novello's breathing or from their wasted mutterings that they were at the end of their tethers I would move in, as Ian probably saw it, for the kill. To me their supreme efforts were obvious and very impressive but I was there to capture whatever happened – warts and all. What they never realised was that I was hurting too.

By early afternoon I held the camera facing backwards, tracking forwards with the lens just a couple of taunting metres from Ian's face. He exploded with a verbal tirade of four-letter words and pulled up. He released himself from the harness and limped on his skis to sit on the pulk to calm down, rest, eat and drink, confessing that he would 'never forget the pain'. His ankle was blistered and swollen, his knee ballooning. By this time Novello had nothing left in her legs. It was the hardest thing they had ever done but, unbeknown to both, things were about to get harder yet.

Base Camp sits a full 1000 metres vertically below the summit. We set off into the notional night, leaving the tents at 9.00 pm, with the moon rising into a clear sky and temperatures plunging. The snow had firmed enough for a fast skin to the shoulder and for seven hours I was at my limit, still having to ski to overtake, letting Nigel, Ian and Novello come past before chasing them again. They carried just a small amount of food and fluids but I was still heavily laden with the camera equipment. Robin sensed I was flagging and offered to carry the tripod and while my heartrate remained

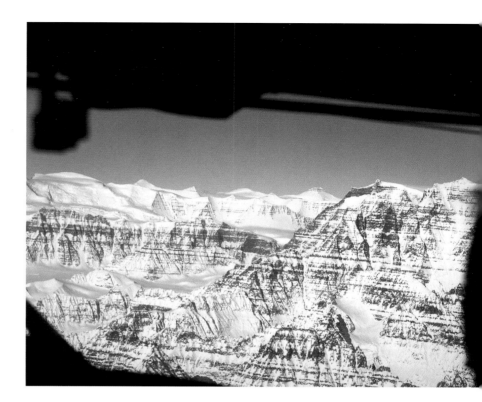

sky high at least my legs no longer felt like they were being totally destroyed. We skied as fast as we could, filming the three silhouetted figures in a mass of ice cliffs, crevasses and serrated ridges, all burnt orange by the lowering sun. Ian sang Motown, trying to remember the last time he had a shower and thinking back to his glory days.

For Ian there is nothing better than scoring the winning goal, but on Gunnbjorns Fjeld he was in danger of facing defeat. As we crested the shoulder he removed his skis and threw them into the rocks before crashing down next to Novello, both of them wiping tears from behind dark glasses before admitting to Nigel that it was 'So bloody hard. Too hard, Nigel'. Ian had spent most of his life winning, but it was losing that stayed with him, hitting the post at the critical moment, letting the team down. He knew that now was the time to dig up that little bit extra, and the final four hours along the summit ridge disappeared in a verbalised mental struggle with words like, stupid, ridiculous, madness... sobs and confession. He had never felt such complete exhaustion in his life.

After the final steep pitch with nerve jangling drops to left and right, the slope eased and Nigel, unwavering in his determination to see Ian and Novello on the summit, paused. He could hear 'the fat lady clearing her throat' and with that looked towards the top, now within their grasp, and allowed our two unexpected mountaineers to take the lead. Ian grabbed Novello under the arm and helped her up the final snowy bulge, scarcely believing they'd made it. Behind was an infinite sea of summits with no sign of human intervention, unsullied Arctic wilderness in every direction that was the worthy reward for their effort. They crashed helmets as they hugged and then both lay down on the snow, utterly spent. In my mind we were only halfway

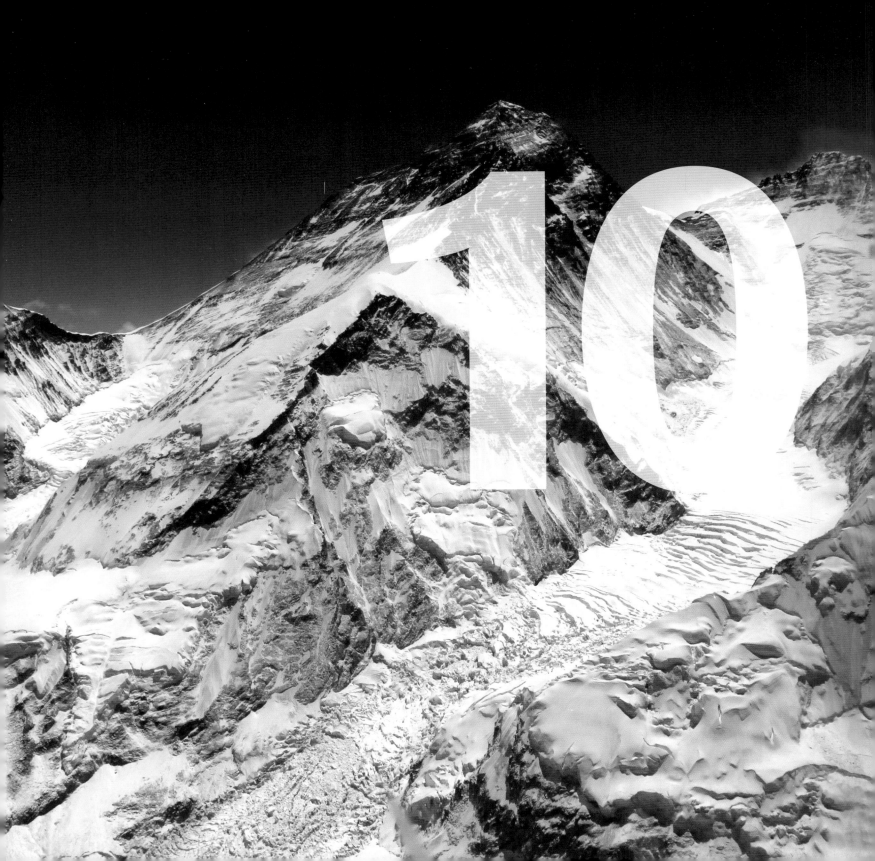

To the Roof
of
the World

Ten years after my first freelance job on the trip to Nanga Parbat with Richard Else and Jim Curran, I was heading back to Northern Pakistan. Producer Mick Conefrey asked me to shoot for another episode in his BBC series *Mountain Men*, examining the events leading up to the first ascents of three of the world's iconic peaks: K2, Mount McKinley, and the Matterhorn. With us again was mountain guide, safety expert and by now great friend, Brian Hall.

Just over one hundred miles East North East from Nanga Parbat lies the Karakorum Range where, set amongst some of the most dramatic and rugged mountain scenery in the world lies K2. Often described as the mountaineer's mountain, additional, more descriptive names have been spurned, the Killer Mountain and others that give an impression of its ability to extinguish life without thinking. Technically more difficult than Everest it has claimed many mountaineers with the tragic events of 1986 in particular sending shockwaves that reverberated through the mountaineering community for decades. That year thirteen mountaineers lost their lives, including one of the world's elite, Alan Rouse. Brian had met Al at his first year at University and climbed with him for seventeen years all over the world. Brian recalled that 'he was my best mate during that period both socially and in mountaineering. We shared houses and bivis and together went on expeditions to the greater ranges six times'.

Having made the first British ascent of K2 Alan, trapped in a terrible storm, was left in a tent above the Shoulder at over 8000m, too delirious and weak to descend. The exact details of his death will never be known.

At Concordia, the meeting of the Baltoro and Godwin-Austin glaciers, no one had seen K2 for two weeks. Undeterred, we took the camera and tripod to the top of a slight rise and sat on a boulder in the hope that something might lift the stubborn grey blanket of cloud. Mick was pouring tea from a rather leaky floral patterned flask when there was a slight shift in the uniformity of light and, suddenly the whole scene cleared to reveal the iconic pyramid of the world's second highest peak.

Between us and K2 Base Camp lay one more day of ankle-twisting, grapefruit sized, rounded boulders and heart-stopping leaps over meltwater streams. The first flowed fast and deep over rock-hard ice, disappearing through a cracked arching tunnel to our left into the bowels of the Baltoro Glacier. One slip and we would have been swept into a very certain and short future.

Wandering through the small tented village of Base Camp Brian met Polish climber Voytek Kurtyka who announced that he'd found the body of Al Rouse and had buried it the day before. He was willing to exhume it for identification. A Berghaus rucksack that had also been found suggested that the body was, indeed, Alan's but, on inspection of its contents, Brian found a box of matches dated after his death. For Brian it was good news but the mountain's atmosphere remained oppressive.

A short way from our tents we climbed a small rise to the eerie Gilkey Memorial. While Art Gilkey had been the first to be commemorated here, from that fateful 1953 expedition that Charles Houston had discussed on the trip to Nanga Parbat, the rocky cairn has since been covered in metal dinner plates, each carrying an inscription to someone who has perished on the mountain. It was a chill, sombre place, dark and brooding under the swirling clouds of another grey day, and a powerful reminder that, while the mountains give so much joy, they can also take away in the most brutal way imaginable. Sometimes even the best are no match for the power of such places. Brian stared pensively into the distance,

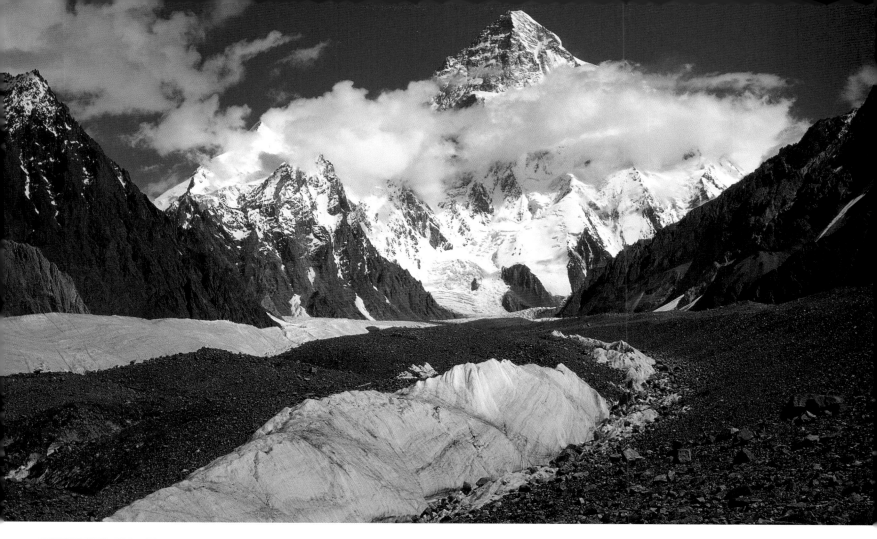

↑ Nobody had seen K2 for two weeks. Within a matter of minutes the clouds parted

← Metal plates inscribed with names of the dead clank in the wind. The Gilkey Memorial, K2.

← *Show me the way.*

familiar with some of the names: Nick Estcourt, Alison Hargreaves. We didn't talk much.

After filming I was glad to escape back to the tents to prepare for the following day and our walk to the base of the Abruzzi Ridge, the start of the classic summit route.

Brian, Mick and I roped up and puffed up the glacier through a series of penitentes, stunted by the intense sun. It was blindingly bright and still. Scale is the most difficult thing to convey in the Greater Ranges and here the foreshortening effect was intense, particularly in the crystal high-altitude air. Where nothing looks very far exactly the opposite is true.

The summit of K2, also referred to as the 'Savage Mountain' was still over 3,300 metres above and around us were some of the greatest peaks on earth, all with echoes of tragedy and legends of mountaineering. At the original Camp 1, at the foot of the Abruzzi, we spent time shooting the route the early pioneers took attempting the summit. In the distance we saw a dark shape on the ice, realising as we approached that it was a human ribcage, torn and desiccated. This gruesome find added to the sinister atmosphere. Brian couldn't wait to leave. Mountaineering was his passion, but it was about fun and friendship and the past few days had been a reminder of bitter events and memories that had been locked away for years. To him it felt more like waging war, and he never wanted to return to K2 again.

Passing, on the way out, one of the campsites we'd enjoyed on the way in, we found it now lay under tons of mud and rubble from a landslide, and had to take several leaps between large boulders to cross a swollen tributary. At the bottom of a series of boulder steps, white letters spelled out 'wish you good luck' in English. This section of the trail consisted of loose, flimsy looking logs resting between rocky ledges and overlain with occasional stone slabs; something to stand on above the seething, silt-laden Braldu River. This section was not lengthy, but felt highly precarious and once again nerves were guitar-string taut. By late afternoon the clouds swirled and built into vast hammerheads, bruised and black. Thunder cracked and boomed around our heads, echoing off the huge mountain walls, demonstrating its power.

On the final day before reaching Skardu the jeep driver stopped. Ahead the ground was moving, boulders and mud flowed off the mountainside and spilled into the gorge. We watched incredulously, waiting until the driver instructed us to get out of the jeep. I grabbed the peli box with the rushes inside and watched as he revved the engine, crunched the gears and set off, aiming the jeep well uphill and away from the edge, allowing the flow of the mud to 'ferry glide' the jeep to the other side. 'Ballsy' driving indeed. Once clear he halted and beckoned to us frantically. Glancing uphill to see if anything 'big' was coming we ran through the debris.

Further on we rounded a corner to find that the road had collapsed into the gorge, the only option was up. The porters strapped the kit to their backs and we climbed a loose, tottering gully. As more porters arrived at the top, their eyes on stalks, so more outstretched hands grabbed at those still clawing upwards.

On the next section we came across another pair of dilapidated jeeps and a single Pakistani road worker leaning on his shovel. We drove on.

The outskirts of Skardu came in sight at the end of the rough track. My spine felt like it had been compressed by a pile driver and my knees were in knots. Brian and I had been squashed onto the front seat holding anything we could find that was solid. With no clutch the driver repeatedly crashed the gears. Stopping wasn't

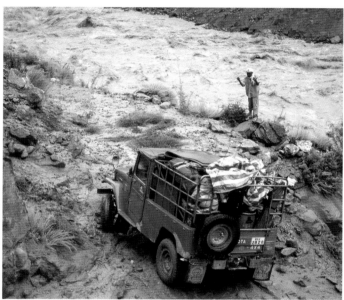

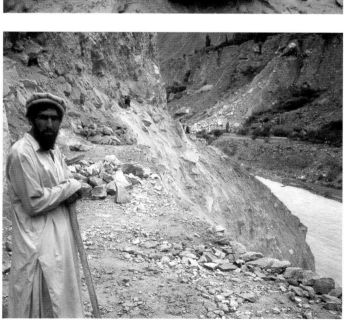

→ Eyes on stalks and hands to grab. We climb steep rubble to bypass the next landslide.

↖ The raging, silt laden Braldu River.

← Our jeep is guided through a torrent of mud and boulders washed down by thunderstorm rains.

↙ Solo workman with an impossible task.

→ Because you'll need it...

... wondering why the urge to summit is so powerful...

an option unless we never wanted to get going again, so we'd taken no oncoming vehicles prisoner. The track got steadily busier as we neared town, the battered jeep revving and bouncing over everything that stood in its path. That it held together at all was a miracle. 'Can you smell burning?' I asked Brian. He thought it was just the engine overheating until smoke started to pour through the dashboard and flames licked round our kneecaps. We bailed out, throwing ourselves onto the dirt, wheels still rolling.

When the driver bravely opened the bonnet a plume of white smoke and flames billowed into the air. The battery had sheared off its mounting and short circuited the wiring loom and we could do nothing except roll into town. The final leg was down the Karakorum Highway, easily ranked in the top ten most dangerous roads in the world. We hoped our maniacal driver was committed to cheating death.

His grin revealed less than a mouthful of stained, rotting teeth, the same colour as his dinner plate eyes. Wide and staring, they looked as if they would pop out of his skull at the first bump. By contrast, we felt it best to close ours tight as he played a fourteen-hour game of 'chicken' with horn-blasting, diesel-smoking trucks as they loomed round blind bends on the wrong side of the road. On river boulders far below lay the wreckage of countless vehicles, which did nothing to ease thoughts of our own mortality. Finally the engine was cut and as nervous wrecks we emptied ourselves into the peace of the Shalimar Hotel.

Mick took the satellite phone through to the back courtyard. 'Hello British Airways? I understand you have a flight leaving tomorrow from Islamabad for London. Do you have three seats available? Good.'

When you have neither influence nor control, stress builds to breaking point and the internal 'get me out of here' demand becomes overwhelming. I suppose we were all glad that Mick made the call.

For a month in the Karakorum I stared at those towering beasts of mountains, wondering why the urge to summit is so powerful, in a cutting edge game that has superseded the notion that the high citadels are the lairs of demons and dragons. For that is what repelled the early would-be mountaineers; beasts that can never be tamed. Maybe it's a good thing that some of us still believe, at least metaphorically, in heinous creatures and fire-breathing monsters. It may even foster respect for the forces at play in the rugged corners of our planet. I wondered if I would ever be good enough to reach into extreme altitude, if I would ever be strong and skilled enough to put my own demons aside.

I'd consumed and been inspired for years by the words of Bonington, Curran, Simpson and Bonatti, and listened to Doug Scott, Stephen Venables and others recount their stories. What must it be like to scan the layers of mountain ridges that recede to the flatlands and seas, and the layers of humanity seeking meaning in the white noise of modern society? There is no meaning in climbing mountains, but they are surely a vehicle for us to measure our capabilities against, and touch a limit that exists for only moments in our minds. A time when everything comes together with an effect that runs deep into the soul and, once experienced, forces us along the slenderest of threads in anticipation of the next sensational moment. Such experiences are elusive, and often thwarted by mishap, disaster or just a mindset not quite open, but it's the search that keeps us going.

A couple of years after being awestruck by the peaks of Karakorum I stood on a small but relatively high, flat area above the Khumbu Glacier in Nepal. A few tent platforms had been constructed

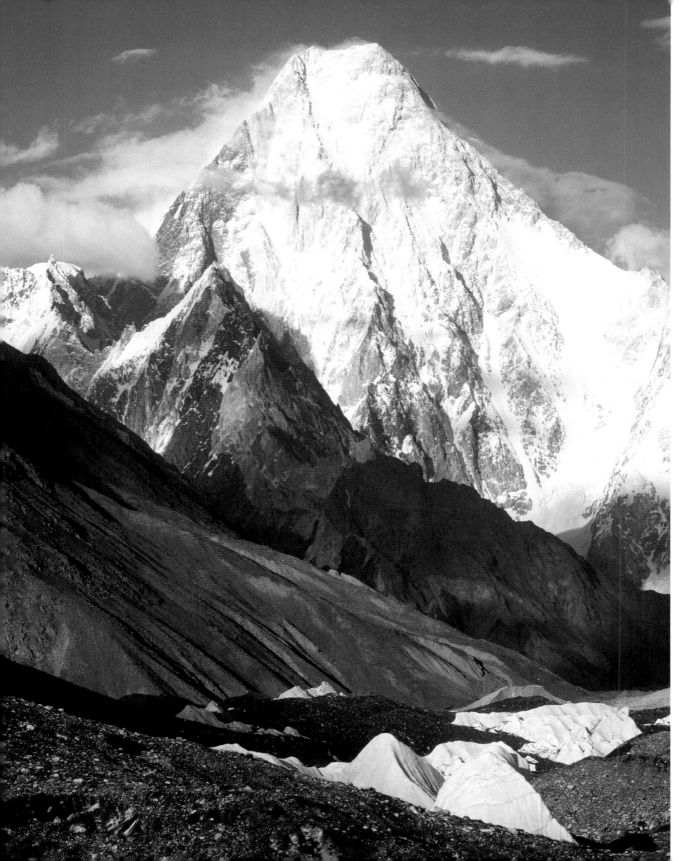

← The Karakorum – home
to some of the world's
most spectacular mountains.
Gasherbrum IV.

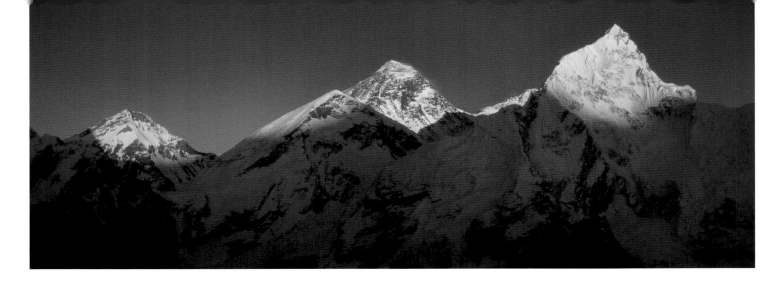

and the view from their doors must have been truly spectacular. Mick Conefrey and I, together with mountain guide Harry Taylor, had scrambled to Camp 1 on Pumori late in the day to film into Everest's famous Khumbu Icefall when Lhotse, the jutting tooth of Nuptse, and the summit pyramid of the world's highest mountain glowed golden then red. It was a fitting spectacle for the film, *The Race For Everest* which examined early attempts and battles between the Swiss and the British to reach the highest point of the planet. In 1952 the Swiss had all but climbed through the icefall, only to be let down by poor oxygen sets and clothing. The following year the British put Hillary and Tenzing on the roof of the world.

As the last kiss of sunlight left the summit an idea was seeded within me. I'd never aspired to Everest, but there was a definite magnetism, a pole in opposition, distant but attracted. It was like a half remembered dream, an effect that was barely perceptible but there nonetheless. We lingered in silence, letting the last light of day creep up the towering ice walls into the purple tinted shadowlands of a frigid dusk.

The shoot moved to the Swiss Alps where mountaineer Stephen Venables joined us to climb a summit pyramid above the ski resort of Verbier, reconstructing the ascent of the now famous Hillary Step, the final difficulty on the SE Ridge of Everest. In ventile clothing and carrying a pretend oxygen set made from painted lemonade bottles, tubing and a false dial, armed with a long wooden ice axe, Stephen demonstrated the climb between the rock and the steeply banked snow that would have overhung the 3,300m Kangshung Face. In

1988 he was the first to climb that face to become the first Briton to summit Everest without oxygen.

In the words of mountaineer Reinhold Messner, Stephen's climb is possibly the finest climbing achievement ever on Everest, greater than Messner's own oxygenless ascent with Peter Habeler ten years earlier and his own subsequent solo ascent. The stories were captivating and I recalled the interviews I'd done with Messner and Habeler, describing how they were fearful for their lives in a gathering storm near the summit, and of Doug Scott standing as the first Briton on the summit with Dougal Haston. I remembered Doug's distant stare as he recounted the moment they stood in hypnotic stupor, the clouds boiling and billowing from the valleys as they watched the sunset, almost too mesmerised to descend. They had been forced to bivouac near the summit and survived.

In 2004, while on a shoot with the blind American climber Erik Weihenmayer and six blind Tibetan teenagers for the film *Blindsight*, I again felt the magnetism, stronger this time as I peered at the North Face, and wondered if I might one day dare to attempt the summit. I was steeped in the history that lay above me, of Mallory, Irvine and their famous 1924 expedition, the disappearance of two of the brightest lights in British mountaineering, but there was another story that I knew little about. At the November 2011 Kendal Mountain Film Festival, mountaineer Kenton Cool shouted, 'Oi Partridge, I want a word with you!' and flipped open his laptop to talk me through the story of the 'Lost Medals of Everest'.

← *Everest's summit pyramid on fire as a frigid dusk creeps up its flanks. An idea was seeded.*

→ *Olympic Gold and a ninety year old promise to take it to the summit.*

For the 1922 British Everest expedition, climbing beyond 8000m and almost reaching the summit must have been like going to the moon. After surviving the horrors of World War One they were now the first expedition with the sole aim of reaching the summit, the first to use supplementary oxygen, the first to use down clothing. They smashed Abruzzi's altitude record set on Chogolisa in the Karakorum thirteen years before and almost reached their goal. So highly regarded were their achievements that Pierre de Coubertin, founder of the modern Olympics, decided to award all the expedition members Olympic gold medals at the Chamonix Games in 1924. Lt. Colonel Strutt, who received the medals on behalf of the team, promised that one would be taken to the summit at the earliest opportunity. The 1924 expedition had already set sail so what could have been never happened, the medals literally missed the boat and the pledge was forgotten.

Finding an original Gold medal whose owner was willing to lend it to us, and then getting it to the top of Everest, sounded challenging enough. Filming added another dimension. There was no major sponsor and I heard nothing more until the end of January while skiing in Austria with family and friends. My text alert beeped: 'It's on – Kenton'. Samsung, key sponsors of the London 2012 Olympics, would underwrite the expedition, keen to link the medal story to the 2012 Games. On the ski slope my friends wondered how a simple text could provoke such a range of emotions as I felt the world around me drain to leave the enormity of what we were about to undertake. To compound matters we only had seven weeks before leaving and I had my personal doubts beyond there being no time to train.

I'd been maxing on anti-inflammatories but my right ankle burnt with all the pain from hell, and seized up when inactive. The broken talus in 1992, eleven months of learning to walk again, bone-grafts and fusion surgery, more months of immobility, of learning to walk and climb yet again were back to haunt me. With just weeks to go before departure, following a scan and X-ray, my surgeon, Nick Short, informed me that there was no evidence of my ankle ever being fused. The bone grafts of 1994 had broken and been ground away to leave a horribly arthritic joint that could take an hour of brutal persuasion before I could weight-bear in the mornings. So bad was the pain, some days I would have gladly chopped off my foot.

Kenton flew to Toronto to meet Charles Wakefield, grandson of Arthur Wakefield. Arthur had been a doctor in a casualty clearing station in Flanders, dealing with oceans of the wounded, and joined the 1922 expedition as climber and medic. Charles brought the medal wrapped in his grandfather's red silk handkerchief, and placed it on the coffee table of his lounge. Kenton carefully pulled back the folds to reveal not only a piece of Everest and Olympic history but an embodiment of the spirit of exploration and mountaineering. Charles was emphatic that Kenton should take it and bring closure to his grandfather's expedition. Insurance for such a valuable family heirloom he considered to be a 'dirty word' and asked Kenton not to drop it.

The Everest Olympic Pledge Expedition gained momentum with backing and support from Lord Coe, the British Olympic Association, the Royal Geographical Society, the Alpine Club, the Himalayan Club, the British Mountaineering Council and the Mountaineering Council of Scotland. All the families of the members of the 1922 expedition were behind us all the way.

Nick Short had wheeled me into the operating theatre to carry out a cortisone injection deep into my ankle joint. I watched the inky fluid ooze into the aggravated bone on the live X-ray and miraculously the pain was gone. I'd been given a stay of execution but the spectre of serious surgery always lurked in the shadows of my mind.

I was to film using Samsung's small cameras and with the newly developed Canon C300. I'd edit full-blown mini films at Base Camp with music and graphics added before sending them back, via satellite, to Samsung, to Kenton's friends Richard and Vitty Robinson, and to my wife Andrea for distribution on websites, across social media and into cinemas including the big screens in Piccadilly Circus. We would also provide live link-ups with BBC News, ABC in Australia and CNN in the US. In addition to the filming we would photograph, blog and provide daily dispatches. In 1922 it would have taken weeks for reports to get back from the mountain. By contrast we were to play out our expedition in near real-time. It was a project and workload that was to push me to the brink.

At Base Camp I coughed for eleven hours at night and had done so for days. I was also using a whole toilet roll each night to mop up the mucus pouring from my nostrils. When I lay down it felt as if I was drowning. My throat was ragged and it seemed that I only had to put a spoonful of food to my mouth and I retched. Kenton tweeted, 'Keith's pushing food round his plate again'. It was no way to start an expedition to the highest point on the planet.

To shake this thing off I would have to drop some height. Pangboche is more than 1000m lower, so I set off in the hope that my body would repel whatever had invaded. Guzzling a mix of cough mixture and codeine I actually slept and, after a few days, felt well enough to head back to Pheriche and then up Dugla Hill where the snow came on heavy. I arrived freezing into Lobuche where the porter with my bag was nowhere to be seen. No dry clothes and I shivered the night. Judging my recovery proved difficult with so many masking factors such as altitude and in retrospect I was not nearly well enough to continue. It was a happy reunion with Kenton at Base Camp but, given the experience of the last two days, I still doubted my ability to perform at height.

The first proper trip through the icefall was slow, the upper third being threatened by a huge shattered ice cliff that clung precariously to Everest's western flank, the very cliff that subsequently avalanched in 2014 causing many Sherpa deaths. Speedy movement was required but I found that impossible as I struggled with leaden legs. Eventually I poured myself into the tent at Camp 1, at the start of the Western Cwm. Kenton lit both gas stoves to melt snow, putting them under a single pot. The following morning we returned to Base Camp.

For the next acclimatisation trip we tried to reach Camp 2, halfway up the Cwm on the left side of the valley. I managed half a dozen paces at most before having to rest, and the last few metres up loose, rock-strewn ice was almost too much.

The next round was to touch Camp 3 on the Lhotse Face, but the icefall proved beyond me. Two hours should have been sufficient, but after four I had only reached the flat, relatively safe slab of ice known as the Football Field. It was like driving with the handbrake on. My head was swimming, and each step left me struggling, not for breath but for equilibrium and balance. Kenton, shoulders pulled up to his ears against the cold, was waiting. He'd been shivering for too long and I knew we had to talk. There was oxygen back at Camp 1, maybe that would help. I was keen to show face but think we both knew that I had to go down. It would have been easy for

him to blow up but he just looked up the icefall and said nothing, fuming in silence.

He put the video camera in my rucksack along with a few other things he'd been carrying for me, and asked if I was okay to start the descent by myself. I nodded and we parted. The expression on his face as he turned his back and stormed off wasn't difficult to interpret. I'd been written off. I recorded a video diary.

I'd never backed off, never failed and never given up, but here I was feeling utterly useless. It was my darkest moment and I was consumed by demons and guilt. In my mind the expedition and the Pledge lay in tatters.

On the descent my brain told my legs what to do to but they really didn't listen too much. Very deliberate in my movements I made doubly sure I was clipped on all the way. On a couple of the steeper sections I chose to abseil down, not trusting the 'rope wrapped round the arm' technique which was the normal for those sections. After the two rappels I spotted Dorje coming up to meet me. KC had radioed through to Base Camp for them to send one of the Sherpas. He waved and kept coming fast, took off my rucksack and plied me with ginger tea, chocolate and biscuits.

I was very grateful but the food and drink made no difference to my energy levels. I was running on empty, but Dorje did a remarkable job. He was like a ghost, a shadow travelling silently behind watching for my every move. Whenever I reached for the rope it was already there.

Phoning Andrea, I cried down the line. I think she reported on the Facebook page that I was 'pretty upset'. All I wanted to do now was go home, and I hated myself for that. Eventually I told myself to sleep on it. Emotions were obviously out of control.

Weather windows usually opened from the first week of May. It was April 28th and time was running out. I felt I owed it to Arthur Wakefied to it give all I had to get his grandfather's 1924 Olympic medal to the summit and, by the 7th May, told myself that Kenton wasn't going to get away again as we pushed beyond Camp 2. We even overtook another team in the upper reaches of the Western Cwm and that felt good, but three rope lengths up the steepening ice of the Lhotse Face my legs ran out of steam. It was enough for the day although we were still a long way from Camp 3. I'm not sure if I was disappointed. I was moving up the gears, but the fact that we hadn't reached the next camp nagged.

The next time up from Base Camp would be the summit push. My head almost bulged with doubt.

KC suggested we went for a holiday to Pheriche to rest and fatten up. I ate chilli chicken with rice at the Himalayan Lodge at least twice a day. There was a terrific atmosphere with other Everest climbers doing much the same thing, preparing for their summit bids by stuffing their faces and breathing slightly thicker air. Those few days must have done me some good because, on the way back up Dogla Hill, we cruised past a group of Australian trekkers. 'Don't beat yourselves up,' I said. 'We've been much higher than this already'. At the top we paused – KC's bladder again – and they caught us up. In the sunshine we came clean about what we'd been doing and they wished us luck. It seemed that I might have turned a corner.

More chilli chicken in Lobuche, soft drink stop in Gorak Shep, no point in pushing too much. Base Camp on the 15th of May. The windows of opportunity were upon us.

The word around the other teams was that they would make their summit bids on the 19th May. Kenton studied the graph on the windgram and listened to the radio for who was heading

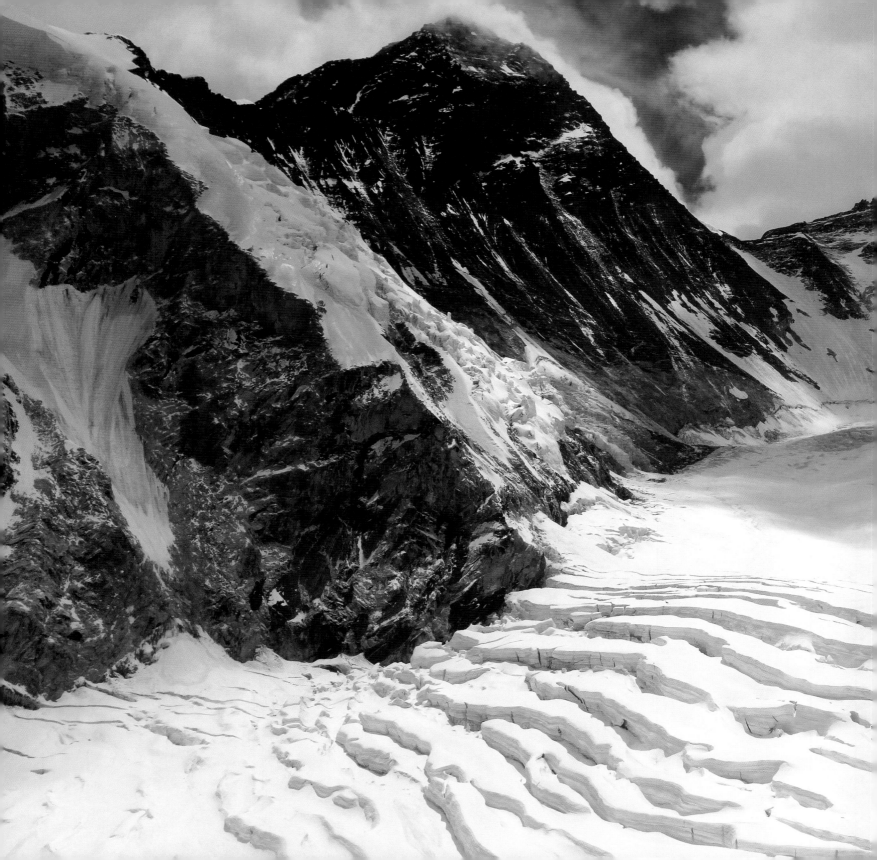

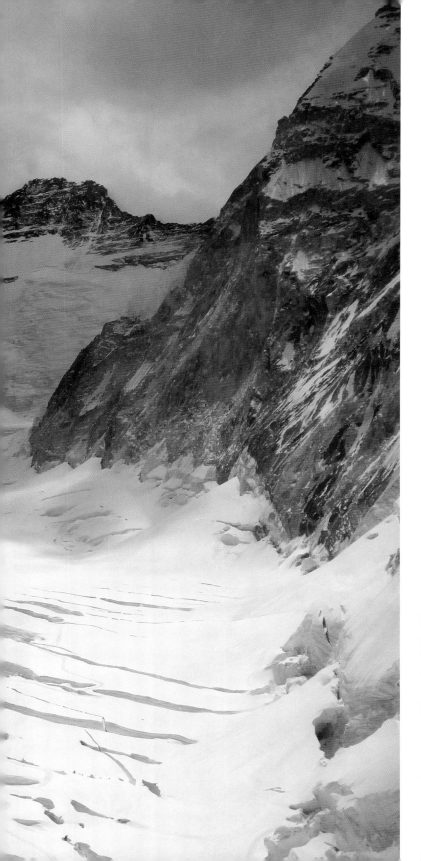

← 'I swore under my breath at the vastness.' Everest's South West Face and huge crevasses at the start of the Cwm.

↓ There were 23 sets of ladders to cross.

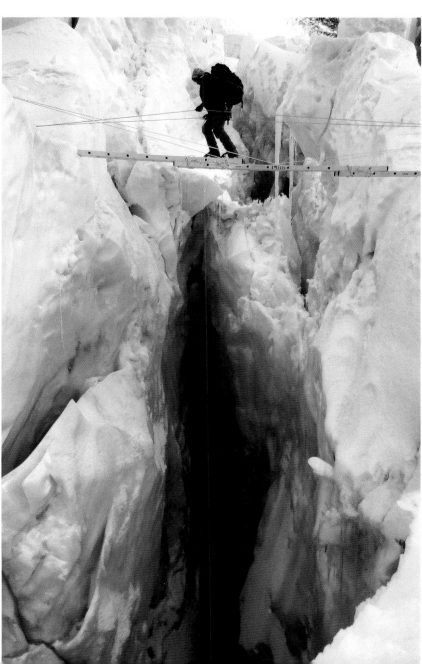

→ The view from Camp 2
in the Western Cwm
to the vast Lhotse Face.

One young woman continued her descent with nine out of ten toes frostbitten.

up the following day. It was a very busy year for climbing Everest and most had probably tired of waiting around. Winds were low, but the forecast was for a dramatic rise. It was a dangerously narrow window.

In 1922, on 19th May the team for the first summit attempt set out from the North Col at 23,000 ft.

Somervell, Mallory, Morshead and Teddy Norton set off at 7.30am in calm and fine weather, but a chill wind blew in from Tibet and after 400m they stopped to put on extra clothing. Norton sat a bit below with his rucksack on his lap and when Mallory pulled a little on the rope he upset the pack containing extra layers and sent it tumbling down the mountain. Soon a veil of grey cloud covered the sun and they leaned heavily into a stiff wind, struggling to breathe. Heading up to the crest of the ridge they hoped that the wind would vortex over the top, leaving them in calmer conditions. On the scoured snow crampons would have been ideal, but they hadn't bothered to bring them. Even if they had the straps would have cut the circulation in their feet causing them to freeze. Cutting steps was the way to go: old school.

They hoped to pitch a high camp at 26,000ft but at 25,000ft, with conditions deteriorating, they searched for a suitable site amongst the outward sloping ledges and rocks. No easy task, but eventually they pitched their meagre shelter. Lying in their sleeping bags they discovered that Norton's ear was badly frost-bitten and Mallory had frostbite to three fingers. Morshead, although never complaining, was frostbitten on his hands and feet. The night was anything but restful.

While sorting themselves out the next morning another rucksack tumbled away, taking breakfast with it, lodging 30 metres below. Morshead retrieved it. Exhausted before they'd begun they roped up

but, after a few steps, Morshead stopped and said he could not go further. He headed back to their camp.

The remaining three, Mallory, Somervell and Norton, continued for the summit. In reality, they should have set off earlier. Short of time, and with the snow lying between 10 and 20 cm deep, progress slowed. Calculating they would still be climbing after night had fallen they retreated, having set a new altitude record of 26,895 feet.

For filming purposes I preferred fewer people on the hill. The sharp increase in winds was also worrying. In addition, any delay in deteriorating weather might escalate matters beyond 'a difficult day out'. Gambling, we decided to defer our summit bid until the next window, should it ever open.

With Arthur Wakefield's gold medal safe in Kenton's pocket we finally set off from Base Camp on the 20th May. Moving up through the icefall was almost pleasurable, with the whole place to ourselves. As ever Kenton pulled ahead but, for the first time, I wasn't struggling. The advantage to me was that, by the time I reached Camp 1, he had already melted water to refill our bottles and we sat on our sacks, relaxed in the sunshine and pushed digestive biscuits into our mouths. The undulations of the trail through the crevasses at the start of the Cwm finally stopped and in the distance the moraine and Camp 2 came into view. The angle had begun to ease.

We were enjoying hot drinks and cake in the mess tent when we heard other climbers on their way down. Some could hardly speak they were so exhausted. One looked shell-shocked with a large pink-white wound on the cheek and a blistered finger. One young woman continued her descent with nine out of ten toes frostbitten. The sheer number of people on the hill had meant long delays in

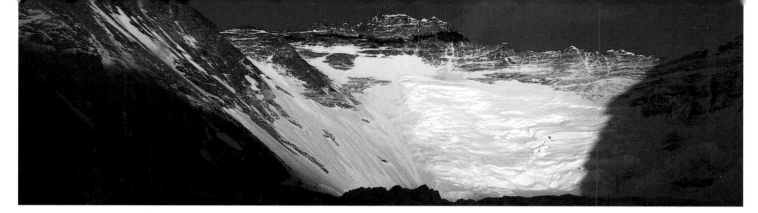

descending the Hillary Step. Caught above 8000m in high winds, others had not been so fortunate and paid the ultimate price.

Pasang Temba and Ganesh prepared a tuna and vegetable pizza for us that evening. Achieving this at 6300m in a very rudimentary kitchen was beyond belief. We failed to eat it all, but the Sherpas doubtless enjoyed it on top of their staple Dal Bhat. We'd scheduled a rest day for the 21st, a day of eating, drinking and avoiding the toilet which by now was saying 'full'.

The following day we walked up the Western Cwm and climbed the steep ice to Camp 3. It was new territory. Early in the expedition climbers and Sherpas had met fusillades of rock and ice let loose by a 'dry' year. The route, originally rigged up the centre of the face was deemed too dangerous and moved into a series of ice bluffs on the right, which offered some protection. There had been a few snowfalls and these fresh coatings had frozen things into place. Adding to the early gloom on the mountain, one of the major commercial operators pulled his entire team off, given the overall state of the Lhotse Face and the serac cliff at the top of the icefall. With countless Sherpa journeys required in support of his clients he felt unable to justify the risks.

My heart pumped hard as I hauled myself up one of the two ropes that dangled down the steep first pitch of 70 degree bullet hard ice. Climber traffic had chiseled out 'footholds', which helped. I stopped two thirds of the way up, kicked in and hung on the rope with camera in hand. Ready to film, I shouted for Kenton to come up and, as he headed into a navy blue sky, the sun burst into the lens. This was what I was here for – to shoot – and it felt good to be strong after all that had gone before.

Camp 3 was on an ice platform cut into the Lhotse Face. It looked like a tent graveyard with the shredded remains of yellow rip-stop

nylon and aluminium poles lying partially buried. 'Rip-stop'; it made me laugh to myself. Through our open tent door, Pumori, the peak that dwarfed Base Camp, disappeared in a sunset orange blaze of ragged cloud that boiled through the Khumbu Valley and up the icefall. We were now level with its summit and spirits were high although we were still 2,000m below the top of Everest. We slept to the gentle hiss of oxygen, our masks held in place.

From the moment we left Base Camp the names had been scrolling through my mind: Khumbu Icefall, Western Cwm, Lhotse face, Geneva Spur, the Death Zone. It looked like we could reach out and touch the South Col but all day long we kicked our way up, downsuits undone, masks on, trying not to feel claustrophobic.

A steeper area of mixed ground, ice and rock, confronted us: great shot. The Yellow Band, a layer of marble, demanded good technique. Crampon points sat neatly on tiny edges and it felt like 'proper climbing'. To our left the rocky ridge known as the Geneva Spur looked like no big deal, a small hump. We were making unremitting progress. Breathing long and steady into the mask I kept a rhythm, trying to get to thirty paces before resting for just a few seconds. It was tempting to stop for longer but my heart rate never really went back down. Then I noticed a climber high on the Spur, a mere speck against the skyline. I muttered under my breath at the vastness.

I felt as if I'd found my real self. I could hack pushing hard. I usually had oceans of stamina, and long days out is what mountaineers do. Although KC always pulled away I no longer felt like I was drowning in a sea of doubt and weakness. The few climbers we'd seen this day were queued on the final broken section leading to the top of the Geneva Spur. Old fixed lines ran like spider's webs over the shattered shaley rocks and I knew that,

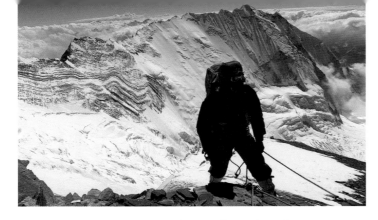

just round the corner, it was a short stroll into the Col. Kenton was waiting on the skyline and we filmed again. The Western Cwm with its contorted rock bands and the delicate ice flutings of Nuptse were sensational.

It was like a pavement rising gently to the highest campsite in the world. Fifteen minutes and we were there. On the Col! Midday.

Kenton helped the Sherpas, Dorje, Chechen and our other Dorje, put up the tents while I filmed, dumping my mask to see better into the viewfinder. Working at almost 8000m without 'O's my eyes streamed into the camera making it difficult to see. Sheets of flimsy fabric bellowed and cracked above the rumble of the wind, but somehow the four of them managed to get our rudimentary shelters pitched, weighing down the guy ropes with the largest rocks they could claw from the frozen ground. Conditions were set to worsen overnight but we'd leave nothing to chance. Sleep was difficult with the constant rattling.

Morning frost lined the inside of the tent and showered us if we touched the roof. Inside, with the stove going, we studied the food packaging in search of calories. They say that Summit Night drains 9,000. I thought it impossible to eat that much and still be able to move but was up for the challenge. A boil in the bag 'meal' contained 178 calories. 'That's no sodding good, pass me the other sort.' Next choice: freeze dried curry at 550, better. Hobnobs and squeezy cheese proved promising with around 100 per biscuit but I couldn't eat 90 of them. Okay, anything goes: two main meals now plus constant snacking.

Many climbers and Sherpas arrived through the day. The number of tents increased fourfold and the stream of people didn't look like abating. I could sense the tension within KC rising. During an interview, sitting on rocks overlooking the hive of activity, he finally broke down in tears. Five days before six people had frozen to the mountain where they slumped. This could happen to us. I felt as if we were climbing into a trap.

Our obligations to our sponsors weighed heavily but we had to remain calm. How much were we willing to give? Everything? As the sun set and the five of us were booting up, the worry of what might happen on our summit bid was almost too much to bear. The last light of the 24th of May was receding over the western horizon and a line of headtorches was already heading over the glacier and up the first slopes. It seemed that everyone had the same idea; to avoid the crowds, go early. It was 7.30pm and the tension was palpable.

We joined the queue. How very British. In the blackness everyone was lost in their own hopes and fears, aspirations and internal struggle. The pace was slower than funereal as the string of lights inched its way up the mountain. KC became increasingly frustrated and removed his jumar from the fixed line. He looked at me. I did the same and Dorje passed me a short length of rope which I clipped into. KC moved solo, Dorje and I moved together, Chechen and the other Dorje moved silently behind. My heart rate was red lining all the way as we overtook the pack. Every fibre of my being was screaming for me to stop, sure that I would destroy myself, but something drew me on. It was pretty clear that Kenton's strategy was to climb fast all the way, minimising the possibility of getting stuck in the latter stages where the terrain is more committing. It was utterly electric. When we found ourselves on our own I unroped from Dorje. The pools of light from the headtorches were well below and distant.

My mind reeled through my memories of friends and times in the mountains and I was joined by friend and foe, hallucinating doubt

→ We're off to climb Everest if she allows us. Departing at sunset on our summit bid.

and success before the ghosts in the snow, staring at the blackness of space, starlit and infinite, with their ice carapace eyes.

On Everest there are so many unknowns and for me it was mainly about the doubts. Would I be able to perform? If things didn't go well those demons would be hard to shift. What was it like for the others? I shook off the negativity and, only four hours after leaving the Col, the Balcony appeared ahead. Time to squeeze an energy gel into my mouth and change oxygen cylinders.

I looked straight up and saw millions of stars in the inky sky. When a few went out I realised that they were actually the headtorches of climbers far above. It was steep. The ridge reared up. We pressed on. The hours blended but I became aware that on all sides the ground was coming up to a point. It was the South Summit and after the short descent I flicked my headtorch onto high power. The pencil thin beam swept across a feature that I knew well from pictures: the Hillary Step and, for the first time, I allowed myself to think that I/we might actually do this.

There was no one around as I moved onto the narrow neck between the South Summit and the Step. If I could have seen through the blackness to my left I would have looked down at Camp 2 over 2,000m below, but my headtorch didn't quite reach that far. Instead I looked up at where, in a normal snow year, the route would go. The margin between the rock and the icy cornice wasn't very inviting so I moved up a broken rock wall and round to the left before carefully climbing a slabby triangular block with my front points on the tiniest of edges. Mantleshelfing over the top, I rode the block before dropping off the other side. No more obstacles now, and Chetchen and the other Dorje carrying the tripod and extra oxygen were close behind.

After the first push to the summit by Mallory, Norton, Morshead

and Somervell, Finch set off with Bruce and Tejir, a tough old Gurkha soldier. With the weather worsening they scurried into the precarious little tent pitched on the ridge by the first team. Eventually Finch wrote that they feared for their lives, realising that if the wind got inside it would tear them from the mountain and hurl them to the East Rongbuk Glacier thousands of feet below.

They were never far from disaster. In the morning the snow stopped but the wind blew unabated. They were pinned down, and at noon a stone ripped through their tent leaving a gash. Luckily the storm passed. Lesser men may have retreated but Finch wanted to have a bash at the summit. They ate the last of their food when six Sherpas arrived with flasks of hot tea and Bovril but remained all that day in the camp. The weather once again was bad.

The climbers settled in for another miserable night and Finch observed that they were 'ravenously hungry to the point of cannibalism'. At their lowest ebb he suggested that they all take a shot of oxygen, which had an incredible warming effect and tingling sensation returned to their limbs.

They set out again on the 25th May having thawed their boots over a burning candle. Tejir soon collapsed and retreated down the mountain leaving Finch and Bruce to continue. Half a mile from the summit and 1,700 feet below, it came like a hammer blow. Never had they thought they would fail, but time was running out, the weather again worsening, and they feared they would not make it down alive.

Finch and Bruce, although disappointed not to have reached the summit, had been higher than anyone before, breaking the altitude record set by Mallory just a few days earlier. They had reached 27,300 feet and climbed three times faster than Mallory,

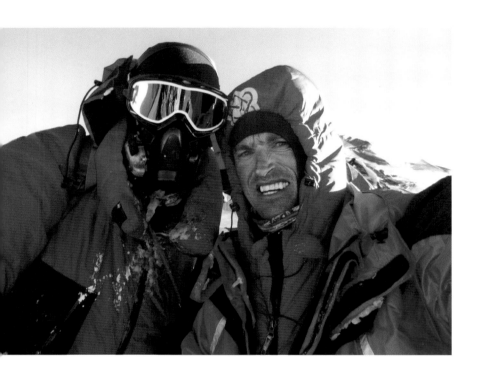

of the front of my downsuit was encased in ice and a thumb-sized icicle hung from the fleece snood. The frozen zips were impossible to open. Food kept in pockets for easy reach was inaccessible. All five of us hunched in what meagre shelter was on offer for forty minutes before a thin line of light stretched round the horizon to the east.

Ten minutes later we were on the Roof of the World and the Pledge was fulfilled. Kenton took the Olympic medal out of his pocket and we filmed. Others came into view and we knew our time was limited.

The summit of Everest should have been all elation and manly poses but the voices in my head were deafening: 'Going up is voluntary, coming down is mandatory', 'It ain't over till the Fat Lady sings'.

The massive triangular shadow of the world's highest peak was projected onto the clouds and peaks of the Himalaya as the sun peeked over the curving edge of the world. I was mesmerised and in conflict. After eight hours of maximum effort things were about to get a whole lot harder. Everest climbers are ticking time bombs, limited supplies of warming, life-supporting oxygen see to that. When the 'O's' run out there is an overwhelming temptation to sit down and go to sleep and, at minus 35C, sleep will more than likely mean a slow drift towards death. Kenton asked if I was alright. Standing with my back to the summit prayer flags I looked back down the South East Ridge, admitted that I felt really 'woozy' and that my head was swimming. Dorje, looked at the gauge on my oxygen cylinder. The needle sat below the red; I'd run out. The sudden hiss of a new one being screwed onto the regulator was a relief and with the first breaths my brain came back to life.

After doing everything we could for the sponsor, Samsung, on the summit it was time to descend. The Hillary Step was clogged,

Norton and Somervell using the oxygen sets. This despite being less experienced mountaineers and carrying loads of 40 pounds.

It was a massive achievement and we were now on our final push to take the Olympic Gold Medal to the summit and fulfil the promise. Strangely, as if by some quirk of fate, it would be ninety years to the day since Finch and Bruce had reached their record-breaking altitude.

I dared to look at my watch; dawn was a long way off. I finally caught up with Kenton and Dorje in an alcove located between iced rocks. There was a stiff breeze and it was perishing cold. The whole

and the Pledge was fulfilled.

holding us up long enough for my left foot to begin to numb.
I wiggled toes and stamped to keep the circulation going. We
dropped to the Balcony where we sorted out oxygen cylinders and
chatted in the sunshine of the 25th of May. KC then sped ahead
to Camp 4 while I made my way down over the broken ground to
the final section of the glacier that clings to the edge of the South
Col. There we melted snow, drank, filled bottles and ate while
contemplating our next moves.

KC was keen to drop all the way to Base Camp. I was pretty much
exhausted but knew the importance of getting down as far possible.
The South Col is on the edge of the 'Death Zone', at 8,000m, and
our bodies were already degenerating. Camp 3 wasn't safe either,
especially with heavy snow forecast for the following day. Getting
buried by an avalanche didn't appeal, so I set off for Camp 2 in the
Western Cwm while KC was sure he could make it all the way. We
hadn't seen the Sherpas since leaving the summit.

I dropped down the traverse line to the crest of the Geneva Spur,
put on crampons, crossed the upper section of the Lhotse Face and
descended the steepening ice towards the remnants of Camp 3.
Shredded and partially buried tents flapped in the breeze but this
was my chance to rest. Progress was slowing dramatically as the
sun beat down and the temperature soared. There was no wind
and the Cwm was heating to blast furnace levels. Descending some
of the final sections demanded the utmost concentration. So steep
were they I sometimes wished the fixed ropes were slack enough
to clip though my figure of eight and abseil down. All I could do was
clip in, wrap my forearm round the rope and, with gloved hands,
slide down hundreds of metres of line, stamping my crampons into
the snow and ice. It took concentration levels I no longer possessed.
I was on my own and that was getting to me.

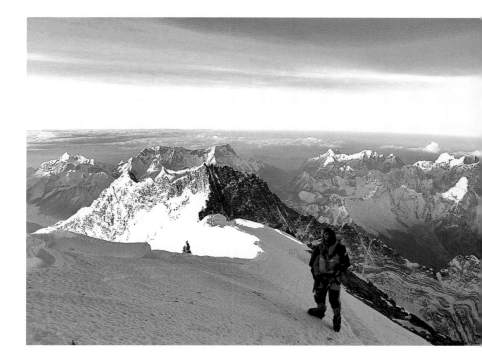

↑ The gentle curve of
the earth. It was like being
in space.

← Summit selfie. It never
occurred to me to remove
my mask and goggles.

209

Finally I reached the ropes of the steepest section. I'd had enough, was totally spent, and needed to revert to techniques that I was really familiar with. I pulled the rope through my figure of eight, looked over my shoulder and slid smoothly and with polished technique downwards.

The Sherpas overtook me just as I dropped onto the main slopes of the Western Cwm. The steep stuff was over but my head was swimming. Dehydration was really stepping up.

Dorje, Chechen and our other Dorje moved easily with their loads down the glacier and came to a stop. I wondered how they did it. Moving closer I saw that Ganesh the cook boy had come up from Camp 2 with cold juice. My throat felt as if someone had been bowing it as cello practice. The pain was excruciating, it was nigh impossible to swallow my saliva. The chilled orange drink soothed until I could speak again, albeit in a feeble croak. I had been using a small amount of oxygen up to this point but now felt that I should stop as the system dried my throat. The Sherpas forged ahead

Camp 2 in the Cwm took an absolute age to reach. I could see it but it refused to come closer. My legs gave up and my feet were badly blistered and sore but I eventually scrambled up the last moraine and into the mess tent exhausted having been climbing either up or down Everest for almost 20 hours.

The following morning I was set to leave at 07.30 but couldn't really be bothered. After a few hours of interrupted sleep on the icy, uneven floor of a tent I plodded down the Cwm, setting off an hour late. 'Just once more', I kept telling myself. 'Once more through the icefall and then we'll be in Base Camp and safe.'

The ice felt different and not in a good way. Daily temperatures had been soaring with the onset of the monsoon. Many of the anchor stakes and ice screws that were 'holding' the fixed ropes just pulled straight out. Everything felt uncertain. Where there was a choice of rope I started to look both ahead and behind to see if the lines had solid multiple anchors. I tried to entertain myself by guessing the state of the next ladder, which I never got right.

Some ladders across the yawning chasms in the icefall were clinging on by only a couple of inches at either end. Some had missing rungs or were 'floating' in mid-air, others wobbled precariously, trying to spit me off. Looking into the deep blue depths would have made my head swim. Instead, control the breathing, control the fear. Focus forwards. It all felt 'last-legs' and by this time I was very, very lonely. Turning a corner I discovered that the route was barred, the ladder warped and twisted, broken and useless.

I was now beyond exhaustion and just needed to be off this thing. I turned right, soloing across the jumbled mess of ice blocks, and detoured round the useless ladder. At least I was fairly well away from the crazy, tottering seracs that had threatened us in the early part of the expedition. I allowed myself that small positive thought, remembering how building- sized blocks of ice had towered over us, toppling with no notice, remembering the 'dusting' from one such collapse and the pale blue of the ice blocks flying towards me. I had nowhere to run. The chunks were big enough to take me out but, thankfully, settled some distance away, leaving just the airborne avalanche to do whatever it wanted. I hit the deck with my head away from the flying debris hoping my rucksack would give protection.

My mind wandered again through many of the mountain days I'd had in Scotland, Greenland, Tasmania, Iceland, all over the world. I'd often had to push hard to get off, get out. Twenty-hour days, but usually I had friends with me. By now I had been alone for a very

I was on the edge of collapse and gave myself a right good talking to.

long time. There was no support. 'You did it then, you can do it now', reeled through my head, but I wasn't very sure.

A party of four other climbers caught up and asked if I was okay. They looked pretty done in and the one at the rear couldn't speak above a whispered croak. I caught them again at the 'Pinnacle Section' and we stopped together on a small, flat stretch of ice. A bit like Ganesh the day before, their cook-boy had come up with cold drinks and snacks which they kindly offered to share. I felt a tiny amount of energy, something to work with, but for how long? I was ordered to finish the half litre of lemon before we parted company but, from then on, struggled to find the route through. It had melted away, and I found myself searching for the smallest of crampon marks in rotten ice that gave way and dropped me into a melt-water pool. Luckily my right foot found solid ice quickly and with surprising speed I jumped clear.

I was on the edge of collapse and gave myself a right good talking to. Talking turned to swearing, beasting encouragement at myself. I promised myself that the next meltwater stream I came to I would stop, rest, drink and try to eat. A few broken biscuits from the bottom of my pack and icy water must serve to get me back to Base Camp

The Pinnacle Section went on and on and on. Kenton said that I would come to despise this section. I'd turn a corner, stamp up a few paces to the crest of another wave of ice and hope to see the immense strings of prayer flags that marked the entrance to Base Camp, only to be thwarted time and again. Base Camp was still a long way off but, eventually, the mess tent appeared at the top of a small rise in the moraine, commanding a terrific view of Everest's West flank, Nuptse, the icefall, and me as I floundered my way on.

In every direction clean, ice-scorched boulders and gravel overlaid the ice of the Khumbu Glacier. Walking over this stuff was never easy. I asked myself if I really could get up just half a dozen steps, but the rocks slid underneath my feet. Sometimes I went further backwards than forwards and each step put pressure on my blisters. Eventually I sat on a boulder, removed my crampons and thought to myself: 'Made it.' Looking up, it was only: 'Nearly'. I was still a few hundred metres from camp.

I slowly stood up and shouldered my rucksack, my Fat Lady's throat well and truly warmed up. She was ready to burst into song at long last. 'It ain't over till the Fat Lady sings...' had stayed in my mind, but for me it wouldn't be over until I stood in our mess tent. It was the focal point of our Base Camp and represented so much more than where I'd eaten countless meals cooked by Bim. It meant the end of the descent, THE finish.

Kenton was pacing across the doorway. I guessed concern was high, I was well overdue, but neither he nor anyone else came to help or take my rucksack, not that I wanted any help. It was important to make it under my own steam and, finally, I walked into the tent and dropped my pack. Kenton gave me a big hug and I felt his relief. I could only speak in a frail croak. The hardest two days of my life consisted of: yesterday from Camp 4 to the summit and back to Camp 2 in twenty hours, today took a mere eight, sleep in between had been fitful, cold, uncomfortable and unsatisfying. Now it didn't matter. Nothing really mattered.

Before dark I decided it was time to head back to my tent to rescue what little personal kit I'd left there. Over the last few days it had been so hot that it was difficult to even get through the doorway. My little orange shelter was now perched on a spike of ice, and everything around had melted. The large boulders that the guy ropes were tied to hung down the sides, slithering worryingly towards a

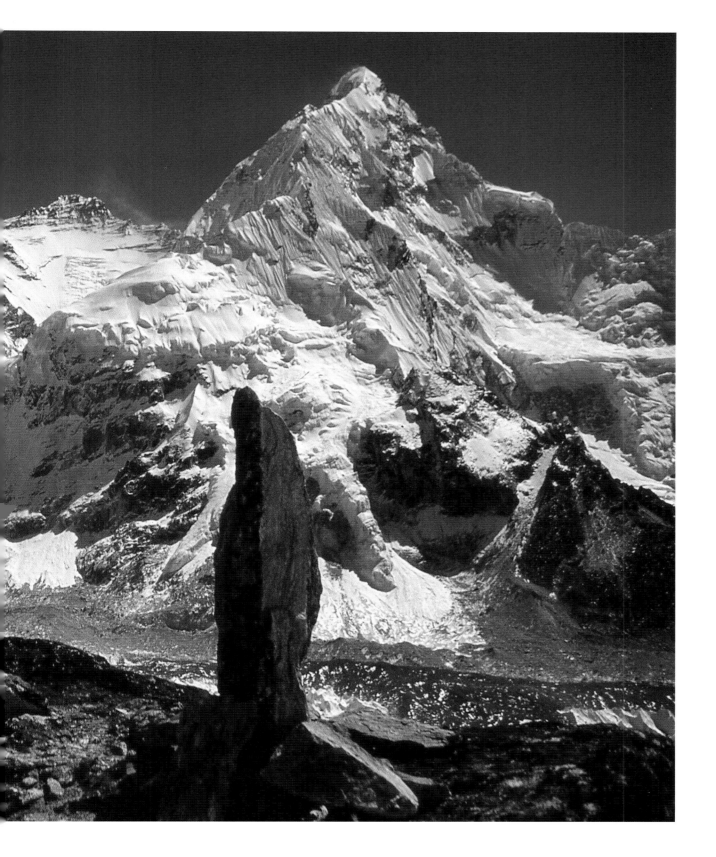

← *Prayer flags blown ragged by Himalayan winds.*

narrow crevasse that had opened up ten metres below. Inside I just sat, feet dangling through the doorway, chucking everything onto the narrow moraine ridge that connected the tent to the rest of the camp. One of my spare pair of boots caught a guy-rope and spun towards the crevasse, narrowly missing it and coming to rest above the entrance to the bowels of the glacier and the water rushing far below. I turned on my Samsung Galaxy phone and the emails downloaded and downloaded and downloaded. Hundreds of messages from family, friends and folk I didn't really know all wishing me well and congratulating me were so utterly overwhelming, together with the release of tension, I burst into tears.

Hundreds of people I met in the following weeks offered their congratulations on a 'huge achievement'. Everyone has heard of Everest and, given the year's Press in 2012, had probably also read about it, but I wasn't sure what I really achieved. What I do know is that it was about so much more than the Summit. Except for fulfilling the Pledge and honouring the members of the 1922 Everest expedition, I almost don't care about the Summit, although I'm sure that in time those moments on the 'Roof of the World' will come to mean more. I care more about the time spent with KC and his drive, his skill and determination. The mountain demanded everything from me and looked into me in a way that I never thought possible. The lows were so deep I never thought I would be able to climb out. The highs were up there with the best. The experience of being on the world's highest mountain is about what happens inside the head for the duration. It questioned every aspect of who I was, what I stand for and just what is important. Ultimately, coming home to family and friends proved to be the highest of highs.

Exactly a year on I found myself again at Base Camp, on this occasion filming with Reinhold Messner. I stole time to look up and contemplate what had been, to see if anything had changed in the way I felt. I had genuinely given everything, but I'd wanted to give more and couldn't because I didn't appreciate just what 'everything' meant. I'd found a limit and therein lay the issue. I was embarrassed that I'd struggled so much. I didn't recognise success just as I didn't see Everest as a golden ticket. It had been my job to climb the mountain and document our expedition.

In the intervening months I spoke with friends, probably boring them senseless, and with people who'd either summited themselves or had to push really hard to succeed in their own adventures. Brian Hall, Leo Houlding, Stephen Venables, Steve Backshall, and Duncan McCallum all offered their insight, but still I wondered what I could take from my time on Everest. After thinking long, I appreciated that I had indeed found a limit but, as with all that had gone before, limits are transitory moments in the mind. They exist only to be pushed and realising that just made me wonder where the next limit lies. I became more relaxed about most things except sitting around and doing nothing.

To some Everest has almost become a dirty word, but to many it is still a place of dreams, hopes and the opportunity to see what they can do. Everyone I met looked up, wondered if they were good enough and doubted themselves. Most made it to the top, some didn't. Others will never see their loved ones again. Everest is still a very beautiful, awesome and at times overwhelming mountain in the way great mountains should be.

Fighting hard for the shot stays with you for a very long time and maybe something of that atmosphere of struggle is communicated within the image itself. I still look hard to see if I can make myself out as an infinitesimal speck, camera in hand, riding the shadow on the mists of the stratosphere

*The mountain demanded everything from me
and looked into me in a way that I never thought possible.*

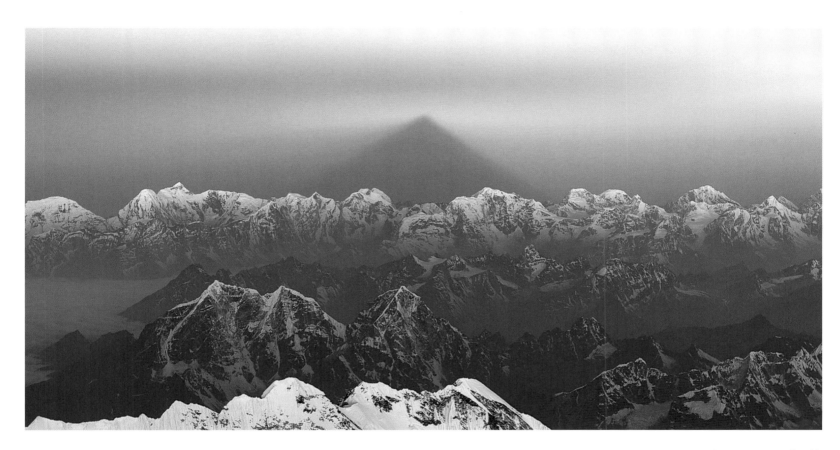

↑ *It was too predictable
to shoot the sunrise. Behind
was much more interesting –
Everest's immense shadow.*

11

The
Adventure
Film Game

The late night glare of an Austral sun was still in my eyes as I wandered through the hut door. Slowly, out of the gloom, as I walked round a long wooden table, a toothbrush in a mug next to a broken comb and a postage stamp, shelving hung with chipped enamel bowls, flour crates, a perfectly preserved penguin, even a photographic darkroom and all manner of scientific equipment were revealed. It was if the occupants had walked out yesterday despite the blubber stove being iron cold to the touch. On the edge of Antarctica the Cape Evans Hut had not only been occupied by Captain Scott, as launch pad for his ill-fated race to the South Pole, but also by Sir Ernest Shackleton's Imperial Trans-Antarctic Expedition of 1914. So much poignancy and history in one space: it was like being in a dream. When I closed my eyes I could almost hear, as the men settled for the night, the scratching of a pencil on the underside of one of the bunks, 'RW Richardson, August 14th... Losses to date' and a list of names, 'Haywood, Mack, Smyth...'

We had stopped off in nearby McMurdo for a few days of acclimatisation and made the short trip to Cape Evans before the three hour flight to the Dark Sector Lab just 800 metres from the Pole, a place so 'Star Trek' the contrast between the two buildings was almost too enormous to comprehend. Shrouded from the ice plateau winds on the roof of a space age building, astronomical telescopes peer deep into space. Bicep 2 (and soon Bicep 3) is examining cosmic microwave radiation, an afterglow from close to the beginning of time, the Big Bang. They rely on constant conditions at the Pole and the absence of pollution. It's the closest to being in space you can get without using a rocket. The telescope's sensors are kept to just 2 degrees above absolute zero. Such technology in such a hostile environment gives a clear indication of just how far we have come as a species over the past century.

Herbert Ponting, Scott's expedition photographer, Frank Hurley, the expedition photographer with Shackleton, John Noel on Everest in 1922 and more recently film-makers like Jim Curran and Leo Dickinson all pioneered the use of cameras and film-making techniques in this most challenging of environments, following the events of some of the most epic stories ever told. Similarly, our adventure film game has seen a whole heap of change. On one hand things have become easier (no more hand-cranked film cameras), on the other they have become much more complex, driven by many factors – not least that the bar has been raised incredibly high and viewer expectation has gone stratospheric.

Adventure films, like all others, are made to entertain and engage. Often the exotic nature of adventure will transport the viewer on a journey to a far-flung corner of the planet, to a place which he or she may aspire to visit but never reach, and provide a chance to marvel at how, as humans, we are capable of pushing to new heights or depths. They inspire and educate, beg questions and, importantly, have the ability to tell a story.

The idea of following a pure adventure in a linear form is simple but the truth is that adventure films come in all shapes and sizes, dressed in as many genres as can be dreamt of: drama, documentary, travelogue...

Many of the film-making principles, story development and treatment, pre-production planning, pre-visualisation, scripting and post-production, remain relatively unchanged – except that standards have risen inexorably. From film stocks to digital resolution and rendition, from standard definition to high definition in all its flavours, to 4K and beyond – everything is so much more

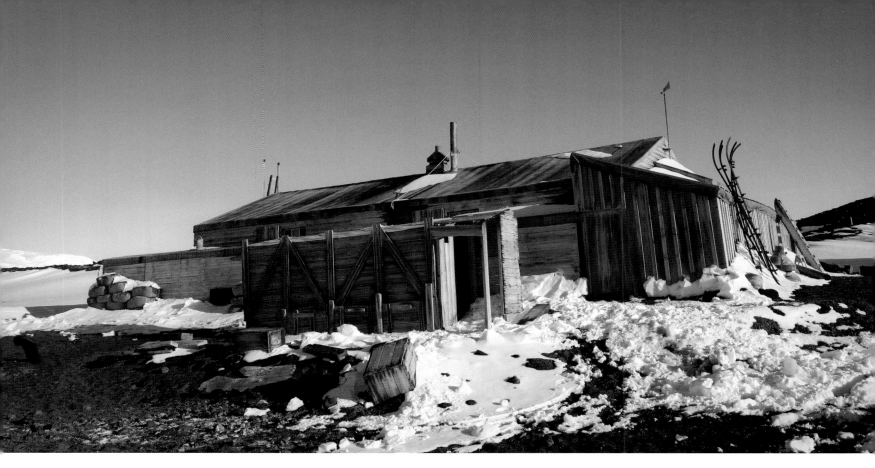

↑ Scott's Hut at Cape Evans.

↖ It was if they'd walked out yesterday.

↗ On a voyage of discovery and learning. Science 'old school'.

Film-making has always been a can of worms and in the adventure film game those worms come spring-loaded.

capable of reproducing images, with more control. Many wonder when the increase in picture clarity and colour reproduction will plateau. Like all forms of progress the answer is surely 'never'.

In some respects it is all just numbers, but to be aware of which formula to work with is vital. The whole game is a potential minefield where, to the unaware, the tail will wag the dog, where a film's paymaster will demand that a film be delivered from a shortlist of available cameras and produced to a particular technical standard. Therein lies a potential pitfall. The choice of shooting format to a given environment or style of filming may be inappropriate but demanded nonetheless, and the impact of such impositions might require a radical rethink in terms of support and team size to ensure a successful shoot.

In technology alone, the march of progress maintains a rapid pace and the arsenal of cameras and associated equipment grows every day, each with its application, advantages and disadvantages. But technology can become a hindrance to effective movement in the field and a barrier to the very thing that a film-maker sets out to capture. Impenetrable menus, poor ergonomics, size and weight all play a part in the potential success of filming adventures. Being 'zen' with a camera is all-important where its operation is second nature, an invisible, intuitive process. As with mountaineering expeditions there may be a temptation to adopt a 'siege' approach to film-making rather than a more 'alpine' style. It is, after all, possible to be weighed down so much that the project becomes too heavy to shoot, with the converse also being true where a project without the correct level of support becomes too light. The art is to decide on an appropriate approach to shooting: light, heavy, somewhere in between or an oscillation between the various approaches.

The plethora of technology available for use in the field and post-production to capture the action, build the story and entertain audiences on a wealth of different platforms is bewildering. But a camera is simply a lens mounted onto a box that records pictures and sound (most of the time) and the flavour of the month will inevitably be superseded and a has-been next month. Nowadays every camera has video capability and with the advent of intuitive editing software the democratisation of film-making is upon us. Anyone can make a film that looks and sounds good but the constant throughout the ages is that the adventure film has to hold the viewer's attention and therein lies the issue. Who is the film aimed at? Who holds the controls? Making a film for mates is all good and well but to get the film to as wide an audience as possible is preferable and may require a broader editorial stance. Funding is a huge issue, and once external money comes into a film project the commissioner will inevitably place demands on its final look and feel. As a film-maker, are you willing to sell your soul?

Audiences have also become more discerning. Production values are higher than ever but there is not necessarily a direct correlation between production cost and production value. It still takes time to develop the 'eye' and feel for the sequence of shots, understand the coverage required to offer editorial choice and to develop the repertoire of techniques necessary to bring a film of merit to the screen, not to mention a team of minds.

The final matter is where the film will be viewed. From movie theatres to online, consuming content across multiple platforms is commonplace where the monetising of a film is the final critical piece of the puzzle and distribution is the key. Arguably, the day of delivery on a physical medium such as DVD is coming to an end. As internet speeds increase so do the possibilities to stream and download.

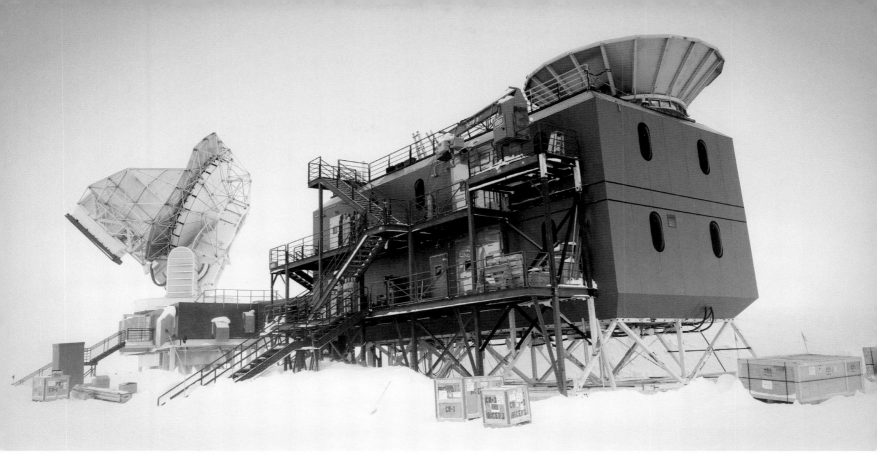

↑ *Progress. The cutting edge of deep-space telemetry. The Dark Sector Lab searches for the afterglow of the Big Bang.*

→ *Another dream is realised.*

'There's no point in being part of

↑ The International
Air Passenger Terminal,
South Pole style.

→ The Transantarctic
Mountains from the cockpit
of the C130. Next time...

→→ Hanging horizontally
filming in a world of crashing
blue. We escape the moulin.

Film-making has always been a can of worms and in the adventure film game those worms come spring-loaded. Amidst all the minefields and uphill struggles once in the field the constant for me over the past twenty years has been to strap in, stay alert and enjoy the ride.

Leaving the Dark Sector, the pilot of the US Air Force Hercules piled on the power and the plane accelerated down the ice way hurling great clouds of snow in its wake. Through a tiny round window I counted the black distance markers going by, thinking we were taking a long time to lift. The nose came up and I waited and waited, casting a glance at the load master whose wide-eyed expression was worrying. The rest of the aircraft seemed glued to the ground and the pilot eventually slammed the nose back down and hit the brakes. We stayed on the ground with the propellers turning for what seemed an eternity before taxiing out to try again. Same thing. I could almost hear above the roar of the engines the cries of 'abort, abort abort!' in the cockpit.

The load master jumped up and pushed the freight pallets to the rear of the fuselage, refixing them to the lashing points before hurling everyone's duffle bags right the way back onto the rear cargo door. Next, all twenty passengers were shifted as far back as the final row of net seating would allow. On the third attempt, with everyone's fingers crossed, including the loadmaster's, the nose came up and we felt the suck of the snow finally release the skis as we powered into the air.

As Richard Else said all those years ago when I jumped out of the helicopter on a wintery Tower Ridge, 'There's no point in being part of an adventure film team if you don't have a bit of an adventure yourself!' Long may the adventures continue.

an adventure film team if you don't have a bit of an adventure yourself!

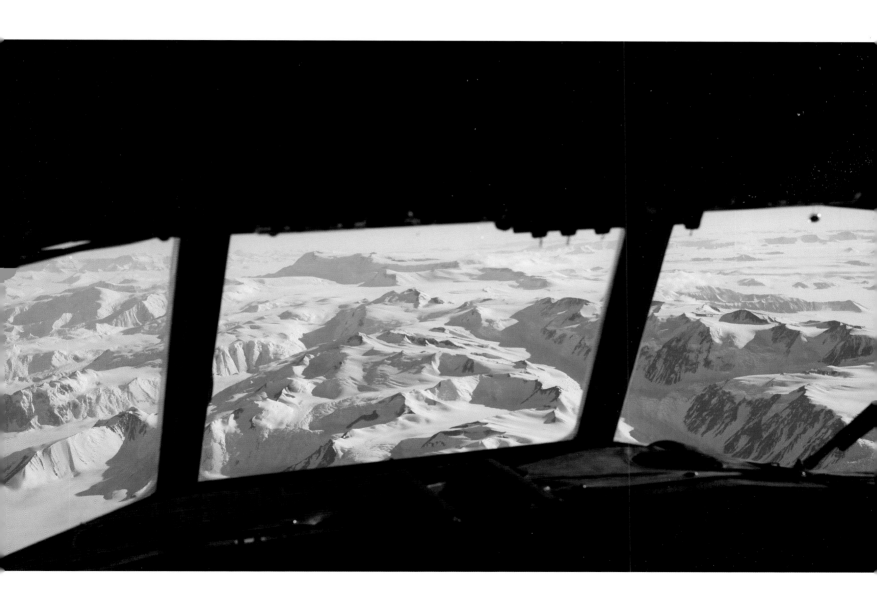

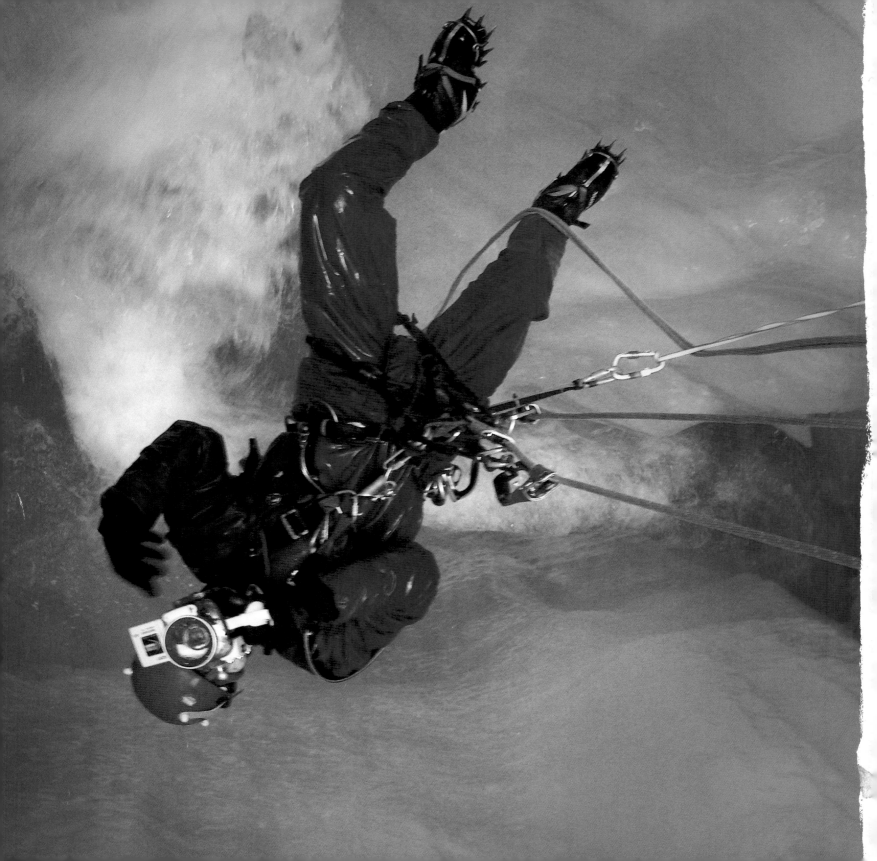